DEAD FUNNY

THE HUMOR OF AMERICAN HORROR

DAVID GILLOTA

RUTGERS UNIVERSITY PRESS

New Brunswick, Camden, and Newark, New Jersey
London and Oxford

Rutgers University Press is a department of Rutgers, The State University of New Jersey, one of the leading public research universities in the nation. By publishing worldwide, it furthers the University's mission of dedication to excellence in teaching, scholarship, research, and clinical care.

Library of Congress Cataloging-in-Publication Data

Names: Gillota, David, 1977– author.
Title: Dead funny : the humor of American horror / David Gillota.
Description: New Brunswick : Rutgers University Press, [2023] | Includes bibliographical references and index.
Identifiers: LCCN 2022046275 | ISBN 9781978834163 (paperback) | ISBN 9781978834170 (hardcover) | ISBN 9781978834187 (epub) | ISBN 9781978834194 (pdf)
Subjects: LCSH: Horror films—United States—History and criticism. | Wit and humor in motion pictures. | LCGFT: Film criticism.
Classification: LCC PN1995.9.H6 G545 2023 | DDC 791.43/6164—dc23/eng/20221117
LC record available at https://lccn.loc.gov/2022046275

A British Cataloging-in-Publication record for this book is available from the British Library.

Copyright © 2023 by David Gillota
All rights reserved
No part of this book may be reproduced or utilized in any form or by any means, electronic or mechanical, or by any information storage and retrieval system, without written permission from the publisher. Please contact Rutgers University Press, 106 Somerset Street, New Brunswick, NJ 08901. The only exception to this prohibition is "fair use" as defined by U.S. copyright law.

References to internet websites (URLs) were accurate at the time of writing. Neither the author nor Rutgers University Press is responsible for URLs that may have expired or changed since the manuscript was prepared.

∞ The paper used in this publication meets the requirements of the American National Standard for Information Sciences—Permanence of Paper for Printed Library Materials, ANSI Z39.48-1992.

rutgersuniversitypress.org

For Amanda and Isaac,
who hate horror but (thankfully) love me

CONTENTS

INTRODUCTION
Approaching Horror through Humor 1

1 **PARODYING HORROR, HORROR AS PARODY** 13

2 **CLOWNS, FOOLS, AND DUMMIES**
Horror's Comic Monsters 43

3 **PAINFULLY FUNNY**
The Humor of Body Horror 73

4 **CAMPING OUT**
Horror's Queer Humor and Gender Play 103

5 **CRINGES AND CREEPS**
Exploring Awkward Horror 135

6 **HORROR, HUMOR, AND CRITIQUE**
Satire in Horror 165

ACKNOWLEDGMENTS 197
NOTES 199
BIBLIOGRAPHY 213
INDEX 223

Introduction

Approaching Horror through Humor

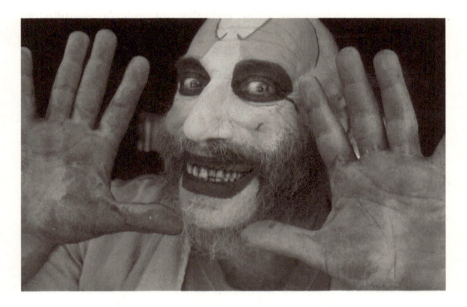

IMAGE 1: *The Devil's Rejects* (2005). Courtesy of Photofest.

Humorists, it seems, are taking over the horror genre. Most notably, in 2017, Jordan Peele—known at the time primarily for his work on the sketch comedy series *Key & Peele* (2012–2015)—released his directorial debut *Get Out*, arguably the most important horror film of the twenty-first century. The next year, John Krasinski, famous for playing Jim in the situation comedy *The Office* (2005–2013), wrote, starred in, and directed the critically acclaimed end-of-the-world monster movie *A Quiet Place* (2018). The same year saw a successful legacy sequel of *Halloween* with a story cowritten by humorist Danny McBride. Ilana Glazer, costar and cocreator of the raunchy comedy series *Broad City* (2014–2019), cowrote and starred in the *Rosemary's Baby*–influenced

False Positive (2021). *Spiral* (2021), a reboot of the brutal *Saw* franchise, stars and is based on a story concept from comedy legend Chris Rock. To this list of recent humorists-turned-horror-artists, we can add Bobcat Goldthwait, Kevin Smith, Zach Cregger, Mark Duplass, and others. While this turn toward horror is remarkable, it is not completely new; horror is full of filmmakers—James Whale, William Castle, Joe Dante, John Landis—who have proven to be fluent in both comic and scary modes.

In a way, I am following the lead of these several artists. While I am a longtime viewer and fan of horror cinema, all my previous scholarship has focused on humor. This book also focuses on humor but looks specifically at its manifestation within texts that are typically identified as horror. In doing so, I place humor as a key component of the genre, particularly as it is manifested in North American film. For many horror fans, this approach may not be of any great surprise. While there are some who see no place for comic elements within horror, a great many of horror's fans, critics, and artists acknowledge the humor of either key horror texts or the genre as a whole. Alfred Hitchcock famously asserted that *Psycho* (1960) "was a big joke."[1] Stephen King comments that there is "humor implicit in horror."[2] Carol Clover, in her landmark study *Men, Women, and Chain Saws*, notes that she discovered "in horror moments and works of great humor."[3] And Robin Wood, arguably the father of modern horror criticism, has frequently pointed out horror's humor, even going so far as to write an essay entitled "The American Family Comedy: From *Meet Me in St. Louis* to *The Texas Chainsaw Massacre*."[4] We can add to this catalog the number of previously mentioned horror artists who not only work in both comedy and horror but also bring a clear comic sensibility to their horror texts. Given these myriad examples, the humor of horror is hardly up for debate.

Largely missing from the commentary on horror's humor, however, is an account of *how* humor operates on either thematic or formal levels. *Dead Funny: The Humor of American Horror* seeks to fill that gap by offering a survey and analysis of the most important types of humor in American horror since its emergence as a recognizable genre in the 1930s.[5] I do not claim that *every* horror film has comic elements, but I find humor to be a prominent part of horror in most major periods, and examples can be found in many of the genre's most canonical works and every recognizable subgenre. I argue that horror's most significant uses of humor do not operate as so-called comic relief, in which laughable moments exist outside of a text's narrative and thematic concerns. Rather than offering relief, horror's humor often functions in tandem with horror elements

and contributes to a work's tone, themes, and structure. Quite often, comic elements occur simultaneously with traditional horror devices, or a text quickly toggles back and forth between comic and scary, creating disorienting effects for audiences. In other instances, a recognizable comic device or signifier (like a clown) is refashioned as horror. In these cases, horror texts may not necessarily generate laughter or amusement but rather use humor in their arsenal of dread-inducing devices.

Each chapter of *Dead Funny*, outlined below, views North American horror through the lens of one specific humorous mode or device: parody, comic monsters, body humor, camp, awkward humor, and satire. These comic lenses are not exhaustive, and readers will surely think of other types of humor that occur in horror. I have chosen to focus on these six, however, because they tend to recur throughout the genre's history in prominent ways and, more importantly, because their usage contributes significantly to the structure, tone, or themes of the films in which they occur. An analysis of these types of humor thus adds nuance and insight into many aspects of horror that tend to preoccupy critics: the figure of the monster, the spectacle of imperiled bodies, issues of identification, and gender and racial politics. These comic devices also reveal the genre as a space of play and fun, which may help explain its enduring popularity and large, devoted fan base. While many point out the playfulness of the genre—often by comparing horror texts to roller coasters and funhouses—there remains a small but stubborn strain of mainstream critics who see horror as inherently sadistic and view horror audiences as emotionally stunted, immoral, and misogynistic. A focus on humor does not necessarily rebuke those claims (humor, after all, can also be immoral, sadistic, and misogynistic), but a discussion of the widespread use of comic devices reveals an active and self-aware intelligence at work.

While I attempt to locate this self-aware and comic intelligence in nearly every pocket of the genre, I also recognize that individual reactions to both humor and horror tend to be subjective and varied. Not everyone will find all my examples funny. Some readers, particularly those who are not avid horror watchers, may be puzzled (or even appalled) as to how a work of shocking violence—like, say, *The Devil's Rejects* (2005)—could ever be viewed as humorous. My sense of a work's humor is derived in part from the existent critical commentary on the work and in part from my own reactions. However, the primary way in which I locate the humor of horror comes through the recognition and analysis of long-established comic devices and signifiers used in a horror context. Just as viewers can recognize a work of comedy as such even if they do not find it funny

personally, we can likewise identify and recognize the tools of humor within a horror text even if those tools don't make us laugh. Indeed, many horror texts strategically employ humor not to generate amusement but rather to add texture to the horror elements. Hopefully, though, readers will come away with a sense of the genre as a space of both fear and play.

A study such as this raises questions of terminology, genre, and inclusion. Here and throughout, I use the words *horror* and *comedy* to refer to media genres or to features that are typically understood as parts of those genres. The word *humor*, on the other hand, refers not to a genre but rather to the collection of devices (also referred to as *comic* elements) that may be used to generate amusement. *Humor*, therefore, is not genre specific and may occur within any genre. Of course, when the elements of humor become the primary aspect of a text, then it is usually considered a comedy. In this light, several but not all of the works discussed here may belong to a mixed category that critics sometimes refer to as either "comedy-horror" or "horror-comedy." *Dead Funny*, however, is not, strictly speaking, a study of this hybrid genre. My focus instead is on the ways in which humor operates in texts that are commonly understood to be just horror. The line is admittedly slippery, though, and quite often, the difference between a horror film, a horror-comedy, or just a comedy is one of emphasis or subjective experience. In my decisions about what texts to discuss, I follow Clover by focusing primarily on works that the "public senses to be 'horror'" rather than on any strict genre definitions.[6] Therefore, the texts I write about are generally listed as horror on streaming services and tend to get analyzed by horror scholars, reviewed on horror-themed websites, and discussed on horror podcasts. Following this logic of the "public sense" of horror, I do not discuss in any detail a film like *Ghostbusters* (1984), which is full of horror signifiers but operates and is understood primarily as a comedy.

Several scholars have tackled the topic of humor's horror in some form or another, but *Dead Funny* is the first full-length study. Bruce G. Hallenbeck's general interest survey *Comedy-Horror Films: A Chronological History, 1914–2008* provides a useful overview of several important films and their production histories.[7] Hallenbeck's interest, however, skews heavily toward comedy, and he passes over many of the canonical horror texts that I discuss, such as *Bride of Frankenstein* (1935), *Psycho*, and George A. Romero's zombie films. William Paul's excellent study *Laughing Screaming: Modern Hollywood Horror and Comedy* is the closest full-length antecedent.[8] Paul establishes the subgenre of the "gross-out film," which includes numerous comedy and horror films from the 1970s and

1980s. In doing so, Paul identifies important overlaps between comedy and horror, but he only rarely discusses humor *within* horror. There are also several stand-alone essays focusing on the humor within individual horror films and two recent essay collections devoted to the topic.[9] Several other critics explore issues that are closely related to horror's humor, such as Linda Williams's discussion of fun in *Psycho* or Murray Leeder's work on the playful aspects of William Castle's gimmick films.[10] Finally, and perhaps most importantly, philosopher and horror theorist Noël Carroll published a theoretical essay about humor and horror, discussed in the next section, in which he begins to tease out important overlaps in humor and horror theory. Given the number of critics circulating around the idea of horror's humor, it appears to be high time for a road map of horror's most important comic elements.

Humor and Horror in Theory

It is standard practice for books about humor to offer a summary of the dominant theories of humor (superiority, relief, and incongruity) and for books about horror to survey major critics and generic definitions. Such a rehearsal of both horror and humor theories, however, may become tedious, and the material is widely available.[11] Instead, I use this space to look at some of the key ways in which humor and horror overlap in either theory or practice. Humor and horror creators often pull from a similar toolbox of aesthetic devices, which may account for the high number of artists who have proven fluent in both comedy and horror as well as for the importance of humor within the horror genre. Furthermore, a survey of the overlaps in prominent horror and humor criticism reveals that while humor and horror scholars tend to analyze very different texts, they are often concerned with many of the same issues.

Fortunately, Carroll has already begun much of the work in outlining similarities in humor and horror theory. Carroll points out that "theories of comedy look as though they are equally serviceable as theories of horror."[12] One particular example is the Freudian influence on both humor and horror studies. In his *Jokes and Their Relation to the Unconscious*, Freud reads jokework as a process of relief from the tensions of social repression.[13] Similarly, one of the most influential theories of horror, outlined by Wood, is that the figure of the monster represents the "return of the repressed." Wood argues that "the true subject of the horror genre is the struggle for the recognition of all that our civilization represses or oppresses."[14] Freud draws a direct connection between the psychological

work of jokes and that of dreams; Wood picks up on this and argues that "horror films are our collective nightmares."[15] While we may not agree that the relief theory for humor or the "return of the repressed" theory for horror can actually account for all instances of the laughable or the horrifying, it is abundantly clear that dominant threads of both horror theory and humor theory depend heavily on Freud's conception of individual and social repression. Moreover, both humor and horror scholars are concerned with how their respective art forms explore and reflect cultural taboos and anxieties.

Humor's incongruity theory is another important avenue for the study of horror texts. Humor theorist John Morreall explains that the "core meaning of 'incongruity' in standard incongruity theories is that something or event we perceive or think about violates our normal mental patterns and normal expectations."[16] This violation of normal expectations relates closely to Carroll's theory of the horror genre as rooted in impurity. As Carroll explains, the "objects of horror . . . are impure, and this impurity is to be understood in terms of the ways in which horrific beings problematize standing cultural categories."[17] The similarities between the two theories—incongruity and impurity—are immediately evident. Carroll thus argues that "one explanation of the affinity of horror and humor might be that these two states . . . share an overlapping necessary condition insofar as an appropriate object of both states involves the transgression of a category, a concept, a norm, or a commonplace expectation."[18] The impurity/incongruity overlap may help explain why so many figures of horror (like Frankenstein's monster or Freddy Krueger) can easily be adapted as objects of humor and why so many signifiers of humor, most obviously clowns, can easily become agents of horror. Depending on context and emphasis, the same impure/incongruous figures can be either amusing or terrifying/disgusting. Many texts play on the tension between these two poles. Incongruity and impurity also help account for the ways that both humor and horror rely heavily on surprise—the incongruous subversion of expectations—in order to achieve their ends.

We can add to Carroll's account of humor and horror's overlaps several other elements. Most obviously, both comic texts and horror texts are affective in that they strive for—and their success is often gauged by—specific emotional or physical reactions from audiences. While they are not typically discussed this way, most theories of humor are implicitly affective, as they attempt to explain how and why comic artifacts trigger the response of laughter.[19] As Leeder points out, there has also been a recent "affective turn" in horror studies, wherein many scholars move away

from psychoanalytic readings or discussions of plot and character in order to focus instead on the manner in which horror texts affect audiences.[20] Anna Powell, for example, notes that "excessive forms of cinematography, *mise-en-scène*, editing and sound are the pivotal tools of horror, used to arouse visceral sensations."[21] While the "tools of horror" may look very different from the devices of humor, it is worth noting again that both tend to rely on elements of surprise, incongruity, and the mechanisms of building and (possibly) releasing tension. In her famous essay on body genres, a precursor to horror's "affective turn," Linda Williams asserts that in horror, as in pornography and melodrama, the goal is to have audiences mimic the emotional states of on-screen characters, whereas in comic texts, the audience's laughter signifies an emotional detachment from the plight of on-screen characters.[22] In general, Williams's thesis makes sense, but in practice, many horror texts and comedies don't adhere to the formulation. Several horror films, as I discuss in chapters 1 and 3, encourage the sort of audience detachment that is usually associated with humor, and many comic texts, as I discuss in chapter 5, work to make audiences markedly uncomfortable. Several other texts discussed throughout this work establish a playful tension between horrifying and amusing their audiences.

The issue of audience detachment brings up another important overlap. Both humor and horror scholars often foreground issues of perspective and audience identification. In humor theory, this is usually traced to philosopher Henri Bergson, who identifies detachment as a key feature of the comic and asserts that if we "look upon life as a disinterested spectator," then "many a drama will turn into a comedy."[23] Other humor scholars emphasize the ways in which humor can be used to either reinforce communal interests or construct exclusionary boundaries, depending on audience perspective.[24] The issue of perspective and audience identification is also of utmost importance to scholars working in horror studies. Wood's formula for the horror genre, normality threatened by the monster, is implicitly concerned with who and what is included in the category of "normality" and may account for the many marginalized individuals who are more likely to identify with horror's monsters than with its status-quo-enforcing victims or heroes. Clover has provided an extended discussion of perspective in horror in her argument that horror texts encourage shifting identificatory practices, asking viewers to identify at times with the monster and in other moments with the hero—most famously the final girl of slasher films.

There are several other places where horror and humor overlap. As discussed in chapter 3, both horror and comedy tend to be concerned with

bodies, particularly with those elements of physicality—linked to repression and impurity—that many other genres ignore: blood, urine, feces, and vomit. This physical preoccupation is certainly not true of all comic or horror texts, but the representation of bodies in peril is quite common in both horror and comedy. This points to another important similarity: both humor and horror tend to be viewed, in mainstream discussions, as lowbrow and disposable. It is a rare event when comedies or horror films get critical recognition or nominations for major awards. In many ways, then, this study focuses on the least respectable aspects of one of the least respectable genres. As I hope to show, however, it is through humor that horror texts often reveal their intelligence, creativity, sense of play, and social commentary.

The Scope and Structure of This Book

Dead Funny is primarily a study of the uses of humor within North American horror from the 1930s until today. The central focus is film, but I do discuss some television texts and occasionally provide examples from other media, just as I also sometimes provide brief examples from outside of North America or from before the 1930s. The majority of books that analyze a particular theme or issue within horror tend to adopt a chronological structure, which allows the authors to trace important period trends and ideological differences from one era to another.[25] In contrast, I opt for a thematic structure, in which each chapter focuses on a particular type of humor or, in the case of chapter 2, a particular figure within horror. I take historical context into account within the chapters, but in contrast to other texts about horror, I focus more on continuity within the genre's history than on major breaks and changes. While some types of humor (like satire) are more prevalent in the modern era, the humor of American horror is remarkably consistent. The thematic approach thus allows us to look in detail at the particular comic devices that horror texts employ and the specific ways in which humor and horror often operate in tandem.

Chapter 1 discusses horror and parody. I argue that parody—defined as repetition with comic difference—is not only something done *to* horror texts but also found *within* horror itself. I first discuss the devices of various comedies—like *Young Frankenstein* (1974) and *Scary Movie* (2000)—that parody horror texts. I then outline how those same devices recur within horror as self-parody. This self-parody occurs through the comic repetition of key horror tropes and icons as well as through self-reflexive

elements that highlight a text's constructedness. There are also horror parodies, like Joe Dante's *Piranha* (1978), which operate as horror but also comically rework the elements of a specific horror text (in this case, *Jaws* [1975]). In the final section, I turn to works of horror that parody nonhorror genres, often offering a critique of their perceived safety. A key example in this section is Wes Craven's *The Last House on the Left* (1972), which is a brutal horror film that also parodies television sitcoms and other family-friendly genres. These varied instances of parody encourage audience detachment and reward audiences who are fluent in horror's codes. They also lay the groundwork for many of the other comic devices discussed throughout this book.

The next chapter focuses on the most important feature of horror: the monster. I identify three types of comic monsters—clowns, fools, and dummies—and relate them to humor theories that focus on repression and on the ways in which humor can be used as a form of boundary construction. I expand the category of the evil clown to include not only those monsters—like Pennywise from Stephen King's *It*—that look like traditional circus clowns but any monsters that display a performative comic sensibility. Monstrous clowns thus transform comic performance into horror, but like traditional clowns, they mock social institutions and upend traditional values. Key examples here include Freddy Krueger from the *Nightmare on Elm Street* series and the Firefly family (who name themselves after Groucho Marx characters) in Rob Zombie's *The Devil's Rejects*. In contrast to the laughing clown, monstrous fools are the objects of laughter. They may be laughed at by audiences or by other characters, but from their own point of view, they are not humorous at all. Important monstrous fools include Frankenstein's monster in the Universal films, the titular monster in *Carrie* (1976), and Annie Wilkes in *Misery* (1990). For the final category, the figures of the clown and fool are somewhat merged in the duo of the ventriloquist and his evil dummy. Ventriloquist dummies are rooted in comic performance, but in horror, their comic energy is also linked—either literally or symbolically—to the repressed violent and sexual impulses of the puppeteer. My discussion of all three types of comic monsters relies on Wood's definition of horror as "normality threatened by the monster." By tracing the ways in which these various monsters laugh, are laughed at, or are laughed with, we can develop a clearer conception of the relationship between "normality" and the monster in various texts.

Chapter 3 turns to comic representations of the body in horror. This chapter complicates discussions of body genres by looking at the manner

in which body horror texts use humor even as they simultaneously horrify or "gross out" audience members. The mixing of humor with body horror suggests an ambivalence in regard to wounded, deformed, and monstrously transformed bodies. I explore an early example of this ambivalence in Tod Browning's *Freaks* (1932) before turning to humorous, effects-driven "splatter" films, such as *Re-Animator* (1985), *Evil Dead II* (1987), and others. Next, I turn to horror's comic bodily transformations. I offer a reading of Jack Arnold's *The Incredible Shrinking Man* (1957) as a comic masculinity crisis and then move to later transformation horror films such as *An American Werewolf in London* (1981), *Ginger Snaps* (2000), and others. The final section considers the overlap between slapstick comedy and body horror. Key to this discussion are the *Final Destination* films. This franchise is built around a series of elaborate slapstick set pieces, which inevitably end in a character's violent death. Taken together, these films' linking of body humor and horror suggests an uneasy and ambivalent attitude toward our own fragile and mortal bodies.

Chapter 4 focuses on horror's use of queer humor or camp. In horror criticism, *camp* is a term that is frequently used but rarely defined. I adopt Moe Meyer's definition of camp as "queer parody" in order to discuss the ways in which horror texts use highly exaggerated performance strategies, include comic and sexualized double entendres, or feature elaborate plots revolving around gender confusion. These devices often mock the tropes of "straight" horror films or otherwise critique rigid conceptions of gender and sexuality. I focus first on the camp elements in James Whale's horror films and then move on to the camp performance strategies of actor Vincent Price. These earlier films often depend on sly winks and nudges for viewers who are attuned to a text's queer sensibility. In later horror films, the queer elements become more overt but are often quite confused. *A Nightmare on Elm Street Part 2* (1985), for example, vacillates between camp play and blatant homophobia. More recent texts like *Seed of Chucky* (2004), *Jennifer's Body* (2009), or the television series *American Horror Story* (2011–) wear their gender play on their sleeve and explicitly foster a camp aesthetic. In the final section, I briefly discuss the myriad films that, following the lead of Hitchcock's *Psycho*, feature cross-dressing or trans-coded monsters. While many of these films are manifestly transphobic, I single out two to read as camp: William Castle's *Psycho* rip-off *Homicidal* (1961) and the slasher *Sleepaway Camp* (1983).

The fifth chapter considers the frequent use of awkward social humor, or cringe comedy, in the horror genre. This sort of humor is driven by the unflinching portrayal of extremely awkward or embarrassing social

situations and often fosters feelings of intense discomfort. Awkward humor is perhaps best exemplified in TV shows like *The Office* or *Curb Your Enthusiasm* (2000–). There are, however, a surprising number of important horror films that employ awkward humor. In particular, many horror films use the comic transgression of social rules and boundaries to prefigure violent bodily violations that occur later. This trend sheds light on larger cultural anxieties about cultural differences or the disruption of social norms. I first look at early examples of awkwardness in *The Old Dark House* (1932) and *I Walked with a Zombie* (1943). Awkward horror became much more common, however, in modern film, as I demonstrate through close readings of key scenes in texts ranging from *Psycho* and *The Texas Chain Saw Massacre* (1974) to more recent critically acclaimed movies like *Get Out* and *Midsommar* (2019). The final section turns toward found footage horror and looks at overlaps between found footage and mockumentary formats. I provide a close analysis of the two *Creep* films (2014 and 2017), which blend found footage horror with the devices of the comic mockumentary to create a uniquely funny and unsettling experience. While horror most often deals with threats to our physical bodies, the widespread use of cringe comedy in horror films reflects our anxieties primarily as social creatures.

The final chapter turns to horror and satire. Satire, one of the most celebrated comic modes, comprises works that use humor to provide a social critique and promote the possibility of change. As humor scholars point out, this results in a paradoxical structure in which satirical works are simultaneously humorous and serious. In satirical *horror* texts, this paradoxical structure is compounded, as works are simultaneously humorous and frightening even as they offer social critique. The most prominent examples of satirical horror occur after the 1960s, but precursors can be found in the work of literary satirists like Mark Twain and Jonathan Swift. The most important figure in satirical horror, and in this chapter, is George A. Romero, who both invented the modern zombie film and brought an explicit social consciousness to the genre. In his apocalyptic zombie films, Romero blends horror tropes with a subversive comic sensibility in order to satirize American media, consumer culture, the Vietnam War, and racial and gender politics. I discuss Romero's influence on other late-twentieth- and twenty-first-century horror films before turning to Romero's satirical heir, Jordan Peele. Peele's *Get Out* and *Us* (2019) mix humor and horror to highlight and critique systems of American inequality, and the influence of Peele's work on contemporary horror is already apparent.

Throughout the chapters, I give numerous brief examples but also single out a handful of texts to look at more closely. The goal of this approach is both to give a sense of the frequency with which a particular comic device recurs throughout horror's history and to provide in-depth discussions of key films. When possible, I provide examples from well-known and canonized texts in order to demonstrate the breadth and frequency of a comic device and thus the centrality of humor to the genre as a whole. Some texts are also discussed in multiple chapters. While I strive to account for all American horror's periods and subgenres, *Dead Funny* is neither encyclopedic nor exhaustive. Readers fluent in the genre will certainly think of examples and important films that I do not discuss or that are mentioned only in passing. I thus hope that *Dead Funny* spurs further research into horror's humor and into works that are not discussed here.

CHAPTER 1

*Parodying Horror,
Horror as Parody*

Mel Brooks's *YOUNG FRANKENSTEIN* (1974) is undoubtedly one of cinema's most famous and respected parody films. Many critics consider it to be Brooks's best work and, along with *The Producers* (1967), it was given a second life as a Broadway musical. Significantly, *Young Frankenstein* is not only a parody of the Universal *Frankenstein* films; it is also something of an unofficial sequel, as various elements suggest it takes place in the same fictional universe as the original cycle. In the film, Victor Frankenstein (Gene Wilder) initially wishes to distance himself from his grandfather, the original mad scientist, but eventually repeats his ancestor's experiments in bringing the dead back to life. As in earlier sequels like *Son of Frankenstein* (1939) and *Ghost of Frankenstein* (1942), local villagers are haunted by memories of the first resurrected monster and distrust the Frankenstein name (despite Victor's insistence that he pronounces it *Fronkensteen*). The sense of narrative continuity is reinforced visually through black-and-white cinematography and a shadowy mise-en-scène. The laboratory scenes even utilize many of the same props from the 1931 film. As both spoof and sequel, *Young Frankenstein* is thus canon and anticanon.

We could make a similar point about several other horror parodies. The first Universal monster parody, *Abbott and Costello Meet Frankenstein* (1948), also takes place in the same universe as the classic monster films and features Bela Lugosi, Lon Chaney Jr., and Glenn Strange reprising their iconic roles as Dracula, the Wolf Man, and Frankenstein's monster. More recently, Dan O'Bannon's zombie parody *The Return of the Living Dead* (1985) implies through its title that it is a sequel to George A. Romero's *Night of the Living Dead* (1968), and a character explains that *Night* was actually based on a true story, in which a toxic gas created a similar zombie attack to the one in the parody. An even more overt connection to a canonical horror text occurs in the parody *Repossessed* (1990), in which

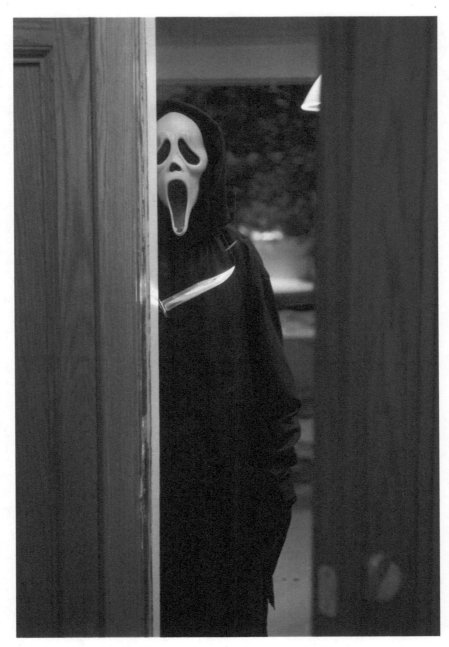

IMAGE 2: *Scream 4* (2011). Courtesy of Photofest.

a housewife is taken over by the same demon who had possessed her during adolescence. Technically, the film does not occupy the same universe as *The Exorcist* (1973), but it recasts its star Linda Blair as the possessed victim, and early flashback footage evokes the original film. Like *Young Frankenstein, Repossessed* thus simultaneously parodies its target text and continues its narrative.

This frequent, close relationship between horror parodies and their target texts reveals (probably unintentionally) an affinity between the horror genre and the parodic mode. The fact that parody films are able to weave themselves so easily into the fictional worlds of classic horror suggests that the genre is inherently open to parodic discourse. Indeed, many of the parodied horror films mentioned participate in a more subtle form of parody themselves. The first *Frankenstein* sequels make several comic references to the first film, and Romero's zombie films also parody themselves as well as news broadcasts, slapstick comedies, and other forms of popular culture. *The Exorcist* is certainly less parodic, but even here, the offensive antics of the demon Pazuzu, who possesses the young Regan (Linda Blair), often operate as a parodic commentary on Catholic rituals.

This chapter thus argues that not only is parody something that is done *to* horror texts by films that are primarily marketed and understood as comedies but parodic humor also frequently occurs within horror texts themselves. The use of parodic devices throughout the horror genre is frequent enough to see parody as an important recurring feature. Of course, as I discuss in the introduction, genres are inherently impure, and the line between comedy and horror is often slippery. The use of parody, however, can be found quite frequently in numerous canonical horror texts that most viewers place firmly and unambiguously within the horror genre proper. In outlining this argument, I first detail the most common devices of cinematic parody and look at their application in various parodies of horror. I then turn to a series of texts that are more commonly understood as horror and illuminate the ways that they utilize the same parodic devices as comedy films. In horror films, this sort of parody operates in two important ways. First, there are numerous self-reflexive horror texts that parody either themselves or other well-known works of horror. Second, many horror texts parodically target other media genres (like the family sitcom or the musical) in order to destabilize their perceived safety or critique their ideology.

An understanding of parody's centrality to horror reveals something of the formal and structural operations of various horror texts and may also shed light on the often-debated pleasures that horror offers.[1] Furthermore,

the widespread use of parodic devices throughout the genre's history helps situate horror texts within a space of play, or what John Morreall calls a "play mode," in which audiences may be emotionally disengaged from narrative events and thus feel free to laugh.[2] This sort of emotional distance is of course often associated with dominant humor theories.[3] Parodies, as outlined below, call attention to themselves as constructed texts, and this self-reflexivity encourages audiences to view them from such a position of detachment. Horror's "play mode," established through its parodic elements, lays the groundwork for many other comic devices that can be found throughout American horror and that are discussed throughout this book.

Defining Parody

Like many terms associated with humor, *parody* is not always easy to precisely define. For the purposes of this chapter, I identify parody as "a form of repetition with comic difference." This definition is adapted from Linda Hutcheon, who sees it as "a form of repetition with ironic critical distance, marking difference rather than similarity."[4] For Hutcheon, humor is not a requirement of parody, and its "ironic critical distance" need not be comic or amusing.[5] In contrast, I choose to emphasize parody's comic potential—in part because humor is the focus of this project and in part because most common understandings see parody as a comic mode. Dan Harries, for example, focuses specifically on film parody and argues that a parodic text's juxtaposition of similarity to and difference from a target text generates incongruity, one of the primary theories for explaining humor. Harries goes on to assert that "*any* incongruency can be potentially funny and therefore, all parodies must be considered to at least have the potential to be comical."[6] Whether this comic potential is fully realized depends on various factors, particularly on viewers' prior knowledge of a parody's target text or genre.

My working definition of parody as "repetition with comic difference" also de-emphasizes the evaluative or critical aspect that some critics choose to stress. Simon Dentith, for example, sees a "deliberate evaluative intonation" and "implicit criticism" in parody.[7] Dentith suggests that this "implicit criticism" may be directed either at the target text or outward, "towards the 'world.'"[8] I agree that a great many parodic texts (probably the majority) are in some manner critical either of their target texts or of something outside them (in which case, the parody may be used for satirical purposes). I do not, however, see it as a requirement. In Mel

Brooks's Hitchcock parody *High Anxiety* (1977), for example, the shower scene from *Psycho* (1960) is imitated, but a harmless rolled-up newspaper comically replaces the deadly knife from the original film. Newspaper ink circles the drain instead of blood, and so forth. The scene clearly intends to be funny, and Brooks's direction evinces an understanding and appreciation of the original shower scene's mechanics. One is hard-pressed, however, to discern any *critique* of Hitchcock nor any outwardly directed satirical thrust. Rather, as in *Young Frankenstein*, Brooks's comic imitation of his target is more affectionate than critical, the parody operating as a comic tribute rather than an evaluative commentary.

Examples like these certainly raise questions about how best to differentiate parody from other allusive forms, like pastiche, homage, or imitation. For Hutcheon, the deliberate marking of difference is a key feature of parody and the primary way to separate it from pastiche or imitation, which both emphasize similarity.[9] This distinction works for my purposes as well, with the only caveat being my emphasis on the parodic text's potential to generate humor. Even so, there may often be moments when the potential for humor is more apparent for some viewers than others, especially if we are looking at the comic uses of parody within a genre, like horror, where humor is often not the most prominent aspect. For this reason, I begin by considering horror parodies that are unambiguously comic and then turn to the horror genre itself to identify the ways in which numerous horror texts utilize those same parodic devices in less overt ways.

Parodying Horror

Building on Rick Altman's semantic/syntactic approach to film genres, Harries provides a useful framework for understanding the mechanics of film parody. For Altman, film genres have easily identifiable semantic or lexical elements, such as props, character types, settings, costumes, and so on. The syntax of genre films, on the other hand, comprises the manner in which those semantic elements are arranged to form a plot or narrative.[10] As Harries explains, "Parody generates both similarity and difference . . . by faithfully replicating either the syntax or the lexicon of the target text while altering the other dimension."[11] The juxtaposition of familiar genre features with distorted elements generates incongruity, which in turn has the potential to generate humor. Along with humor, the parody also has the potential to critique the target text or genre or to reveal "the structural configurations of any textual entity or canon."[12]

One does not have to look far to see this parodic formula in practice. Many horror parodies follow fairly straightforward horror plots but nonetheless generate humor by transforming certain character types—usually either monsters or potential victims—into something comic or ridiculous. This is the approach used in the Abbott and Costello monster parodies as well as in earlier films like the Bob Hope vehicles *The Cat and the Canary* (1939) and *The Ghost Breakers* (1940). In these films, the monsters and villains are played in a fairly straightforward manner, but the comic personalities of Bob Hope or Lou Costello create an incongruous juxtaposition that comically deflates the monsters' threats. We see this in the Wolf Man's first transformation scene in *Abbott and Costello Meet Frankenstein*. Here, Wilbur (Costello) takes a phone call from Lawrence Talbot (Lon Chaney Jr.). Midway through the call, Talbot transforms into a werewolf. As the film cuts back and forth between Wilbur and the werewolf, humor is generated through the incongruity of the werewolf's monstrousness and Wilbur's responses. At one point, for example, Wilbur says, "You'll have to get your dog away from the phone. I can't hear a word you're saying." Other parodies, like *Attack of the Killer Tomatoes* (1978) or *Killer Klowns from Outer Space* (1988) follow a similar formula by having serious heroes and victims face off against comically ridiculous monsters. (See chapter 2 for a detailed discussion of comic monsters.)

Other horror parodies make smaller lexical changes by comically distorting props or costuming. The slasher parody *Student Bodies* (1981), for example, mimics the first-person camera of films like *Halloween* (1978) and *Friday the 13th* (1980), and in an early scene, we see from the killer's point of view as he chooses his murder weapon. In this case, though, the killer bypasses the expected choices like a knife or hatchet and instead opts for a paper clip. Underscoring the incongruity of the choice, dramatic music plays the moment we see a gloved hand pick up the paper clip. In other instances, a generically appropriate prop may generate a humorously unexpected response. In Roman Polanski's *The Fearless Vampire Killers* (1967), for example, a woman attempts to fend off a vampire by brandishing a cross. The vampire, however, comically signals his Jewishness by exclaiming, "*Oy vey*, have you got the wrong vampire!" Both examples generate humor through their juxtaposition of familiar and distorted horror elements.

In other cases, syntactic changes are stressed, especially when a parody closely follows the narrative of a particular target text but then comically distorts specific plot elements. In *Young Frankenstein*, for example, the monster (Peter Boyle) visits the cottage of a blind hermit (Gene

Hackman). In most respects, the scene closely follows a similar scene in *Bride of Frankenstein*. While in *Bride* the hermit and the monster enjoy a cigar and a goblet of wine together, in *Young Frankenstein* slapstick pratfalls ensue, as the blind hermit spills hot soup on the monster and lights his thumb on fire instead of his cigar. We see similar syntactical distortion in Keenan Ivory Wayans's *Scary Movie* (2000), whose plot parodies the 1990s teen slashers *Scream* (1996) and *I Know What You Did Last Summer* (1997). In one scene that closely resembles a similar moment in *Last Summer*, the group of teenage friends accidentally hits a man with their car. As in *Last Summer*, the protagonists debate how to best handle the situation. In *Scary Movie*, however, the man who was hit stands up and tries to tell the teens that he is uninjured. They are too busy arguing, however, and do not hear him. Soon, they accidentally knock him out again with a bottle and dump his body into the ocean. The moment highlights and comically exaggerates the self-involved and clueless behavior of teenage slasher protagonists.

Parody films also frequently make comic use of horror iconography. Steve Neale defines iconography loosely as "the objects, events and figures in films," but goes on to point out that discussions of iconography are particularly useful to "stress the visual aspects of popular films."[13] In horror, Jason's hockey mask, Freddy's glove, and the recognizable appearance of Dracula or Frankenstein's monster are key icons, as are important horror performers like Boris Karloff, Vincent Price, and Jamie Lee Curtis. Horror parodies frequently make comic use of these sorts of icons. This can occur through the casting of a well-known horror star (like Linda Blair in *Repossessed*) or through a deliberate retooling of an iconic monster or character. *Scary Movie*'s killer, for example, clearly parodies Ghostface from the *Scream* franchise. Throughout the film, however, the iconic white mask continuously and comically changes facial expressions to reflect the killer's mood or mental state. The earlier haunted house spoof *Saturday the 14th* (1981) revels in such iconographic play, even featuring a final battle between a vampire (Jeffrey Tambor) and Professor Van Helsing (Severn Darden). In this case, though, Van Helsing is actually the villain, and the vampire tries to protect the world from his evil plot.

By calling attention to a genre's iconic, thematic, and structural elements, parody films are also highly self-reflexive. Occasionally, this metacinematic aspect is pushed into the foreground as their comic distortions include various signals to their own (and thus their targets') textuality. Perhaps the most famous and prolonged instance of self-reflexive parody occurs in the finale of Brooks's western spoof *Blazing Saddles* (1974), in which the narrative first

spills over into the studio where *Blazing Saddles* is being filmed and then, later, the film's characters actually watch *Blazing Saddles* from a movie theater. We see similar fourth-wall-breaking devices used in a number of horror parodies. In the first sound version of *The Cat and the Canary*, for example, Bob Hope's character Wally Campbell is an actor, and he frequently discusses the film's events as if they are occurring in a play and refers to the main character Joyce (Paulette Godard) as "the leading lady." A more overt moment of metacinema occurs in *Repossessed* when the demon, attempting to impress exorcist Jebedaiah Mayii (Leslie Nielsen) with its power, makes "the film break." On-screen, we see film appear to catch in the projector and then melt. The moment reminds viewers that both *Repossessed* and its target text *The Exorcist* are cinematic constructions.

The various devices enumerated here display the manner in which horror parodies generate humor by distorting certain elements either of the horror genre as a whole or of specific horror texts. These films, however, operate primarily as comedies, and the involvement of recognizable comic personalities like Leslie Nielsen, Mel Brooks, or Keenan Ivory Wayans underscores this fact. Many of these same devices, however, can also be found—albeit in a more subtle manner—in numerous texts that operate and are understood primarily as horror. Unlike most other parodied genres, horror is itself often parodic and self-aware.

Parody in Horror Part 1: Horror Icons

The horror genre—as many critics have pointed out—is inherently self-reflexive and has long utilized intertextual and allusive devices.[14] The popular *Scream* franchise—discussed in the next section—is most famous in this regard, and its success ushered in a wave of explicitly self-referential and comic horror films, like *Behind the Mask: The Rise of Leslie Vernon* (2006), *The Cabin in the Woods* (2011), *The Final Girls* (2015), and *Scare Package* (2019). Even four years before *Scream*'s release, however, Carol Clover noted that the "case could be made for horror's being, intentionally or unintentionally, the most self-reflexive of cinematic genres" and that "horror talks about itself."[15] Along similar lines, Valerie Wee argues that while self-reflexivity is the "actual *text*" of the *Scream* franchise, it was a common "subtext" of numerous earlier horror films.[16] In this light, *Scream* and its ilk emerge not only as revisionist and parodic challenges to earlier horror but also as films that playfully emphasize one long-standing aspect of the genre.

Parody, as has been established, is also allusive and inherently self-reflexive. By calling attention to the structured nature of their target texts

or genres, parodies also call attention to their own textuality. This does not mean that all self-reflexive and allusive works are also parodic. In our working definition of parody, humor—or at least the possibility of it—is also necessary and is typically generated through the incongruous juxtaposition of similarity and difference. In other words, not all self-reflexive horror texts are necessarily humorous or parodic. Nevertheless, there are numerous horror texts whose self-reflexive or allusive elements do generate humor and operate parodically. And even when the source of humor is not immediately clear to some viewers, there is evidence to suggest that experienced horror fans may still laugh or be amused simply by recognizing an intentionally allusive or self-reflexive moment. One of the main ways through which horror texts speak to these experienced viewers is through the playful retooling of horror iconography.

As Hutcheon, Harries, and others have pointed out, successful parody relies in large part on viewers' recognition of similarity to the parodied text or genre. Building off literary theorist Stanley Fish, Harries notes how "getting" all the jokes in a parodic text may depend on membership in an "interpretive community" that is fluent in the specific grammar and devices of the text or genre being parodied.[17] Dedicated horror fans very much form such an interpretive community. Matt Hills, for example, considers online message boards and notes how horror fans construct themselves as connoisseurs, viewing horror texts from a position of knowledgeable detachment.[18] Detachment, as previously mentioned, is also often theorized as a key way of experiencing the pleasures of humor. In a personal essay about being part of horror fandom, film critic Mark Kermode discusses this audience detachment and links it directly to humor and laughter. Calling attention to horror's self-reflection, Kermode notes that "More than any other genre, horror movies play to and feed upon the knowledgeability of their fans."[19] One of the ways that horror texts do this is through the playful use of an iconic horror personality, visual element, or line of dialogue. Kermode, for example, describes how the "correct response" to a film cameo from special effects wizard Tom Savini was a "knowing laugh" or how he and another viewer "chuckled smugly" at David Cronenberg's portrayal of a doctor in his own film *The Fly* (1986). Kermode goes on to note, in a manner that stresses horror's tendency to reuse its own iconography, that "to the horror fan, a chainsaw is not a threatening weapon—it's a magical talisman conjuring up a heritage of horror." Recognizing these various references and allusions becomes a "rarified form of 'getting the joke.'"[20]

Despite Kermode's emphasis on laughter, the sort of cameos and allusions that he describes do not initially appear to be jokes or to operate as

humor, and they will likely not be funny for casual horror viewers. However, the repetitive nature of a cinematic allusion combined with its ability to cause laughter within horror's "interpretive community" does fit nicely with our working definition of parody as "repetition with comic difference." Furthermore, horror's allusive and parodic elements help situate many horror texts within a detached "play mode," in which audiences can view a work's otherwise horrifying elements from a position of detachment.[21] This playful aspect of horror films is similar to Thomas M. Leitch's discussion of Alfred Hitchcock's cameos. Leitch describes Hitchcock's cameos as a game ("find the director") and argues that they "provide an additional source of pleasure for sharp-eyed audiences, and both director and audience are called on to exercise considerable ingenuity in devising and recognizing these cameos."[22] Like Hitchcock, the horror genre as a whole plays a similar game with audiences and provides competent viewers with an "additional source of pleasure," which—as Kermode makes clear—often results in appreciative laughter.

We can see sources of this appreciative laughter throughout the genre's history, as horror continuously and parodically reframes its own iconography. When critics discuss horror's self-reflexivity, they tend to focus most heavily on "postmodern" horror, generally during the 1980s or later, and especially after the emergence of *Scream*. Horror films have been parodic, however, since at least the 1930s, when the first stable of horror icons—Universal's monsters—entered the public consciousness, and many of Universal's horror films engaged in a sort of iconographic self-parody. The most famous moment in James Whale's *Frankenstein* (1931), for example, is undoubtedly the laboratory scene when, upon seeing the monster awaken, Dr. Frankenstein (Colin Clive) yells, "It's alive!" The line is repeated in some manner at least six times throughout the first sequel, *Bride of Frankenstein*. For example, when the villagers think that Dr. Frankenstein himself has been killed, his movement prompts the comic servant Minnie (Una O'Connor) to scream, "He's alive!" In the laboratory scene, as Drs. Frankenstein and Pretorius (Ernest Thesiger) attempt to animate the monster's potential mate, Dr. Frankenstein yells, "She's alive!" These and other repetitions of the famous line depend on viewers' familiarity with the first film, but as in parody, the context is different enough in each case to generate incongruity and potential humor. In other words, *Bride of Frankenstein* (like the more overtly parodic *Young Frankenstein*) operates as both a sequel and parody. *Bride* anticipates several other horror sequels that parody the originals. *The Texas Chainsaw Massacre 2* (1986), for example, not only comically exaggerates

many of the characters and features from the first film but also ends with victim/hero Stretch (Caroline Williams) wielding a chain saw above her head while spinning around. The moment operates as a parodic inversion of the original's ending, in which the monster Leatherface (Gunnar Hanson) performs the same action.

Filmmakers during the classic horror era recognized the iconic potential of not only monsters like Dracula, the Wolf Man, and Frankenstein's monster but also performers like Karloff, Lugosi, and Chaney. Very often, these performers were ripe for parodic play. Edgar Ulmer's deeply weird *The Black Cat* (1934), for example, had a marketing campaign built on the pairing of Karloff and Lugosi,[23] and the film itself makes a parodic nod to *Frankenstein* when Karloff's character Poelzig is first introduced. Poelzig is lying in bed, and his servant announces a visitor's presence. Filmed in silhouette from the side, Poelzig slowly sits up, with his back unusually straight. The silhouetted profile clearly evokes *Frankenstein*'s monster, and the fluid, straight-backed motion through which he sits up recalls the scene in *Frankenstein* when Karloff's sleeping monster slowly awakens to kill Dr. Waldman (Edward Van Sloan). Poelzig is *The Black Cat*'s primary villain but otherwise shares nothing with Frankenstein's monster. Nonetheless, Ulmer shows his awareness of Karloff's iconic value and references his most famous role to introduce and frame the villain.

MGM's *Mark of the Vampire* (1935) takes a more overtly parodic approach to Lugosi's iconic persona. The film marks the reunion of Lugosi with *Dracula* director Tod Browning, and for most of its sixty-minute runtime, it feels something like a retread of *Dracula*. The plot details a murder investigation, and Professor Zelen (Lionel Barrymore)—a Van Helsing–like expert in the occult—suspects the victim was killed by a vampire. Naturally, suspicion falls on Lugosi's character, Count Mora, and his creepy, pale daughter Luna (Carroll Borland). Browning recaptures the haunting atmosphere of *Dracula*, and Lugosi's Count Mora is indistinguishable from Count Dracula with the exception of a black spot—the titular mark—on his face. In the climax, however, a sudden reversal reveals that the vampire plot was all an elaborate ruse (which also involves hypnosis) to trick the real murderer into confessing. "Count Mora" and his daughter are actually hired actors, working with investigators. Once the ruse is revealed, the ominous tone shifts to comic, and in the final metacinematic scene, Lugosi's character proclaims to his fellow actors, "This vampire business, it has given me a great idea for a new act! Luna, in the new act, I will be the vampire! Did you watch me? I gave all of me! I was greater than any *real* vampire!" His colleagues are unimpressed,

and the film ends. In retrospect, the entire movie feels like an elaborate set up to a punchline about Lugosi playing an actor who is playing a vampire. Within only four years of the release of *Dracula*, Lugosi's iconic status was already ripe for parody.

We can see a similar parodic impulse in the casting of particular actors in horror films. Universal Studios, for example, would often cast one iconic actor in a role that had already been made famous by another. Both Chaney and Lugosi had a turn as Frankenstein's monster in *Ghost of Frankenstein* and *Frankenstein Meets the Wolf Man* (1943), respectively. Chaney also took a shot at a vampire—the comically named Count Alucard—in *Son of Dracula* (1943). *House of Frankenstein* (1944) features Karloff not as the monster but instead as the mad doctor figure, cementing the conflation of scientist and monster suggested in the earlier films. This mashup of roles is inherently playful and presents the Universal monsters and stars as existing in a sort of studio toy box. The repetition of icons and stars anticipates the explicitly parodic turn that the Universal monster films would take in the Abbott and Costello cycle as well as the intentionally ironic casting of horror icons that we see in later films. In the horror mockumentary *Behind the Mask: The Rise of Leslie Vernon*, for example, Robert Englund (famous for playing Freddy Krueger in the *Nightmare on Elm Street* franchise) plays not the monster but instead a monster-hunter, clearly inspired by *Halloween*'s Dr. Loomis (Donald Pleasence).

After the decline of 1930s and 1940s monster films, self-reflexivity and parody did not go away in horror. Fifties horror classics like *The Blob* (1958) and *The Tingler* (1959), for example, feature key self-reflexive scenes, operating as a form of self-parody, in which the titular monster invades a movie theater; and the 3D *House of Wax* (1953) directly and comically addresses its audience, as do many of William Castle's gimmick films, including *The Tingler, House on Haunted Hill* (1959), and *13 Ghosts* (1960). During this period, Vincent Price (discussed in chapter 4) also emerged as an important horror icon. It was not until the late 1970s and 1980s, however, that there emerged a new stable of iconic monsters that would rival, and in some ways displace, the icons of the Universal era. These include Michael Myers from *Halloween*, Freddy Krueger from *A Nightmare on Elm Street*, Jason Voorhees from *Friday the 13th*, Chucky from *Child's Play*, and Pinhead from *Hellraiser*. Out of this group, Freddy and Jason would prove the most iconic and hold a comparable cultural position to that of Dracula and Frankenstein's monster in the 1930s and 1940s.

Just as we saw in the classic monster era, these new iconic monsters were ripe for parody and self-reference. Other media texts, particularly

but not exclusively in the horror genre, would often reference Freddy and Jason, and this time, the references were both more frequent and more explicitly parodic than what we saw in the classical era. The poster for *Sleepaway Camp II: Unhappy Campers* (1988), for example, shows the franchise's killer Angela Baker (Pamela Springsteen) marching off to camp with a hockey mask and a knife-fingered glove (the iconic objects most closely associated with Jason and Freddy) poking out of her backpack. In the film, two campers attempt to scare Angela by dressing as Jason and Freddy; she one-ups them, however, when she shows up with a chain saw and dressed as Leatherface. Similarly, *Bride of Chucky* (1998), in addition to parodically referencing *Bride of Frankenstein*, opens with the evil doll trapped in a police evidence locker. The same locker also contains a hockey mask and knife-fingered glove. The comic repetition of these icons winkingly places their films within the horror genre and openly admits that they exist within the iconic shadows of the *Friday* and *Nightmare* franchises. There are numerous other examples, and—demonstrating that audiences see such allusions as a playful game—fan websites and wikis track these sorts of references.[24]

Anticipating the eventual crossover film *Freddy vs. Jason* (2003), the two franchises also occasionally reference each other. In *Friday the 13th Part VI: Jason Lives* (1986), a character named Nancy describes having a dream about a monster hunting her.[25] Nancy is also the name of the protagonist in the first *Nightmare on Elm Street* film, in which Freddy Krueger hunts teens through their dreams. The franchise makes an even more explicit reference to Freddy at the end of *Jason Goes to Hell: The Final Friday* (1993). In the final moments, after the heroes have dispatched Jason once again, we see the iconic hockey mask lying atop the ground. Freddy Krueger's glove then reaches out of the dirt and pulls the mask below. Similarly, in *A Nightmare on Elm Street 4* (1988), Freddy Krueger dresses like a doctor, and his nametag reads "Dr. Voorhees." This sort of cross-referencing recalls the use of horror icons in Universal's monster series and also suggests that this sort of affectionate parody operates as a playful competition between the two franchises.

Most of these examples consist primarily of playful winks to audiences and thus generate isolated moments of humor, but Tobe Hooper's *The Funhouse* (1981) offers a more sustained and sophisticated meditation on—and parody of—horror iconography throughout the genre's history. Hooper, of course, helped create his own iconic horror monster, Leatherface, in 1974's *The Texas Chain Saw Massacre*. In *The Funhouse*, he combines *Massacre*'s sleazy grindhouse aesthetic with both the recently

emerged teen slasher subgenre and the icons of classic Hollywood horror, particularly the Frankenstein monster. As the title suggests, the primary action of the film takes place at a carnival funhouse, and Hooper uses the fairground setting to generate an uneasy mix of horror and humor and to meditate on the genre itself.

The Funhouse's opening sequence establishes both the film's comic sensibility and its playful attitude toward horror history. After the opening credits, the first image is of a poster advertising a carnival; the camera moves forward, and we see that this advertisement decorates the outer door of a child's bedroom. The camera explores the room, which is full of horror iconography: one wall is decorated with an assortment of masks and another with weapons and torture devices. There are busts of the Wolf Man and Frankenstein's monster and posters for Universal's *Frankenstein* and *Dracula* films. A gloved hand reaches out to inspect some toy spiders, revealing that the camera is from a first-person point of view. The first cut is to a bathroom and a teenage girl, Amy (Elizabeth Berridge), preparing to take a shower, and it soon cuts back to the bedroom and a shot of the gloved hand removing a knife from the wall. After another cut to Amy actually entering the shower, the first-person dons a clown's mask, and the camera now films through its eyeholes. As one would expect, this first-person "killer" moves into the bathroom and attacks Amy in the shower. When the knife touches her flesh, however, the blade bends back, and it is revealed to be a toy. Amy removes the killer's mask and finds her younger brother, Joey (Shawn Carson), laughing maniacally.

The sequence works like a parodic tour of American cinematic horror. First, we see the icons of the 1930s and 1940s: Dracula, Frankenstein's monster, and the Wolf Man. These are all found in a child's bedroom, along with paraphernalia associated with childhood (baseball gear, pet mice, etc.). The setting suggests a connection between early horror films and childhood and perhaps points to the genre's infancy. The shower scene (with nudity) takes us into more "mature" territory, both in subject matter and in horror history. Even though *Psycho* is not explicitly named, the reference to its shower murder is no more subtle than the *Dracula* poster. And of course, the point of view, through mask eyeholes, of a knife-wielding "killer" recalls the opening sequence of *Halloween*, released only three years earlier, in which a young Michael Myers dons a clown's mask before murdering his older sister. The connection is made even more explicit once we learn that this scenario features another brother/sister relationship. Significantly, this tour of genre history is framed in comic/playful terms. The film's title and the opening shot of the carnival ad both

announce the scene—and really the film as a whole—as a space of play, and the multiple allusions to horror classics—through plot, set design, and cinematography—operate as genre parody. The rubber knife works as a sort of comic punchline, subverting audience expectations and transforming dread into humor.

This humor is important, but it does not mean that we are about to watch a comedy. Like nearly all of Hooper's work, *The Funhouse* has an overt sense of humor but is very much a horror film. Even the movie's opening, in which the threat of violence is comically diffused, has an air of real menace. Joey's "attack" on his naked, showering sister may have been with a toy knife, but it also displays violent and certainly sexual impulses toward her.[26] There is also a macabre and sinister aspect to the boy's obsession not only with horror films but with instruments of violence. As Bruce Kawin notes, Joey "is a straightforward image of the child not as horror-object but as horror-audience."[27] If this is the case, then viewers could assume that in addition to being a fan of classic monsters, he has also watched *Psycho* and *Halloween* (or has at least read about them in horror fan magazines) and is intentionally reenacting their most iconic scenes. His obsession with movie monsters marks him as similar to other horror movie children like Mark Petrie in *Salem's Lot* (1979, also directed by Hooper) and Tommy Jarvis in *Friday the 13th: The Final Chapter* (1984). Joey's impulse to act out the horror films he sees, however, reads as more dangerous and anticipates the movie-obsessed killers of the *Scream* franchise. This opening also foreshadows the rest of the film, for Amy will soon meet a real monster firsthand.

The majority of *The Funhouse*'s action takes place at the same carnival advertised on Joey's door. Against her parents' wishes, Amy attends the carnival with three of her friends, and Joey sneaks out to follow her. The carnival's attractions extend the opening's preoccupation with horror iconography. The magician gives a lecture on how Vlad the Impaler formed the basis for the Dracula myth; the magician then proceeds to "impale" a volunteer from the audience (actually his daughter, serving as a plant). The freakshow, recalling Tod Browning's *Freaks* (1932), has various mutated animals and a deformed human fetus. The titular funhouse references King Kong, with a giant gorilla's open mouth serving as the entrance to a tunnel, and also has various less-specific horror signifiers, such as creepy animatronic clowns and fake skeletons. A large part of the film's runtime, then, works like an extension of its parodic opening, as viewers and characters are continuously inundated with horror iconography. The actual horror plot emerges when Amy and her friends decide

to secretly spend the night inside the funhouse and accidentally witness the funhouse manager's severely deformed son murder the palm reader in an act of frustrated sexual aggression. Following basic slasher formula, the son, billed as "The Monster" (Wayne Doba), and his father stalk and kill Amy's friends; Amy herself barely escapes after killing the monster in the gears of the funhouse machinery.

This monster is *The Funhouse*'s most significant use of classic horror iconography. For most of the film, he wears a rubber Frankenstein mask to hide his deformity, and his true, monstrous appearance—created through Rick Baker's makeup work—is only revealed after the first murder. The use of this mask obviously continues the allusions to classic horror established in the opening, and its larger significance can be read in various ways. Kawin notes that Frankenstein's monster serves as an apt "prototype" for *The Funhouse*'s monster, as both are "rejected by [their] creator and looking for love."[28] This is true to an extent, but that the monster's father goes on a killing spree with his son (and the suggestion that he has similarly helped clean up prior murders) shows a greater fatherly fidelity than Dr. Frankenstein. Tony Williams argues convincingly that the Frankenstein mask connects the monster to Joey and thus the monster "enacts Joey's repressed desires" for violence against his sister.[29] To these readings, we can add the ways in which the monster places the film in genre history. The opening sequence, as we saw, presents a condensed history of the American horror film from the 1930s through *Halloween*. The funhouse monster sends a similar message by having one period's monster serve as a literal mask for another's. On the one hand, this masking can be read as a commentary on horror film continuity: Frankenstein's monster doesn't go away; it just takes on new shapes. On the other hand, we can read it as a significant break between horror periods and a commentary on how contemporary monsters are more hideous and frightening than the classic creators could have ever imagined. The tension between these readings is yet another manifestation of the film's parodic approach to horror iconography.

Parody in Horror Part 2: Horror Texts and Genres

The majority of examples discussed in the previous section make parodic use of either specific horror icons or iconic moments in famous films (like the shower scene in *Psycho*). With the exception of *The Funhouse*, the majority of these films use their parody of horror iconography in mostly discrete or circumscribed moments. There are a smaller number of films,

however, that offer a more sustained parodic treatment of a specific horror text, subgenre, or filmmaker. These parodic horror films are remarkable in that they simultaneously operate as both parody and horror, and neither their humor nor their self-reflexivity dilutes the traditional horror aspects. In fact, the parody often operates in tandem with traditional horror elements, as both feed on each other. This sort of sustained, parodic horror reaches its apex in *Scream* and has since become much more common, but there are several pre-*Scream* films that anticipate the genre's explicit parodic turn.

Because horror is full of films that intentionally imitate earlier, successful horror films, it may at times be difficult to precisely decide whether a film is an actual parody or a simple rip-off, created merely to generate revenue from the similarity to another movie's popularity. The first *Friday the 13th*, for example, repeats numerous elements from *Halloween*, released only two years earlier. Some of these elements include the holiday title, the use of a prologue, killer-point-of-view shots, a series of murdered teenagers, and a final girl who battles the monster and survives. These elements are also not simply repetitive. *Friday the 13th* doubles down on certain aspects, offering a higher kill count and more graphic violence. Due to the repetition and difference, one may thus be tempted to see *Friday the 13th* as a parody of *Halloween*. Ultimately, though, most viewers or critics would not do so. This is due in part to the wide availability of extratextual information about the making of *Friday the 13th*. Producer/director Sean S. Cunningham, for example, has openly admitted that *Friday the 13th* was conceived as an imitation of *Halloween*, created to cash in on its success.[30] More important, while *Friday the 13th* is not humorless, the comic sensibility is not readily discernible through its similarity to the earlier text. In other words, it is safe to call *Friday the 13th* an imitation rather than a parody. The early 1980s of course saw numerous other slasher films—including sequels to both *Friday* and *Halloween*—that repeated the formulaic elements outlined above.

In contrast to *Friday the 13th*, Joe Dante's *Piranha* (1978) appears to be a simple rip-off of Steven Spielberg's *Jaws* (1975) but reveals itself to be a parody through its comic (yet still violent and potentially scary) reworking of many of *Jaws*'s themes and stylistic devices. *Jaws*, itself indebted to films as diverse as *Creature from the Black Lagoon* (1954), *The Birds* (1963), and any number of 1950s and 1960s creature features, was a massive success and its legacy in American movies looms large. *Jaws* has been imitated and parodied perhaps more than any other film in American history. Its influence can be seen in bleak and realistic shark-attack films

like *Open Water* (2003) or *The Reef* (2010), in outrageous direct-to-video fare like *Sand Sharks* (2011) and *Sharknado* (2013), as well as in many non-shark-related animal-attack movies like *Anaconda* (1997) and *Lake Placid* (1999). *Piranha*, which Spielberg has named the "best of the *Jaws* rip-offs," precedes most of these and places itself in direct conversation with the earlier blockbuster.[31] Also, *Piranha* was released only three years after *Jaws* and less than two months after *Jaws 2* (1978), thus ensuring that audiences would have *Jaws* fresh in their minds when they encountered Dante's parody.

Even though it is not short on horror elements, *Piranha* has a clear humorous tone and utilizes many of the allusive and self-reflexive elements discussed throughout this chapter. The opening shot is of a full moon, recalling the setting for Universal monster movies (and anticipating Dante's later self-reflexive werewolf film, *The Howling* [1981]), and in the very first scene, a character refers to *Creature from the Black Lagoon*. When protagonist Maggie McKeown (Heather Menzies) is first introduced, she is playing an arcade video game called *Shark JAWS*.[32] Later in the film, two minor characters watch the monster movie *20 Million Miles to Earth* (1957). Toward the end of the film, we see a newscaster standing in front of a beach littered with bleeding and wounded bodies from the piranha attack. He says, "Terror, horror, death: film at 11:00." These self-reflexive moments call attention to the film's textuality as well as its position in the horror genre. Furthermore, they help make it clear that *Piranha* has its own style and comic sensibility and is doing something more than simply cashing in on the *Jaws* phenomenon (although it *is* certainly doing that).

Piranha is most successful when it riffs on key elements or scenes from *Jaws*, which it often does in a hyperbolic manner. Like *Jaws*, *Piranha* begins with a young couple preparing for a late-night swim. This couple makes the unfortunate decision to skinny dip in the pond at a research facility where lethal, genetically engineered piranha are being bred. The scene ups the ante of *Jaws*'s opening. In *Jaws*, only the young woman is the victim of the first shark attack; here, man and woman are both devoured by piranha. This scene is quickly followed by the above-mentioned *Shark JAWS* video game scene, thus cementing the film's intention of parodying Spielberg's film. As *Piranha* moves forward, we see several elements and stylistic devices that were made famous in *Jaws*. Like its predecessor, *Piranha* features sequences of swimmers playing and splashing in the water intercut with POV shots from beneath the water's surface. It also uses ominous music to announce an imminent attack and

has moments of frightened swimmers clamoring for shore as the water fills with blood. And as in *Jaws*, there are various commercial interests and authority figures that refuse to take the aquatic threat seriously. Character actor Dick Miller, for example, plays a resort owner who, with his ostentatious suits and salesman charisma, appears to be modeled directly after Mayor Vaughn (Murray Hamilton) in *Jaws*.

These elements are not simply repeated; rather, they are revised, exaggerated, or otherwise played with for comic effect. This is particularly true of the piranha attack scenes, of which there are several. Whereas *Jaws* famously withholds a view of the shark until the final act, *Piranha* often shows shots of schools of the titular fish moving through the water, their large eyes opening, or their mouths biting on flesh; as they attack, the water around them churns and bubbles, and the sound effects include a chattering noise (presumably the piranha's teeth). It should be noted that the piranha themselves also look quite fake, even by 1970s special effects standards, and their tiny, bug-eyed appearance feels like a comic deflation of *Jaws*'s imposing great white.[33] All these hyperbolic elements give the piranha attack scenes a ridiculous and comic tone, even as they are genuinely unsettling. This tone is reinforced in other aspects of the film. For example, one character is seen reading a newspaper, with headlines such as "Big Rattler Bites Teen" and "Dogs Tear Up Newborn Baby." The over-the-top irreverence of these headlines makes it clear in what sort of world *Piranha* takes place.

Piranha's parody can also be seen in the narrative itself. *Jaws* somewhat cynically highlights how economic interests can trump safety when the mayor refuses to shut down the beaches or when various inept citizens attempt to catch the shark themselves to secure the reward. However, this cynicism is tempered by the film's positive representation of its three heroes. Chief Brody (Roy Scheider) represents the law, and marine biologist Matt Hooper (Richard Dreyfuss) represents the authority of science. Shark hunter Quint (Robert Shaw) stands somewhat outside of traditional realms of authority, but his practical expertise and gruff manner place him in a heroic lineage with figures like Daniel Boone and Natty Bumppo. *Piranha*, however, offers very little of such traditional reassurance. The film's main "heroes," Maggie McKeown and Paul Grogan (Bradford Dillman), are in fact responsible for unleashing the piranha on the local populace when they drain the pond where the piranha are being kept. Furthermore, the inept and dishonest authority figures are expanded to include scientists and the military-industrial complex. The piranha were genetically engineered to destroy the river systems of

Vietnam, placing the film's carnage as the direct result of American imperialism. In the final moments, military scientist Dr. Mengers (horror icon Barbara Steele) assures a reporter that the threat has been contained, even as viewers know that the piranha—able to survive in both fresh and salt water—have moved into the ocean. The film ends with a shot of waves crashing on the beach alongside the sound of the piranha chattering. The promise of more carnage to come stands in sharp contrast to *Jaws*'s ending, in which viewers are assured that Amity has returned to normal. Part of *Piranha*'s parody, then, comes through its refusal to give viewers traditional stabilizing elements like strong heroes, faith in social institutions, or narrative closure.

It is worth pointing out, though, that despite its parodic elements and nonrealistic special effects, *Piranha* is still an effective horror film with the power to unnerve, frighten, or gross out audience members. One sequence, when the school of piranha attacks a summer camp where scores of children are playing in the water, is genuinely intense, and there are several hair-raising moments where some clueless swimmer dips his or her fingers or toes into the piranha-infested waters. Maybe it's just me, but the thought of numerous piranha nibbling away at my flesh is quite a bit scarier than the chomp of a giant shark. Through the combination of myriad comic and scary devices, *Piranha* thus simultaneously operates as both horror and parody.

We can say with some level of confidence that *Friday the 13th* is a straightforward rip-off of *Halloween* and that *Piranha* operates as a parody of *Jaws*. Director Brian De Palma's overt foregrounding of his cinematic influences (particularly Hitchcock), however, seems designed to frustrate those categories. Many critics and reviewers have tended to view De Palma, negatively, as merely a thief, plagiarist, or imitator of Hitchcock.[34] This makes a certain amount of sense, as De Palma has directed several horror-thrillers that deliberately lift major plot points, thematic concerns, and stylistic flourishes directly from Hitchcock's films, particularly from *Rear Window* (1954), *Vertigo* (1958), and *Psycho*.[35] There is a strong case, though, to view De Palma's horror-thrillers through the lens of parody. In her book on parody, Hutcheon even devotes a paragraph to De Palma, stressing the ways in which his work establishes both similarity to and difference from Hitchcock. She notes, for example, that "*Dressed to Kill* [1980] is a parody of *Psycho*, but the psycho or killer is, significantly, the psychiatrist."[36] Robin Wood does not explicitly see De Palma as a parodist but uses terms that are quite similar to most critical definitions of parody, arguing that De Palma's relationship with

Hitchcock is a "complex dialectic of affinity and difference."[37] Neither Hutcheon nor Wood, however, stresses the potentially comic aspects of De Palma's parodic approach.

A full discussion of De Palma's allusive relationship with other texts and genres is outside the scope of this project. It is worth briefly discussing, though, the manner in which De Palma's use of Hitchcock and other cinematic "masters" often works alongside more overt and comic parodies of lowbrow media genres or formats. For example, De Palma's first explicitly Hitchcockian film, *Sisters* (1972)—a psychological horror film openly influenced by both *Psycho* and *Rear Window*—begins with a locker-room scene that is soon revealed to be part of a bizarre candid-camera-style game show entitled *Peeping Toms*. The parody of the game show generates humor through its incongruity and exaggeration, but it also introduces the Hitchcockian theme of voyeurism and announces the film's intent to play games with the audience. De Palma is quite fond of these sorts of film openings, and later movies would use the device to deliberately parody the horror genre. *Dressed to Kill* begins *and* ends with violent shower scenes (parodying *Psycho*) that are both ultimately revealed to be dreams. The protagonist of *Blow Out* (1981) is a sound man for B-horror films, and it opens with a movie-within-the-movie fake out that parodies low-budget horror. This parodic opening shows a fake film entitled *Coed Frenzy* and features yet another shower murder. In this case, though, the parody is not so much of Hitchcock's *Psycho* as the myriad slasher movies that have themselves ripped off or parodied Hitchcock. In other words, the scene operates more as commentary on Hitchcock's legacy than on any of his specific films.

This aspect is even more prominent in De Palma's *Body Double* (1984), which reworks the plots and themes of both *Rear Window* and *Vertigo*. As in *Blow Out*, the protagonist works in the film industry (this time as an actor), and the film opens on the set of a movie entitled *Vampire's Kiss*. (Four years later, this would be the title of an actual horror-comedy featuring a signature over-the-top Nicolas Cage performance.) While the opening could technically be considered a fake out in the same manner as *Sisters* and *Blow Out*, De Palma stresses the artificiality of the film within the film rather than trying to fool audiences into mistaking it for reality. The camera pans over a cemetery where the tombstones are clearly made of Styrofoam, and the fog is openly fake. This opening, then, could be considered something of a self-parody, for by the time *Body Double* was released, many viewers were already used to De Palma's metacinematic games.

Viewers would also be aware, by this point, of De Palma's tendency to rework Hitchcock, and both *Body Double*'s story and many of its cinematic devices are openly—even aggressively—Hitchcockian. *Vertigo* is the primary template: the hero Jake Scully (Craig Wasson) suffers from claustrophobia rather than a fear of heights, but De Palma mimics *Vertigo*'s famous dolly zoom in a scene when Jake, attempting to catch a purse snatcher, suffers from a panic attack inside of a long tunnel. Immediately after that, De Palma gives us a long 365-degree pan while Jake kisses his potential love interest. The excessively long shot is an open parody of *Vertigo*'s own spinning kiss. *Body Double* also heavily mimics many aspects of *Rear Window*, particularly in the numerous scenes when Jake, supposedly house-sitting for a friend, watches through a telescope as a mysterious woman dances, undresses, masturbates, and eventually gets attacked. As Leitch points out, these overt moments show De Palma "imitating himself imitating Hitchcock" and display De Palma's "fondness for parody and self-parody."[38]

The one point that I want to add to this is how De Palma integrates his parodies of both Hitchcock and himself into a film that is ripe with parodies of other genres. As previously mentioned, *Body Double* opens with a parody of a low-budget vampire romance film. Later, Jake stars in a porno scene—set to the tune of "Relax" by Frankie Goes to Hollywood—that parodies both adult films and MTV music videos. *Body Double*'s violent centerpiece is a scene in which a woman is killed by a man wielding a giant power drill. The drill is filmed from between the man's legs, unsubtly emphasizing the phallic implications. The killer then drills not only through the woman but also through the floor below, thus raining blood upon Jake downstairs. The extreme violence and sexual implications of the scene notoriously garnered charges of misogyny from contemporary reviewers. However, while the scene does work as an effective horror set piece, it also—like *Coed Frenzy* in *Blow Out*—works as a parody of the slasher genre, which was a dominant form of American horror at the time of *Body Double*'s release. In fact, the murder weapon of the drill may be a direct reference to and parody of *Slumber Party Massacre* (1982). *Body Double*, then, offers multiple levels of parody, as De Palma spoofs Hitchcock and himself as well as vampire films, slashers, pornography, and music videos. However, not all these parodic thrusts operate in the same way. The moments of Hitchcock parody display an affection for and deep understanding of Hitchcock's mechanics and thematic concerns. For the horror films and pornography, however, De Palma emphasizes instead the shoddiness of the production values and the ways in which the genres

commodify sex and violence. One way of reading De Palma, then, may be as cynical and comic commentary about how the Hollywood machine, including De Palma himself, has absorbed Hitchcock.

A discussion of horror's parody would of course be incomplete without accounting for the *Scream* franchise. Its postmodern, parodic, and comically self-reflexive elements have been discussed at length.[39] My focus here will thus primarily be on the ways in which the franchise shifts its parodic target over time. The original film operates primarily as a commentary about and revision of the tropes of the horror genre in general and the slasher subgenre in particular. The sequels do not abandon this aspect but, responding to the massive success of the first film, shift their attention inward and comment on *Scream*'s own canonical status. This metacommentary reaches its apex in the fourth and fifth films (2011 and 2022), which each operate on some level as parodic remakes of the original.

The first *Scream* repeats several aspects of the slasher subgenre—namely, its use of a mask-wielding killer, its group of teenage victims, and its focus on a heroic female protagonist. As a parody, however, it also changes many of these elements. For example, the film offers us two final girls in Sydney Prescott (Neve Campbell) and Gale Weathers (Courteney Cox). It should be pointed out, though, that the final girl trope, as outlined by Clover, is not quite as omnipresent in classic slashers as it is often made out to be. Several earlier films such as *Slumber Party Massacre*, *The Burning* (1981), and *Sleepaway Camp* (1983) have offered their own twists on the device. More unique to *Scream* is the revelation of two killers working together and having those killers come from within the film's core teenage friend group. The most explicit parodic device, however, comes not through plot points or even through the repetition of key horror scenes but rather through dialogue, in which the characters continuously talk about horror movies and engage in horror trivia. The script's repetition of the rules of slasher films allows *Scream* to become explicitly self-referential, as the victims, heroes, and killers discuss the similarities of their own situations to horror films. *Scream* thus simultaneously offers the pleasures and scares of a horror movie while also standing back and commenting on its own textuality. In parodic fashion, humor is generated, in part, through detachment.

Like much of the humor found throughout the genre, *Scream*'s humor is not separate from its horror elements, but the humor and horror tend to operate in tandem. We see a good example of this in the final act of *Scream*. Here, a group of teenagers reacts to the news that a killer is on the loose by having a slasher movie marathon, wherein horror expert Randy

Meeks (Jamie Kennedy) lectures them on slasher conventions. As the party winds down and more characters are killed off, a drunken Randy ends up alone, watching *Halloween*, and speaking directly to its main character Laurie Strode (Jamie Lee Curtis). Referring to Laurie by the actress's name, Randy says, "Watch out, Jamie, you know he's around.... Jamie, look behind you." *Scream*'s masked killer, Ghostface, then emerges behind Randy with knife poised. From the point of view of audiences, Randy's admonishment to "turn around" applies equally to himself. The metacinematic layers multiply when we remember that the actor playing Randy is also named Jamie. The visual elements reinforce the self-referentiality, for whenever the camera cuts to a shot of *Halloween* on the television, we see the reflection of Randy's watching face superimposed on the screen. Therefore, two Jamies share the same screen space, each with a killer lurking nearby. On the one hand, this doubling may serve to increase identification with Randy, as he is literally doing the same thing (watching a horror movie) as the audience. For some viewers at least, the layers of dramatic irony and the parodic repetition of *Halloween*'s climax may only increase the distance from the on-screen action and cause the scene to be read as more humorous than frightening. This playful tension between humor and horror drives the scene and much of the film itself.

This tension is compounded a few seconds later, as *Scream* adds yet *another* metatextual layer but also ramps up the horror elements. Ghostface is distracted from Randy by protagonist Sidney running for help to a news van parked outside. Inside the van, Sidney and the cameraman watch feed from a hidden camera, which shows the same scene we had just watched, in which Randy watches *Halloween* while Ghostface lurks behind him. This time, the cameraman yells "behind you!" to the on-screen Randy, who we know is yelling the same thing at Laurie Strode. When the cameraman goes to help, he remembers too late that there is a thirty-second delay on the camera feed. Ghostface suddenly appears and kills him. As the screens inside of screens pile up, the self-referentiality starts to feel stretched to its limit. Thus, when the killer suddenly appears in the outermost frame (closest to "reality" for viewers) it creates a genuine surprise. The humor in this case does not relieve tension but rather distracts viewers from the looming threat and sets the stage for a jump scare.

The above sequence does not only use another horror text (*Halloween*) to refer to *Scream*'s textuality; when Randy appears on the cameraman's television screen, it literally turns *Scream* itself into a textual object within the world of the film. This sort of self-parody in which the film simultaneously repeats and revises itself anticipates the *Scream* sequels,

which increasingly repeat and revise key scenes and elements from the earlier films. *Scream 2* (1997) begins in a movie theater in which a film within the film, entitled *Stab* and based on the events of the first *Scream*, is premiering. *Stab* operates as a parodic repetition of *Scream*, and we briefly see a new version of the original's opening kill scene, with a new actress playing the victim (Heather Graham instead of Drew Barrymore) and a comic sexualization of the material. *Scream 3* (2000) pushes this aspect further, as the majority of the film's action takes place on the set of another *Stab* sequel, and the main characters meet and interact with the actors who play their on-screen counterparts and walk around on studio sets modeled after the setting of the original. Parts 2 and 3 both continue the first film's tendency to have characters discuss larger horror tropes, but their parody is directed mostly at the original film, as it uses the *Stab* franchise to comically repeat scenes and double characters.

Both *Scream 4* and the fifth installment, also titled *Scream*, continue to parody the original, and in fact, both films operate loosely as parodic remakes. *Scream 4* explores the concept of a franchise reboot by introducing an ostensible new protagonist to replace Sidney. As a potential reboot, the film repeats several key scenes and plot points from the original. It also opens with not one but two De Palma–style film-within-the-film fake outs, each of which parody the opening phone call in the original *Scream*. *Scream* (2022) works almost the same way, this time situating itself as a "legacy sequel," in which new main characters are introduced and characters from the original play supporting roles. The most obvious horror template for this is *Halloween* (2018), but like *Scream 4*, *Scream* (2022) is most interested in the first film and again repeats and revises key scenes and plot points. The most significant moment in this regard comes in the third act when Randy Meeks's niece Mindy (Jasmin Savoy Brown), also a horror expert, watches the scene in *Stab* where the on-screen version of her uncle watches *Halloween*. The scene repeats the doubling aspect of the *Scream* scene discussed above where Randy yells at an on-screen character to turn around while a killer lurks behind him. The scene obviously parodies the original, but it also aggrandizes itself by replacing *Halloween* with *Stab*. In doing so, the filmmakers suggest that the original *Scream* has been canonized as a horror touchstone in much the same way as the original *Halloween*. The influence of the *Scream* films can be seen all over the contemporary horror landscape, which is full of self-aware parodies. More than any other horror franchise, however, *Scream* influences and parodies itself, returning again and again to the same well of scary phone calls, movie trivia, paired killers, and lectures from winking horror experts.

Parody in Horror Part 3: Nonhorror Genres

While the horror films discussed so far are indeed parodic, they are not particularly critical of the horror texts, conventions, and icons that they parody. Rather, even as horror parodies play with and revise particular horror elements, they tend to treat their target texts with reverence and respect. This reverence is much less common in horror films that parody other, nonhorror genres. Since the 1970s, it has become increasingly common to see horror texts parody seemingly "safe" genres, like the situation comedy or the children's film, often in ways that are as disturbing as they are comic. Horror's parodic invasion of other genres often simply juxtaposes different modes for comic effect; in other cases, though, horror's genre parody has a distinctly satirical bent, as horror texts use their genre parody to suggest that the clean or sanitized worlds represented in dominant art forms are actually masking real horrors embedded in the culture.

Wes Craven's debut *Last House on the Left* (1972) is a good example of genre parody used for satirical ends. Along with *Night of the Living Dead*, *The Texas Chain Saw Massacre*, and Craven's own *The Hills Have Eyes* (1977), *Last House* is part of a wave of 1960s and 1970s American horror films that combined a low-budget aesthetic with brutal violence and social commentary. The film, a loose remake of Ingmar Bergman's *The Virgin Spring* (1960), tells the story of two teenage girls, Mari and Phyllis (Sandra Peabody and Lucy Grantham), who on their way to a rock concert are abducted by a family of criminals who rape, torture, and kill them. The criminals then seek refuge at Mari's house. Once Mari's parents learn of her murder, they subsequently kill the family of criminals. *Last House* is genuinely disturbing; the murders of Mari and Phyllis, in particular, are shot in an unflinching manner, and even the killers appear to be disgusted by their own actions. As many critics have pointed out, the film's two families—one criminal and one respectable—serve as mirrors of each other. According to Robin Wood, *Last House* thus suggests that violence is "inherent in the American situation," as evinced by the "respectable" family's turn toward and aptitude for violence.[40]

One of the ways in which the film manifests its themes is through a disorienting mixture of tones and the juxtaposition of realistic brutality with humorous parody. The sequence in which Mari and Phyllis are initially abducted, for example, cuts back and forth between the criminals' apartment, where they threaten and assault the girls, and Mari's house, where her parents happily prepare for Mari's birthday. Shots of

the parents hanging a banner and decorating a cake are set to an upbeat musical score, and their house oozes middle-class respectability. The wooden performances of the actors playing the parents (Richard Towers and Cynthia Carr) make it all feel like a parody of the happy families in TV sitcoms or Norman Rockwell paintings (the latter, if updated for an early 1970s decor). The filmmakers clearly have something like this in mind, as the father looks around and says, "This room belongs in a magazine." During the sequence, the cuts are abrupt, and we only spend about a minute in each setting. Craven thus forces us to see the two families as linked. At one point, the connection is made explicit: Mari's father flirtatiously tells his wife that he wants "to attack" her, and the next cut shows the criminals leering at Phyllis as she begs to be let go. Immediately following this sequence, we get a scene of the villains putting the tied girls into the trunk of their car; during this, we hear the same sort of happy, jaunty score that we previously heard during the parents' birthday preparations. Once again, Craven invites us to see connections between the two families.

Last House is therefore filled with juxtapositions between "good" and "bad" families and between comic and horrifying tones. Later, we have a similar juxtaposition as Mari and Phyllis's escape attempt is juxtaposed with the comic misadventures of two bumbling police officers, who repeatedly fail to read the signs that could lead to the girls' rescue. Just as Mari's parents making a cake works as a parody of family sitcoms, the bumbling policemen read as a parody of material like the Keystone Kops comedies or a police sitcom like *Car 54, Where Are You?* (1961–1963). The experience of watching these juxtapositions is quite unsettling. Rather than working as comic relief, the humorous moments are a foil for the brutality, and viewers are never able to settle in to either mode. Just as the film's process of linking its two central families is designed to highlight the potential for violence lurking beneath the surface of middle-class respectability, its juxtaposition of horror with the parodic treatment of television and film comedy suggests that fun, sanitized narratives simply hide the reality of American violence. Released in the midst of the Vietnam War, *Last House* brings violence home, forcing American viewers to confront the carnage that they saw happening abroad on the nightly news.[41] The film is not subtle, but it is effective.

The parody of sitcoms or of other texts that represent idyllic visions of American family life can be found throughout the 1970s and into the 1980s, reflecting a growing disillusionment, in certain segments of the culture, with overly idealistic representations of traditional family values.

Two years after *Last House*, *The Texas Chain Saw Massacre* presented its own distorted vision of the American family through the Sawyers, former slaughterhouse workers whose jobs had been made obsolete by technology. The film's climax takes place at the Sawyer family dinner table, where final girl Sally is "both guest of honor and main course."[42] The Sawyers' dining room is elaborately designed and includes a lamp made from a human skeleton, a chandelier fashioned from a human head, and an armchair with real arms. The all-male Sawyer family sits around their dinner table, with their decaying, elderly patriarch at the head and Leatherface dressed as a woman. As Kim Newman points out, "Hooper's degenerates are a parody of the traditional sit-com family."[43] While it has a very different visual aesthetic, Bob Balaban's satirical horror comedy *Parents* (1989) also presents a cannibalistic American family. The film is about ten-year-old Michael Laemle (Bryan Madorsky) coming to the realization that his seemingly normal parents are, in fact, murderous cannibals. *Parents* takes place in 1958 and overtly parodies 1950s family sitcoms through its bright mise-en-scène and shots of the mother doing housework (usually preparing a meaty dinner) while wearing a dress and high heels. Like *Last House* and *Texas Chain Saw*, *Parents* represents the American family as rooted in violence and uses a parodic subversion of traditional family representations to drive the point home.

While clichéd representations of the American family seem to be the most common target of horror's parody, there are also several horror texts that play with other genres. The 1970s saw parodic horror musicals like De Palma's *Phantom of the Paradise* (1974) and *The Rocky Horror Picture Show* (1975). Later, the very odd *Slumber Party Massacre II* (1987) has a guitar-playing, dream-invading killer who both sings a musical number and kills teenagers with a drill on the end of his guitar. The horror-musical has been picked up again recently with the Canadian slasher *Stage Fright* (2014) and the British zombie musical *Anna and the Apocalypse* (2017). Horror has also invaded the romantic comedy genre with films like *Warm Bodies* (2013) and *Life after Beth* (2014). Filmmaker Christopher Landon parodically applies the slasher formula to specific high-concept fantasy movies. His films *Happy Death Day* (2017) and *Happy Death Day 2U* (2019), for example, both use the conceit, made famous in *Groundhog Day* (1993), in which a character lives the same day over and over. In both films, Tree Gelbman (Jessica Rothe), both victim and final girl, repeatedly and comically relives the day of her own murder until she is finally able to foil the killer. Similarly, Landon's *Freaky* (2020) turns children's body swap films (most obviously *Freaky Friday*, which was originally

released in 1976 but has been remade three times since) into a slasher when a teenage girl (Kathryn Newton) swaps bodies with a Jason/Michael-style masked killer named the Butcher (Vince Vaughn). Many of these films lean more heavily toward comedy than horror, but they collectively display an increasing trend of applying horror tropes to diverse generic modes.

Outside of film, there are also several works of horror fiction that creatively parody other types of texts. Grady Hendrix's novel *Horrorstör* (2014) is about a haunted furniture store that is clearly fashioned after Ikea. The book itself is made to resemble an Ikea catalog and features pictures of medieval torture devices along with traditional furniture items. Likewise, Max Brooks's *Zombie Survival Guide: Complete Protection from the Living Dead* (2003) resembles a nonfiction "how to" book and includes advice about the best weapons for fighting zombies and how to prepare your home for a zombie invasion. Horror has also playfully invaded the novel of manners and historical fiction through works like Seth Grahame-Smith's *Pride and Prejudice and Zombies* (2009) and *Abraham Lincoln: Vampire Hunter* (2011), both of which have been adapted into feature films. These works display not only how horror's parody goes beyond film and television but also the ways in which cinematic horror tropes—particularly those found in the slasher and zombie subgenres—have become so recognizable that they can easily be inserted into and adapted for other textual situations.

Conclusion

As Steve Neale points out, "Genres do not consist solely of films. They consist also of specific systems of expectation and hypothesis which spectators bring with them to the cinema and which interact with films themselves during the course of the viewing process."[44] In a horror text, the "system of expectation" is primarily composed of those aspects designed to frighten or horrify audiences: monsters, terrible places, and so on. As we have seen, however, numerous horror texts also include parodic elements that allow audiences to view their frightening aspects from a safe distance. This extra layer of distance lets viewers have fun with horror stories and establishes the genre as a "play mode." Horror's parody has a cumulative effect: the more horror texts audience members consume, the more likely they are to recognize allusions and to see its parodic patterns of representation. In other words, horror demands a fairly high level of genre literacy and rewards audiences who are fluent

in its codes. Parody, of course, does not occur in every horror film or text. As I hope to have shown, however, parodic devices, which create similarity with comic difference, recur frequently enough over nearly a century to be considered a core aspect of the genre. As such, dedicated horror fans (and horror fans tend to be very dedicated) may understand the genre as a space of comic and self-reflexive fun even if particular texts are dead serious.

CHAPTER 2

Clowns, Fools, and Dummies
Horror's Comic Monsters

IN THE FINAL moments of the silent version of *The Phantom of the Opera* (1925), the Phantom (Lon Chaney), like so many early horror monsters, finds himself chased by an angry mob. Just as the mob is about to catch him, the Phantom reaches into his coat and raises his fist menacingly. The mob, coming at the Phantom from both sides, stops their attack, afraid of what he may be holding. Upon seeing the crowd's fear, the Phantom begins laughing. He then reveals his empty hand and continues to laugh as the mob overtakes him and tosses his body into the river. The Phantom's last act is thus a joke, and the last time viewers see him, his face is contorted in laughter. The monster is destroyed, but he gets the last laugh.

From the Phantom's point of view, the laughter is clear enough. He understands the mob's fear and that they view him as monstrous. His trick, in which he pretends to pull a bomb (or something) out of his coat, exploits that fear. The Phantom's laugh, then, is one of superiority. He celebrates his easy manipulation of the mob; even as they are about to kill him, he still has the power to frighten. But how should viewers react to the Phantom's laugh? Like the mob, we too may view the disfigured Phantom as a monstrosity and may also be fooled by his bomb-in-the-coat-pocket trick. In this regard, viewers are also the target of the Phantom's laughter. It is just as likely, though, that viewers may identify with the Phantom. Like many of cinema's monsters, he is not unsympathetic and is certainly more developed than the anonymous, angry mob. In this light, we may laugh *with* the Phantom in these final moments. Identification, however, is not a requirement. We may watch the film simply from a position of detachment. If this is the case, then we will almost certainly find some humor in this ending, out of either appreciation for the Phantom's trick, disdain for the manipulated mob, or some recognition of the ridiculous situation.

The Phantom's laughter—along with our ambivalent and varied responses to it—anticipates scores of other horror monsters who display

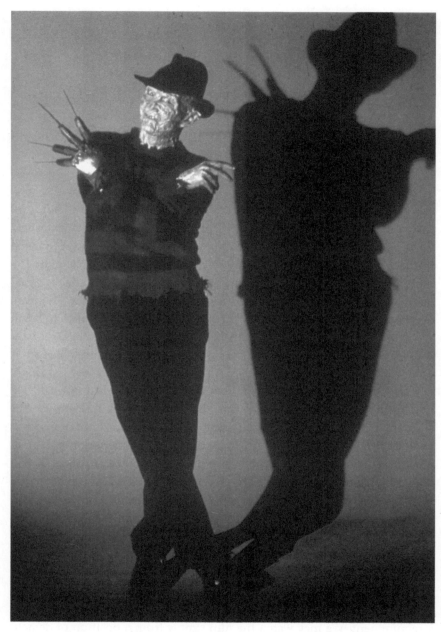

IMAGE 3: *A Nightmare on Elm Street 3: Dream Warriors* (1987). Courtesy of Photofest.

a comic sensibility. In Peter Straub's novel *Ghost Story* (1979), protagonist Ricky Hawthorne, attempting to describe the type of creature that haunts him and his friends, notes that these monsters "have wit" and "love jokes."[1] The same can be said about numerous monsters throughout the horror canon who can be found laughing, joking, or smiling. Both *Psycho* (1960) and *The Omen* (1976) end with a chilling close-up of the smiling face of their monster. *The Exorcist*'s (1973) demon continuously mocks and taunts its human adversaries. The most iconic image from *The Shining* (1980) is of Jack Torrance (Jack Nicholson) grinning as he smashes in the door with an axe and proclaims, "Here's Johnny!" Horror's monsters are often very funny, even if they are the only ones laughing.

When a monster is not laughing, there is a good chance it is the object of laughter. Brian De Palma's *Carrie* (1976) provides a key example. The film is framed with important scenes in which social outcast Carrie White (Sissy Spacek) becomes the object of derisive laughter. The opening takes place in a high school locker room where Carrie menstruates for the first time and reacts in horror. The other girls surround her to laugh and throw tampons. In the climax, Carrie is the butt of a cruel practical joke at prom. Feeling that everyone in the room is again laughing at her, Carrie uses her telekinetic powers to take violent revenge. *Carrie*'s prom scene works like an inversion of the ending of *The Phantom of the Opera*. In *Phantom*, the monster plays a trick on the mob and laughs even as they destroy him. In contrast, Carrie is the victim of a prank, and only then does she become fully monstrous. Her community creates her monstrosity. Both films place their monster in direct opposition to a large group, and both use laughter to underscore the monster's outsider status. Whether they are comic agents like the Phantom or objects of laughter, like Carrie, horror's monsters are frequently tied to jokes and humor.

This chapter investigates horror's comic monsters and explores the ways in which laughter and humor frequently play key roles in delineating a monster's relationship with its cultural context. This investigation resonates with dominant theories of both monstrosity and humor. Horror theorists have long articulated the monster as a symbolic manifestation of cultural anxieties about the Other. Through his classic formula for the genre—"normality is threatened by the monster"—Robin Wood notes that the relationship between the monster and dominant cultural values "constitutes the essential subject of the horror film."[2] In those texts that Wood deems progressive, the monster symbolizes some idea or marginalized group that society either represses or oppresses. In contrast, the films that Wood deems reactionary feature a wholly evil or conservative

monster, and the victims are often those who fail to conform to dominant norms. Numerous critics have further developed Wood's thesis, particularly that thread that sees the monster as a representative of Otherness. Jeffery Jerome Cohen, for example, views the monster as "difference made flesh,"[3] and important horror studies read monsters as metaphors for cultural anxieties about women, homosexuals, or racial minorities.[4] Horror texts thus mark the boundaries of cultural acceptance, and those deemed unacceptable are symbolically refashioned as monsters.

In quite a similar manner, humor often delineates boundaries of inclusion and exclusion. Freud sees joke telling—particularly of the hostile variety—as essentially social, a "psychical process between three persons": the joke teller, the audience, and the object of laughter.[5] In this formulation, the joker and the audience form a community of laughter, which excludes the butt of the joke. Many contemporary scholars have further developed this manner of thought. Werner Sollors, for instance, notes that "laughing at others is a form of boundary construction" and that "the community of laughter itself is an ethnicizing phenomenon, as we develop a sense of we-ness in laughing with others."[6] In my own work on stand-up comedy, I discuss the ways through which stand-up comedians strategically position themselves in relation to group affiliations, at times using humor to establish solidarity with a particular group but at other moments adopting an adversarial position through which to challenge group norms. Comedians also often turn themselves into fools or comic outsiders who are the objects of derisive laughter.[7] In other words, comedians transform their audience into a community and use their humor to situate themselves as either a member of that community or an outsider.

In this sense, monsters and comedians have quite a bit in common. Both have the ability to challenge the status quo, and like comedians, a monster's outsider status is often reinforced through laughter or the devices of humor. Like most other types of horror's humor, comic monsters do not operate as comic relief. Instead, their humor contributes in some manner to their monstrosity and, more important, to our understanding of their relationship with their cultural context. Finally, it should be noted that not all comic monsters are designed to generate audience amusement. I am less interested in the ways in which the texts under discussion prompt actual audience laughter than I am in how they utilize elements of humor for horrific ends. Most viewers, I hope, will not be amused when Carrie's prom night is ruined by the cruel practical jokers who dump a bucket of pig's blood onto her. Nevertheless, the practical joke is obviously a type of humor that the text uses to drive the narrative forward and, in this

case, prompt the monster's development. In other instances, the monster might laugh or joke, but the audience for this humor is simply the monster itself and may contribute to viewers' or victims' fear.

The Killer as Clown (and Killer Clowns)

The clown is the rare figure that serves as an equally appropriate signifier for either humor or horror. The definition of "clown" is slippery and varies from culture to culture. In nearly all cases, though, the clown (along with its cousin the trickster) uses humor to challenge or upend dominant cultural values.[8] As Joshua Louis Moss points out, the "clown archetype has functioned for thousands of years as a privileged form of transgressive trickster. The clown behaves in radically disruptive ways toward sacred objects and institutions."[9] In Western cultures, the clown's transgressive disruption is typically reserved for particular spaces: carnivals, circuses, parties, and so on. Moritz Fink thus argues that clowns become monstrous when they are found outside of these venues. Fink states that "a clown within a 'serious' context tends to be emotionally disturbing" and that the monstrous clown therefore "perverts the carnivalesque nature of the clown."[10] Fink's point is supported not only by the multitude of evil-clown-based horror films like *It* (1990 and 2017), *31* (2016), and the *Terrifier* films (2016 and 2022), but also by the wave of hysteria caused by a series of real-life "clown sightings" throughout 2016, in which people in Europe and the Americas reported seeing creepy clowns lurking in unexpected places.[11] Outside of the circus, a clown is probably up to no good.

Even in their natural context, though, clowns have the capacity to generate fear. Coulrophobia, the fear of clowns, is said to afflict nearly 8 percent of Americans.[12] Furthermore, the behavior of clowns can be unsettling in and of itself. Kimberly A. Christen notes clowns' "complete disregard for social and religious mores. They often do things backward, out of order, or in reverse order." For Christen, "these characters are not merely funny; they are also frightful."[13] Of course, contemporary media are saturated with images of evil, violent, or sadistic clowns. They can even be found outside of horror, most notably in Batman's evil clown nemesis, the Joker. The supervillain is so well known that two actors—Heath Ledger and Joaquin Phoenix—have won Academy Awards for playing him. Rather than reflecting an already common fear of clowns, all these media texts may simply be creating that fear. In other words, we may have gotten to a point where clowns are perhaps more likely to be associated with evil than humor.

In American horror, however, the white-faced, red-nosed, giant-shoed evil circus clown is but an extreme and literal manifestation of a certain sort of comic monster. For my purposes, the category of monstrous clown includes not only traditional circus clowns but any monsters with a comic sensibility and a penchant for performativity. While Wood points out that all monsters threaten normality, monstrous clowns—unlike, say, killer sharks—do so with both intention and enjoyment. Like regular clowns and tricksters, monstrous clowns upend social institutions and achievements. They mock human aspirations and emotions, and they often rely on deception. The vast majority of such monsters are irredeemably evil. As such, they appear at first glance to occupy what Wood calls the "reactionary wing" of American horror. "Evil incarnate," for Wood, is a "metaphysical, rather than a social," designation of the monster. As such, he argues, "nothing is to be done but strive to keep it repressed."[14] In Wood's conception, horror texts with simply evil monsters tend to reinforce dominant norms rather than interrogate them.

I see quite a bit more ambiguity than Wood suggests. Cohen, for example, notes that while monsters generate fear, they "also attract."[15] He explains that "the linking of monstrosity with the forbidden makes the monster all the more appealing as a temporary egress from constraint."[16] We see this appeal in our tendency to dress as monsters for Halloween or in the fact that throughout the late 1980s, it was a common sight to see grade-school children sporting Freddy Krueger T-shirts and lunchboxes. Like a transgressive comedian who uses humor to challenge social norms, monstrous clowns show disdain for cultural systems and institutions. Occasionally, a comedian—like Lenny Bruce during his 1960s obscenity trials—might be so transgressive that segments of the dominant culture deem them monstrous. The flip side of this scenario is to see our monsters as not only threats but also something of cultural heroes or outlaws who threaten dominant norms.

The vast majority of cinema's early monsters lack the requisite sense of humor that would make them clowns. There are isolated instances of monstrous clowning, as we saw in the earlier discussion of *Phantom of the Opera*. A more extended example occurs in James Whale's *The Invisible Man* (1933). Claude Raines's portrayal of the titular monster—who is driven insane by the same chemical that makes him invisible—is often overtly clownlike, and actor Mark Hamill has even cited the Invisible Man's maniacal laugh as inspiration for his voice portrayal of the Joker on *Batman: The Animated Series* (1992–1995).[17] In one scene, the Invisible Man, named Jack Griffin, finds himself confronted by a group of

townsfolk who demand to know why he disguises his face. A frustrated Griffin exclaims, "I'll show you!" and begins removing his face covering. Upon "viewing" Griffin's invisibility, the villagers run away in fear while Griffin emits a high-pitched, diabolical laugh. Soon, Griffin removes all his clothes and runs out into the streets to, in his words, "give a bit of a shock" to the "country bumpkins." He steals a bicycle, pulls the hat off an old man, and breaks a shop window, laughing all the while. He even tips over a baby carriage. Soon, Griffin's antics become more explicitly evil; he derails a train, killing hundreds, and forms a plot to take over the world. In this first "appearance" as an invisible man, however, his monstrosity is presented as playful, and his pranks on the villagers are distinctly performative; he wants his invisibility to be seen.

When Griffin removes his coverings and laughs at the shocked crowd of villagers, he resembles Lon Chaney's Phantom, and once he ventures into the street, his disruptive behavior places him firmly in the realm of the clown or trickster who, to recall Christen, has a "complete disregard for social ... mores." In a very literal way, Griffin uses his invisibility to disrupt the status quo and has fun doing so. In this manner, Griffin's comic rampage likely provides vicarious pleasure for viewers. Many have suggested that apocalyptic and disaster narratives provide audiences with a certain level of wish fulfillment, as we enjoy seeing, from a safe space, "symbols of order die in flames."[18] To a lesser degree, Griffin's disruptive antics fulfill a similar vicarious pleasure. The scene makes invisibility look fun, and viewers will likely be more inclined to identify with Griffin than with the anonymous "country bumpkins." Furthermore, the fact that Griffin is doing all this naked (including riding a bicycle, which just seems uncomfortable) makes his behavior even more transgressive and adds ribald humor to the proceedings. Perhaps for this reason, the recent *Invisible Man* remake (2020)—which is much more serious—has the titular monster wearing an invisibility suit rather than parading around in the nude.

In the decades that followed, monstrous clowns remained rare, as there is generally not much clowning to be done by the blobs, giant insects, and faceless alien invaders that populate 1950s horror. During this period, however, we can see an impulse toward monstrous clowning through the character of the Crypt Keeper in E. C. Comics's *Tales from the Crypt* series. The original Crypt Keeper has a ghoulish face with long hair and warts and a mouth that always seems to be dripping saliva. Despite his monstrous appearance, however, the Crypt Keeper was clearly a clown and introduced his "Tales" with a series of groan-inducing puns or over-the-top

alliteration. Consider a representative example from a 1954 issue: "Crawl into the creepy old cruddy crypt of terror, fiends. This is your ghostly host, Le Crypt-Keeper . . . your Master of Cemeteries . . . ready to thrill you, chill you, and kill you with a slimy selection from my fiendish file."[19] This sort of comically monstrous persona can also be found in the work of television horror hosts like Vampira or Ghoulardi, who gained prominence throughout the 1950s and 1960s. These horror hosts would not only introduce movies but also read viewers' letters, perform skits, and provide comic commentary on the films. Not long after the rise of late-night horror hosts, comic monsters invaded prime-time television on the situation comedies *The Addams Family* and *The Munsters* (both ran from 1964 to 1966). The vast majority of the above characters, though, are more clowns than monsters and do not really "threaten normality" so much as they create a carnivalesque atmosphere of fun.[20]

The 1970s horror renaissance saw a greater variety in the types of monsters presented, and monstrous clowns began to appear in earnest. The demon Pazuzu, who possesses Regan (Linda Blair) in *The Exorcist*, certainly displays some of the features of an evil clown. This demon taunts those around it through the perfect replication of human voices, particularly of the priest Damien Karras's (Jason Miller) recently deceased mother. More importantly, the demon mocks many of our most sacred values, particularly when it defiles Regan's body by masturbating with a crucifix, thereby violating both religious taboos and feminine innocence. The demon's transgressive behavior is inherently performative, for it engages in these acts to torture not only Regan but also her watching mother (Ellen Burstyn). Like the Invisible Man, Pazuzu wants an audience. We see a similar mockery occur in the behavior of the deranged family in *The Texas Chain Saw Massacre* (1974). In one of the more disturbing moments, the final girl Sally, tied to a chair, screams in terror. The film immediately provides a reverse shot from Sally's point of view, and we see the family parroting (and parodying) her screams. Neither Pazuzu's nor the Sawyer family's mockery of their victims is particularly funny for audiences (although the grotesque absurdity of *Chain Saw*'s family comes close), but both instances display that their monsters have a sense of humor and a fondness for performance.

John Carpenter's *Halloween* (1978) introduced another important evil clown in Michael Myers. While Michael's total silence causes many to think of him as an animalistic killing machine (like Jason), there are various moments to suggest we read Michael as a clown. Most obviously, the young Michael wears a clown costume when he murders his older sister

in *Halloween*'s prologue. The costume establishes Michael's compulsive need to wear a mask, but it also invites us to note his sense of humor in his later killing spree. We see this comic sensibility when Michael kills the teenage couple Lynda and Bob (P. J. Soles and John Michael Graham). After the two have sex, Michael kills Bob when he goes into the kitchen for a beer. When Michael moves on to kill Lynda, he disguises himself in a simple ghost costume: a white sheet with two eye holes cut out. Over the eye holes, Michael wears Bob's glasses. The sight of Michael standing in the doorway dressed as a ghost is fundamentally comic. In particular, the glasses lend the image an air of deliberate silliness. Lynda, thinking that Michael is Bob, seems to agree, as she laughs out loud before Michael strangles her. Another comic moment comes later when final girl Laurie Strode (Jamie Lee Curtis) discovers the bodies of her murdered friends. The body of Annie (Nancy Kyes) is openly displayed on the bed with Judith Myers's stolen tombstone placed above her head. The bodies of Bob and Lynda, however, are hidden in nearby closets. When Laurie moves closer, the closet door where Bob is hidden suddenly pops open, and we see him dangling upside down. A moment later, another closet door pops open, revealing the corpse of Linda. These bodies have apparently been rigged to pop out—like a jack-in-the-box—upon Laurie's arrival.

Both scenes reveal an active intelligence and a dark sense of humor. In the first, Michael makes the active decision to disguise himself in a ghost costume, which means he had to find a sheet, cut out eyeholes, and so on. It also reveals that he understands human behavior well enough to know that Lynda would find his appearance in the sheet and glasses amusing. The disguise is not necessary for him to kill Lynda—he could have just walked in with a knife—but rather adorned for his own amusement. Similarly, the rigged corpses suggest that Michael had to perform some offscreen labor to achieve the desired, and quite theatrical, effect. Michael's comic behavior is less prevalent in the sequels and reboots, but there are still traces of it. The legacy sequel *Halloween* (2018), for example, has a moment where Michael, outside of a bathroom stall, announces his wicked intentions by dropping a handful of human teeth (!) over the stall's door. I'm not sure if this qualifies as a joke, but it is certainly a vicious taunt that Michael performs for no other reason than to instill fear and amuse himself. An acknowledgment of Michael's sense of humor does not make him any less evil; however, it does make him more of a distinct *character* and less of the anonymous "bogeyman" that psychiatrist Dr. Loomis (Donald Pleasence) makes him out to be. Furthermore, it displays Michael's understanding of—and disdain for—normal human behavior.

Horror's most recognizable comic monsters appeared shortly after *Halloween*. In 1984, Freddy Krueger debuted in *Nightmare on Elm Street*, and two years later, Stephen King's novel *It* introduced Pennywise the Dancing Clown. The two monsters have a lot in common, as both possess supernatural powers, rely on tricks, and feed on the fear of their usually young victims. Freddy was once a human—he was burned alive for murdering children—whose spirit now kills teenagers through their dreams. The creature in *It*, on the other hand, is some sort of ancient alien who takes on the clown avatar in order to lure children. Pennywise has his comic moments, but the novel and its adaptations all make it clear that underneath the clown disguise there is an inhuman monster, and its true form (a giant spider) is something of a humorless beast. Freddy, however, is an evil clown through and through and is American horror's most iconic comic monster.

Freddy is both clown and trickster. The most unique aspect of the *Elm Street* films is their method of blurring dreams and reality. Able to control the dream world, Freddy deceives his victims by appearing to them as loved ones or tricking them into believing they are awake. One of the more frightening instances of the latter actually occurs in the poorly received 2010 remake. Teenager Kris Fowles (Katie Cassidy) has a series of encounters with Freddy (Jackie Earle Hailey) in which "reality" is revealed to be a dream. In her final dream, she awakens to the apparent safety of her bed and gets up to splash water on her face. When she returns to bed, Freddy suddenly appears next to her. "Fooled you," he says and then proceeds to brutally murder her. Freddy's comment could be directed at the audience just as easily as Kris. Having been trained by the pattern of Kris escaping Freddy and then waking up, viewers too are likely fooled by the dream within a dream. Furthermore, in a nod to *Psycho*, Kris had been set up earlier as the protagonist, so audiences may be fooled when she dies after half an hour. Overall, the 2010 remake is a pale imitation of the original; in this scene, however, the filmmakers effectively capture Freddy's role as a trickster and display how his games are engineered to play with both victims and audiences.

As a clown, Freddy is also quite performative and has a fondness for jokes and puns, a trait that only increases with each sequel. *A Nightmare on Elm Street 3: Dream Warriors* (1987) features some of the monster's most famous one-liners. When he kills aspiring actress Jennifer (Penelope Sudrow) by smashing her head through a television set, he says, "Welcome to prime time, bitch!" Later, Freddy disguises himself as a beautiful nurse to lure and capture the libidinous mute teenager Joey (Rodney Eastman).

Freddy ties Joey to a bed with, bizarrely, four disembodied tongues. The main purpose for this restraint seems to be the set up for Freddy's bad joke: "What's wrong, Joey? Feeling tongue-tied?" Joey manages to survive this film but not the sequel. In *A Nightmare on Elm Street 4: The Dream Master* (1988), Freddy once again tricks Joey by appearing as a beautiful woman and then kills him in his waterbed. As Joey thrashes in the surprisingly deep waters of his bed, Freddy exclaims, "How's this for a wet dream?" Like the knife-fingered glove, horrible burns, and striped shirt, one-liners like these are a big part of what makes Freddy a horror icon.

The closest precursors to these types of jokes in horror are the groan-worthy puns of the Crypt Keeper, and it is thus not surprising that Freddy eventually became a horror host in the low-budget television anthology series *Freddy's Nightmares* (1988–1990). Within the world of the films, however, it is worth exploring the ways in which Freddy's humor functions. His jokes, it should be noted, are not good; the puns and wordplay are unsophisticated and obvious, and anyone looking to delegate the *Elm Street* films to the cultural trash heap may be inclined to use Freddy's bad jokes as evidence for their appeal to the lowest common denominator. The low quality of the jokes is part of the point, however, and humor is derived not from the jokes themselves but from an ironic acknowledgment of their silliness and the incongruity of corny jokes being delivered in the midst of brutal murders. Another related possibility is that the jokes serve to reinforce Freddy's evil and make him an even scarier monster. Not only does he kill you, but he has so much fun doing it.

It is also worth considering the audience for Freddy's humor. On the most surface level, it seems that Freddy delivers his one-liners both to amuse himself and to contribute to the torment of his victims. At the same time, though, his jokes are also for the benefit of the film's audience and thus suggest some sort of alliance between killer and viewer. In this light, we should remember that the *Elm Street* films were most popular during the heyday of the blockbuster American action film, in which Arnold Schwarzenegger, Sylvester Stallone, Bruce Willis, and others winked, smirked, and joked their way through numerous adventures, usually leaving behind a higher body count than most horror films. In this respect, Freddy's corny jokes and one-liners could put him in the same sort of position as those action stars who, as Laura Mulvey might say, acted as an "ego-ideal" for many viewers.[21]

The latter reading would seemingly support the often-made claim that many horror films, particularly 1980s slashers, are inherently conservative. That the jokes and one-liners of both Freddy and 1980s action stars

share some similarities with corny "dad jokes" may further reinforce the patriarchal nature of such films. I am hesitant, however, to endorse such a reading. While there is little doubt that the vast majority of Schwarzenegger and Stallone films adhere to a Reagan-era conservative ideology, the slasher films of the same period are much more ambivalent and ambiguous.[22] For one, the charge that most slashers of the period are conservative is usually supported by an analysis of who lives and who dies within the films. When the "bad," drug-using, sexually active teens die and the "good" virginal teens live, this reasoning goes, then the monster becomes a stand-in for puritanical, patriarchal judgment. If, however, the monster is indeed an agent of patriarchy, then it seems logical that the films are suggesting, on at least some level, that patriarchy itself is monstrous. Also, the supposedly "bad" behavior of the teens is almost always presented as fun. Therefore, when the patriarchal monster arrives, with his bad jokes and his homemade knife-fingered glove, he may be nothing more than the world's worst party pooper: a literal killjoy.

None of this is to suggest that the *Elm Street* films—or the vast majority of 1980s slashers, for that matter—are progressive. Rather, as Carol Clover has convincingly argued, these films' ideological ambiguity and ambivalence can be seen in their frequently shifting points of view, as audiences are encouraged at times to identify with the monster and other times with the victim. Ultimately, this is also the best approach to Freddy's jokes and one-liners. As American horror's primary evil clown, Freddy is inherently performative, and his evil demands an audience. That audience's orientation to his performance and to his humor, however, is always shifting. Sometimes we laugh with Freddy, sometimes at him. At other times, we might not laugh at all, and his jokes only serve to solidify his evil. And quite often, Freddy fools his audience just as much as his victims. At their most effective, Freddy's antics thus create a tension between various contradictory readings. Throughout all, however, Freddy's antics stand opposed to our own value system. That this disdain can alternately scare or amuse us points to the ambivalent nature of the monstrous clown.

Freddy's rise to prominence paved the way for scores of other quippy monsters who appeared in his wake. Chucky in the *Child's Play* series and the evil Djinn of the *Wishmaster* films both similarly rely on deception and display performativity and a penchant for one-liners. The same can be said for the various masked, game-playing killers of the *Scream* franchise. The most extreme example of this sort of monster is the crazed Dr. Evan Rendell (Larry Drake) in the little-known slasher *Dr. Giggles* (1992). This film must have some sort of world record for the most puns

and one-liners. Every time the crazed "doctor" kills someone, it is either followed or introduced by a medical-related joke: "The doctor is in," "Is it my bedside manner?" "Get ready to take your medicine," "Check out time!" "Visiting hours are over," "It's a good thing I make house calls," and so forth. After he has finally been defeated and lays dying, Dr. Giggles looks directly at the camera and asks, "Is there a doctor in the house?" The film's sheer commitment to medical-themed one-liners makes it perhaps one of the most explicitly comic of slasher films.

Based on the above examples, it may seem that joke-spouting comic monsters are reserved for lowbrow, schlocky slashers. The trend, however, can be found in prestige horror as well. For example, Oscar winner *Silence of the Lambs* (1991) ends with one of monster Hannibal Lecter's (Anthony Hopkins) most famous zingers: "I'm having an old friend for dinner." The joke is far less ambiguous than Freddy's one-liners, and this is a moment in which we are clearly supposed to laugh *with* Lecter. The "old friend" whom Lecter will presumably be eating soon is the smarmy Dr. Chilton, the man in charge at the asylum from which Hannibal has recently escaped. Throughout the film, viewers had been conditioned to dislike the doctor, and thus they may feel free to laugh at both Hannibal's joke and the fact that Chilton will soon be murdered and eaten. The film's humor thus fosters audience complicity with an insane murderer and cannibal.

A similar impulse can be found in Rob Zombie's Firefly trilogy, consisting of the films *House of 1000 Corpses* (2003), *The Devil's Rejects* (2005), and *3 From Hell* (2019). While American horror had no shortage of clown monsters after Freddy, Zombie's films provide some of the most interesting twenty-first-century examples. Brutally violent, self-aware, and highly stylized, Zombie's trilogy is influenced primarily by 1970s "hillbilly horror" films such as *The Texas Chain Saw Massacre* and *The Hills Have Eyes* (1977). Like those films, the Firefly trilogy features a family of rural, depraved murderers. The film *1000 Corpses* follows a fairly familiar slasher formula, as the main characters are ostensibly a group of youths who cross paths with the Firefly family, only to end up tortured and murdered. The sequels shift the focus to the Fireflys themselves, and both *Devil's Rejects* and *3 From Hell* operate partly as outlaw films in the mode of *Bonnie and Clyde* (1967) or *The Wild Bunch* (1969). *Devil's Rejects*, in particular, combines its horror aesthetic with a neo-Western sensibility, and it features—along with the murder and torture of innocents—multiple shootouts, an obsessed lawman, and a classic rock soundtrack with the prominent use of the Allman Brothers' "Midnight Rider" and Lynyrd

Skynyrd's "Freebird." Zombie's mixing of brutal horror violence with the tropes of romantic outlaw films underscores Cohen's point that while monsters repel us, they "also attract."

The most original aspect of this monster family is their pop-culture awareness, which often adds an element of humor. In particular, the family members adopt as their aliases the names of characters played by comedian Groucho Marx, the star of numerous Marx Brothers comedy films throughout the 1930s and 1940s. Rufus T. Firefly is Groucho's character in *Duck Soup* (1933); the Firefly surname is taken by the family as a whole, and two others go by Rufus. Additionally, Otis. B. Driftwood (Bill Moseley) and family patriarch Captain Spaulding (Sid Haig) are named after Groucho's characters in *A Night at the Opera* (1935) and *Animal Crackers* (1930). The family's fondness for Groucho-inspired aliases reveals both their self-conception and Zombie's vision of the sort of comic monsters he has created. Linnie Blake notes that the family comes "to encapsulate all the anarchic potentiality of the irrational other."[23] The statement could apply just as easily to the Marx Brothers themselves. The plot of most Marx Brothers films features Groucho, along with the silent Harpo and the heavily accented Chico, disrupting some social event or civilized setting (the opera, a swanky party, etc.) with their madcap antics and uninhibited comic energy. Groucho, clearly the Fireflys' favorite, is well known for his verbal wit and continuously insults those around him, showing no respect for the rules of civilized decorum by which others abide.

In a manner similar to the Invisible Man's comic rampage discussed above, the pleasure of watching a Marx Brothers film comes from seeing the brothers upend the orderly world of wealthy society. The often shockingly violent Firefly films do not offer similar pleasures, but the Fireflys' brutality comes from a similar place of antisocial aggression. Otis, in particular, displays disgust for social institutions. In *Devil's Rejects*, he asks his hostage Roy (Geoffrey Lewis) if he finds Baby Firefly (Sheri Moon Zombie) attractive. When Roy responds that he is "a married man," Otis derisively mocks him: "A married fucking man? . . . Well, let's give 'em a big round of applause, folks!" Later, before he kills him, Otis tells Roy to "pray to your god." As Roy mumbles a prayer to Jesus, Otis begins dancing and sarcastically exclaims, "I feel it! Oh, great god almighty, I repent. I repent! Oh, the holy spirit is in my body." Otis then claims to be the devil and beats Roy to death with a log. The two scenes show Otis's disdain for conventional morality and institutions like marriage and religion. Otis singles out Roy for more sustained derision because of Roy's unflagging belief in such institutions. If there is humor in these scenes, it is only for

the Fireflys themselves. Otis, in particular, seems to see himself as a contemporary embodiment of Groucho Marx, upending social norms and mocking conventional behavior. He is a monster with nothing but disdain for "normality."

The most explicit monstrous clown character, however, is Captain Spaulding who actually dresses as a circus clown. Less sadistically violent than Baby or Otis, Spaulding nonetheless exhibits a dark sense of humor and a disdain for conventional morality. When he steals a car from a woman and her young son, Spaulding confronts the little boy: "What's the matter, kid, don't you like clowns? Don't we make you laugh? Aren't we fucking funny? You best come up with an answer 'cause I'm gonna come back here and check on you and your mama. If you ain't got a reason why you hate clowns, I'm gonna kill your whole fucking family." Spaulding's speech strips away the veneer of innocence and fun that is often associated with clowns and instead posits the clown as a violent transgressor of social mores. Spaulding clearly finds delight in knowing that he has emotionally scarred the child.

While the Fireflys' acts of violence are amusing from their point of view, most audience members—hopefully still bound to *some* notions of conventional morality—are more likely to be frightened or disgusted. Zombie, however, crafts several comic moments in which these psychopaths interact with one another. The most famous of these is in a *Devil's Rejects* scene with Otis, Baby, and Captain Spaulding. Baby sees a sign advertising ice cream and wants to stop. Otis refuses, and the two proceed to bicker. Spaulding chimes in and also wants ice cream, saying, "I'm gonna get me some Tutti-Fuckin' Frutti." Baby and Spaulding begin chanting "Tutti-Fuckin' Frutti" repeatedly while Otis continues to protest. There is then a quick cut, and we see Baby and Spaulding happily eating ice cream cones while Otis scowls. The scene ends with Baby smearing Otis's nose with ice cream.

This scene generates humor first through the actors' naturalistic performances. Otis, Baby, and Spaulding really seem like bickering family members, and the scene establishes a sitcom-like charm, as Otis and Baby bicker like stereotypical siblings, and Captain Spaulding emerges as a playfully indulgent father. After Otis refuses to stop, the quick cut to Baby and Spaulding happily licking their cones works like a punchline to underscore that despite Otis's grumpiness, he can be easily manipulated by the other two. The ice cream smear on Otis's nose provides a similar punchline to the entire scene. Finally, though, the moment is funny because it is so incongruous with much of what we have already seen of

these characters. Not long before this scene, Otis was wearing the face of one of his murder victims in order to taunt the victim's screaming wife. The juxtaposition of that sort of sadistic evil with playful family bickering is disorienting but has the potential to be quite funny. Humor aside, the scene also humanizes its monsters. While Otis, Baby, and Spaulding might mock the morality and personal bonds of their victims, we can see that they have also created an alternative ethos in which their familial relationships matter. They are monsters, and they are clowns, but Zombie uses humor to make them also be people. It is perhaps because of effectively comic scenes like this that Rob Zombie was chosen to helm the recent reboot of the horror-comedy sitcom *The Munsters* (2022).

Frightening Fools

Monstrous clowns enjoy being monsters, and their laughter frequently signifies disdain for conventional norms. In contrast, monstrous fools do not laugh but are laughed at; they are social pariahs who, in different circumstances, would like to fit in. Monstrous fools may garner audience sympathy, or they may represent our guilty fear that those who society deems unacceptable will come back to destroy the culture that spurned them. In texts featuring monstrous fools, humor generally works in one of two ways. In the first, as in *Carrie*, society's laughter creates the monster. Humor exists within the fictional world, but audiences are not encouraged to laugh along. In the second, the monstrous fool does potentially prompt audience laughter—although not through any intention of their own. Instead, we laugh at the monster's outcast status, even if we fear its destructive capability.

The first sort of monstrous fool has been explored in the most detail by Florent Christol, who posits the "foolkiller movie" as a distinct horror subgenre that includes some films from the monster's perspective—like *Carrie*, *Willard* (1971), or *Fade to Black* (1980)—as well as numerous slashers, such as the *Friday the 13th* series, *Prom Night* (1980), *The Burning* (1981), *House on Sorority Row* (1982), and *Sleepaway Camp* (1983). Drawing upon Rene Girard's work on the scapegoat, Christol argues that the "fool represents a collective concept of a kind of person distinguished from the normal group member by a deviation in person or conduct that is regarded as ludicrous, improper, and inferior." Christol goes on to note that this character "often incites mockery or the hostility of the social group to which he belongs, and constitutes henceforth an 'ideal' scapegoat."[24] In these films, the monster "escapes" from the fool role by getting

violent revenge on those who have bullied or mocked them.[25] Tellingly, Christol also identifies a comic variant of this form in Hollywood comedies like *Revenge of the Nerds* (1984).

Christol's formulation provides a useful means of discussing the role of humor and laughter in the construction of the monstrous fool. If humor is a form of boundary construction, then it is used in these movies to exclude the fool. The fool, in turn, lashes out violently. Carrie White's monstrosity, as we have seen, is a direct result of the cruel pranks and mocking laughter of her peers. The loose sequel *The Rage: Carrie 2* (1999) follows a nearly identical plot structure and shows Carrie's half sister also driven to monstrosity through a cruel prank. While the original *Friday the 13th* (1980) explained Jason's drowning as the product of neglectful camp counselors, some sequels retroactively suggest he was viciously mocked and bullied by the children at Camp Crystal Lake. The list goes on and includes numerous films from the late 1960s through the 1980s that Christol discusses. Once we identify the monstrous fool as a distinct type, we can begin to find examples that go beyond Christol's narrow scope. In particular, there are monstrous fools who are not explicitly laughed at in their fictional worlds but who nonetheless fulfill a similar narrative function and who often prompt audience laughter. In these films, the audience, through laughter, becomes complicit in ostracizing the fool.

In this regard, the quintessential monstrous fool is Frankenstein's monster. Particularly in the first three Universal *Frankenstein* films, the monster is one of horror's most sympathetic creatures, and his primary motivation is to find acceptance, friendship, or sexual union. Unlike Carrie and her monstrous brethren, the civilized world tends to react to him with screams rather than laughter; however, Boris Karloff's ungainly, shambling portrayal of the monster has enough potential humor that parodies of it, in films like *Abbott and Costello Meet Frankenstein* (1948) and *Young Frankenstein* (1974), are able to generate humor with very little modification to the original portrayal. The monster's comic potential became clear to me once in a film class I was teaching. Two students gave a presentation on Universal horror, and they showed the scene from *Frankenstein* (1931) in which the monster befriends—and then unintentionally kills—a little girl. The girl throws flower petals into a pond to watch them float. The monster is delighted by the display, and when the petals are gone, he picks up the girl and tosses her into the pond. She drowns, and the monster runs away. When the monster tosses the girl into the water, the majority of my students burst into laughter. Their laughter, of course, should be taken with a grain of salt; people unfamiliar with classic films often find

them amusing simply because they are "old." Nevertheless, director James Whale has a distinct comic sensibility (see the earlier discussion of *The Invisible Man*), and there *is* something darkly humorous about the scene.

My students' laughter, I suspect, is driven primarily by incongruity. The scene has a sudden and dramatic shift in tones from sentimental to horrific, and this shift registers as a shock to viewers who may laugh at the incongruity even as they recoil from a child being killed. The monster's actions, however, also make him a fool. In the most surface definition of the word, it is *foolish* of him to believe that the little girl will float, and it is *foolish* of him to run away after she sinks. The monster is also a fool in the sense of the social outcast defined above. He will never find a place in the social order due to his monstrous physicality, but here and elsewhere he also evinces an inability to understand basic guidelines for social conduct. The humor of the scene is driven by both of these readings: humans laugh when someone acts in foolish ways, and they also laugh at those who do not adhere to dominant social guidelines. In this particular scene, the humor is ambivalent; we laugh at the monster's foolishness, but we may also feel sorry for him and be horrified by his actions. This sort of ambivalence drives the humor of the monstrous fool.

Horror has plenty of other fools in the vein of Frankenstein's monster. The lonely, horny merman in *Creature from the Black Lagoon* (1954) comes to mind, but the majority of monsters in the 1950s and 1960s do not have the same comic potential as Karloff's monster. Famed B-movie director Roger Corman, however, offered two comically monstrous fools in his low-budget cult classics *A Bucket of Blood* (1959) and *The Little Shop of Horrors* (1960). More comedies than horror films, both are about unintelligent misfits who commit grisly murders in their attempts to fit in. In *Bucket of Blood*, Dick Miller plays aspiring artist Walter Paisley, who becomes a successful sculptor by covering the corpses of his murder victims in clay. Miller plays the part as a clueless dimwit, and the script is full of dark humor. Walter, for example, gives his sculptures comically unsubtle and possibly incriminating names like "Dead Cat" and "Murdered Man." The film primarily satirizes "beatnik" culture, as nearly all the bohemians whom Walter hopes to impress are portrayed as pretentious fools, but Walter himself is the biggest fool of all. *Little Shop of Horrors*—more well known because of its musical adaptations in film and on Broadway—has a fairly similar plot and aesthetic. Seymour Krelborn (Jonathan Haze) works in a flower shop and becomes popular when he raises a mysterious man-eating plant and eventually has to kill people to feed it. In both *Bucket* and *Little Shop*, the monstrous fools get their

comeuppance in comically appropriate ways. Walter covers himself in clay and hangs himself—thus becoming one of his sculptures—and Seymour is eaten by his plant. Both characters are fools from beginning to end, and their attempts to be accepted transform them into monsters. As with Carrie, their monstrosity can be viewed as a manifestation of social boundary construction.

Rob Reiner's *Misery* (1990), adapted from the 1987 Stephen King novel, offers another iconic fool in Annie Wilkes (Kathy Bates). The film tells the story of romance novelist Paul Sheldon (James Caan), who is rescued from a car crash by Annie, his "number one fan." Having broken both of his legs, Paul is nursed back to health at Annie's country house. Annie—whose birthday in King's novel is April Fool's Day—initially seems like an amusingly dowdy but good-natured caretaker, but her murderous insanity is gradually revealed. She forces Paul to burn the manuscript for a new novel that she deems offensive. Then having learned that Paul killed off Misery Chastain, the protagonist of his long-running series of romance novels, she forces Paul to write a new novel that brings her back to life. Along the way, she hobbles both of his feet with a sledgehammer and murders the local sheriff. Paul eventually manages to kill Annie and escape but is left traumatized.

Annie is an uncommon horror monster. Like other monstrous fools, she is very much a social outcast, living by herself on the outskirts of a New England community. While she does not exhibit most fools' desire to fit in, she sees herself as a standard bearer for proper social behavior and displays a puritanical morality that stands in ironic contrast to her capacity for violence. Furthermore, she very much wants to be accepted by Paul. Annie is far less sympathetic than the vast majority of monstrous fools. However, she is one of the rare monsters—thanks in part to Bates's performance—who manages to come across as funny and scary at the same time. While she has little sense of humor herself, humor is generated by the incongruous juxtaposition of her priggish sensibilities and air of menace. Her use of language is particularly funny. Early in the film, she makes clear her distaste for "obscene" language when she forces Paul to burn his novel manuscript, in which the characters often swear. When Paul protests that "everybody talks like that," Annie yells, "They do not! What do you think I say when I go to the feed store in town? 'Oh now, Wally, give me a bag of that effing pig feed and ten pounds of that bitchly cow corn?" Annie's outburst displays her foolishness and is funny primarily because of her comic misunderstanding of the social contexts in which people actually use profanity. Her use of the word "bitchly"—a

neologism, to my knowledge—is also quite funny, especially to describe cow corn.

This speech, however, also offers viewers (and Paul) the first glimpse of Annie's monstrous potential. During the monologue, ominous music swells, and the camera moves in on Paul's face to highlight his discomfort. Annie gets so caught up in her anger about foul language that she spills soup all over the bed. Numerous other moments in the film similarly display Annie's monstrousness even as viewers are invited to laugh at her. The first scene in which Annie's monstrousness is made fully apparent, for example, occurs after she finishes reading Paul's latest Misery novel, in which Misery dies in childbirth. The scene opens with a shot of a full moon. Annie then appears in Paul's room, her face partially concealed in shadows. She looks down at Paul and says, "You. You dirty bird. How could you? She can't be dead." The full moon, the shadowy lighting, and the low angles and close-ups through which Annie is shot all announce her as a threatening monster. These elements, though, stand in comic contrast to her word choice, and "dirty bird" generates humor even as the rest of the scene induces dread. Throughout the film, Annie uses these sorts of "innocent" curses ("cockadoodie," "oogie mess," etc.) that create humor even as Annie is engaged in otherwise monstrous activities.

Annie's humor is also linked to her gender. Not only is Annie a monstrous fool, but like Carrie, she is also an example of what Barbara Creed identifies as the "monstrous-feminine." Creed explains that the term encapsulates the female monster but "emphasizes the importance of gender in the construction of her monstrosity."[26] Many critics have placed Annie within this category, pointing out how she infantilizes and emasculates Paul: the hobbling of his legs and the burning of his manuscript, for example, can both be read as symbolic forms of castration.[27] While Annie's capacity for violence and her physical strength both masculinize her, she also attempts to adhere to the outdated standards of ideal femininity that are on display in the Misery novels she adores. As Avalon A. Manly points out, "Annie cannot meet the impossible standard of womanhood set forth by Misery Chastain, and ... she lashes out monstrously, with spectacular violence."[28] Annie thus emerges as a monstrous iteration of Don Quixote—or perhaps Madame Bovary—in that she sees the world through the idealized lens of genre fiction. As in those texts, humor is generated by a recognition of the gap between those fictionalized ideals and reality. In the case of Annie, the gap is most apparent through her use of language.

Misery effectively upends traditional gender roles in multiple ways, but there is a misogynist element to this strain of humor. First, Annie's

failure to adhere to idealized gender norms is also reinforced through her large body, and the film draws a connection between her and her pet pig, named Misery; Annie actually oinks at Paul at one point. Furthermore, the film's last scene suggests that Annie's monstrosity might not be unique but is latent in all women. Eighteen months after killing Annie, Paul is at a restaurant with his agent when he sees Annie walk toward him. It turns out that it is not Annie at all but just the waitress. In a repetition of Annie's most famous line, however, the waitress tells Paul that she is his "number one fan." The fact that Paul sees the waitress as Annie before she repeats her line suggests that Paul senses similarity between the two and encourages audiences to also see this connection. The ending—and the film as a whole—thus mocks the traditionally feminine readers of romance novels and suggests that lurking not far beneath their dedicated fandom is a creepy violence. The irony, of course, is that Paul created Misery Chastain and is thus responsible for perpetuating these impossible standards of female decorum. The result makes Paul something like Dr. Frankenstein and the foolish Annie his monster run rampant.

In the years since *Misery*, horror has seen plenty of monstrous fools. Annie Wilkes herself got something of an origin story in season two of the Hulu series *Castle Rock* (2018–2019), and in addition to its sequel, *Carrie* was remade twice, in 2002 and 2013. Additionally, throwback slasher films like *Valentine* (2001) and *Thriller* (2018) continue the foolkiller tradition of monsters created through childish pranks and cruel laughter. *Spree* (2020) takes the monstrous fool into the found footage format in its story of a misfit who records himself committing several murders in an attempt to elevate his social media profile. I end my discussion of monstrous fools, however, with another example of the monstrous-feminine in Lucky McKee's *May* (2002). The film is about May (Angela Bettis), a lonely and socially inept young woman whose only friend is a doll named Suzie. After enduring several failures at finding a human friend, May goes on a killing spree, dismembers her victims, and makes a new doll out of her favorite body parts from each victim. May is a standout in the monstrous fool category because of the ways in which the character simultaneously elicits audience sympathy, laughter, and revulsion.

Star Angela Bettis also portrayed Carrie White in the made-for-TV remake of *Carrie* released the same year. Bettis is thus particularly suited to portraying a sympathetic social outcast, and much of the film's humor is driven by May's awkward attempts to make friends or find romance. Bettis's performance is a big part of the film's success in this regard. In an early scene, for example, May sees Adam (Jeremy Sisto), with whom she

is infatuated, walking across the street. As they pass, Adam stops to light a cigarette, and May smiles and walks up to him as if to start a conversation. At the last second, she loses her nerve and turns around. The moment is sweetly comic and establishes May as a sympathetic character at the outset. One could easily imagine a quirky romantic comedy having the same scene. The sympathy established in an early moment like this carries over into later scenes when May's behavior becomes erratic and violent. On their eventual date, Adam shows May a short film he made that features two lovers simultaneously making love and eating each other. May describes the film as "sweet" and nuzzles closer to Adam as they watch. Later, though, May attempts to recreate the film; she bites Adam's lip and smears his blood all over her face. "It's just like your movie," she says. This behavior, of course, drives Adam away. May's cluelessness and romantic ineptitude are funny even as her biting and smearing of blood are disturbing. Despite our laughter and revulsion, the film stays within May's perspective, and we never lose sympathy for her.

May features no bullies or cruel pranks, but May's transformation into a monster is, like Carrie, precipitated by the laughter of others. After her biting misadventure with Adam, she is heartbroken when she overhears Adam and his friends laughing and referring to May as a "lunatic." May later begins an affair with her coworker Polly (Anna Faris) but is disillusioned when she finds her with another woman. Polly teases May for being jealous, and her lover Ambrosia openly mocks her. Eventually, May kills Adam and his new girlfriend, Polly and Ambrosia, and a young man who she picks up on the street. She builds a new doll that features Adam's hands, Polly's neck, Ambrosia's legs, and the young man's arms and torso; one of the arms, appropriately, has a tattoo of Frankenstein's monster. When May is distraught that her doll cannot see her, she cuts out her own eye and gives it to the doll. In the final moments of the film, May lays next to her creation, crying that it has not come to life. Then the creation's hand (once belonging to Adam) reaches up and strokes her face. The film ends with this image.

It is clear that May's creation does not actually come to life but that its movement is a product of her imagination and thus of her mental illness. The ending has May completely isolated from any living humans and essentially living within her own mind. This situation underscores May's status as a monstrous fool and provides an extreme example of the ways in which horror films can generate contradictory audience reactions toward their monsters. May's capacity for brutal violence can elicit our fear, and the sight of her with one eye gouged out cuddling up next to a grotesque

assembly of human remains is repulsive. At the same time, though, May remains a sympathetic character and, despite the graphic violence of the final act and the disgusting display of its last moments, it is relieving to see May find peace, even if we know it cannot last. Throughout it all, however, May remains an object of humor, whether we are laughing at her awkward attempts to socialize or at her cuddling up to her absurdly grotesque new "friend." By balancing these contradictory attitudes, the film encourages viewers to interrogate their varied reactions. Our laughter at society's outcasts works as a form of boundary construction, but what—these films ask—are the consequences of these boundaries? May, in particular, and monstrous fools in general reflect a guilty anxiety about the points of view of those whom we discard or laugh at and suggest that we are all—like Paul Sheldon in *Misery*—avatars of Dr. Frankenstein, creating the very monsters that we fear.

Diabolical Dummies

May's preoccupation with dolls points to horror's long-standing use of such toys to generate dread. In fact, my two earliest memories of being scared by a horror text are both linked to evil dolls. The first is from the season five *Twilight Zone* (1959–1964) episode "Living Doll," and the second is from Tobe Hooper's *Poltergeist* (1982), in which a boy's clown doll becomes possessed by spirits and attacks him. Evil dolls further populate the genre through numerous texts and long-running franchises like *Puppet Master*, *Child's Play*, *Annabelle*, and *The Boy*. The fear generated by dolls is typically explained through the concept of the "uncanny," which Freud describes as "that class of the terrifying which leads back to something long known to us, once very familiar."[29] A sentient doll is thus a familiar object and a wholly alien being. Freud's work on the uncanny is built upon an essay by Ernst Jentsch, who explicitly ties the word (*unheimlich*, in German) to a fear of inanimate objects that appear lifelike. As Chifen Lu summarizes, "Objects with features that are human-like yet are not exactly like actual human beings tend to elicit visceral feelings of revulsion."[30] We can also flip this around and point out that people are equally disturbed by a living thing that either appears or becomes inanimate, as we see in a horror film like *Mystery of the Wax Museum* (1933, remade twice as *House of Wax*, in 1953 and 2005). Both scenarios (living dolls or doll-like humans) are uncanny, according to Freud's definition of the strangely familiar. Victoria Nelson builds upon this and points out that evil doll stories "play on the seeming self-contradiction of an inanimate object invested with the aura of

childhood innocence that is suddenly infused with . . . demonic energy."[31] The juxtaposition of innocence with evil thereby generates the impurity associated with horror but also, potentially, the incongruity associated with humor.

Out of all horror's evil dolls, none is so closely tied to elements of humor as the ventriloquist's dummy, which was used as an object of horror as early as the 1945 British anthology film *Dead of Night* and as recently as *Dead Silence* (2007) and the child-friendly *Goosebumps* films (2015 and 2018). Even outside of the horror genre, many already find the ventriloquist's dummy inherently frightening. In a humorous consideration of the topic, Neil Norman writes, "So what is it about these man/child mannequins that creates such fear and creepiness? First, there is their appearance: the mad, swivelling [sic], psychotic eyes beneath arched eyebrows and that crude parody of a mouth (with painted teeth) that opens and shuts with a click that's rather too close to the sound of a trap for comfort." Norman goes on to note that "all ventriloquist's dummies look like the badly embalmed corpses of small boys" and also suggests that the entire ventriloquist scenario has a whiff of pedophilia due to the image "of a man with a young boy sitting on his knee while the adult's concealed hand ferrets around inside him."[32] Perhaps because of these myriad frightening or disturbing associations, many contemporary ventriloquists have abandoned the classic wooden dummy for less lifelike (and thus less uncanny) soft Hensonesque puppets. In horror texts, though, the classic wooden dummy reigns supreme, and it provides a key link between humor and horror.

A ventriloquist's act operates in two ways. The first is through a simple display of skill, as the performer shows off how he or she can make the dummy talk or sing without moving their lips. The second and more important part of a ventriloquist act is the comic interaction between the ventriloquist and dummy; the two typically work as a comedy team in which the dummy is the funny one and the ventriloquist is the "straight man," a term which may represent various aspects of repression. The dummy, of course, has the social license to say things that the ventriloquist does not. As such, the dummy emerges as the act's unfiltered id whereas the ventriloquist is the stodgy superego. As Norman points out, there is a "nagging suspicion that ventriloquists use dummies to express their darkest thoughts—to vent their wrath and exorcise their own psychological demons."[33] Herein lies the scenario's capacity to generate horror. If, as Wood argues, horror's monsters represent all that we repress as a culture and in ourselves, then the ventriloquist dummy, particularly when

telling transgressive or bawdy jokes, is already an expression of repressed impulses. It doesn't take much to transform the ventriloquist's situation into a scary story where the dummy, either due to insanity or through supernatural means, overtakes the ventriloquist, entailing "the puppet master's loss of identity."[34] In this sense, the evil dummy—who is either literally or figuratively a part of the ventriloquist's own psyche—works as a variation of the Jekyll and Hyde scenario. It also represents something of a fusion between the two main types of comic monsters. The dummy's comic performativity establishes it as a monstrous clown, whereas the suffering ventriloquist emerges as the fool. The dummy's capacity for both humor and violence are thus manifestations of the ventriloquist's repressed sexual or aggressive impulses.

We see this in an inchoate form in the early sound film *The Great Gabbo* (1929), one of the first to explore the more unsettling implications of the relationship between ventriloquist and dummy. The film is about the ventriloquist Gabbo (Eric von Stroheim) and his fraught relationship with his girlfriend/assistant Mary (Betty Compson). Gabbo is extremely talented but is an insensitive megalomaniac, abusive to Mary and everyone else. In his act, Gabbo's doll Otto fulfills the traditional role of the transgressive funny dummy, and Gabbo often accuses Otto of getting too "fresh" with women in the audience. Offstage, however, Gabbo uses Otto to express emotions that he cannot articulate himself, and there are multiple scenes featuring conversations between Gabbo and Otto where, ironically, the doll exhibits more emotion and compassion than the human. If *The Great Gabbo* were released today, it would likely be read as an inversion of well-known horror tropes. For in *The Great Gabbo*, the ventriloquist is the brute, and the dummy is a sweetheart. Mary is well aware of Gabbo's tendency to project his more sensitive emotions onto the doll; before she leaves him, she says, "Little Otto there is the only human thing about you."

The Great Gabbo is essentially a tragedy about a man who is unable to confront his own emotions, for it is clear that Gabbo's attempts to repress his feelings (or project them onto Otto) are quite unhealthy. Fittingly, Gabbo eventually has a nervous breakdown on stage, in which he screams again and again—in his own voice—that he knows "how to laugh." The statement references the song "I'm Laughing," which Otto sings twice during the film. Otto, it seems, has the human capacity for laughter and humor that Gabbo lacks, and Gabbo realizes too late that he has put the best parts of himself into the doll. Although *The Great Gabbo* is not really a horror film, its use of a doll to chart one character's descent into madness lends it some horrific qualities. Furthermore, there is a distinct eeriness

to Gabbo and Otto's prolonged conversations; one character actually says that it is "uncanny" to see the man and puppet having dinner together. More importantly, the film lays out themes and motifs that will be transformed into horror in later texts, particularly the use of a doll to represent the fractured psyche of the ventriloquist.

While *The Great Gabbo* makes it clear from the start that Otto is not actually alive, many horror texts display an ambiguous tension between psychological and supernatural explanations. The season three *Twilight Zone* episode "The Dummy" is a good example.[35] Here, the ventriloquist Jerry (Cliff Robertson) is convinced that his dummy Willie is alive, but everyone else sees his belief as a symptom of mental illness or a side effect of alcoholism. Since it is a *Twilight Zone* episode, viewers may be more likely to believe that Willie is alive, but the text foregrounds psychological explanations for most of the runtime. Jerry himself explains and rejects his diagnosis: "Patient goes from himself to a lifeless dummy and then is unable to separate himself from the dummy. Oh, that's all very psychiatric and erudite . . . but it's not right . . . Willie's alive!" Despite his rejection of the psychological explanation, various clues point to Jerry's madness. Much of the episode takes place in Jerry's dressing room, where mirrors are very prominent, and we often only see Jerry and Willie's reflections, and at one point, Jerry throws a magnified mirror at the dummy. The shot then cuts to Willie's face reflected in the mirror's cracked surface. These examples suggest that Willie is simply a reflection of Jerry, and the cracked mirror points, not very subtly, to a fractured identity.

Later in the episode, Jerry hears Willie's voice when no one else can, and the camera films events through a series of expressionistic Dutch angles, both of which seemingly underscore that Willie's coming to life is all in Jerry's mind. Thus, when the two start having conversations with each other, it is unclear whether we are viewing an actual living doll or Jerry's hallucination. Willie's explanation as to how he came alive doesn't clear anything up either: "You made me real. You poured words into my head. . . . You made me what I am today." The comment could just as easily refer to Willie as a product of Jerry's unconscious as to the supernatural. The closing of the episode feels the most explicitly supernatural, although it could still be read as an elaborate hallucination. In the end, we see, from behind, a ventriloquist and his dummy taking the stage. As the camera moves to the front, it reveals that the ventriloquist is now a bushy-eyebrowed man who looks a lot like Willie, and the dummy has the face of Jerry. No explanation is given, but in his deadpan closing narration, Rod Serling refers to this situation as "the old switcheroo."

The ambiguity creates an unsettling effect, which is only reinforced by its use of humor tropes. Willie is very much a comic monster, and the episode uses humor not as relief but rather to develop both the horror elements and psychological themes. In the opening scene, we see a few moments of Jerry and Willie's nightclub performance. The jokes are not particularly funny, but as we would expect, Willie is the comic one, and he gets the most laughs when insulting Jerry. In the act, Willie even claims he could be a better ventriloquist, and the two briefly take on each other's voices, foreshadowing the episode's "switcheroo" ending. Later, when Jerry tries to prove to his manager that Willie is alive, he says, "He talks when I don't talk. He tells jokes I've never heard of before, gives me bum cues. He's alive." The comment explicitly ties Willie's aliveness to his capacity for humor; even the "bum cues" suggest Willie is deliberately playing with Jerry. Read through a supernatural lens, this simply highlights Willie's status as a comic monster. A psychological lens, though, suggests that both Willie and his jokes come from a repressed place within Jerry's mind. Later, when Jerry begins hearing Willie's voice, Willie's comments are punctuated by maniacal laughter, and he rapidly repeats one of the act's more tepid jokes—about living outside of the Ritz Savoy—over and over again, turning the corny punchline into a sort of demonic chant. Willie's evilness is thus directly linked to his sense of humor, and through the episode's blurring of supernatural and psychological explanations, both evilness and humor are tied to Jerry's own fractured psyche. Given the "switcheroo" ending, Willie could be read as a manifestation of Jerry's aggressive impulses and self-loathing.

These issues are explored most fully in Richard Attenborough's *Magic* (1978) about timid magician Corky Withers (Anthony Hopkins). Corky is extremely talented with card tricks, but because he has no stage presence, he begins using a ventriloquist dummy named Fats to liven up his act. Over the course of the film, Fats takes increasing control over Corky's mind, eventually spurring him to commit two murders. The only way Corky is able to finally defeat Fats is to kill himself. Despite its title, there are no supernatural elements in *Magic*, and the film makes it very clear that Fats is a part of Corky's mind. Even though we know that Fats is not real, however, the camera work and editing make the dummy feel like an actual monster with a personality distinct from Corky's. For example, Corky attacks his agent, Ben Greene (Burgess Meredith), by clubbing him over the head with the dummy. The attack features a series of POV shots from Ben's perspective, in which it looks like Fats is flying through the air to make the attack. Only at the edge of the frame can we see that Corky's

hands are holding the dummy's body. In another particularly chilling scene, Corky has sex with his love interest Peggy (Ann Margaret). The sex scene features soft lighting and sentimental music. It is periodically interrupted, however, with sudden cuts to Fats, sitting in the next room with his back turned to the lovers. The point is clear: Fats—and thus a part of Corky's own mind—is unhappy with the romantic development. In another similar moment, Corky, under Fats's instructions, attempts to sink Ben's body at the bottom of a lake. While Corky is thus engaged, we get a shot of Fats "watching" from the cabin window. These and other moments create the sense that Fats is a distinct character. The fact that he is an uncanny dummy only adds to this sensation.

Magic's premise of a shy, nervous man compromised by a murderous alter ego certainly owes a debt to *Psycho*. A key difference, though, is the way in which *Magic* links its murderous alter ego to humor and thus establishes Fats (or the part of Corky's mind where Fats resides) as a comic monster. When Corky adds Fats to his act, he becomes immensely popular because of the humor the dummy brings to the routine. Fats's style of humor is an obscenity-laden mix of hostility and sexual energy. When viewers first meet Fats, he is a disembodied voice heckling Corky during his performance. Corky then brings the dummy, whose heckling was revealed as part of the act, onto the stage, and Fats continues to berate Corky for his card tricks, saying that he can "guaran-fucking-tee" he could do the trick better. A moment later, Fats refers to a young woman in the audience and says, "You see the broad with the big jugs? ... Why don't she want a roll in the shavings with me?" As the film progresses, we see Corky depend on Fats to liven up not only his magic act but also his life. When Corky woos Peggy, for example, he uses Fats to make her laugh and to make his sexual interest in her clear. And when Peggy's husband is suspicious of her relationship with Corky, Fats jumps in with a joke to defuse the tension.

Through Fats, *Magic* thus links humor, violence, and sexual energy. The aggressive and sexual nature of Fats's comic sensibility reads like a textbook example of Freud's study of humor, in which he asserts that jokes, particularly of the hostile or sexually explicit variety, serve to relieve the excess tension created by the repression of aggressive or sexual energy. Corky, as we see when Fats is not around, clearly represses nearly all his aggressive, sexual, and emotional impulses to the extent that he comes across as a timid, stammering fool. Fats helps Corky unlock reservoirs of confidence and humor, but this also opens the floodgates for a monstrous violence. The monstrous Corky/Fats duo can thus be directly tied to Wood's

Freudian conception of the horror monster as the "return of the repressed." Before Fats, Corky is imprisoned by his inhibitions, but after Fats, he is even more imprisoned by the funny, violent energy that he has released. *Magic* suggests, then, that Corky's insanity is derived from his inability to find a healthy way of channeling his repressed energies. The film's use of an uncanny ventriloquist dummy to dramatize this situation displays how a horror text can draw direct connections between humor and monstrosity. In fact, as we saw earlier in the discussion of evil clowns, humor can be an integral aspect of the monstrous rather than a relief from it.

Conclusion

Most critics and fans of horror would agree that the monster is the key figure of the genre. The monster is the face of numerous franchises, and horror's most iconic images are typically associated with its monsters. The general agreement is that the monster represents either specific cultural anxieties or deep-seated psychological fears. As numerous critics have pointed out, the monster is essentially a border creature, existing at the boundaries between life and death, human and object, or civilization and savagery. These characters also often sit on the border between laughter and fear. An acknowledgment of horror's comic monsters does not change our basic understanding of the monster's various roles, but it does add texture to our understanding of the relationships that audiences and other characters form with monsters. Monstrous clowns and fools both demonstrate the ways in which laughter and humor operate as forms of boundary construction. Laughter establishes the monster's conflict with its social context. The dummy/ventriloquist duo, rooted in comic performativity, internalizes this boundary construction by dramatizing conformist and antisocial impulses within a single person. While not all horror's monsters can be placed in the categories of clowns, fools, or dolls, the comic monster both is common enough and has existed in horror for long enough to make it an important element of the genre.

CHAPTER 3

Painfully Funny
The Humor of Body Horror

HORROR IS ABOUT bodies. Its victims and heroes fight for their lives, which is really another way of saying that they fight for their bodies: to keep them alive, uncorrupted, and free from pain. Horror films make this struggle explicit by often dwelling on the spectacle of tortured, mutilated, and dead bodies. Horror has an equal preoccupation with monstrous, threatening bodies: the shuffling, decaying corpses of zombie narratives; the imposing teeth and claws of creature features; the seemingly indestructible bodies of a Michael Myers or a Jason Voorhees; or the

IMAGE 4: *The Fly* (1986). Courtesy of Photofest.

revolting, unnatural bodies created by mad scientists or radiation. The figure of the ghost is typically defined by and derives its horror from its lack of a body or from its unnatural way of being simultaneously embodied and disembodied. Numerous horror films conflate these threatened and threatening bodies.[1] In *The Exorcist* (1973), the possessed Regan (Linda Blair) functions as both monster and victim. In David Cronenberg's version of *The Fly* (1986), Seth Brundle (Jeff Goldblum) is both a revolting monster and the victim of his own botched experiment. In nearly all cases, though, the spectacle of distressed or horrifying bodies is one of horror's premiere attractions.

In addition to horror being *about* bodies, it also encourages bodily reactions from audience members in the form of screams, nausea, and so on. Linda Williams makes this point in her classic discussion of "body genres." Williams focuses on horror, pornography, and melodrama as three genres in which "the body of the spectator is caught up in an almost involuntary mimicry of the emotion or sensation of the body on the screen."[2] Despite the fact, however, that humor theorists also stress the importance of bodies,[3] Williams argues that in physical comedy films, "the reaction of the audience does not mimic the sensations experienced by the central clown. Indeed, it is almost a rule that the audience's physical reaction of laughter does not coincide with the often dead-pan reactions of the clown."[4] Williams's characterization of the audience's reaction to physical comedy films is consistent with theories of humor that emphasize superiority and detachment. In many cases, however, the audience's physical reaction is not this clear-cut. For example, there is an early scene in the comedy *There's Something about Mary* (1998) when the protagonist Ted (Ben Stiller) accidentally gets his penis and testicles caught in the zipper of his pants. The film is undoubtedly a comedy, and the moment surely generates humor. At the same time, however, many audience members may also moan, gasp, wince, or feel physically ill at the sight or idea of Ted's predicament. In other words, the moment fosters *both* detached laughter and the same sort of "involuntary mimicry" of the on-screen body that Williams discusses.

There's Something about Mary is not an isolated instance. Joshua Louis Moss, for example, articulates a "crisis slapstick" in his discussion of the *Jackass* films and other similar texts, in which performers attempt dangerous stunts that often end in severe injury.[5] Violent, unsafe slapstick comedy of this sort can elicit a similar blend of laughter and discomfort from audiences. This chapter considers the flip side of that coin and analyzes numerous horror texts that encourage a mixture of horrific revulsion

and laughter. William Paul points out that "disgust inevitably involves an ambivalence, a simultaneous attraction and repulsion." For Paul, comedies "play to the positive pole of disgust" and "horror films to the negative."[6] This ambivalence is key to understanding the humor of body horror. Rather than placing horror and comedy on opposite poles, as Paul does, I am more interested in those texts and moments when the positive and negative reactions to disgust happen at approximately the same time: comedies that generate horror and, particularly for our purposes, disgusting horror texts that generate humor. These sorts of texts both display and generate a high level of ambivalence about bodies and, by extension, about mortality, gender, and the stability of identity. In their attempts to shock audiences, many horror films generate an uneasy blend of horror and laughter. Other texts utilize a pop-existentialist approach to embodiment that posits laughter as a way of coping with mortality or with the fragility of our corporeality. This ambivalence toward embodiment is thus an important overlap between humor and horror.

A Whole Planet of Cronenbergs

Before analyzing the ways in which this overlap manifests in horror, it will be useful to consider a particularly illustrative comic example from the irreverent animated television series *Rick and Morty* (2014–). The series is about a genius scientist named Rick who goes on science-fiction adventures with his fourteen-year-old grandson, Morty. The show parodies high-concept science fiction, as its often elaborate story lines deal with space travel, aliens, and the multiverse. The season one episode "Rick Potion #9" brings this parody to body horror, but in doing so, the episode ultimately descends into horror itself. "Rick Potion #9" thus highlights key themes and issues of body horror and also demonstrates the inherent slipperiness of body horror texts and the ways in which they vacillate between humor and horror.

In the episode, Rick reluctantly gives Morty a love serum to help him woo his crush, Jessica. Jessica has the flu, however, and the love serum attaches to the virus, becomes airborne, and soon causes every person in the world to fall in love with Morty. Rick attempts to create an antidote, but this only has the effect of turning everyone into humanoid praying mantises who still want to mate with Morty but also want to eat him afterward. Rick tries to develop *another* antidote, but this one transforms everybody into shapeless, monstrous blobs. Rick dubs these monstrosities "Cronenbergs," after the Canadian body horror auteur David

Cronenberg, and asserts that the planet is beyond saving. Finally, in a parody of television sitcoms in which all is "returned to normal" by episode's end, Rick searches the multiverse and finds an identical version of Earth that is not overrun by Cronenbergs but where he and Morty had recently died. Rick and Morty travel to this alternate Earth, bury the dead versions of themselves, and slip into their lives. The return to normality is undercut, however, by the soundtrack playing the gloomy Mazzy Star song "Look on Down from the Bridge" and especially by the horrified look on Morty's face.

The explicit mentioning of David Cronenberg is one of many instances in which the series playfully calls attention to its pop-culture influences. In this case, it also invites viewers to see the episode as a work of body horror itself. The most obvious manner in which this works is through the "Cronenbergs" themselves, which—like the protagonist of Cronenberg's *The Fly*—are human beings transformed into inhuman monsters. Furthermore, like the parasite-infected humans in Cronenberg's *Shivers* (1975), the episode's humans are transformed into sex-crazed maniacs. In fact, "Rick Potion #9" makes sexual desire even more explicitly monstrous. In *Shivers*, the humans' transformation into libidinous monsters is an unintentional side effect of an experimental medical procedure. Here, Morty's own sexually aggressive energy is the catalyst. Rick makes this clear later, when he blames Morty for the apocalypse, telling him that he is a "creep" for wanting to "roofie" Jessica. Like a Cronenberg film, "Rick Potion #9" is preoccupied with deformed bodies and posits sexuality as a monstrous force.

Despite the horrific situation of Rick and Morty bringing about the apocalypse, the majority of the episode is still basically a parody of sci-fi body horror films and mostly functions as humor. The fairly crude animation tempers the horror, as the animated images suggest monstrosity but are not actually revolting in the manner of what we might find in a Cronenberg film. This allows the monsters to be more amusing than scary. The episode also generates humor through the ridiculous situation of Morty running for his life while all his classmates chase him through the streets expressing their love for him. Finally, there is comic hyperbole in the speed with which the monstrous mutations spread throughout the whole world and irony in the fact that each of Rick's attempts to fix the problem only makes it worse.

The episode's ending, when Rick and Morty bury their own corpses, moves much closer to straightforward body horror. Rick is apparently unaffected by the sight of his own dead body, but Morty is visibly horrified.

He does not speak again in the episode but only looks upon his own corpse and grave and then moves about the house watching his parents (who are not his original parents) argue. The trauma of the situation is apparent, but the episode leaves it unarticulated. Two episodes later, in "Rixty Minutes," Morty's "sister" Summer plans to run away after learning that she was the result of an unwanted pregnancy. To put things in perspective, Morty tells her about the events in "Rick Potion #9": "Every morning, Summer, I eat breakfast twenty yards away from my own rotting corpse.... Don't run. Nobody exists on purpose. Nobody belongs anywhere. Everybody's gonna die. Come watch TV." Morty's speech highlights the nature of the traumatic events in "Rick Potion #9" and posits detached nihilism and acceptance of mortality as the only ways to move forward.

Taken together, the two episodes further highlight the workings of body horror and resonate with a passage from Stephen King's introduction to his story collection *Night Shift*. In a particularly chilling passage, King explores what he calls the "shape" of human fears: "The shape is there, and most of us come to realize what it is sooner or later: it is the shape of a body under a sheet. All our fears add up to one great fear, all our fears are part of that great fear—an arm, a leg, a finger, an ear. We're afraid of the body under the sheet. It's our body. And the great appeal of horror fiction through the ages is that it serves as a rehearsal for our own deaths."[7] King literally gives shape—that of our own corpses—to our fear of mortality. In this sense, *all* horror that deals with death is body horror. King's description recalls Julia Kristeva's assertion that "the corpse, seen without God and outside of science, is the utmost of abjection. It is death infecting life."[8] "Rick Potion #9" both resonates with Kristeva's assertion (death infects Morty's life) and literalizes King's "body under the sheet" metaphor. We all know, in an abstract way, that we will die, but Morty confronts tangible evidence by handling his own corpse.

"Rick Potion #9" therefore explores multiple facets of body horror. It begins by asserting, through Morty's frustrated libido, the monstrous power of sexual energy and then presents a series of mutated and monstrous bodies, which blur the border between human and other. Finally, it ends with a meditation on the inevitability of death through the signifier of one's own corpse. Significantly, this is all packaged in an animated comedy series and is presented as mostly humorous throughout. The episode thus displays a profound ambivalence about bodies and death. The horror genre, as the following sections discuss in more detail, reveals a similar ambivalence, as its monstrous and threatened bodies often simultaneously signify as objects of horror and humor.

"Gross-Out" Films and Shocking Bodies

Rick and Morty's preoccupation with the humorous and horrific potential of corpses and monstrous bodies can be seen as a contemporary version of what Paul has termed a "gross-out" aesthetic. Paul uses the umbrella term "gross-out films" to discuss several horror and comedy movies from the 1970s and 1980s. These films "embrace ... explicitness as part of their aesthetic" and make "revulsion into a sought-after goal."[9] The very fact that Paul finds such important similarities in comedy and horror speaks to the ambivalence of explicit or "gross" displays of the human body. There are several films throughout horror's history that, like "Rick Potion #9," use "gross" and shockingly monstrous bodies to generate humor and horror, thereby displaying an ambivalence about monstrous bodies and corporeality in general. Like the other devices of humor discussed throughout this book, the humor of violated and violating bodies does not operate as comic relief. Rather, in gross-out horror, humor and disgust operate in tandem.

As the scope of Paul's study suggests, the 1970s and 1980s were a prime period for texts that revel in bodily excess. This is due in part to relaxed restrictions on what could be explicitly shown in mainstream films. This period also arguably sees the peak of practical special effects. Makeup and effects artists like Tom Savini, Rick Baker, and Rob Bottin found ways of bringing to life nearly anything that directors and screenwriters could imagine. Indeed, many horror films of the period feel like something of a toy box for effects artists who take their creations as far as possible. This means that the images that horror films displayed during this period are not only scary but also amazing in the very fact of their existence. The humor of many gross-out horror films, then, stems in part from disbelief or shock at what is being shown on-screen. This simultaneous sense of disbelief, humor, and horror is perhaps epitomized best in the famous moment of John Carpenter's *The Thing* (1982) when what appears to be a severed human head suddenly sprouts spider legs and scurries across the floor. The camera cuts to the stunned faces of the protagonists, and then Palmer (David Clennon) says, "You've got to be fucking kidding." Palmer's response mirrors and validates the audience's own and underscores the potential for humor in such a monstrosity.

Disgusting practical effects of this sort were not really seen in American horror until Herschell Gordon Lewis's gore films in the mid-1960s and were not commonplace for at least another decade. There are, however, earlier examples of horror's ability to gross out and potentially

amuse audiences with monstrous bodies. Tod Browning's notorious cult classic *Freaks* (1932) is a key early text in the history of body horror and one that also displays the ambivalent humor that would become common decades later. In *Freaks*, there is no need for extensive makeup or special effects, for Browning cast actual circus sideshow performers, with a wide array of physical disabilities, as the titular "freaks." In doing so, the film puts on display real-life bodies that could be deemed "monstrous" and represents them in a manner that is alternately funny, scary, shocking, and sympathetic.

Freaks is a backstage story about the lives of circus performers. The primary plot concerns the attractive trapeze artist Cleopatra (Olga Baclanova) who, with the help of circus strongman Hercules (Henry Victor), plots to marry the short-statured Hans (Harry Earles) and then kill him in order to access his recently inherited fortune. Once the other disabled performers learn of this plot, they kill Hercules and severely mutilate Cleopatra, turning her into a legless and horribly scarred chicken woman. While this is the primary narrative, the majority of *Freaks*'s 64-minute runtime actually deals with the fairly mundane lives of the performers. The bearded lady and the skeleton man have a baby; the Siamese twins interact with their respective love interests; the romance between the clown and the seal trainer burgeons. During all this, viewers are privy to the spectacle of severely disabled individuals performing everyday tasks. The "Armless Woman," for example, drinks a glass of beer with her foot, and the "Human Torso" lights and smokes a cigarette using only his mouth. All these details make it clear that *Freaks* isn't only *about* a circus freakshow; it *is* a mass-mediated version of one.

Scholars are torn on how to approach the film. Some read it as an exploitation piece,[10] while others see it as primarily sympathetic and assert that its process of showing the performers in their everyday lives normalizes them for audiences.[11] This mixed critical reaction is due in part to the film's own contradictory ways of presenting the performers. We may be able to debate whether the mundane activities represented throughout most of the film normalize the freaks or exploit them, but there is no question that when they turn on Cleopatra and Hercules, they are presented as horrifying. The attack occurs during a thunderstorm, and there is a series of shots of the freaks crawling through the mud and holding knives menacingly. The mud and rain make them appear primordial and inhuman. Furthermore, the shot of Cleopatra transformed into a chicken woman is truly disturbing, especially as it forces viewers to imagine what the freaks have done to her.

The freaks, then, are alternately horrifying and sympathetic. For many viewers of the period, the very sight of severe physical disfigurement would have qualified the film for gross-out status,[12] and this aspect surely contributed to the film's commercial and critical failure. The ambivalence toward the freaks is compounded by the film's use of humor. For the most part, *Freaks* does not play for laughs. Rather, humor is presented as a weapon to further marginalize the freaks. Hans's original short-statured love interest Frieda (Daisy Earles) warns Hans that Cleopatra and Hercules are laughing at him behind his back, and indeed, we often see them do just that. In another scene, two men mock the "half-man, half-woman" with a series of pronoun-switching barbs: "Don't get her sore, or he'll bust you in the nose." In these instances, the film shows that the freaks are objects of derisive laughter but does not attempt to generate humor itself. The argument could thus be made that this only increases audience sympathy. Of course, there may very well be viewers who laugh along with the cruel characters.

Sometimes, though, the film itself treats the freaks as objects of humor. This is perhaps most explicit in the scenes dealing with the romantic lives of the conjoined twins, played by real-life twins Daisy and Violet Hilton. Daisy's husband Roscoe (Roscoe Ates) bickers with Violet and complains about her sitting up reading all night. When Violet announces her engagement to Mr. Rogers (Demetrius Alexis), the two husbands exchange niceties and each says that the other couple "must come to see us sometime." The line works as a gag, since the men will likely see quite a bit of each other. And in general, the moments with Daisy and Violet attempt to generate humor simply by pointing out the unusual domestic situations of the conjoined twins. The humor here is not as cruel as that fostered by characters like Hercules and Cleopatra, but it turns Daisy and Violet into something of a spectacle and encourages audience members to laugh at both their bodies and their lives.

Overall, *Freaks* is aware of the ways in which bodily disabilities and deformities can generate both humor and horror. It strives to create sympathy for its titular freaks, but it also exploitatively capitalizes upon the shock value of the bodies that it displays. In its time, *Freaks* was both a box-office and critical flop, and it is usually credited with ruining the career of director Tod Browning. It seems audiences were not ready for such shocking bodies in 1932. In the 1960s, however, it was rediscovered and has since become a cult classic. The new appreciation for *Freaks* in the 1960s makes sense, for horror films created during this decade began to show bodily violence and monstrous mutation in more explicit detail.

The Brain That Wouldn't Die (1962), for example, is about a doctor whose fiancée is decapitated in a car accident. He keeps her head alive as he attempts to find a new body for her. The film is ultimately misogynistic and unfunny, but its dominant image of a decapitated woman's head, kept alive in a tray, has shocking comic potential and anticipates the wild, severed body parts of later films like *Re-Animator* (1985) and *Frankenhooker* (1987).

During the 1960s, Herschell Gordon Lewis, the "Godfather of Gore," also started directing his low-budget splatter films. Shown primarily at late-night screenings and drive-ins, these films' main attraction is their explicit and colorful representations of violence, which often used animal intestines and other body parts to simulate the disembowelment and dismemberment of on-screen victims. Lewis's gore films tend to be poorly acted and artlessly directed and depend almost exclusively on shock value. There is a comic sensibility in Lewis's approach to violence, though, and this is most apparent in his second gore film, *2000 Maniacs* (1964). Sort of a horror version of *Brigadoon*, the film is about a Southern town that was wiped away by the U.S. Army in the Civil War. One hundred years later, the town returns for a centennial celebration, in which the townsfolk brutally murder several northern tourists in revenge.

Released in the midst of the 1960s civil rights movements, the film works in part as a satire of the South's reluctance to change with the times. The satire, however, takes a backseat to the spectacle of brutal, over-the-top violence and body humor. The townsfolk don't just murder their Northern visitors; they make those murders an integral part of the centennial celebration's festivities. For example, in the "barrel roll," they place a man in a barrel with nails hammered through it and roll him down a hill to be punctured to death. In another kill scene, the townsfolk take turns throwing softballs at a target that will release a boulder and crush a woman tied below. Throughout these ritualized murders, the citizens laugh, hoot, and holler in a ridiculous fashion, and the corpses are slathered in blood so red that it looks like the effects artists simply poured a can of red paint all over the actors. The film's humor is thus driven by excess and hyperbole. Later films—particularly *The Texas Chain Saw Massacre* (1974)—would explore the displaced rural killer theme with more sophisticated humor, but *2000 Maniacs* remains a fascinating and amusing celebration of gore and exaggerated violence.

Over the next decade, gore films and the gross-out aesthetic became much more prominent in American horror. *Night of the Living Dead* (1968), discussed in more detail in chapter 6, was a game changer. As Paul

points out, however, it was *The Exorcist* "that really established gross-out as a mode of expression for mainstream cinema."[13] The film was a commercial and critical success, and it is still somewhat mind-boggling to think that a movie featuring projectile vomiting, spinning heads, and a young girl masturbating with a bloody crucifix was nominated for Best Picture at the Academy Awards. *The Exorcist* does not play its revulsion for laughs, but Paul makes a good case for seeing parts of the film as "hideous slapstick comedy." In particular, Paul compares Regan's excessive vomiting into Father Karras's face to a "full throttle" shot from a seltzer bottle.[14] After *The Exorcist*, gross-out horror became more prominent and more explicitly comic.

This is particularly true in the 1980s, and one could fill an entire book just cataloging the numerous funny, gory, and gross moments that occur in 1980s horror films. The slasher's dominance during this period has a lot to do with that. Slasher films tend to follow a fairly standard formula, so the main variation from film to film is the murders themselves, which became more frequent and more excessive throughout the decade. Indeed, for most slasher fans, the primary attraction is the innovative, practical-effects-driven kill scenes. One can Google any slasher franchise with the phrase "best kills" and be taken to an array of articles, blog posts, and YouTube videos of fans discussing and appreciating their favorite murders.[15] Similarly, reviews of slasher films on websites like IMDb or Letterboxd often focus on the quality of kills, which tend to be judged by creativity, ability to surprise, and the quality of the special effects. This aspect of slasher-fan culture reveals the level of detached humor through which many fans tend to approach the subgenre.

The most often-celebrated slasher kills are those that adhere to the ambivalence of the gross-out aesthetic. A successful kill can potentially generate two audience responses, either in sequence or at the same time: a groan of disgust and a laugh of either surprise or appreciation. For example, one kill that often makes top-ten lists for the *Friday the 13th* films comes from *Part III* (1982). After having intercourse with his girlfriend, a young man walks through the house on his hands. Jason appears with his machete and cuts the upside-down young man down the middle. The implied castration continues, in a comically exaggerated manner, the franchise's tendency to punish those who have sex, even as it incites groans of sympathy and laughs of both disbelief and appreciation. A similar response is generated from the popular kill in *Part VII* (1988) when Jason drags a young woman in a sleeping bag from her tent and then brutally slams the bag, with the woman inside, against a tree. The descriptions

of these kills may make some readers question the morality or sanity of anyone who would laugh at such scenes. However, their creativity about bodily violence, combined with the common ambivalence toward vulnerable bodies, allows them to function as both humor and horror.

The most outrageous and explicitly comic of 1980s gross-out films, however, are not slashers. Low-budget, practical-effects-driven, comic horror films like *Re-Animator*, *Evil Dead II* (1987), and *Society* (1989) each push body horror and its inherent shock value to the limit, and all three have since become cult classics.[16] Based on an H. P. Lovecraft story, Stuart Gordon's *Re-Animator* tells of medical student Herbert West (Jeffrey Combs) and his attempt to develop a serum that reanimates the dead. The film reworks the *Frankenstein* story, and Combs plays the mad scientist role with an intense and comic energy. West and his reluctant roommate Dan (Bruce Abbott) reanimate several corpses, including the dean of the medical school, who also happens to be the father of Dan's fiancée, Megan (Barbara Crampton). Most reanimated corpses come back basically as zombies, and the film gets comic mileage out of their hijinks. However, when West decapitates rival doctor Carl Hill (David Gale) for attempting to steal the reanimator formula, the film gets truly crazy. West, always on the lookout for fresh corpses upon which to test his serum, injects both Dr. Hill's head and body with his formula. Due either to the freshness of the corpse or Dr. Hill's intelligence, he does not turn into a zombie like the other reanimated corpses. Instead, he is able to telepathically control both his own detached body and all the other bodies that West reanimated. Unlike *The Brain That Wouldn't Die* twenty years earlier, *Re-Animator* mines its talking head gag for all its gruesome and humorous potential; there are multiple scenes of Dr. Hill carrying around his own head, often in a bag, as he emerges as the primary monster and begins a reign of terror.

Many gory horror movies have one infamous scene that viewers remember and talk about for years. In *Re-Animator*, that scene is Dr. Hill's attempted sexual assault of Megan. Hill ties Megan naked to a table, and his headless body begins groping her while his head, sitting in a tray of blood, groans in pleasure. Hill's body picks up his head and holds it close to Megan so that he can profess his love to her and begin licking her face; all the while, blood leaks from the bottom of Hill's neck. To top it off, Hill's body begins to place his head between Megan's legs. Thankfully, for viewers and Megan, West intervenes before this rape can go any further. The threat of sexual assault makes the scene truly horrifying. At the same time, David Gale's over-the-top performance combines with the shocking and ridiculous sight of the headless body and the talking head to give

the scene a darkly comic and surreal quality. Also, as many viewers point out, the scene works as a visual pun, literalizing the idea of "giving head." The joke works not so much because of its sophistication or inventiveness but simply because the filmmakers had the audacity and technical know-how to actually put a scene like that in a movie. The best reaction may be to follow the lead of Palmer in *The Thing* and say, "You've got to be fucking kidding."

Re-Animator's preoccupation with severed body parts moving around independently derives humor in part through its incongruent blurring of the boundaries between self and other. Paradoxically, our body parts are both self and something other than self, and body horror generates uneasiness and laughter through its exploitation of that paradox. Sam Raimi's *Evil Dead II* pushes this idea to its full comic potential. A sort of hybrid remake and sequel to *The Evil Dead* (1981), the film is about a young man, Ash Williams (Bruce Campbell), who accidentally awakens demonic forces at a cabin in the woods. While the original has several comic elements, particularly through its excessive gore and fast-moving shaky cam, *Evil Dead II* expands on both of these aspects and adds a hyperbolic performance from Campbell, who plays Ash with an over-the-top comic energy that seems designed to match the excessive gore effects. *Evil Dead II* is certainly a horror movie, but it hews closely to pure comedy.

Campbell's performance and the film's hyperbolic body humor work together in a crazy scene, early in the film, when Ash battles his own possessed hand while it is still attached to his body. The hand first starts moving back and forth on the wrist while Ash holds on to his arm and mutters, "You dirty bastards" and yells, "Give me back my hand!" Soon, the possessed hand attacks Ash outright; it breaks several dishes against his head, pulls his hair, punches him in the stomach, and flips him over. Eventually, the hand knocks Ash unconscious and begins dragging his body across the floor, presumably going for a meat clever. Ash wakes up and manages to impale the hand with a knife and saw it off with a chain saw. Throughout the scene, we somehow hear the hand's chattering, demonic voice, which lends to the feeling of surreal humor. The whirling camera reinforces this aspect, and we even get a shot from the hand's point of view as it drags Ash across the floor. The humor, however, is driven primarily by Campbell's committed performance. He throws his own body around with a gymnastic dexterity, and the scene feels like something of a one-man Three Stooges routine. *Evil Dead II* has plenty of other comic body horror moments, including one where Ash is sprayed in the face with a seemingly impossible amount of blood. This scene, however, captures

Evil Dead II at its most outrageous, and it playfully literalizes the uneasy, ambivalent feeling that our bodies are both ourselves and not ourselves.

I'll conclude my discussion of 1980s gross-out horror with the class warfare satire, *Society*. Director Brian Yuzna was the producer for *Re-Animator* and the director of its two sequels, *Bride of Re-Animator* (1990) and *Beyond Re-Animator* (2003). This should give a sense of Yuzna's gross-out aesthetic and affinity for comic body horror, which is on full display in *Society*. The film is about Bill Whitney (Bill Warlock), a Beverly Hills teenager who suspects something sinister and perverted about his wealthy family and their "society" friends. The film works as a sort of teenage version of films like *Rosemary's Baby* (1968) or *The Stepford Wives* (1975). The protagonists of both films have a strong but unsubstantiated suspicion that they are in horrible danger. The reality of the danger, however, is not fully revealed until it is too late. Likewise, in *Society*, Bill is told several times, with ominous overtones, that he "will make a real contribution to society," but the import is not clear until the climax, when Bill learns that his parents, sister, and their "high-society" friends are actually members of a nonhuman race that literally consumes poor people. For his entire life, Bill has been raised by his family only in preparation for the day in which they will feed upon him in an outrageous and violent orgy, referred to as "the shunting." In other words, *Society* casts the rich as a different species from the rest of humanity and literalizes the metaphor of the rich feeding off the poor.

It is difficult to describe the sheer disgusting excessiveness of the shunting sequence. The wealthy society folks begin with Will's friend Blanchard (Tim Bartell); they strip him naked and begin licking him and running their hands all over his body. Soon, the flesh of everybody involved becomes viscous, and the bodies melt into one another. Blanchard screams in horror while all the society members laugh and moan in gluttonous (and glutinous) ecstasy. All the while, Johann Strauss II's waltz *The Blue Danube* plays in the background. The gentle classical music works as an ironic counterpoint to the disgusting proceedings and contributes to the humor. The insanity doesn't end there. With the help of his society love interest Clarissa (Devin DeVasquez), Will escapes and stumbles into a bedroom where he finds his fake parents and sister engaged in a body-melding orgy of their own. His mother and sister have morphed into a bizarre single body, and his father's face now protrudes from his own buttocks. Will's father laughs and says, "You always said I was a butt-head." Finally, in the somewhat forced happy ending, Will fights his society high school rival Ted (Ben Meyerson) and manages to win by reaching inside

Ted's body and pulling him inside out. The inside of Ted's body—and presumably of all society members—is crawling with worms. The other socialites look on in horror and allow Will to leave.

The above description does not really do justice to the outrageousness of the scene or to the jaw-dropped shock of most viewers upon a first watch. Aside from generating humor and shock, however, the shunting sequence provides a visual counterpart and comic literalization to the film's thematic preoccupations. As already mentioned, the shunting ritual literalizes the metaphor of the rich feeding off the poor. The image of bodies melting into one another also literalizes the rich "sticking together" and visualizes the society members' disregard for moral boundaries, particularly through their breaking of the incest taboo. We also, of course, get the comic literalization of the word "butt-head." On a more primal level, the shunting sequence causes disgust and anxiety because it disrupts our common conception of closed and individualized bodies. If the bodily borders that separate us from other individuals are permeable, then how do we even know who we are? The scene is not a carnivalesque celebration of open and fluid bodies but rather a depiction of the abject terror of being slowly absorbed and obliterated. The scene's innovative use of makeup and practical effects thus manages to disgust, amuse, and contribute to the film's themes.

Society was completed in 1989 but not released in the United States until 1992. It thus feels like something of a coda to the decade's comic, practical-effects-driven body horror. Many of the more recent disgusting body horror films, like those in the *Saw* or *Hostel* franchises, keep the disgust and shock value but largely dispense with the humor, particularly in their depiction of bodies. Other films like *Slither* (2006) and *Bad Milo* (2013) are effectively funny and gross, and *Drag Me to Hell* (2009) sees Sam Raimi return to his *Evil Dead* style of hyperbolic violence. These works, though, are deliberate throwback pieces, waxing nostalgic for the comic insanity of the practical effects heyday. This is not to say that comic body horror has gone away. As demonstrated in the following sections, which focus on comic and horrific transformations and horrific slapstick, body horror and humor have other important manifestations.

Bodily Transformations

Horror is full of human characters literally changing into something else. Sometimes, the transforming human becomes a monster, and in other cases, the very process of mutation is horrifying. Some of the gross-out

films previously discussed have elements of bodily transformation and quite a few of the films discussed in this section could be easily read through the lens of gross-out. The films discussed here, however, either focus more heavily on the process of bodily transformation—which often spans the entire film—or foreground the destabilization of identity that comes with bodily changes. The humor of many of these texts takes on an absurdist quality, as they use bodily changes to explore larger existential issues, albeit through a "lowbrow" pop-culture approach.

The most common body transformation stories, particularly in early horror, are of the werewolf and Jekyll and Hyde varieties. *Werewolf of London* (1935), *The Wolf Man* (1941), and the two classic sound versions of *Dr. Jekyll and Mr. Hyde* (1931 and 1941) are mostly light on laughs, and due to the primitive special effects, the actual transformations are suggested more than shown. Tudor points out, for example, how the transformations in *The Wolf Man* are achieved through "a combination of tension-building cues," such as shots of a full moon or ominous music, and then "a series of lap dissolves," ending with the full transformation.[17] *Cat People* (1942) completely withholds any visual marker of transformation—to the extent that for much of the film, viewers may not be sure if Irena (Simone Simon) really does transform. Furthermore, these early examples tend to present the human and the monstrous transformation as two distinct characters, and thus there was little exploration into how a character's identity and sense of self were also being altered by bodily changes.

In the 1950s, however, science fiction dominated American horror, and the genre became full of monstrous bodily mutations, usually caused by some sort of atomic radiation or space invasion. The most famous of these feature mutated monsters running wild, as with the giant insects in *Them!* (1954) and *Beginning of the End* (1957). The period, however, also saw its fair share of monstrous human transformations in films like *Attack of the 50 Foot Woman* (1958) the original version of *The Fly* (1958), and *The Wasp Woman* (1959). Many of these movies will certainly generate laughter for contemporary viewers, but that is due more to the preposterous plots, ridiculous costumes, or shoddy special effects than to any significant comic sensibility. A key exception, however, is Jack Arnold's *The Incredible Shrinking Man* (1957), adapted from Richard Matheson's 1956 novel.[18] The film makes innovative use of special effects and, thanks to Matheson's screenplay, has a clear sense of humor even as it fully explores the horror of the protagonist's situation.

The film tells the story of Scott Carey (Grant Williams), a regular-sized man who, after exposure to a combination of radiation and pesticides,

begins steadily shrinking. Doctors manage to temporarily stall the shrinking but can never make it stop. Eventually, he shrinks to near subatomic size. During the film, Scott becomes increasingly angry and bitter, and as he gets smaller and smaller, his life becomes endangered by everyday monsters, particularly the family cat and a spider living in the basement. As Scott battles these mundane monsters, the film works like many other 1950s creature features, except instead of giant killer animals, we have a shrunken man. The film derives body horror, though, through the way Scott's progressive shrinking causes his life and sense of self to steadily slip away from him. In addition to these horror elements, the film generates quite a bit of humor out of Scott's situation. It is very much about a shrinking *man* and can easily be read as a comic crisis of masculinity, one which is quite ahead of its time for a 1950s genre film. At the same time, it explores a dark, absurdist laughter about our place in the universe, even if its ending ultimately steps back from true absurdism.

The film foregrounds Scott's precarious sense of masculinity. As Cyndy Hendershot points out, Scott's "anxieties about living up to the 1950s masculine ideal pre-exist his physical devolution."[19] We see this first in the opening; Scott and his wife, Louise (Randy Stuart), are vacationing on a boat, and when Scott asks Louise to fetch him a beer, she refuses. Scott has to bargain with Louise—usually referred to as the masculine "Lou"—by offering to exchange cooking dinner for the beer. As Lou heads inside the boat, Scott yells, "To the galley, wench!" The line seems intended as playful, and Lou receives it that way, but it also suggests a longing on Scott's part for a more traditional patriarchal structure. Significantly, while Lou is below deck, Scott becomes enshrouded by the radioactive mist that will precipitate his diminution. Carolina Núñez Puente asserts that Scott is thus "punished for forcing his wife to do the kind of tasks that he considers feminine."[20] Scott, however, does not "force" his wife to get his beer. He bargains with her. It may thus be more accurate to read Scott's shrinking not as punishment but, following Robin Wood's "return of the repressed" thesis, as a manifestation of Scott's anxiety regarding masculinity. We later learn that Scott works for his brother Charlie (Paul Langton) and is borrowing the boat from him. This suggests that even before shrinking, Scott lives in his brother's shadow and fails to adhere to contemporary standards of masculinity.

Once Scott begins shrinking, the humor of his gendered anxiety is achieved mainly through visual gags that reveal, in surprise shots, how small Scott has become. At one point, Charlie tells Scott that he can no longer afford to give him a paycheck. Charlie's speech is filmed from behind a large

armchair, where Scott presumably sits. When the film finally provides a reverse, high-angle shot, we see that Scott is the size of a small child, and the chair is so deep that his legs stick straight out. The sight of Scott looking like a child, achieved through the use of giant props, is both horrifying and comically surprising. A similar but funnier gag is provided later when we learn that Scott has become the size of a doll. We first see Scott moving around a room in which everything is in proportion to his body. The entire room begins shaking, and there is a cut to Lou walking down the stairs. A moment later, Lou kneels in front of a dollhouse and calls for Scott, who emerges onto the dollhouse's balcony and yells, "Do you have to make such a racket?" The image of Scott yelling at his wife from a dollhouse balcony is quite comic; despite his extremely small size, he attempts to maintain patriarchal control, which renders him ridiculous. Furthermore, the scene provides a visual pun at the expense of Scott's masculinity: he is tiny, but he is still the man of the (doll)house.

There are also verbal jokes at the expense of Scott's manhood. After the media learns of Scott's condition, Lou tries unsuccessfully to get them an unlisted number. Scott asks if Lou told the operator who he was and says, "I'm a *big man*! I'm famous." Scott is clearly aware of the irony of saying he is a "big man," but the sight of him saying it only adds to the irony and renders the scene comic. Later, after he is stranded in the basement like a tiny Robinson Crusoe, Scott makes a sword and hook out of two of his wife's sewing pins. Scott's voice-over tells us, "With these bits of metal, I was a man again." As Puente points out, this is a "deeply ironic moment" as Scott looks to "an external element to compensate for his lack of a phallus."[21] The fact that these external elements are the tools for his wife's sewing only adds to the irony. Even though Scott is only inches tall at this point, his use of phallic weapons and his need to fight for survival ironically bring him closer to idealized, heroic masculinity than he was at full size. In this manner, the film achieves an ambivalent humor of masculinity: it celebrates traditional, violent manhood even as it mocks Scott's adherence to it.

Along with its gendered body humor, *The Incredible Shrinking Man* uses Scott's transformation to generate an existential humor about mortality and humans' place in the universe. It seems likely that Matheson, who also wrote the film's screenplay, may have had absurdist/existential works like Franz Kafka's *The Metamorphosis* (1915) or Albert Camus's *The Myth of Sisyphus* (1942) in mind. Like Kafka's Gregor Samsa, who finds himself inexplicably transformed into a giant insect, Scott questions the stability of his identity. When his shrinking is still in its earliest stages,

Scott intuits that his sense of self is tied to embodiment and tells his wife, "You love Scott Carey. He has a size and a shape and a way of thinking. All that's changing now." Scott's decisions to speak about himself in the third person and to connect his "way of thinking" to his "size and shape" tie identity to embodiment and suggest that as one changes, so will the other. Later, like Camus's "absurd man," he holds a small knife and wishes he "could find the courage to end my wretched existence." Like Sisyphus—or a traditional sci-fi hero—Scott keeps living and fighting despite the apparent futility of his situation.

Like much absurdist literature, the film finds humor in Carey's preposterous situation. At one point, he explicitly says, "I felt puny and absurd," and in other moments, he describes himself as a "caricature" or "one more joke for the world to laugh at." This aspect is even more pronounced in the novel. In a key scene, when Scott is the size of a child, he tries on his old suit coat and looks in the mirror. A "wheezing giggle puffed out his cheeks." A moment later, Scott "snickered hollowly at the child playing grownup. His chest began to shake with restrained laughs. They sounded like sobs. . . . Sobbing laughter burst out against the mirror. He felt his body trembling with it. The room began to resound with his taut shrill laughter."[22] Soon, Scott's hysterical, ambivalent "sobbing laughter" reaches its peak as he falls to the ground. Scott lays on the floor and thinks, "I'm funny."[23] The moment recognizes the humorous potential of Scott's situation but does not aim to generate laughter itself. While Scott's laughter is never fully explained, it is clearly about more than just the sight of himself wearing clothes that are too big. This is the bitter laughter of someone who recognizes and accepts the full absurdity of his situation. The endings of both film and novel ultimately step back from a true absurdist point of view. The novel ends with Scott preparing for new subatomic adventures, and the film ends with Scott making a leap of faith and asserting that "to God, there is no zero. . . . I exist." The reassuring endings, however, do little to ameliorate the horror or bitter humor of Scott's situation.

The Incredible Shrinking Man is very much ahead of its time, and bodily transformation would not be explored with this much attention or intelligence until the films of David Cronenberg. In his infamous "dissenting view" of Cronenberg, Robin Wood describes the filmmaker's work as "joyless."[24] It is tempting to also describe his films as *humorless*. This isn't exactly true, though; as we saw in the *Rick and Morty* parody discussed earlier, Cronenberg's bodies have clear comic potential. On paper, for example, there is much to laugh at when Rose (Marilyn Chambers) grows a phallus in her armpit in *Rabid* (1977) or when heads explode in

Scanners (1981). And the very idea of the vagina that opens in the abdomen of Max Renn (James Woods) in *Videodrome* (1983) is quite funny. In practice, however, these films have a fairly serious tone and rarely prompt actual laughter. Critics often note, usually in passing, the humor of horror auteurs like George A. Romero, Tobe Hooper, or Wes Craven, but Cronenberg's films rarely prompt such responses.

Cronenberg's funniest film is his remake of *The Fly*, which is also his most extended exploration of bodily transformation. The film's comic sensibility is driven mostly by Jeff Goldblum's energetic portrayal of Seth Brundle, the mad scientist who accidentally mixes his DNA with that of a housefly. *The Fly* is very much part of the 1980s practical-effects-driven gross-out films discussed in the previous section. As such, it generates an ambivalent dark humor through its representation of Brundle's transformation. In particular, as Brundle becomes less human and more fly-like, Cronenberg revels in the often-disgusting changes happening to his body. The first of these are seemingly positive and consist of heightened strength and agility. Soon, though, Brundle has odd hairs protruding from his back and sores all over his face; his behavior becomes increasingly erratic and aggressive. As Brundle steadily becomes less and less human, his body parts begin falling off. The most common way of reading this transformation has been as a metaphor for cancer or, more frequently, for AIDS.[25] This focus may perhaps be why the majority of Cronenberg critics ignore the implicit humor of Brundle's transformation.

Humor is most apparent in a particularly disgusting-yet-comic sequence when a hardly recognizable Brundle carries a handful of his teeth to his medicine cabinet. Before opening the cabinet, Brundle considers his gnarled and inhuman face in the mirror and speaks directly to his teeth. Using the sort of mock-playful voice that is typically reserved for toddlers or kittens, Brundle says, "You're relics. Yes, you are. You can't deny it. Vestigial, archaeological, redundant." Brundle opens the medicine cabinet, and a shot of its interior reveals a disgusting assortment of other body parts. Surveying his collection, Brundle says, "Artifacts of a bygone era, of historical interest only." Brundle's comments suggest that he is embracing—or at least accepting—his transformation. The moment works as humor primarily because Brundle's own attitude is one of detached amusement. Even though he looks sick, he views his transformation from the objective standpoint of a scientist or historian. Brundle's odd attitude is driven home when his love interest Veronica (Geena Davis) arrives and looks upon him with only horror and pity. Brundle says, "You've missed some good moments" and invites her to

look inside his medicine cabinet, which he refers to as "the Brundle Museum of Natural History." The scene is darkly comic. Brundle's playful descriptions of his radically altered body invite viewers to also take a detached view and see the ridiculousness and humor of a medicine cabinet full of body parts. At the same time, Veronica's disgust and pity undermine this comic effect. The result is a gross and ambivalent body horror that reveals Cronenberg's comic sensibility.

During the same era, Hollywood put out a series of often comic updates to the werewolf films of the 1930s and 1940s. As critics often point out, 1981 saw a renewed interest in the werewolf movie, with the release of *The Howling, Wolfen, Full Moon High*, and *An American Werewolf in London*. Before the end of the decade, there was also *Silver Bullet* (1985), *Teen Wolf* (1985), and werewolf-adjacent films like *The Beast Within* (1982) and the remake of *Cat People* (1982). Werewolves also feature prominently in *Deadtime Stories* (1986) and *The Monster Squad* (1987). This wave of werewolf films can be explained both through nostalgia for old Hollywood and through the fact that makeup and special effects finally got advanced enough to believably represent a human body transforming into an animal.

Most of the werewolf films mentioned so far have some comic elements, and a few of them are more comedy than horror. *An American Werewolf in London*, however, deftly balances both humor and horror and explores many of the same themes of transformation as *Shrinking Man* and *The Fly*. It tells of two American tourists who are attacked by a werewolf in the English countryside. Jack (Griffin Dunne) is killed and condemned to wander the Earth as a ghost until the bloodline of the wolf that killed him ends. David (David Naughton) survives the attack but eventually becomes a werewolf himself. Prior to *American Werewolf*, director John Landis had made the comedies *Animal House* (1978) and *The Blues Brothers* (1980), and those films' raunchy, comic aesthetics permeate *American Werewolf*. The soundtrack, featuring only songs that mention the moon, announces the film's playfulness, and early conversations between David and Jack—mainly about women's bodies—feel like they could be leftover material from *Animal House*, whose title not very subtly suggests something animalistic about the young men who form the film's central fraternity. *An American Werewolf* simply literalizes this metaphor.

The film's body horror works in two ways, both of which have a comic element. The first is through Jack's ghost, who periodically appears to try to convince David to kill himself. Unlike the spectral appearance of most movie ghosts, Jack takes the form of his own corpse, and in each appearance, his body is in a more advanced state of decay until his skin

finally takes on a rotten gray-green hue and begins rotting away, revealing the skull underneath. The humor of these encounters, as in the ambivalent humor of *The Fly*, comes from the contrast between Jack's gruesome appearance and his casual, somewhat amused demeanor. At one point, he tells David not to "be a putz." In another moment, Jack's severely rotting corpse appears with the more freshly dead victims of David's first werewolf spree, and they collectively offer suggestions for how David should kill himself. A blood-drenched yet remarkably upbeat female victim, for example, cheerfully tells David to "put the gun to your forehead and pull the trigger." The incongruity of the visuals and dialogue generates humor.

The second element of body horror comes through David's own transformation, and *American Werewolf* is most famous for the comic yet brutally graphic scene when David first turns into a werewolf. David sits in a chair reading and suddenly leaps up, screams in pain, and pulls off his clothes. The full transformation takes about two and a half minutes, and we see, in excruciating detail, the changes to David's body. Particularly disturbing are the shots that show the bones in his hands and feet stretching and his spine contorting to the shape of an animal's. Throughout, David continues his agonized screaming. Even here, though, humor is quite prevalent. The suddenness with which David springs to his feet and begins screaming is funny and surprising, and Sam Cooke's version of the romantic song "Blue Moon" plays in the background, providing an ironic counterpoint to David's screams. The camera cuts at one point to a ceramic Mickey Mouse sculpture, which, like the song choice, provides a comic juxtaposition to David's writhing. When David is nearly all wolf, he looks directly into the camera and reaches out his hand; it feels as if he is breaking the fourth wall and beseeching viewers. The music, the Mickey Mouse, and David's look at the camera all encourage viewers to see David's painful transformation from a position of detachment, but David's screams of agony and the realistic special effects may simultaneously horrify and gross out viewers. Once again, incongruity drives the humor, and the scene is a great example of the ambivalence of comic body horror.

Like *Shrinking Man* and *The Fly*, *American Werewolf* uses its transformation premise to explore the boundaries of identity. In fact, the transformation scene lets us see, in real time, David's change from human to animal. David's screams assure us that there is still humanity present, but in the end, a wolf's howl replaces them. At the film's conclusion, David's love interest Alex (Jenny Agutter) confronts the werewolf and tries to reach some part of David inside. It first appears as if the wolf recognizes her,

but he lunges to attack, and the police shoot and kill him. The moment suggests that even if some semblance of David remains, it is too small to overcome the wolf. After the wolf dies, however, there is a shot of David's naked corpse on the street. In death, David's humanity is restored, and it briefly feels as if we are watching a tragedy unfold. There is then a quick cut to the credits, however, and The Marcels' energetic doo-wop version of "Blue Moon" begins playing, once again providing an ironic juxtaposition with the events on screen. The tragedy we have just watched becomes a comedy once again.

Released nearly twenty years later, the Canadian werewolf film *Ginger Snaps* (2000) shares many comic elements with *American Werewolf* but uses its central transformation to explore issues of female adolescence and sexuality. The film is about two teenage misfit sisters Brigitte (Emily Perkins) and Ginger (Katharine Isabelle) who loathe their high school peers and their bland Canadian suburb. The sisters, both aged fifteen, have made a pact to either run away or kill themselves by age sixteen. Everything changes when Ginger, the slightly older of the two, gets her first period and is bitten by a werewolf on the same day. The rest of the film focuses on Ginger's changing body and personality and conflates her menstruation with her developing monstrosity; both are of course tied to lunar cycles. Brigitte attempts to find a cure but eventually must kill her sister. On the surface, *Ginger Snaps* appears to be a textbook example of Barbara Creed's conception of the "monstrous-feminine," in which a female monster dramatizes male anxiety toward women's bodies and is represented "almost always in relation to her mothering and reproductive functions."[26] As critics have pointed out, however, the film's focus on the relationship between Brigitte and Ginger and its attention to a female perspective both separate it from earlier texts—like *Carrie* (1976) or *Cat People*—featuring a female monster.[27]

Ginger Snaps's intelligent use of humor also contributes to its subversive qualities and has surely helped the film establish a cult following with female viewers.[28] The comic elements appear in the very first scene, in which a mother finds her young son playing with the severed paw of the family dog, Baxter. The mother runs into the streets crying, and Brigitte says, "Baxter's fertilizer." Ginger and Brigitte go on to talk about the best way to kill themselves followed by a shot of Ginger, apparently dead and impaled on a white picket fence. This image, revealed to be staged for a photograph, is followed by a montage of similar images of Ginger and Brigitte playing dead in various macabre scenarios, recalling the prominent use of staged suicides in *Harold and Maude* (1971). This

montage is actually being screened at school for a class project toward which Ginger and Brigitte take a comically subversive attitude. The opening scenes thus establish the dark sense of humor of both the film and its central protagonists.

The humor is most pronounced in the treatment of Ginger's transformation. While the opening makes a comic spectacle out of Ginger's and Brigitte's bodies through fake deaths, the film understands that sexualization creates the real spectacle of teenage girls' bodies. The point is made in an early scene when a group of teenage boys happily watch as the girls' gym class plays field hockey, and Jason (Jess Moss) singles out Ginger for her "rack." Ginger and Brigitte—dressed in baggy sweaters and long skirts—stand out from the other girls in their explicit resistance to such sexual attention. This resistance is also seen through their dread of menstruating and thus entering "womanhood." Once she gets her first period, Ginger says, "I just got the curse" and tells Brigitte, "If I start simping around tampon dispensers and moaning about PMS, just shoot me, OK." Brigitte's only response to the news is "Ew." Both sisters, then, are susceptible to the larger culture's tendency to see menstruation as "gross," but they also understand it as a symbolic entry into a form of adult womanhood that they view with disdain.

Ginger, of course, experiences more drastic bodily changes when she transitions into a werewolf. Unlike most other werewolf films, where the transition from human to animal and back again happens fairly quickly, in *Ginger Snaps*, Ginger's transition, like the onset of puberty, occurs slowly but steadily, and it seems that once she becomes a full wolf, she will never change back. She first grows coarse hairs from the werewolf attack wounds and then begins growing a tail and fangs. This coincides with behavioral changes that may be seen as typical of a young person going through puberty: irritability, drug experimentation, and a heightened sex drive. In this manner, the werewolf transformation externalizes the horrific feelings of a young person in puberty who feels that they are no longer themselves or who is disgusted by uncontrollable bodily changes.

Ginger Snaps drives this aspect home in a series of particularly funny moments when female authority figures, unaware of the werewolf infection, attempt to normalize Ginger's experience. Brigitte and Ginger visit the school nurse, who smugly asserts that "everyone seems to panic their first time" and proceeds to explain that a "thick, syrupy, voluminous discharge is not uncommon." When Brigitte asks about "hair that wasn't there before," the nurse says it "comes with the territory" and gives the girls condoms and an admonishment to "play safe." Ginger has similarly

comic encounters with her mother. After finding a pair of Ginger's bloody underwear in the laundry, Ginger's mother attempts to celebrate the rite of passage by baking a strawberry shortcake, covered with a sticky red syrup that recalls the school nurse's earlier description. Her mother proudly announces, "Our little girl is a young woman now." Later, in the bath, Ginger discovers a wolf claw growing out of her ankle. When her mother comes in, Ginger hides behind the shower curtain. Her mother voices the parental cliché, "You don't have anything I haven't seen before." Ginger wryly replies, "That's what you think." To deflect her mother's attention, Ginger says she is upset because she is fat, and her mother attempts to turn the moment into a heart-to-heart about body image. The nurse's and Ginger's mother's attempts to explain away or celebrate Ginger's changing body create humor primarily through dramatic irony; the audience knows they are watching a werewolf movie, so it is funny to see the language of normal bodily changes applied. At the same time, these moments effectively satirize the inability of authority figures to recognize or understand the actual struggles that Ginger is going through.

The movie also humorously plays with gender roles and male bodies. Ginger's tail, for example, can be seen as a phallic growth, and when she begins growing hair, Ginger alludes to male puberty, telling Brigitte, "I can't have a hairy chest. . . . That's fucked." There is a male version of this after Ginger has sex with James and infects him with the werewolf "curse." James's first symptom is to bleed out of his penis, and his friends tease him and say he's "on the rag." In each instance, the film connects the werewolf transformation to the onset of puberty but comically inverts gender expectations: Ginger is somewhat masculinized as a werewolf, but James's bleeding penis suggests castration and emasculation. These transformations generate humor primarily through their surprising reversal of gender expectations.

By actively revising gender roles and presenting a humorous depiction of growing up female, *Ginger Snaps* avoids the underlying misogyny that is traditionally fostered in texts about monstrous women. Rather than female monstrosity representing male anxieties about women's bodies, Ginger's transformation gives voice to the fears of young women about their passage into adulthood, their emerging sexuality, and the ways in which their bodies will be objectified by the culture at large. *Ginger Snaps* was followed by two sequels, and the franchise's influence can be seen in other films that followed in its wake, such as *Teeth* (2007), which updates the vagina dentata myth for contemporary American suburbia, and *Jennifer's Body* (2009), discussed in more detail in the next chapter.

Collectively, these films combine humor and body transformation narratives to revise traditional conceptions of the monstrous-feminine.

Scary Slapstick

Most horror texts have clear and visible monsters that threaten victims' bodies and often have monstrous bodies of their own. However, there is a small group of films that keep their monsters offscreen and instead generate horror from the everyday, mundane dangers of the physical world. In particular, *The Omen* and *Final Destination* franchises establish a horrific slapstick comedy in which malevolent forces—the Devil or Death itself—cause victims to face death through elaborate misadventures with the physical world. The kill scenes in these films work as gory updates to classic physical comedy, wherein performers like Charlie Chaplin play protagonists who often run afoul of the physical world. The humor of slapstick can be explained both through Thomas Hobbes's superiority theory and through Bergson's conception of "mechanical inelasticity," in which we laugh at a human's inability to adapt to his or her environment.[29] As Moss points out, however, "The classic slapstick performer *always* survives calamity uninjured."[30] The horror texts under discussion revise this premise by offering elaborate slapstick routines that ultimately end in violent or gory death. This bloody slapstick generates humor in much the same way as traditional slapstick, but as in the other body horror texts discussed here, they are also quite ambivalent due to their shock value and gore. Furthermore, the death scenes themselves often play with audience expectations and thus function as elaborate physical jokes with a bloody punchline.

The Omen (1976) and its first sequel *Damien: Omen II* (1978) have several famous death scenes that operate in this manner. The films tell the story of the Antichrist Damien Thorn (Harvey Spencer Stevens and Jonathan Scott Taylor). While Damien is certainly creepy, he is not the primary monster of the narratives. The real "big bad" of the *Omen* franchise is the devil himself, who remains unseen but makes his presence felt, primarily through orchestrating the deaths of anybody who threatens Damien. These deaths often take on the quality of horrific slapstick and, like the celebrated kills of slasher films, they can create humor through both surprise and appreciation for the filmmakers' execution.

The most elaborate death of this sort in *The Omen* is the decapitation of the photographer Keith Jennings (David Warner) after he uncovers clues to Damien's origins. Jennings searches a construction site for magical

daggers that can kill the boy. Here, an invisible force releases the clutch on a flatbed truck; the truck rolls backward, and viewers may at first suspect it will simply run over or crush Jennings. Instead, it stops before hitting him, but a large pane of glass in the truck's bed slides out and cuts off Jennings's head, which is shown spinning through the air in a series of slow-motion shots. While this death is not played for laughs, the gruesomeness of the kill and the sustained attention to the spinning head lend it a quality of hyperbolic excess that can easily slide into humor.

Jennings's death is one of the signature kills of *The Omen*, and the filmmakers lean into this sort of violent spectacle more heavily in *Omen II*. One character falls through the ice of a frozen pond, another is run over by a semi (after having her eyes pecked out by a raven!), and yet another is crushed by a suddenly released locomotive. The most elaborate kill, however, occurs after Dr. Phillip Kane (Meshach Taylor) learns that Damien is part jackal and thus not human. First, Dr. Kane is in a high-rise elevator, which suddenly starts plummeting. The elevator stops on the third floor, however, and Dr. Kane is uninjured. As he sits on the elevator floor, breathing a sigh of relief, elevator cables fall through the ceiling and bisect him at the waist. As with Jennings's death, Kane's bisection is shown in slow motion in a series of graphic shots. The death is clearly structured to play with audience expectations: we prepare ourselves for Kane to be killed by the plummeting elevator and are relieved when he survives. The sudden graphic bisection, then, works like a surprising punchline.

Despite the playful gruesomeness of these kills, *The Omen* films are not particularly comic. Their casting of prestige actors, high production value, and conservative ideology place them in the vein of horror films that seek to achieve critical respectability.[31] There are no such pretensions in the *Final Destination* franchise, which adopts aspects of *The Omen*'s famous kill scenes but ramps them up to preposterous proportions. *Final Destination* (2000) is about a high school senior class trip set to fly to Paris. Minutes before the plane takes off, Alex Browning (Devon Sawa) has a premonition, shown in detail, that the plane will catch fire and eventually explode, killing everyone on board. Alex makes a scene, and he and several others end up getting off the plane, which goes on to explode just as in Alex's premonition. Soon after, all the people who were supposed to be on the plane begin dying in bizarre ways. With help from the creepy mortician (Tony Todd), Alex and the other survivors learn that by getting off the plane, they have interrupted Death's design, and now Death uses freak accidents to set things right. Alex and two survivors manage to dodge Death for a while, but the final scene makes clear that Death still

stalks them. *Final Destination* has so far had four sequels, each of which follows the exact same plot of a mass disaster averted through premonition, and survivors dying one by one in freak accidents, in the same order that they "should" have originally died.

The films take a playful approach to the material and participate in many of the types of parody discussed in chapter 1. Character names, for example, allude to past horror icons. In the first film alone, there are characters named Browning, Hitchcock, Chaney, Lewton, and Murnau. Furthermore, the relatively young cast of victims who are dispensed with one at a time, along with the films' preoccupation with the order of those deaths, marks them as something of a parody of the slasher subgenre, with the figure of Jason or Michael replaced by Death itself.[32] In this manner, the *Final Destination* films strip horror down to its most basic element, dispensing with metaphors and monsters to simply make Death itself an unstoppable force. Death, however, does have a sense of humor, which evinces itself in the various signs and clues that it provides before taking a life. Death is especially fond of thematically appropriate songs to announce its presence: "Highway to Hell," "Dust in the Wind," and so on. Like the personified, chess-playing Death of Ingmar Bergman's *The Seventh Seal* (1957), Death in the *Final Destination* films likes to play games.

Due to the fact that nearly every character in the franchise dies, *Final Destination* may appear to be one of horror's bleakest modern franchises, and Eugenie Brinkema describes the series as "bitter, anhedonic, paranoid, and sad."[33] However, the films' inherent playfulness and comic sensibility temper the sense of despair and make their tone closer to that of a silly 1980s slasher than to bleak contemporaries like the *Saw* or *Hostel* films. The parodic elements mentioned above are important, but the films' key source of humor comes through their inventive, elaborate, and often prolonged death scenes. Like the Devil in *The Omen* films, Death prefers to kill off its victims through mishaps with the physical world, thus creating an over-the-top, brutal slapstick. The death scenes in the *Final Destination* films, however, occur more frequently, take longer, and are more explicitly comic.

The humor of the kill scenes tends to work in one of two ways. The first is through a hyperbolically prolonged set up, as characters' deaths are caused by elaborate chain reactions, reminiscent of Rube Goldberg machines. Like the elevator death in *Omen II*, these scenes often end with a brutal punchline. A good example comes in the death of Evan Lewis (David Paetkau) in *Final Destination 2* (2003). Evan first arrives in his apartment with various packages. He tosses a pan full of spaghetti out the

window, and it lands in the street below. He begins preparing a meal of reheated Chinese food and what appears to be frozen mozzarella sticks. Unknown to him, a magnet falls from the refrigerator into his Chinese takeout container before he puts it in the microwave. While waiting for his food to heat up, he tries on a new gold watch. Then in rapid succession, his ring falls in the sink, and his hand gets caught in the drain trying to get it out; his pan on the stove suddenly bursts into flames. With his hand still caught in the sink, he attempts to put out the fire with a rag but instead knocks over the pan and spreads the fire, which ignites his garbage can. Soon, his entire kitchen is in flames. Evan manages to free his hand and eventually crashes through his window onto the fire escape. His apartment explodes above him, probably from the magnet in the microwave. When the fire escape ladder gets stuck, he falls several feet and lands safely but slips—banana peel style—on the mess of spaghetti he had thrown out earlier. As he lays on his back, the stuck fire escape ladder falls, and its leg stops just above his head. Evan yells, "Jesus Christ" and mutters a sigh of relief. Then the ladder finishes falling, and its leg goes through his eye, killing him.

The entire sequence lasts about five minutes and, without the gruesome ending, would not be out of place in a Buster Keaton film. The scene is a great example of the ambivalence of comic body horror; Evan's struggles cause tension and fear but also generate humor through the prolonged elaboration and the overall preposterousness of the situation. As each new thing goes wrong for Evan, the tension builds, but so does the sense of hyperbole. Furthermore, there is a nice symmetry to the scene, as the spaghetti that Evan throws out the window—likely forgotten by viewers—eventually causes his literal downfall. The sense that the seemingly random and chaotic series of events was planned out from the beginning (by Death and/or the filmmakers) may also cause laughs of pleasurable appreciation. Finally, the ladder through the eyeball punctuates the scene as a brutal punchline. The franchise is full of scenes like this, with equally elaborate scenarios occurring in a tanning salon, a car wash, the eye doctor's office, and several other locations.

Viewers may wish to read scenes like this in relation to issues of fate, free will, and intelligent design, but the films offer little interest in such heady themes, as they simply move from one elaborate kill scene to the next, with small breaks where characters attempt to interpret Death's signs. Audiences, in turn, are also in the position of interpreting signs and, in particular, of looking for the next cause of death. Sometimes this attention can cause humor on its own. For example, there is a scene, also in *Part 2*,

when two characters on Death's list step into an elevator. The other occupant of the elevator is a man carrying a large box of sharp metal hooks for prosthetic limbs. The sight of these hooks is quite unexpected, and they basically announce themselves as instruments of death. There is a humorous situational irony in the fact that someone who should be avoiding dangerous situations at all costs ends up in an elevator with a box full of sharp, twisted metal.

The other sort of comic death in the *Final Destination* films is basically the direct opposite of the elaborate accidents discussed above. In these, Death comes swiftly and unexpectedly, and the sudden shock and surprise can simultaneously foster laughter and jumps of fright. A good example occurs in the first film when Terry Chaney (Amanda Detmer) yells at her boyfriend for fighting with Alex. She says, "If you want to waste your life beating the shit out of Alex every time you see him, then you can just drop fucking dead." As soon as Terry says the word "dead," she is suddenly run over by a bus. The next shot shows the other survivors, faces splattered with Terry's blood, staring in shocked disbelief. Humor and horror, as we know, both tend to depend on surprise and shock to achieve their ends, and a scene like this can cause laughing disbelief even as viewers are horrified by the violence. Occasionally, *Final Destination* films will mix the two sorts of deaths. In *Part 2*, for example, there is a painfully elaborate set up where it seems certain that teenager Tim Carpenter (James Kirk) will suffocate in the dentist's chair, but the hygienist rescues him at the last moment. When he leaves the dentist's office, however, workers accidentally drop a giant pane of window glass, which crushes him. The elaborate set up for a death that does not materialize followed by the quick, surprising kill makes it clear that the filmmakers are deliberately playing with audience expectations. This playfulness allows audiences to view the proceedings from a position of detachment and to appreciate the humor of the game.

Conclusion

Embodiment may be the ultimate source of ambivalence. Our bodies are both self and other. They bring us pleasure and pain. They are a key signifier of our identity, but a constant reminder of our inevitable death. Bodies are funny but also gross. It is thus no surprise that the struggles and failures of our bodies are so common throughout comedy and horror, and it is through bodily predicaments that the boundaries of humor and horror are most likely to blur. When a clown slips on a banana peel, our laughter

may be one of detached superiority, but behind that laughter is the knowledge that our own bodies are no more stable than the clown's. Horror captures this ambivalence quite often. The effects-driven gross-out horror films that were so common in the 1980s (as well as proto–gross-out classics like *Freaks*) shock us into a stunned disbelief, which often carries with it a surprised and appreciative laughter. Bodily transformation films often work in the same way, but like *The Incredible Shrinking Man* or *The Fly*, they may additionally invite audiences to laugh at the absurdity of existence and the instability of identity. Finally, horror's brutal slapstick—as found in the *Final Destination* franchise—reflects our ambivalence about our relationship with the physical world. All these comic body horror texts collectively suggest that embodiment is painfully funny.

CHAPTER 4

Camping Out

Horror's Queer Humor and Gender Play

IN THE THIRD episode of the horror-themed television drag show competition *The Boulet Brothers' Dragula* (2016–), the contestants—competing to be crowned the world's first "drag supermonster"—are challenged to embody drag zombies and act out a kill scene. Cohost Swanthula Boulet instructs the contestants to "gay it up, camp it up, make it gory, make it gorgeous." In the montage that follows, each contestant, outfitted in a wide range of drag zombie costumes, takes a turn attacking a scantily clad beefcake. The zombie queens leap on their victim's back, straddle him, lick his bloody face, simulate feasting on his genitals, and engage in a variety of other sexual and violent acts. At first glance, the montage, and the show itself, appears to be a radically revisionist and parodic approach to both horror tropes and to mainstream perceptions of drag shows and drag queens.[1] The vision of a sexually objectified man preyed upon by feminized monsters subverts horror's more common use of sexy female victims, and the gender-bending, beautiful, and disgusting monsters themselves defy easy classification. *Dragula*, however, is just one example of a long line of LGBTQ+ audiences and artists appreciating horror or retooling its tropes. Indeed, Swanthula's instructions to "gay it up, camp it up, make it gory, make it gorgeous" could seem to come from any number of horror creators. *Dragula*'s approach to horror is thus not so much a revision as it is an exaggeration of the comic, queer, and gender-bending strains that have always been present.

Numerous critics have discussed the prevalence of horror's queer motifs. Harry M. Benshoff argues that historically, "the figure of the monster" can be "understood as a metaphoric construct standing in for the figure of the homosexual."[2] This metaphoric construct may be read in various ways. The equation of monsters with homosexuals may reinforce stereotypes of queer individuals as "unnatural, predatory, plague-carrying killers." On the other hand, monstrous homosexuals "might provide a

IMAGE 5: *Bride of Frankenstein* (1935). Courtesy of Photofest.

pleasurable power-wish fulfillment fantasy for some queer viewers."[3] Furthermore, certain performers may bring an "unmistakable homosexual 'air'" to their characters, and viewers who are "attuned to the possibility of homosexuality within culture-at-large" may perceive queer connotations in a wide range of horror films.[4] These elements may foster additional sources of pleasure and humor for savvy audiences. The focus on connotative elements, however, may tend to keep queer sexuality in the margins

or in the shadowy realm of the closet.[5] In recent years, of course, numerous horror texts have overtly foregrounded queer themes and characters, rendering little need for metaphors or connotative decoding.

This chapter does not attempt to offer a full discussion of horror's queer elements but rather focuses on how those elements may combine with humor, either openly or obliquely, to trouble heteronormativity. In this sense, I follow Alexander Doty's assertion that queerness "should challenge and confuse our understanding and uses of sexual and gender categories."[6] Many horror texts do this through playful winks to savvy audiences or mocking portrayals of heteronormative values. Horror also tends to rely on stylized or exaggerated gender-destabilizing performances. When these devices are used to generate humor, they fall under the umbrella of camp. In mainstream horror criticism, the term *camp* is widely used but rarely defined. In his encyclopedic survey *Nightmare Movies*, for example, Kim Newman includes a chapter entitled "The Weirdo Horror Film or: Cult, Kitsch, Camp, Sick, Punk, and Pornography."[7] The chapter itself, however, barely mentions camp and does nothing to differentiate it from *kitsch*, a term with which camp is often conflated. Likewise, film reviewers often describe any horror film with comic elements as "campy."

The tendency of critics to not define camp would not be a problem if there was common agreement, but meanings seem to vary from writer to writer. Camp's most famous theorist Susan Sontag defines "pure" camp as a "seriousness that fails,"[8] but most general interest writers seem to think the opposite. Jim Goad, for instance, defines "campy" as *purposely ridiculous*" and "cheesy" as "unintentionally low quality."[9] Sontag also says that it "goes without saying that the Camp sensibility is disengaged, depoliticized—or at least apolitical."[10] The vast majority of camp theorists after Sontag, however, have stressed the political implications of camp objects and performances.[11] Similarly, many critics downplay or gloss over camp's queer aspects, whereas others, like Moe Meyer, accuse Sontag of erasing camp's gay sensibility and instead posit homosexuality as the "binding referent of Camp."[12] With such diverse approaches, it is difficult to discern what a particular writer precisely means when describing something as "campy."

I derive my reading of camp horror primarily from Meyer, who defines "camp" as the "strategies and tactics of queer parody."[13] These strategies and tactics are best enumerated by Richard Dyer, who sees camp as "a characteristically gay way of handling the values, images, and products of the dominant culture through irony, exaggeration, trivialisation, theatricalisation and an ambivalent making fun of and out of the serious and

respectable."[14] For Meyer, these devices are primarily performative and must come from a position of queer identity. Meyer asserts that the "unqueer do not have access to the discourse of Camp, only to derivatives constructed through the act of appropriation."[15] Meyer deems appropriated camp texts or performances a "camp trace."[16] My own use of the term is a bit less rigid. The camp horror I discuss often does come from a queer positionality, but given the collaborative nature of film and television, it is often impossible to discern intentionality or authorship. The texts on which I focus, however, take a playful and fluid approach to gender and sexuality and often use humor to mock the tropes of "straight" horror or of heteronormative narratives in general. This is not to say that all the texts discussed below offer a progressive vision of gender and sexuality. Rather, there are many camp moments within works that otherwise reinforce traditional heteronormativity. Furthermore, there are texts for which camp interpretation is plausible but certainly not definite. I thus agree with Chuck Kleinhans and see camp not just as a collection of devices inherent in texts themselves but also as a "strategy of reading."[17]

James Whale and Classical Camp Horror

Many 1930s and 1940s horror films have a not-so-subtle queer subtext. These include *Island of Lost Souls* (1932), *Dracula's Daughter* (1936), and *The Seventh Victim* (1943). None of these films, however, are as iconic, queer, or campy as the Universal horror movies directed by the openly gay James Whale. In particular, *The Old Dark House* (1932) and *The Bride of Frankenstein* (1935) have a more explicit camp style than perhaps any other American horror film prior to *The Rocky Horror Picture Show* (1975). Both *Dark House* and *Bride* employ numerous camp devices, including sexualized double entendres, exaggerated or gender-bending performances, and a comically irreverent attitude toward heteronormative values. Both films thus operate as queer parody in their mockery of rigid gender roles and of the tropes of traditional heterosexual romance narratives. The queer and comic elements of both films, particularly *Bride*, have been discussed at length.[18] I thus use this section primarily to establish Whale's work as camp and to set the stage for the strain of queer parody that runs through the genre.

The Old Dark House concerns a group of travelers who seek shelter at a creepy house during a thunderstorm. The travelers include a bickering married couple, Philip and Margaret Waverton (Raymond Massey and Gloria Stuart), and their close friend Penderel (Melvyn Douglas). This

threesome is later joined by the wealthy William Porterhouse (Charles Laughton) and his chorus girl companion Gladys Perkins (Lilian Bond). While these assorted travelers are the film's ostensible protagonists, the real stars are the house's inhabitants. This group initially includes the brother and sister Horace and Rebecca Femm (Ernest Thesiger and Eva Moore) and their mute butler Morgan (Boris Karloff). The travelers are later introduced to elderly patriarch Roderick Femm (Elspeth Dudgeon) and the psychotic pyromaniac Saul Femm (Brember Wills). As one would expect in an "old dark house" film, the family is quite eccentric, and there are references throughout to a dark and mysterious past.

On the surface, the quirky and eccentric Femms appear to anticipate later comically creepy families, like *The Addams Family* or the genetically defective family in Jack Hill's *Spider Baby* (1967). Gender play and the devices of camp operate not far below the surface, however, and the film codes the family as queer in numerous ways. Most obviously, their last name is *Femm*, suggesting a gender fluidity for a family made up primarily of men. Whale literalizes the Femms' effeminacy by casting female actor Elspeth Dudgeon to play family patriarch Roderick Femm (although she is billed as "John Dudgeon" in the credits). Similarly, Ernest Thesiger, whom Benshoff describes as an "outrageously campy character actor,"[19] brings a queer aura to his portrayal of the snobbish and effeminate Horace. Horace is very nervous but also quite quick-witted. When the guests first arrive, Horace picks up a bouquet of flowers and explains, "My sister was on the point of arranging these flowers." He then unceremoniously tosses the bouquet into the fireplace. Later, when Rebecca insists on saying grace before dinner, Horace refers to her prayers as "strange tribal habits." And when, at dinner, Horace repeatedly tells his guests to "have a potato," there is an unmistakable comic lasciviousness in Thesiger's delivery.[20] Horace's queerness is thus reinforced by both his stereotypically effeminate mannerisms and his disdain for conventional behavior.

In contrast, the nearly deaf Rebecca is exceedingly prudish but clearly harbors repressed homosexual desires. When the first group of guests arrives, Rebecca reluctantly allows them to spend the night but repeats several times that there are "no beds." Her compulsive repetition suggests a desire to police the house's sleeping arrangements. Later, Rebecca leads Margaret to a bedroom upstairs so she can change out of her wet clothes. The room (where there is, in fact, a bed) used to belong to Rebecca's sister Rachel. "She was a wicked one," Rebecca says, "handsome and wild as a hawk. All the young men used to follow her about with her red lips and her big eyes and her white neck." Rebecca explains that Rachel broke her

spine in a hunting accident and died in bed, screaming in pain, "godless to the last." Rebecca says the entire family was "godless" and that her father and brothers used to fill the house with "laughter and sin." Rebecca's characterization of her family's past hints at incest, homosexuality, and a general disregard for traditional morality and gender roles. Even the dead sister, Rachel, was injured while hunting, a traditionally masculine pastime. Throughout this monologue, Whale films Rebecca through distorted lenses, giving her face a ghoulish cast. The technique suggests that Whale wants audiences to see the prudish, repressed zealot—as opposed to her lusty family—as monstrous.

While Rebecca talks, Margaret changes out of her clothes. Once Margaret is wearing only her slip, Rebecca looks her up and down and says, "You're wicked too.... You think of nothing but your long, straight legs, and your white body, and how to please your man." After Margaret puts on her dress, Rebecca grabs the material. "That's fine stuff," she says, "but it will rot." She then points her finger at Margaret's chest and says, "That's finer stuff still, but it'll rot too in time." With this, Rebecca places her hand fully on Margaret's chest as she screams and squirms away. The scene is one of the film's best examples of camp humor. Moore's exaggerated performance and Whale's direction both make Rebecca comically monstrous. More important, her fixation on the "finer stuff" of Margaret's body suggests that her prudishness is but an attempt to cover her own repressed desires. The scene works as a "queer parody" of traditional, heteronormative mores and suggests that queer impulses lurk beneath the surface of conservative zealotry.

The Old Dark House's queer parody also operates in its representation of the ostensibly "straight" characters. Rather than being a desirable alternative to the Femms' queerness, heterosexual romance seems either miserable or ridiculous. The very first scene features a prolonged and nasty argument between the Wavertons, thus foregrounding traditional marriage as unhappy. The Femms, therefore, do not so much disrupt normality as they offer relief from it. The romance between Penderel and Gladys also contributes to the queer parody. At first, Gladys seems to be involved with Porterhouse, and Penderel is a third wheel with the Wavertons (perhaps suggesting a *menage a trois*). Very soon, though, Gladys reveals that her relationship with Porterhouse is platonic because he is still grieving for his dead wife. As Benshoff notes, this "acceptable" explanation "effaces" Porterhouse's potential queerness.[21] Once Gladys's availability is apparent, Penderel wastes no time, and the ensuing rapid courtship emerges as a shoehorned-in narrative device, even for a Hollywood film.

After a sojourn in the barn drinking whiskey—during which Penderel tells Gladys that he would like to "pretend" to be lovers—Gladys tells Porterhouse that she's "fallen in love" with Penderel, who reacts with amused disinterest. In the final moments, Penderel awakens from being knocked unconscious in his fight with Saul and immediately proposes to Gladys. She kisses him in response. The proposal and kiss, however, are both punctuated by the sound of Porterhouse snoring. The comic implication of these snores is clear: Penderel and Gladys's heterosexual romance may be a necessary plot device to call attention away from the film's queer elements, but it is also boring.

Bride of Frankenstein may be an even campier film, for it explicitly mixes a queer sensibility into both its story and its structure. Its first scene is a narrative frame in which Mary Shelley (Elsa Lanchester) tells the film's story to Lord Byron (Gavin Gordon) and Percy Bysshe Shelley (Douglas Walton) on a dark and stormy night. This frame foregrounds the film's camp humor and gender play. Gordon's portrayal of Lord Byron is particularly campy and performative, and as Benshoff points out, the three writers seem to form an "erotic triangle."[22] This triangle in turn creates a queer space for the story that follows. In other words, the comic and queer elements in the narrative itself can be seen as emanating from the queer and playful space of the prologue. Indeed, it would not be hard to imagine Byron delighting in the queer story that Mary tells.

Byron, I imagine, would be especially amused by Dr. Pretorius, played by *Dark House*'s Ernest Thesiger, who brings an unmistakable gay sensibility to his stylized and effeminate portrayal of Pretorius, a mad scientist who coerces Dr. Frankenstein (Colin Clive) into renewing his experiments. All the *Frankenstein* films have a certain queer element in their stories of men who, usually aided by a male assistant, attempt to create life without help from women. In *Bride*, this element is brought to the foreground as Pretorius, introduced by Frankenstein's housekeeper as a "very queer-looking old gentleman," repeatedly woos Frankenstein away from his new wife, Elizabeth (Valerie Hobson), in order to, in his words, "probe into the mysteries of life and death." Significantly, Pretorius interrupts the couple in the bedroom, and Frankenstein sends Elizabeth away. As she exits, Pretorius watches her with a comic look of disgust. These and other moments suggest that Pretorius seeks more than a scientific partner; he wants to displace Frankenstein's wife. This accounts for one of the several possible meanings of the word "bride" in the film's title; the titular bride could refer to the monster's mate, to Dr. Frankenstein's wife, or, potentially, to Pretorius himself.

One of the film's campiest scenes occurs when Pretorius shows off his own experiments. Pretorius explains that "science, like love, has her own little surprises" and proceeds to show Frankenstein a series of small humans he has created, which he keeps locked in glass canisters. These include a tiny king and queen, whom he keeps segregated from each other. Just as he interrupted Frankenstein and Elizabeth in the bedroom, Pretorius prevents heterosexual union even in his own creations. There is also a disapproving bishop, who looks with disdain upon the lusty king; a ballerina, who Pretorius describes as a bore; and even a mermaid. All Pretorius's homunculi wear elaborate costumes, and their glass cases are decorated in a manner fitting their personalities. It thus becomes clear that Pretorius not only created these tiny creatures, but he also took a great deal of time making them outfits, grooming them, and decorating their homes. The gender play is quite overt here as Pretorius engages in the traditionally feminine behavior of sewing costumes and playing with dolls. In this case, of course, he is also a mad scientist, and the dolls are alive.

Out of all his creations, Pretorius is most proud of his tiny devil, who even has a small pitchfork. As he looks upon the goateed devil, Pretorius makes a short, revealing speech: "There is a certain resemblance to me, don't you think, or do I flatter myself? I took a great deal of pains with him. Sometimes I have wondered whether life wouldn't be much more amusing if we all were devils and no nonsense about angels and being good." Pretorius's remarks reveal his disdain for conventional morality. His proud assertion that the devil looks like him, however, suggests that Pretorius likely used his own semen to create his creatures. He later confirms this when he explains that he grew his creations "from seed." In this light, Pretorius's comment that he "took a great deal of pains" with his devil emerges as a double entendre, and the insinuation that his private "experiments" include masturbation brings a decided bawdiness to the scene. This bawdiness becomes explicitly queer when we remember that the entire point of Pretorius's display is to convince Frankenstein to join him. After showing off his homunculi, Pretorius tells Frankenstein that "normal size has been my difficulty." In another double entendre, he says, "You did achieve size. I need to work that out with you." Thesiger pointedly lingers over the word "size," solidifying the sexual innuendo for any viewers who are even moderately receptive to a queer interpretation.

Pretorius is *Bride*'s primary villain and, fittingly, both he and the monster are destroyed in the film's climax, thus paving the way for the seemingly happy heterosexual union of Frankenstein and Elizabeth. This narrative may reinforce the idea that queerness is monstrous and needs

to be repressed. In other words, Pretorius is but one example in a long line of horror's evil queers. However, there are several ways to complicate this reading. First, the film's humorous attitude toward queer sexuality makes the heterosexual ending feel fairly perfunctory. Pretorius, in particular, is a fun character, and his evilness, when viewed through the lens of Thesiger's camp performance, comes across less as villainy and more as a comic mockery of heteronormativity and traditional, repressive morality. Second, the happy, heterosexual ending for Frankenstein and Elizabeth is made entirely suspect by the film's queering of Frankenstein throughout most of the narrative. Frankenstein may repeatedly denounce his (queer) experiments, but he always ends up back in the laboratory. Finally, with Frankenstein himself queered by the narrative, *Bride* does not give viewers any other traditional heterosexual alternatives. Benshoff points out that, in "an ironic reversal, Karloff's monster is the most heterosexual character in the film. He certainly desires his female mate more than Frankenstein desires his."[23] *Bride* thus works similarly to *Dark House*. While both films feature queer monsters, they also locate monstrousness within heterosexuality itself. Both films operate as queer parody and use sexualized and exaggerated humor to mock traditional "straight" values.

Vincent Price and Camp Performance

Whale's horror films are classics of queer parody primarily because of their knowing playfulness. Whale mocks heteronormative conventions even while offering narratives that ostensibly follow those same conventions. Horror would not be this explicitly—or comically—queer again until the 1970s and 1980s.[24] In between, however, horror icon Vincent Price kept camp alive in American horror through his portrayals of several arch- and cultured villains. Well known for his gentle and melodious voice, effeminate mannerisms, and thin mustache, Price often reads as queer in the cultural imagination. He was also a supporter of gay rights and was likely bisexual himself.[25] In a piece written specifically about the actor, Benshoff describes Price's public and on-screen persona as a "queer male diva" and notes that "no matter what role he was playing, Price's persona as an educated aesthete always came through, sometimes contributing to the characterization, but just as frequently mocking a role."[26] Benshoff notes that Price's persona points to a "world where queer artistry, wit, and high style trump the heteronormatively banal."[27] These comments fit nicely with our sense of camp as queer parody. Through his persona and

performance style, Price brought a queer and comic sensibility to numerous films that may have registered quite differently had others been cast in the same roles.

Price's most overt camp performances came in a series of British films made in the early 1970s, such as *The Abominable Dr. Phibes* (1971) and *Theater of Blood* (1973). While these later British films feature Price at his over-the-top campiest, they utilized a Price persona that had already been established in American productions. Price's earliest foray into horror was in *The Invisible Man Returns* (1940), but 1950s films like *House of Wax* (1953), *The Fly* (1958), and *House on Haunted Hill* (1959) cemented his reputation as a horror star. *House of Wax*—a remake of *Mystery of the Wax Museum* (1933)—is less humorous than later Price films but shows an early example of his persona as a tortured, vengeful aesthete. Price plays Henry Jarrod, a talented wax sculptor who is driven mad after he is severely burned in a fire started by his corrupt business partner. Jarrod not only gets revenge but begins using the corpses of his murder victims in his statues. Before the fire, Jarrod is established as an uncompromising artist when he refuses to sculpt violent and salacious statues that would earn more money. Jarrod tells his partner that "there are people in the world who love beauty." Once he has gone insane, this love of beauty trumps traditional morality, as he has no qualms about murder if he can use the corpse to create a work of art.

House of Wax also begins a trend of ambiguous sexuality that will be found in the majority of Price's villains. While Jarrod is not explicitly queer, he may register as such through the ways the film distances him from traditional masculinity. Like Dr. Frankenstein before him, Jarrod has a male assistant named Igor; however, rather than a deformed hunchback, this assistant, unwaveringly devoted to Jarrod, is played by a young, muscular Charles Bronson. The closest Jarrod comes to expressing heterosexual interest is through his obsession with protagonist Sue Allen (Phyllis Kirk). He is obsessed, however, because of her resemblance to his destroyed Marie Antoinette statue. Jarrod eventually kidnaps Sue with the intention of dipping her in hot wax in order to recreate the lost sculpture. Just as he is about to coat her with the boiling wax, Jarrod laments, "That look of horror spoils your lovely face. What if it should show even through the wax?" The line, especially when delivered by Price, makes clear that Jarrod sees Sue as an aesthetic object but not a sexual one. The physical disfigurement, the company of a handsome male assistant, and the preoccupation with beauty all combine with Price's persona to create a character that can easily register as queer. Predictably, Jarrod himself

falls into the wax at the end, thus following the tradition of keeping queer monsters repressed. Price's portrayal, however, makes him one of horror's more sympathetic and human monsters even though it never reaches the levels of queer parody that we find in later films.

A more explicit camp performance comes in William Castle's *House on Haunted Hill*. Price plays an eccentric millionaire, Frederick Loren, who throws a party in a supposedly haunted house. Loren invites several guests and promises to give them each ten thousand dollars if they stay the entire night. The party is ostensibly for Loren's fourth wife, Annabelle (Carol Ohmart), but it soon becomes clear that he and Annabelle are plotting each other's murders. As in *Old Dark House*, the preoccupation with an unhappily married couple challenges and mocks traditional heteronormative unions. Even though Loren is married to a woman, his character—filtered through Price's persona—seems to be in on this mockery. In fact, we learn that Loren's previous wives all died under mysterious circumstances. The suggestion that he is a serial wife murderer highlights his disdain for traditional marriage. Despite making the potentially queer character a murderer, the film steps back from equating Loren's queerness with monstrousness. In part, this is because the film's only heterosexual couple (Annabelle and her lover, Dr. Trent [Alan Marshall]) have constructed an elaborate plot to kill Loren and get his money. Thus, when Loren manages to kill them both, viewers are invited to applaud his ingenuity. Unlike most 1950s movies, which make sure that both queer characters and murderers are punished, Loren not only survives, but it is heavily suggested that he gets away with the killings.

The most important aspect of the film's queer parody, however, is Price himself, who presides over the proceedings with a mischievous charm and whose persona overshadows any sense of Loren as a distinct character. In other words, we are always aware that we are watching *Vincent Price*. This is established, in part, by the opening sequence in which Loren addresses the audience directly and invites them to attend a party at a haunted house. By breaking the fourth wall, the film highlights the text's performative aspects and suggests that Price's character stands somewhat apart from the rest of the cast. Unlike the other characters, Price (or Loren) knows he is in a movie. We get a clear sense of this aspect during certain scenes. At one point, for example, Loren theatrically presents his guests with tiny coffins, each of which holds a pistol. Loren picks up one of the guns and casually (and with a stereotypically queer limp wrist) shoots a vase. "You see," he says with a grin, "they're loaded." The playful presentation of a table full of murder weapons and

the nonchalant manner in which he fires the gun both recall Benshoff's comment that Price, as a queer male diva, takes a mocking attitude toward his own roles.

Cult B-movie director Roger Corman probably utilized Price's campy talents more effectively, and more often, than any other director. In the 1960s, Corman directed a series of Edgar Allan Poe adaptations, the majority of which starred Price. As in the other films, Price's characters are not written as queer, but Price nevertheless exudes a queer camp energy. The films are all period pieces and thus feature Price dressed in ruffled shirts, velvet robes, and other lavish and extravagant costumes. In nearly all the Poe films, both the script and Price's performance (as well as Poe's source material) distance his characters from any semblance of heteronormative masculinity. This often works for comic effect, as in *House of Usher* (1960), where his character, Roderick Usher, mostly lounges around the house, sadly playing the lute and complaining about his extreme sensitivity to sound, touch, and light. In *The Pit and the Pendulum* (1961) he plays Nicholas Medina, a character traumatized by having witnessed his father torture his mother to death as a young child. As his sister explains, in a winking double entendre, "Ever since then, Nicholas has been unable to live as other men." The most comic of Corman's Poe films is *The Raven* (1963), which stars not only Price but also horror icons Boris Karloff and Peter Lorre, as well as a very young Jack Nicholson. The film features Price giving an over-the-top reading of Poe's poem, which anticipates his later Shakespearean soliloquies in *Theater of Blood*. *The Raven*'s climax consists of an extremely campy duel between sorcerers, played by Price and Karloff, which basically consists of the two actors dramatically wiggling their fingers at each other while cheap special effects flash across the screen. Clearly, none of these films take themselves seriously, and Price's winking camp performances are a great fit for Corman's low-budget sensibilities.

In most of the Price/Corman Poe films, Price plays characters that are sad, tortured, sensitive, and often dangerously insane. In *The Masque of the Red Death* (1964), however, his character, Prince Prospero, is quite evil. Nevertheless, Price plays him with a mustache-twirling camp flair which makes great use of his persona's mocking derision of conventional morality. The character is a Satanist, and early in the film he asks protagonist Francesca (Jane Asher) if the cross around her neck is "only a decoration, or are you a true Christian believer?" Price lingers over the word "Christian," thereby suggesting his amused contempt for religious piety, an attitude that reinforces Price's libertine persona and that likely appealed to the burgeoning counterculture at the time of

the film's release. Also, while Prospero shows more heterosexual inclinations than most of Price's Poe characters, the film nonetheless aligns him with nonheteronormative sexuality. Prospero's primary pastime, it seems, is throwing lavish, debauched parties (like the titular masque), which seem barely a step away from polysexual orgies. On the one hand, Prospero, like Price's other Poe characters, can be constructed as a queer monster. On the other, Price's theatricalized performance combines with the character's disdain for what Benshoff calls the "heteronormatively banal" to make Prospero something of a camp hero, standing comfortably outside of conventional mores.

In his late career, Price's iconic persona, and particularly his recognizable voice, frequently added a queer and playful edge to numerous texts, such as Tim Burton's short, animated film *Vincent* (1982) and *Michael Jackson's Thriller* (1983). One of Price's last roles is in Burton's satire *Edward Scissorhands* (1990), in which he plays a lonely inventor who builds himself a new friend in Edward (Johnny Depp). While *Edward Scissorhands* is not a horror film, it makes deliberate use of many horror tropes, especially the *Frankenstein* mythology. It upends those tropes, however, to provide a satire of suburban America, for in *Edward Scissorhands*, both the monster and the Inventor are sympathetic, and angry villagers are recast as conformist American suburbanites. As in Whale's *Frankenstein* films, the queer subtext is barely below the surface. Like Frankenstein, Price's Inventor builds a new man without the aid of a woman. In the Inventor's case, however, this new man is built for companionship rather than science, a distinction that makes the queer implications even more overt. That the Inventor would rather make a new human than try to form relationships with the suburbanites who live just down the hill drives home the character's inability to live among "normal" society. Price's "queer male diva" persona is intact in the film, but this time Price plays it for pathos rather than camp. The result is a fitting swan song for the actor.

Camp in Modern Horror

Throughout the 1970s, camp humor thrived in several British and European horror films, particularly those produced by England's Hammer Studio. In addition to the British Price films mentioned above, Hammer productions such as *The Vampire Lovers* (1970), *Twins of Evil* (1971), and *Dr. Jekyll and Sister Hyde* (1971) feature most of the requisite camp elements, including highly theatricalized performances, farcical plots, and queer characters. As

Benshoff points out, however, most of these films were primarily made by heterosexual men, and their bosomy lesbian vampires were clearly "intended for a heterosexual male spectator" and thus rarely explored any genuine queer subjectivity.[28] In this sense, the films are closer to the queer appropriation or "camp trace" outlined by Meyer. Even this camp trace, however, is more than what we find in most American horror productions during the same period. The 1970s are rightfully considered a transformative decade in American horror, and numerous films use satire and parody to challenge patriarchal norms. These films' humor, however, is rarely tied to the sort of queer challenge to heteronormativity that we saw in Whale's Universal pictures or in Price's campy performances.

A possible key exception is, of course, the cult classic *The Rocky Horror Picture Show* (1975). I am hesitant, however, to include it here because both its Americanness and its status as an actual *horror* film (rather than a comedy/musical) are debatable.[29] Nevertheless, it is a landmark of camp filmmaking. While *Rocky Horror* may not operate as horror, it pays homage to and parodies many horror tropes and classic texts. Benshoff points out that its reworking of classic horror "laid bare the queerer implications of the genre for all to see."[30] Indeed, *Rocky Horror* makes explicit many of the themes that were just below the surface in Universal horror films, and at times, it feels like a love letter to James Whale. Its story of a couple seeking refuge from a storm bears more than a passing resemblance to *Old Dark House*, and the gender-bending mad scientist Dr. Frank N. Furter (Tim Curry) is clearly a play on Frankenstein even as his identity as an alien from the galaxy Transylvania points to the Dracula mythology. *Rocky Horror* mixes these elements with highly theatrical performances, outlandish costumes, and a mocking attitude toward heteronormativity, all of which mark it as a camp classic. While *Rocky Horror*'s representation of trans identity has not aged well,[31] its long-standing queer cult following anticipates later texts like *The Boulet Brothers' Dragula* and *American Horror Story* (discussed later) and makes clear the genre's appeal to many queer spectators.

Throughout the 1980s and 1990s, queerness continued to operate in mainstream American horror primarily as subtext. At times, though, that subtext comes quite close to bursting through the surface, often with potentially campy results. A case in point is *A Nightmare on Elm Street Part 2: Freddy's Revenge* (1985), often referred to as "the gayest horror film ever made."[32] While the majority of 1980s slashers tend to focus on teenage girls, *Nightmare 2* is about dream monster Freddy Krueger's (Robert Englund) attempt to steal the body of teenage boy Jesse Walsh (Mark

Patton). The queer elements have been pointed out at length,[33] but some highlights include Jesse dancing suggestively in his room, simulating masturbation and shutting a drawer with his buttocks; Jesse wandering into an S&M bar; Jesse waking up in a sweat surrounded by phallic candles dripping wax; and Jesse running to spend the night with his male friend Grady (Robert Rusler) after his first kiss with nominal female love interest Lisa (Kim Myers). The first time Freddy and Jesse meet, Freddy caresses Jesse's lips with his finger knives and says, "I need you, Jesse. We've got special work to do here." The film's two most graphic kills are of men, both of whom Freddy attacks from behind; one of these men (Jesse's queer and sadistic gym teacher) is also stripped naked and whipped across the buttocks with a towel. The list goes on.

Viewed through Robin Wood's "return of the repressed" thesis, these examples all suggest that Freddy is a metaphor for Jesse's repressed homosexual impulses, constructed here as violent and monstrous. This reading is supported by the fact that after each of the homoerotic kills, the camera reveals either Jesse wearing Freddy's glove or Freddy himself having taken Jesse's place. When Jesse is unable to keep his homosexual impulses (Freddy) at bay, those impulses erupt in violent sexual energy. A scene in which Freddy crashes a high school pool party also suggests pent-up sexual energy; Freddy's appearance is precipitated by a series of beer cans suddenly spraying foam and a plate of hot dogs (!) spontaneously sizzling and bursting into flames. In the climax, Freddy is only defeated by Jesse and Lisa declaring their love for each other. Heterosexual romance thus represses the gay monster. In the ending, however, Jesse finds himself in yet another Freddy-induced nightmare, and the last sound before the credits roll is Freddy's maniacal laughter. The gay monster, it seems, is not so easily repressed.

The queer elements are definitely present in *Nightmare 2*, but whether or not those elements are humorous likely depends on the opinions of individual viewers. More important, if one sees humor in the text, does that humor operate as camp (i.e., as a queer parody of heteronormativity)? A camp reading is certainly plausible. Freddy's final laugh at the film's closing, for example, can be read as a mocking acknowledgment of the silliness of the heteronormative ending, similar to Porterhouse's snore at the end of *Old Dark House*. And as usual, Englund plays Krueger with a theatrical flair, which, in the context of the film's other queer elements, may be read as camp. Patton's somewhat effeminate portrayal of Jesse also has a camp theatricality, particularly in the numerous instances when he emits the sort of high-pitched scream that is typically associated

with women. Furthermore, the overt sexual imagery of phallic candles, sizzling hot dogs, and so on, are so over-the-top that it is easy to read them as deliberately and comically excessive.

These camp readings, however, must be chosen and read against the film's more overt homophobic elements, like the figure of the gay monster, the stereotypically dangerous queers that populate the S&M bar, or the sadistic and queer gym teacher. Furthermore, locating any sort of camp intent among the filmmakers has proven difficult. Director Jack Shoulder has long maintained that he was unaware of any gay subtext; screenwriter David Chaskin initially denied any intention of queer themes in his screenplay but has later said that those elements were intentional. Mark Patton was a closeted gay actor during the production and says he was well aware of the script's queer elements but was not deliberately instructed to play the character as gay.[34] The film is thus more a collection of contradictory impulses regarding homosexuality than it is any sort of stable and consistent commentary. Its various possible interpretations, however, provide a good example of the ways in which camp can operate as a reading strategy rather than a stable collection of textual features.

Joel Schumacher's *The Lost Boys* (1987) provides a perhaps more intentional form of camp horror. Released about a decade before openly gay Schumacher's most explicit camp films *Batman Forever* (1995) and *Batman and Robin* (1997)—the latter of which is notorious for its nippled bat suit—*The Lost Boys* has many camp elements and offers a comic critique of heteronormativity. The film is about Lucy Emerson (Dianne Wiest) and her two sons, Michael (Jason Patric) and Sam (Corey Haim), moving to live with Lucy's father in a vampire-infested California beachfront community. Michael gets involved with the glammed-out, motorcycle-riding local vampire gang (the titular Lost Boys), who turns him into a "half vampire," a state in which he will remain until he either makes his first kill and becomes a full vampire or until the death of the pack's leader makes him human again. Michael's requisite heterosexual love interest is another half vampire, Star (Jami Gertz), and she even has a half-vampire son, thus promising Michael the potential for the full heteronormative nuclear-family package. Star is undeveloped as a character, however, and Michael's real significant relationship is with the vampires' apparent leader, David, played by a bleached-blond, mullet-sporting Kiefer Sutherland. In classic queer love triangle fashion, Michael and David ostensibly compete over Star, but they are clearly obsessed with each other. This subtext becomes text during a scene when Michael visits the vampires' underground lair. After drinking blood out of a jewel-adorned wine bottle, Michael goes

into a sort of trance. Here, the image of Star's face is superimposed over Michael's, suggesting an attraction between the two. Soon, however, Star is replaced with the image of David, smiling suggestively and slowly whispering "Michael" over and over again. The melodramatic moment comically brings to the forefront the homoerotic tension between Michael and David.

Despite this moment, the film mostly follows a traditionally heteronormative story line. Eventually, Michael, Sam, and the local vampire hunters the Frog Brothers (Corey Feldman and Jamison Newlander) kill the vampire gang, and Michael and Star become fully human again. In this light, we could read Michael's story similarly to Jesse's in *Nightmare 2*: the queer lost boys represent Michael's homosexual impulses, and the film tells the story of repressing those "monstrous" urges. There are several important distinctions, however, which suggest the heteronormative ending is merely pro forma, and the film's real perspective is playfully queer. The first difference is the construction of the queer monsters themselves. The scar-covered Freddy Krueger is repulsive, and his propensity for corny dad jokes and one-liners (see chapter 2) makes him something of a square. The Lost Boys, in contrast, are hip, attractive, and glamorous. When I watched the film as an adolescent—and I watched it quite often—the queer elements went over my head, but I knew that those vampires were cool, attractive, and stylish.

Also, *The Lost Boys* gives an equivalent amount of screen time to Michael's younger brother Sam. Even more so than Michael, Sam reads as queer. As Benshoff nicely puts it, Sam is "coded so heavily as gay that one suspects the production designer must have had a direct pipeline into gay culture. Throughout the film, Sam wears a Mondrian-inspired bathrobe, a 'Born to Shop' T-shirt, and his bedroom wall sports a sultry mid-1980s pin-up of Rob Lowe baring his belly and pouting at the camera."[35] Significantly, Sam's queerness is never presented as monstrous, nor does the film bother shoehorning him into a heterosexual relationship (of course, it never goes so far as to give Sam a homosexual love interest either). The film thus invites viewers to read Michael and Sam as foils: Michael's attempts to repress his queer urges have monstrous repercussions, but Sam's relative openness appears much healthier.

Lost Boys's representation of heterosexual romance ultimately pushes it most explicitly into queer parody. With the exception of Michael and Star's questionable romance, all other heterosexual relationships are treated as a joke. Lucy just got out of a bad marriage and is forced to live with her father. Her father (Barnard Hughes) has an ongoing affair with

the unseen Widow Johnson. This relationship is played solely for laughs, particularly in a scene when, prior to his date, he rubs Windex on his face in lieu of aftershave. And most importantly, in the film's twist ending, it turns out the vampire pack's leader is not David but rather Lucy's nerdy love interest, Max (Edward Herrmann). After the protagonists have successfully killed all the cool, queer vampires, Max reveals himself and expresses his desire to bring Lucy, Michael, and Sam into his family. "Boys need a mother," he says, and he goes on to assert, "It was all going to be so perfect, Lucy, just like one, big happy family: your boys and my boys." The true monster, then, is not the cool, queer vampires but rather the nerdy, patriarchal one. Max's final speech thus operates as a mockery of traditional "family values." This point is underscored when one of the Frog brothers quips, "Great, the blood-sucking Brady Bunch!" Thus, while *Lost Boys* never goes so far as to bring homosexuality fully into the open, its queer parody ultimately presents heteronormativity as simultaneously comic and monstrous.

Several other films in the 1980s and 1990s—especially vampire movies—can be read through a similar camp lens, particularly *Fright Night* (1985), *Vamp* (1986), and *Interview with the Vampire* (1994). The late 1990s and early 2000s also brought the *Child's Play* series firmly into camp territory with its late-franchise sequels *Bride of Chucky* (1998) and *Seed of Chucky* (2004). *Child's Play* has always been one of horror's most playful franchises; it is, after all, about a wisecracking killer doll, and in the first three entries, series monster Chucky quips and laughs his way through numerous kills and resurrections. As Lisa Ellen Williams points out, the franchise "evolved" to become a "campy commentary regarding the sociopolitical expectations of family, gender, and sexuality."[36] This transformation begins in the fourth film, when Chucky becomes part of a nuclear family. As its title suggests, *Bride of Chucky* gives the killer doll (voiced by Brad Dourif) a mate in Tiffany (Jennifer Tilly), who also ends up with her soul inside of a doll. The story revolves around Chucky and Tiffany's plan to steal the bodies of teenage lovers-on-the-run Jesse (Nick Stabile) and Jade (Katherine Heigl).

The ridiculous plot lends itself well to camp theatrics, and openly gay screenwriter and franchise creator Don Mancini announces his camp intentions through the title's homage to *Bride of Frankenstein*. In fact, in a very unsubtle transformation scene, Tiffany watches the climax of *Bride* on television at the very same moment when Chucky transports her soul into a doll. *Bride of Chucky* only has one queer character, killed off before the climax, but it manifests a camp sensibility through the portrayal of

Chucky and Tiffany as a heterosexual couple. The hyperviolent, foul-mouthed, and libidinous Chucky has always been something of a parody of masculinity. In *Bride*, this is matched with Jennifer Tilly's portrayal of Tiffany. Tilly—already a queer icon for her role in the thriller *Bound* (1996)—is famous for her sultry schoolgirl voice, and her performance lends Tiffany something of a hyperfeminine aura. Chucky and Tiffany thus portray a highly parodic and exaggerated form of heteronormative romance. Tiffany often quotes Martha Stewart and, despite her love for a violent psychopath, attempts to adhere to traditional gender roles. Inside a stolen RV, Tiffany enacts a show of domestic tranquility, donning an apron and serving Chucky freshly made cookies (here, we also catch a glimpse of the murdered owners of the RV stuffed into a closet). Soon, Chucky tells Tiffany that the "dishes won't wash themselves," and the two dolls descend into a violent fight. The scene works as camp theatricality. The stereotypes of both domestic bliss and domestic violence are rendered comically surreal by the fact the characters are not only mass murderers but are also plastic, artificial dolls. In this manner, the scene, and really the whole film, literalizes the concept—central to camp—that traditional gender roles are constructed and performed.

The next sequel *Seed of Chucky*, written and directed by Mancini, pushes the camp elements further and offers an explicit exploration of gender identity and queer subjectivity. Tilly returns to voice Tiffany but also plays a fictionalized version of herself; the fictional Jennifer Tilly is playing Tiffany in a movie based on the exploits of Chucky. In addition to this sort of self-aware, post-*Scream* parody, the film wears its camp affiliations on its sleeve by casting camp icon John Waters as a sleazy tabloid photographer. As in *Bride*, *Seed* derives humor through its camp portrayal of Chucky and Tiffany's adherence to traditional gender roles. In *Seed*, however, they also have a doll child, so we see the killer dolls navigating parenthood. For Tiffany, being a good parent means no more killing, and there are very comic scenes featuring Tiffany reading self-help books to cure her of her addiction to murder. Chucky makes no such attempt and wants the child to become a killer too. In fact, after murdering the John Waters character, Chucky and the child pose with the corpse for a grotesque family portrait. Once again, the site of killer plastic dolls going through the motions of traditional domestic roles generates a queer parody of heteronormativity.

Seed of Chucky's most overt object of gender play, however, comes through Chucky and Tiffany's child, who is either gender nonbinary or genderfluid. Early in *Seed*, Chucky and Tiffany disagree about whether

their androgynous doll child is a boy or a girl, named either Glen or Glenda in an homage to Ed Wood's 1953 cult classic. When they remove the child's clothes, they find that Glen/da has no genitalia at all. In a satirical critique of heteronormative culture's need to assign gender along binary lines, both Chucky and Tiffany attempt to project their own ideas on to the bare plastic crotch. Tiffany says, "See . . . a beautiful little *girl*." Chucky responds, "Are you blind? That's my boy. He just hasn't had his growth spurt yet." Neither parent has the tools to conceptualize a child that does not conform to their expectations of gender identity. There are signs, however, that Chucky and Tiffany may adapt their parenting strategies to accommodate Glen/da. As the parents argue about the gender, Glen/da yells, "You're tearing me apart. What about what I want?" At first shocked by Glen/da's outburst, Chucky and Tiffany make a point of recalibrating. Chucky says, "OK, interesting. Tell us." Tiffany asks, "What *do* you want, sweetface?" It's hardly model parenting, especially when we consider the murdered bodies strewn about, but it does suggest, in exaggerated camp fashion, a move toward accepting and attempting to understand Glen/da's gender confusion.

Ultimately, Glen/da gets to be both a boy and a girl. Like most *Child's Play* films, the plot revolves around Chucky's attempt to transport his soul (and, in this case, Tiffany's and Glen/da's) into a human body. Their plan involves kidnapping Jennifer Tilly and her chauffeur, artificially inseminating Tilly, and then, once the baby is born, transporting all three bodies into the human hosts. (Tiffany explains that Tilly is having an accelerated "voodoo" pregnancy, which causes her to give birth within days of insemination!) Predictably, Tilly gives birth to twins: a boy and a girl. In the climax, Chucky is once again killed, but Tiffany successfully transports her soul into Tilly's body, and Glen/da splits into both Glen and Glenda. The film ends with Tiffany (now living the life of Jennifer Tilly) raising her twins as a single mom. This plot is ridiculous, and the ending's suggestion that Glen/da's gender confusion stems from a split personality (*Psycho* is explicitly referenced in multiple scenes) undermines the more progressive representation of a nonbinary individual. Nevertheless, *Seed of Chucky* has a remarkably playful and fluid attitude toward gender and offers a camp critique of rigid heteronormativity.

Karyn Kusama's *Jennifer's Body* (2009) is another twenty-first-century horror film that makes its queer themes explicit. While camp is most often associated with gay men, *Jennifer's Body* stands out through its lesbian camp humor. The film focuses on two high school friends: the nerdy Needy (Amanda Seyfried) and the sexy, popular cheerleader Jennifer (Megan

Fox). Jennifer becomes the victim of a botched sacrifice by a satanic rock band and is reborn as a demonic succubus who needs to regularly feed on human blood. While Jennifer assures Needy that she goes "both ways," Jennifer clearly prefers to eat boys, and after she kills Needy's boyfriend, Chip (Johnny Simmons), Needy retaliates and kills Jennifer. Before dying, however, Jennifer bites Needy who absorbs her demonic energy and, as Lisa Cunningham points out, transforms "into a being that... more closely resembles her undead friend."[37] The final credit sequence shows that the newly demonic Needy has slaughtered the satanic rock band that sacrificed Jennifer.

The film's camp sensibility is driven first and foremost through its representation of Jennifer who, both before and after her demonic transformation, performs an exaggerated caricature of the "hot high school cheerleader." At the time of the film's release, actress Megan Fox was a recognizable Hollywood bombshell who had already been presented as an object of the male gaze in two *Transformers* movies. Kusama and Fox make comic use of Fox's sexpot persona, and there are frequent stylized shots that ironically linger on Jennifer's body in a parody of the male gaze. It is also clear that the character understands and utilizes the sexualized way people view her. To get served at a bar, she explains that she will "play hello titty" with the bartender, and she later uses her sex appeal to lure the horny teenage boys upon whom she feasts. Diablo Cody's script contributes greatly to the construction of Jennifer's self-awareness and intelligence, for Jennifer frequently spouts the sort of comic and savvy dialogue that made Cody famous for her *Juno* (2007) screenplay. Jennifer tells Needy, for example, that PMS was created by the "boy-run media" to make women "seem crazy." In the same scene, she asks another student if she can copy his English homework because she forgot to read *Hamlet*. Thinking about *Hamlet*, she suddenly asks, "Is he gonna fuck his mom?" Lines like these reveal that beneath Jennifer's ditzy prom-queen exterior, there is an active intelligence. Even though PMS is not actually a media construct, Jennifer's comment shows an awareness of the ways in which the "boy-run" patriarchy shapes ideology. And even without doing her homework, Jennifer picks up on *Hamlet*'s incestual subtext. When we combine these moments with Jennifer's overt sexualization of herself, it becomes clear that, in keeping with camp theatricality, Jennifer consciously performs the role of the "hot girl."

Camp humor also emerges in the mocking representation of heteronormative relationships and in its construction of Needy and Jennifer as a potential queer couple. The primary heterosexual relationship, between

Needy and Chip, is bland and passionless. Chip is a stereotypically "nice" boyfriend but is comically insecure and jealous of Jennifer. One sequence intercuts Needy and Chip having sex and Jennifer killing and eating a boy from school. Chip fumbles around, struggles with the condom, and is generally bad at sex. During intercourse, however, Needy has a psychic connection with Jennifer as she feeds on her victim. Chip, sensing Needy's distress, proudly smiles and asks, "Am I too big?" Later, Chip tells Needy, "I care about you, as a person, not just some girl I made love to for four minutes the other night." Comments like these comically highlight Chip's attempts to be nice and sensitive even as they reveal his obsession with his own questionable sexual prowess. Combined with his immaturity and inexperience, the character becomes a parody of teenage masculinity.

Needy and Chip's romance is comically bland, but Kusama reserves her cinematically romantic flourishes for scenes focusing on Needy and Jennifer. Early in the film, the camera provides a slow-motion shot of Jennifer twirling a flag at a pep rally; the reverse shot shows Needy watching wide-eyed from the bleachers. Still in slow motion, the two girls wave at each other. In conventionally heteronormative films, this would be used to set up a romance between male and female leads. The queer sensibility becomes quite overt here, for rather than letting the homoerotic moment stand as subtext, the film cuts to another classmate, who tells Needy, "You're totally lesbi-gay." Needy protests that Jennifer is just her best friend, but the homoerotic tension is undeniable. Needy's repressed impulses are suggested again when Jennifer, over the phone, asks Needy, "You know when you kiss a boy for the first time, and your entire body is on vibrate?" Needy responds, "Yeah," but her wrinkled brow and a pregnant pause both make it clear that Needy has never had that feeling. Later, though, Needy and Jennifer share a long kiss, and while Needy eventually pulls away, the moment is more erotically charged than the earlier sex scene with Chip. As Cunningham asserts, Jennifer and Needy's kiss is "the only truly romantic scene in the film—shot in soft-focus, close-up, with pale white lighting and subdued music."[38] The romantic presentation of Needy and Jennifer contrasts with the comic treatment of Needy and Chip and foregrounds the queer parody.

Jennifer's Body was a box-office flop, possibly due to an advertising campaign that misrepresented the film as a "sex romp for straight teen boys."[39] In the years since its release, however, *Jennifer's Body* has been reevaluated and become something of a queer, feminist cult classic. This reconsideration is likely due in part to the fact that since the release of *Jennifer's Body*, many horror texts have become more explicitly queer and have

found less need to bury homosexual themes and characters in metaphors and subtext. The best example of this shift toward the explicit queering of American horror is the anthology television series *American Horror Story* (2011–), created by Ryan Murphy and Brad Falchuk, who also created other queer-themed shows such as *Glee* (2009–2015) and *Pose* (2018–2021). *AHS* has not been universally lauded for its queer representation, but it has an undeniable camp aesthetic that, like *Rocky Horror*, provides a queer parody of canonical horror texts and traditional tropes.[40]

Given limits of space, it is impossible to provide a full discussion of *AHS*'s camp elements. The series, however, engages in a high level of parody and gender play, and its very structure and premise lend themselves to a camp aesthetic. Each season tells a stand-alone story that revolves around a key theme or location—announced through a subtitle—that is closely associated with horror. Season one focuses on a haunted house, season two on an insane asylum, season three on a coven of witches, and so forth. The show heavily alludes to many canonical horror texts and rewards horror-literate viewers. The fifth season, *AHS: Hotel*, for example, has lavish sets that are clearly based on the design of the Overlook Hotel in Stanley Kubrick's *The Shining* (1980). In the context of *AHS*, this heavy use of allusion and intertextuality aids the show's camp aesthetic, as it encourages viewers to pay close attention not only to character and narrative but also to visual and aesthetic elements.

AHS's camp sensibility is clearest, though, in the attention it pays to performance. Theatricality and performance are typically considered central to a camp aesthetic, and *AHS* shows this in several ways. First, the series has a stable of actors that it uses season after season, and certain performers like Sara Paulson, Jessica Lange, Evan Peters, Lily Rabe, and Kathy Bates are closely associated with the show's brand. The recasting of actors in multiple roles serves to highlight *AHS*'s performative aspects, as longtime viewers will see the same actor playing drastically different characters. Many of the actors are also either queer icons (like Lady Gaga, cast in season five) or visible members of LGBTQ+ communities. *AHS*'s narratives also foreground performative aspects. Many of the actors—particularly Lange and Lady Gaga—perform in a heightened fashion that is consistent with camp. In the spirit of both *Rocky Horror* and *AHS* creators' own *Glee*, musical performance pieces also appear quite often. *Asylum*, for example, features a fantasy sequence in which Lange's character Sister Jude leads the asylum patients in a rendition of Shirley Ellis's 1964 gimmick song "The Name Game." In *Coven*, rock star Stevie Nicks appears as herself to perform "Rhiannon" and

"Seven Wonders." *Freakshow*, the fourth season, is perhaps the most performative, as it centers on 1950s circus performers. Over the course of the season, Lange channels Marlene Dietrich to play freak show leader Elsa and performs various anachronistic songs, such as gender bender David Bowie's "Life on Mars" and Lana Del Ray's "Gods and Monsters," the latter of which also alludes to *Bride of Frankenstein*. These musical numbers are performed with a knowing, excessive campiness and drive the queer sensibility.

This element of excess carries into the story lines. Rather than telling small, focused stories, Murphy and Falchuk opt for an "everything but the kitchen sink" approach, in which they pile horror trope upon horror trope until the narratives threaten to break under the strain. *Asylum*, for example, takes place in 1964 and focuses on the inmates of Briarcliff asylum, which is used to introduce numerous other horror plots, such as a serial killer named Bloodyface, a nun possessed by the devil, and an alien abduction. These elements are in turn intertwined with various social problem stories through which Murphy and Falchuk posit the asylum as an institution designed to separate social undesirables (homosexuals, the physically disabled, interracial lovers) from the conservative mainstream. Through this approach, Murphy and Falchuk provide both social commentary and traditional horror thrills even as their hyperbolic narratives are somewhat comic in their excess.

Finally, the camp aesthetic is probably driven the most clearly by its approach to sexuality, characterized by a frequent use of queer characters and signifiers and a mocking portrayal of heteronormativity. If there is a single image that represents the series as a whole, it is the BDSM-inspired rubber man suit from season one, which figures prominently in the narrative and was widely used in promotional materials. On the one hand, the suit is a kinky signifier, indicative of *AHS*'s playful approach to sexuality; on the other hand, as Harriet E. H. Earle asserts, it "is a symbol of sexual violence, domination, and deviance within *AHS* that taps into the history of queer stereotyping."[41] This dual register points to the show's overall sexual politics: it undeniably pushes horror's queer representation forward even as some aspects simultaneously participate in negative stereotyping. *AHS*'s heterosexual characters, however, do not fare much better. In addition to the plethora of heterosexual-coded serial killers, monsters, and mad scientists, it takes aim at the traditional heteronormative American family. The first season focuses on such a family and, in camp fashion, overdramatizes many clichés, such as the unfaithful father and angsty teen daughter. The family does achieve a happy ending of sorts, but in an ironic

and comic reversal of expectations, they only achieve it as ghosts, once they have all been killed. The ending reveals Murphy and Falchuk's comically derisive attitude toward the traditional TV family.

Camping the Trans Monster

The final section of this chapter turns to one of the most controversial figures in American horror: the trans-coded or cross-dressing monster. Typically, discussion of this figure begins with Norman Bates (Anthony Perkins) in *Psycho* (1960) and ends with Buffalo Bill (Ted Levine) in *The Silence of the Lambs* (1991). Prominent examples in between include *Homicidal* (1961), *The Texas Chain Saw Massacre* (1974), *Terror Train* (1980), *Dressed to Kill* (1980), and *Sleepaway Camp* (1983). Cross-dressing or trans-coded killers, however, can be found in films at least as early as *The Devil Doll* (1936) and as recent as *Insidious: Chapter 2* (2013).[42] These films offer a wide array of explanations for their killers' gender-bending activities, ranging from insanity to simple disguise, and the majority of them were produced before discussions of transgender identity entered the dominant (read: cisgender) public sphere in any sustained way. Regardless of a particular film's explanation, the image of a knife-wielding gender nonconformist (usually a man in a wig and dress) is remarkably common in horror and may simply reinforce the widespread demonization of transgender individuals. While the case can be made for reading all the above-mentioned texts as transphobic, I hope to single out two films, *Homicidal* and *Sleepaway Camp*, for a more nuanced and extended analysis. Both films, I assert, posit a fluid and comic approach to rigid gender roles and have the potential to be read as camp.

Gender-bending representations have long been central to both horror and humor. Carol Clover discusses the drag implications of the slasher subgenre, in which male monsters are frequently coded as feminine and final girls are coded as masculine. For Clover, this causes cross-gendered identification processes, as male viewers may alternate between identifying with feminized male monsters and masculinized final girls. Clover, for example, reads the ending of *The Texas Chainsaw Massacre 2* (1986), where protagonist Stretch (Caroline Williams) usurps Leatherface's chain saw and raises it above her head, as "a moment of high drag."[43] Trans-coded monsters may thus be an extreme extension of horror's gender-bending impulses.

The comedy genre is also full of cross-dressing scenarios, as can be seen in successful mainstream films like *Tootsie* (1982), *Mrs. Doubtfire* (1993), or *She's the Man* (2006). While the majority of these texts do not

demonize the cross-dressing protagonist, they nonetheless reinforce rigid gender roles by treating the image of gender nonconformity as essentially laughable. We may remember here that Hitchcock famously asserted that *Psycho* was a "big joke"; it is certainly possible to see, from a conservative, heteronormative point of view, the reveal of Norman dressing up like his mother as part of that joke. After all, only a year before *Psycho*, Billy Wilder's *Some Like It Hot* (1959) earned huge laughs by having men dress up as women. In mainstream media, then, cross-dressing of any sort is typically treated as either a comic punchline or a signifier for monstrosity. There are, though, several more playful, inclusive, and fluid examples of gender play that push back against such stereotyping. Previously discussed texts like *Rocky Horror* and *Seed of Chucky* may not be perfect in their representations, but they nonetheless see gender as an avenue for play and attempt to trouble heteronormativity. The same may be said of *Homicidal* and *Sleepaway Camp*.

At first glance, *Homicidal* appears to be a simple rip-off of *Psycho*, released only a year earlier. In addition to similar titles, the films share many superficial elements: black-and-white cinematography, hotel rooms, knife murders, long takes of a blonde woman driving, a shocking staircase moment, and the surprise reveal of a cross-dressing, trans-coded murderer followed by a lengthy explanation from a minor character. In *Psycho*, Norman Bates involuntarily takes on the personality of his overbearing mother to kill women to whom Norman is attracted. In *Homicidal*, the female killer Emily deliberately performs two personalities and purposefully seeks revenge on various people who forced her as a child to take on the identity of a boy named Warren. (Actress Joan Marshall, billed as Jean Arless, plays both Emily and Warren.) While the explanations are drastically different, both movies seek to shock audiences with the image of a gender-blurred, knife-wielding killer. For this reason, even though neither killer is actually transgender, both films can be read as transphobic.

It is possible, however, to also read Castle's film as a parody rather than a rip-off of *Psycho*, in the manner of the relationship (discussed in chapter 1) between *Piranha* (1978) and *Jaws* (1975). *Homicidal* doesn't merely mimic *Psycho*'s signature elements, but it greatly exaggerates them. Many of the film's excessive elements simply foreground the violence that made *Psycho* famous. Rather than waiting for nearly forty-five minutes for a murder, *Homicidal*'s first kill occurs fairly soon. While *Psycho*'s Detective Arbogast (Martin Balsam) falls down a staircase after being stabbed, *Homicidal*'s invalid Helga (Eugenie Leontovich) is decapitated in her wheelchair, and her head rolls off and tumbles down the stairs. Hitchcock

famously marketed *Psycho* by insisting that nobody could enter the theater once the film had started, and Castle gave *Homicidal* a "fright break" during which frightened viewers could leave. All these moments call attention to *Psycho*'s influence even as they playfully differentiate *Homicidal*.

Homicidal's parody is most interesting when it explores gender roles. Here Castle's exaggeration often takes on a decidedly queer element that may move the film into the realm of camp. The prologue foregrounds this aspect. *Homicidal* opens with a William Castle introduction in which the director sits before a fireplace doing needle work and speaking directly to the audience. Castle explains that the current film is about a "lovable group of people who just happen to be *homicidal*." Upon his pronouncement of the last word, Castle flips over his needlepoint to reveal the word HOMICIDAL embroidered upon it. The borders around the word are decorated with various designs, most noticeably handguns and knives dripping blood. The opening immediately calls attention to the film's playful attitude toward gender. First, there is the image of Castle himself engaging in the typically feminine activity of needle point. Second, the needlepoint itself is a camp object. The design of the stitched embroidery is coded as feminine, but the word *homicidal* and especially the phallic weapons surrounding it all have masculine connotations. Castle thus blurs the boundaries of gender before the film even starts.

The gender play continues in the next scene, in which the camera pans across a large bedroom. On one side are a series of masculine signifiers that would be expected in a young boy's room (toy trains, sports equipment), and on the other side, we see dolls and a young girl having a pretend tea party. A boy walks across and steals the girl's doll, and the girl yells, "No, Warren!" Upon a second viewing, we understand that "Warren" is biologically female but that their mother is raising the child as a boy in order to please the father, who would only make the family fortune available to a male heir. In this light, when "Warren" steals their sister's doll, they are merely trying to follow the gender role with which they identify. As a child, Warren crosses over to the other side of the room to steal the doll; as an adult, Warren "crosses over" gender lines again through the persona of Emily, who hunts down and kills those who were complicit in forcing her to become Warren. The knowledge that Emily and Warren are the same person also explains other moments in the film, such as when Emily sneaks into Miriam's room to steal the doll again or when Emily smashes various wedding paraphernalia in her sister's flower shop. The action shows a marked disdain for the signifiers of traditional gender boundaries.

The convoluted scenario of Emily and Warren underscores the parodic attitude toward *Psycho*. First, *Homicidal* inverts *Psycho*'s plot twist. Norman Bates is a biological man who dons the clothing and personality of a woman to perform murders. Emily/Warren, on the other hand, is biologically female, and it is as a female that they commit murder. Second, Hitchcock strategically withholds a full view of Norman's "mother" until the final reveal, in which he simply looks like a man wearing a wig and dress. In contrast, *Homicidal* shows both Emily and Warren in full view multiple times throughout the film. This is a risky decision that requires confidence that both the makeup and Joan Marshall's performance will be good enough to keep viewers from guessing the twist. Judging from other critics and most audience reviews on websites like Letterboxd, this gambit mostly pays off, and Emily and Warren read as two distinct characters. Nevertheless, Warren's appearance in the film seems, for lack of a better word, *off*. Warren is often presented as a force of stability and voice of reason, but "his" features are so different from the square-jawed men that Hollywood has trained viewers to associate with stability and reason that each scene "he" is in has a disconcerting quality. Decades before Judith Butler wrote *Gender Trouble*, Castle thus presents gender as a performance. Once we are aware of the twist, Joan Marshall's portrayal of Warren becomes an example of performative camp.

This camp performance opens up other possibilities for understanding the film's critique of rigid gender roles. We can certainly read Emily/Warren as a trans-coded monster whose violence is linked to gender nonconformity. It is equally possible, however, to read them as a victim of patriarchal control and forced gender conformity. Emily/Warren's story is not truly transgender, as they are forced to adhere to a gender role other than the one assigned at birth, but the scenario nonetheless suggests psychological damage can be done when an individual is forced to adhere to a gender with which they do not identify. This becomes clear in a scene where Warren complains to his sister about how their father abused Warren to toughen "him" up and even paid other boys to pick fights with "him." As Peter Marra points out, the scene resonates with the "personal experiences of femmes, trans women, and transfeminine people, feeling socially pressured to accomplish a correct and socially recognizable masculinity."[44] The comment underscores how *Homicidal* can be read not only as another example of Hollywood transphobia but also as a sympathetic representation of trans struggles in an era in which trans representation was virtually nonexistent.

The cult slasher *Sleepaway Camp* has several similarities with *Homicidal*. Both films exist in the shadow of earlier and more influential horror

films. For *Sleepaway Camp*, the obvious influence is the *Friday the 13th* franchise, which had already seen three entries by the time of its release. Similar to *Homicidal*'s relationship to *Psycho*, *Sleepaway Camp* simultaneously mimics and parodies many elements of *Friday the 13th*, particularly a series of grisly murders, often filmed from a first-person camera, in a summer campground setting. More important, *Sleepaway Camp* shares with *Homicidal* the sudden reveal, in the final moments, of a trans-coded killer. As in *Homicidal*, this killer was forced to adhere to a gender other than the one assigned at birth. Upon its release, the film was lumped in with the other numerous slashers. More recently, however, it has received renewed attention, particularly from transgender critics. Some of these, like Willow Maclay, understandably see *Sleepaway Camp* as a film "that works only to make a woman with a penis a vessel for horror."[45] Others, however, have reclaimed the film. Harmony M. Colangelo, for example, argues that it is "one of the most gender affirming films ever released."[46] The polarized reactions underscore both the contradictory ideology of the film and how interpretation of this sort of material will always be somewhat subjective. *Sleepaway Camp* is surely transphobic in a number of ways, but there are many aspects of it—like the possibly punning title—that simultaneously invite a camp interpretation.

The film is about teenage cousins Angela (Felissa Rose) and Ricky (Jonathan Tiersten) who attend summer camp together. A prologue shows Angela's father and, we are led to believe, her brother dying in a boating accident years before. At the camp, Angela is quite shy, and various campers bully and abuse her. In slasher fashion, the bullies are killed off one by one. Angela also has a love interest in Ricky's friend Paul (Christopher Collett), but when they begin kissing, it triggers a memory of Angela seeing her father and his male friend in bed together. In the climax, we learn that Angela is the killer, and the final moments reveal, in another flashback, that *Angela* was actually killed in the boating accident but that her Aunt Martha (Desiree Gould) decided to raise Angela's brother Peter as female because she had "always wanted a little girl." The infamous last shot shows that Angela/Peter has beheaded Paul, and the camera pulls back to reveal the killer's nude body. The camp counselors gasp at the sight of Angela's penis. Angela lets out an animalistic howl, and the credits roll over a freeze-frame of their face.

It's not an easy film to parse. The final image of a killer female with a penis is clearly designed to shock the audience and feels unambiguously transphobic. The rest of the film, however, is not as clear-cut. Alice Collins argues that Angela's shy and nervous demeanor is "accurate . . . to the lived

experience of so many trans women I know, myself included."[47] Indeed, throughout most of the film, Angela is the most sympathetic character, presented as the primary point of identification. If this were a *Friday the 13th* film, Angela would be the masculinized final girl who battles the feminized monster. Instead, as Chris McGee points out, "there is no killer and heroine who do battle, only Angela, who stands in for both."[48] Through Angela, then, *Sleepaway Camp* makes explicit the gender-bending subtext of the slasher subgenre. Angela's character also underscores the film's challenge to audience expectations of how slashers operate. In other words, *Sleepaway Camp* appears to have the primary elements of an early 1980s slasher, but it refuses to follow the rules.

In addition to its conflation of killer and final girl, *Sleepaway Camp*'s overall representation of gender contributes to its queer parody. Like many of the other texts discussed in this chapter, the film treats heteronormativity as a joke and shows a distrust of authority figures. The camp chef is a pedophile, and the owner—a man in his fifties—is having an affair with one of the teenage counselors. Both thus present cisgender men as sexually aberrant. Many of the campers, male and female, perform an exaggerated version of gender roles. This is particularly true of Angela's primary bully, Judy (Karen Fields), who is a stereotypical "mean girl" that attempts to seduce Paul when he shows an interest in Angela. As one would expect from a slasher movie set at a summer camp, teenage bodies are often sexualized and put on display. *Sleepaway Camp* is remarkable, though, in that it focuses more heavily on male bodies, often showing muscular teenage boys wearing cutoffs and midriff-baring shirts. There is even a scene where an entire group of boys strips naked as a group of fully dressed girls watch in amusement. The gender reversal underscores *Sleepaway Camp*'s queer parody of films like *Friday the 13th*.

The most overt camp figure in *Sleepaway Camp* is undoubtedly Aunt Martha, who appears in the opening and closing scenes. Thomas M. Sipos points out that Gould's performance is "broadly overplayed to the point of caricature."[49] This is certainly true, but "caricature" doesn't really capture how bizarre the performance really is. In her first appearance, she wears red lipstick, a pussy-bow blouse, and a blue-and-red beret. The outfit causes her to stand out from the rest of the film's characters. Aunt Martha enthusiastically tells Ricky and Angela, "Look what I did. I packed you and your cousin some goodies for the ride up to camp. Wasn't that nice of me? Hmmm?" In addition to this affected dialogue, she occasionally stops and speaks to herself. At the end of the film, Aunt Martha appears again in the flashback that reveals her intent to raise Peter as a girl. In both

scenes, Aunt Martha exudes a highly exaggerated and performative version of traditional femininity. It feels explicitly like a camp drag show performance. This performance underscores Aunt Martha's apparent belief that Peter/Angela should be able to easily change their gender identity on a whim. By bookending the film's primary narrative with the two bizarre Aunt Martha scenes, the film uses the idea of exaggerated gender performance as both a framing device and a narrative catalyst.

Conclusion

With its mostly female victims, male scientists and experts, and feminized monsters, horror frequently operates along traditional gender lines. It often marginalizes or punishes those who do not adhere to the dominant binary logic of gender and sexuality, and it often participates in the sexual objectification of women and the demonization of queer individuals. Alongside this conservative story of horror, however, there is another narrative where gender, like the genre itself, is a space for play. Like the conservative strain, this gender play has been present since the genre's cinematic origins, and James Whale—arguably American horror's first auteur—laid the groundwork for a camp sensibility that has only become more pronounced. As a space of queer parody, horror also offers queer viewers relatable characters and narratives that dismantle the blindly heteronormative ideology that runs through most mass media. We see horror's embrace by queer audiences in midnight screenings of *Rocky Horror Picture Show*, in a series like *The Boulet Brothers' Dragula*, and in the iconic status of a "queer male diva" like Vincent Price. We also see it in the current cult status of various queer horror films like *The Old Dark House*, *Sleepaway Camp*, *Seed of Chucky*, and *Jennifer's Body*. In the vast majority of these texts, representations of gender and sexuality are far from perfect. However, through their willingness to mock traditional gender roles, they serve as a counterpoint for much of popular culture and generate quite a bit of humor along the way.

CHAPTER 5

Cringes and Creeps

Exploring Awkward Horror

AS PART OF the promotional materials for *Get Out* (2017), College-Humor released a short video entitled "Awkward at Parties Horror Movie," featuring *Get Out* stars Allison Williams and Lil Rel Howery. The video is a trailer for a fake movie entitled *Bad at Parties* and shows Williams attending a surprise party and committing a series of awkward faux pas that make the experience uncomfortable: she clogs the toilet, regifts a present, mistakes a man with long hair for a little girl, forgets she has met someone before, and ruins the surprise for the guest of honor. Throughout, the video uses devices most commonly associated with

IMAGE 6: *Psycho* (1960). Courtesy of Photofest.

135

contemporary horror: foreboding music, rapid cuts, strobing lights, and so on. At one point, a woman ominously whispers, "You're not supposed to be here," in Allison's ear. All these devices comically transform the awkward and mundane party into a horror text.

The video operates as horror parody and generates humor by juxtaposing horror techniques with a mode of humor that is commonly referred to as *awkward humor* or *cringe comedy*. This strain of humor is exemplified in television series or films like *Curb Your Enthusiasm* (2000–), *The 40-Year-Old Virgin* (2005), *The Office* (2005–2013), and the *Borat* films (2006 and 2020). Jason Middleton associates awkward humor specifically with contemporary documentary and mockumentary formats and describes it as arising out of "moments when an encounter feels *too* real" or when "an established mode of representation or reception is unexpectedly challenged, stalled, altered."[1] "Awkward at Parties" is not a documentary, but it does track Allison through a series of uncomfortable encounters that may disrupt our notions of how to act in social situations or that feel "too real." The juxtaposition of awkward humor with horror devices, however, also taps into a notion with which many would likely agree: uncomfortable social situations can *feel* horrifying.

While awkward humor is most common in comic formats like television sitcoms and mockumentaries, it is also used in a surprising number of horror films. In fact, as I discuss later in this chapter, *Get Out* (the horror film that "Awkward at Parties" was advertising) uses awkward humor to great effect, but it is by no means an isolated example. This chapter explores the role of awkward humor in American horror. After first discussing the horrific potential of awkward humor within comedy, I trace the ways in which awkwardness has long operated within horror. The final section looks at the role of awkward humor in recent films that blend representational strategies from mockumentary comedies and found footage horror films.

Horror's awkward humor sheds light on anxieties about cultural differences or the disruption of social norms. In his social theory of horror, Stephen Prince points out that horror texts often operate "by dramatizing the tenuousness of the human world."[2] Indeed, horror often shows the breakdown of social rules and guidelines; zombie and apocalypse texts literally tell the story of society collapsing, and other horror texts—the *Purge* franchise comes to mind—posit scenarios in which characters are completely cut off from the perceived safety of civilization. Even small-scale horror films, in which society remains intact, find ways of disconnecting protagonists from the world in order to force them to face the

monster's threat alone. Cell service will be down, phone lines will be cut, and cars will not start. There is an entire subgenre of "backwoods" horror films, which find protagonists far from their own sense of social safety. The final act of numerous horror texts seems to take place in a nightmarish, Hobbesian state of nature in which the only goal is survival. If we accept the commonplace assertion that horror reflects and projects society's fears,[3] then the loss of civilization's safety net is one of the biggest fears out there (even if, on another level, we actually enjoy seeing society collapse).

Before the monstrous threat of a horror work fully emerges, and before social norms completely break down, many texts use uncomfortable social situations to prefigure the violent physical violations that occur later. In *The Exorcist* (1973), for example, the possessed Regan first displays aberrant behavior when she interrupts her mother's party to tell an astronaut that he will die in space and then urinates on the rug. The party is subsumed in awkward silence. The entire plots of films like *Rosemary's Baby* (1968) and *The Stepford Wives* (1975) deal with protagonists who see increasingly odd behavior in their social milieu and suspect that something is wrong. However, their own fear of offending people causes them to ignore odd behavior until it is too late. Not all horror's awkward tension is humorous, but there is a comic strain in many films that use this device, and the humor quite often contributes to a mixture of tones that can be quite unsettling for viewers. The humor is there, but rather than working as comic relief, it adds to those devices that induce fear.

The Horror of Cringe Comedy

Awkward humor / cringe comedy has more in common with horror than most comic modes. As the word *cringe* suggests, it seeks not only to prompt laughter but also to create feelings of dread or discomfort in audiences. These same feelings, of course, are often encouraged by horror texts. Since awkward humor occurs most often when social norms are violated or when a character is deeply embarrassed, feelings of uneasiness tend to be generated by audience identification with the embarrassed subject or by an empathetic reaction to the awkward situation. The *humor* part of awkward humor, on the other hand, is created through a distanced reaction to the awkward or embarrassing situation and, as Middleton points out, can be explained most easily through the superiority or incongruity theories of humor.[4] Like slapstick, awkwardness can create feelings of superiority in audiences and generate derisive laughter. Awkward humor is also

incongruous in that it works against expectations about how social interactions typically operate. Successful cringe comedy manages to strike an appropriate balance between humor and uneasiness and thus allows audiences to laugh even as they feel a measure of discomfort.

This balance, however, is not universal, and some viewers might turn away in distress from the same thing that makes others laugh appreciably. As an illustration of the ways that awkward humor can potentially slide into horror, I consider a polarizing episode, entitled "Scott's Tots," of the popular sitcom *The Office*. *The Office* frequently engages in awkward humor, particularly in episodes focusing on the socially inept and inappropriate manager Michael Scott (Steve Carrell). In "Scott's Tots," from season six, we learn that Michael had ten years earlier promised to pay the college tuition for a group of underprivileged third graders. The students are now primed to graduate high school, and the episode details Michael having to tell the eager teens that he does not have the money to keep his promise. Michael's confession does not occur until after halfway through the episode, and the time until then is an uncomfortable buildup to the inevitable cringe-inducing moment. The high schoolers wear custom shirts reading "Scott's Tots," the school has named a room after him, and there is even a performance in which the children sing about Michael making their "dreams come true." Throughout, the camera frequently cuts to Michael's pained smile to remind us that he will severely disappoint the teenagers.

Since its original airing, "Scott's Tots" has become one of the series' most notorious episodes, and several *Office* fans have reportedly said that it made them so uncomfortable that they will never watch it again.[5] Even more interesting is the language that reviewers use to describe "Scott's Tots." Kayla Cobb notes that the episode tests "the limits of cringe comedy," and Dan Phillips says that "if it weren't so damn funny, it might have actually been too excruciatingly painful to watch."[6] Adam Chitwood says, "The whole episode kind of plays out like a horror movie" and compares it to a "*Saw*-like torture device."[7] These responses illustrate both the subjectivity of humor and, more importantly, how humorous devices can create feelings of discomfort and unease that are more typically associated with horror. For some viewers, the "cringeyness" went so far that the episode ceased to operate as comedy and became something closer to horror.

The Office is full of awkward and embarrassing situations, but there are some reasons why this particular episode strikes such a chord. One explanation is the sustained attention and buildup that this awkward situation receives. *The Office* is an awkward show, but it is still a traditional sitcom, with some relatable characters, love stories, and recurring jokes. The

awkwardness is generally only one part of all this. In "Scott's Tots," however, the creators do not allow viewers much relief. Another reason has to do with point of view. Typically, when a situation on *The Office* is especially awkward, the camera cuts to the face of a more relatable and socially savvy character, usually either Jim (John Krasinski) or Pam (Jenna Fischer), and that character looks upon Michael's awkward hijinks with an amused or confused expression. This provides audiences a filter through which to watch the awkwardness unfold, which in turn may help to create the distance necessary for audiences to laugh. "Scott's Tots," however, allows no such distance, as the primary point of identification is Michael. Furthermore, the stakes are quite a bit higher in "Scott's Tots" than in most awkward humor. Audiences are not watching a character's passing discomfort or a single moment of embarrassment but are rather the awkward witness to a moment in which a man will crush the dreams of a group of children. Finally, there is a racial component to the scenario; Michael is White, and the majority of the teenagers and their teacher are Black. In this context, Michael emerges not only as an individual who didn't follow through but also as the representative of a racist system that consistently makes false promises to marginalized communities. Once the awkwardness passes for these characters, the effects of Michael's lie will live on for years. This knowledge may preclude laughter for many viewers.

As we have seen in previous chapters, devices of comedy can often be modified to generate horror as well as laughter. Unlike slapstick or "grossout" comedy, however, awkward humor is unique in that it can generate feelings of dread and discomfort without any accompanying physical threat. While there is plenty of "psychological horror," the vast majority of those texts ultimately involve physical violence in some form. The threat in "Scott's Tots," on the other hand, is purely emotional and social. Embarrassment, shame, and disappointment drive the cringe reaction; this ultimately reflects our anxiety as *social* creatures. "Scott's Tots" would never—and should never—actually be placed within the horror genre, but it reveals the manner in which the devices of awkward humor can be potentially horrifying. In horror texts, the comic violation of social norms anticipates a more menacing threat and often foreshadows the total breakdown of any social guidelines.

Awkward Humor in Early Horror Cinema

Awkward humor is more common in recent comic texts than it had been in the past. This is also true for the use of awkward humor in horror. There

are, however, some early films that demonstrate how anxiety over social interactions can lay the groundwork for more material horrors. One such example comes in James Whale's *The Old Dark House* (1932), which, as we saw in the previous chapter, opens with a scene of a married couple bickering in the car while their friend listens from the backseat. The awkwardness only continues when this trio arrives at the Femm house. The mute/brute butler Morgan; the prudish, deaf Rebecca Femm; and the nervous, effeminate Horace Femm all combine to create an awkwardly unwelcoming environment for the waterlogged travelers. In fact, when the travelers first arrive, Horace immediately admits that the situation is "very awkward." Many of the best camp moments discussed in the previous chapter can also be read through the lens of awkwardness—particularly Rebecca's simultaneously prudish and queer obsession with Margaret's body—and I will not repeat them all here. However, it is worth noting that the forced heterosexual love story between Penderel and Gladys creates a decidedly awkward moment when the two lovers break the news of their newfound love to Gladys's rich, platonic suitor Porterhouse. Depending on one's perspective, it either increases or deflates the awkwardness when Porterhouse agrees to attend the wedding. In any case, for contemporary viewers, the film's process of forcing a heteronormative love story into an otherwise queer film feels quite awkward indeed.

Another early example comes in the atmospheric Val Lewton–produced *I Walked with a Zombie* (1943). In an early scene, nurse Betsy Connell (Frances Dee) sits in an outdoor café with Wesley Rand (James Ellison) on the Caribbean island of San Sebastian. Betsy, a Canadian, was hired and brought to the island by Wesley's half brother Paul Holland (Tom Conway) to care for Paul's catatonic wife (the titular zombie). As Betsy and Wesley make polite conversation, and as Wesley steadily gets drunk, they are interrupted by the song of a local calypso singer, played by real singer Sir Lancelot. The song, the original version of "Shame and Scandal in the Family," is openly about the film's characters and relates a love triangle in the Holland household: "The Holland man he kept in a tower / a wife as pretty as a big white flower. / She saw the brother, and she stole his heart / and that's how the badness and the trouble start." When the song begins, Wesley tries to talk over the music. Betsy listens, however, and once she understands the content, the mood becomes markedly tense. When the Calypso singer realizes Wesley is present, he stops singing and apologizes. Later, after Wesley has passed out drunk and the café has emptied, the singer returns to finish his song, including some lines that he apparently wrote on the spot for Betsy's benefit: "The brothers

are lonely, and the nurse is young / and now you must see that my song is sung."

The song displays how the scandals in the Holland household have become part of the local lore, and it is a clever way of providing exposition. In the context of the scene itself, however, it generates a curious mix of humor and tension. Following Middleton's definition of awkward humor, the song unexpectedly alters the context of Betsy and Wesley's dinner. Betsy becomes suddenly privy to a family scandal, and Wesley has his dirty laundry aired in public. What had been a polite and mildly flirtatious dinner suddenly becomes much more intimate and uncomfortable. The fact that it is a catchy song that creates such public awkwardness only increases the humor. The calypso singer's reappearance to sing a final verse—this time only for Betsy—is quite haunting, but it also pushes the absurd humor of the situation over the top and suggests that poor Betsy may have just found herself embroiled in an ongoing family drama.

Awkward Humor in Modern Horror Cinema

The Old Dark House and *I Walked with a Zombie* are both fairly atypical horror films, and their early use of awkward humor is also unique. Since cringe comedy is a more modern form of humor, it may come as no surprise that it is used to great effect in Alfred Hitchcock's *Psycho* (1960), often cited as the dividing line between classical and modern horror. As has been mentioned, Hitchcock himself maintained, without much elaboration, that the "content" of *Psycho* was "a big joke,"[8] and critics have noted the director's frequent mingling of suspense and humor.[9] James Naremore, noting that *Psycho* kills off its apparent protagonist and then forces audiences to identify with a murderer, asserts that the film's "entire mechanism of suspense, surprise and bloody horror is structured like a practical joke."[10] In addition to these larger games with structure and point of view, however, *Psycho* also presents several small moments of uncomfortable social interaction, many of which have a comic element. Most of these comic interactions occur before the famed shower scene and foreshadow its violent disruption of narrative and life. Christopher Sharrett notes that after *Psycho* and Hitchcock's other horror film, *The Birds* (1963), horror "has become heavily involved in asking questions about the fundamental validity of the American civilizing process."[11] It is thus appropriate that as part of this exploration of civilization, Hitchcock and other modern horror artists frequently rely on awkward and uncomfortable social situations to establish their world.

As I am sure most readers are aware, the first forty-five minutes of *Psycho* detail Marion Crane's (Janet Leigh) decision to steal forty thousand dollars. This narrative is violently disrupted once Marion stops at the Bates Motel and is murdered by the psychotic Norman Bates (Anthony Perkins), who takes on the personality of his dead mother. Until the murder occurs, the film establishes tension primarily through Marion's social interactions and through Bernard Herrmann's classic score. As soon as Marion steals the money, she begins having unnerving social encounters. The first occurs when she is in her car, and her boss and his client (from whom she is stealing the money) cross in front of her. Marion and her boss make brief, uncomfortable eye contact. The next awkward encounter comes when Marion has stopped to sleep on the side of the highway and is awakened by a police officer. Marion is clearly nervous, and when the officer asks if something is wrong, she replies, "Of course not. Am I acting as if something is wrong?" The officer says, "Frankly, yes." I would hesitate to call this exchange comic, but there is subtle humor here in its acknowledgment of just how bad Marion is at being a criminal. If, as the first chunk of the film suggests, *Psycho* had really turned out to be some sort of heist narrative, then it would have to be one about a bumbling criminal. Furthermore, when viewed in conjunction with Marion's earlier encounter with her boss, the scene with the policeman establishes a pattern of Marion having unnerving social encounters with men.

This pattern continues when Marion trades in her car. This scene *is* explicitly comic in a number of ways. Ostensibly, Marion replaces her car to make it harder for her, and the stolen money, to be tracked. During the entire car-purchasing scene, however, the same police officer whom she had encountered earlier watches from across the street. Marion sees him, and the police officer sees her see him, but she goes ahead with the exchange and even pays seven hundred dollars in stolen cash. All this looks quite suspicious, and only solidifies the notion that Marion is a poor criminal. Marion's gender, of course, only adds to her visibility. The policeman's eyes are hidden behind sunglasses, but Marion—an attractive woman with a purse load of cash sleeping on the side of the road and trading in her car on a whim—is hypervisible not only in her suspicious behavior but through that behavior's incongruity with traditional late 1950s / early 1960s gender roles. Her efforts to cover her tracks, ironically, only result in her being seen more.

Marion's interactions with the used car salesman (John Anderson) give us the film's first sustained example of awkward humor. California Charlie is a stereotypically performative car salesman who rapidly spews

canned jokes and one-liners. Marion displays zero patience for Charlie's obnoxious spiel; she interrupts him midsentence, refuses to laugh at his jokes, and declines his offer of coffee. The scene's humor is thus driven by Charlie's attempts to maintain the veneer of the smooth-talking salesman persona in the face of Marion's odd behavior. When Marion immediately agrees to Charlie's presumably overpriced offer, his facial expression shows his confidence starting to falter, and he asks Marion if she can prove the car is hers. The encounter generates humor primarily because of the incongruity between Charlie's and Marion's different approaches to the transaction. Charlie follows a script for how a car sale is supposed to go, and we can tell he has said his "lines" thousands of times. Marion, in contrast, refuses to play the role that Charlie has in mind for her. The audience, of course, understands Marion's behavior and is free to laugh at both Charlie's discomfort and the awkwardness of the situation. The funniest part for me is when Marion looks over her shoulder at the police officer and then Charlie looks over *his* shoulder at Marion looking at the police officer. Character actor John Anderson perfectly understood the role he was playing, and the uncomfortable look on Charlie's face drives the awkwardness of the situation.

Once again, gender is important to the scenario, and Charlie calls attention to this when he tells Marion, "You can do anything you have a mind to. Being a woman, you will." The attempt at a joke displays that Charlie thinks he "understands women," but Marion upsets his understanding, and there is little doubt that Charlie's discomfort is exacerbated by Marion's departure from feminine behavior. This is made clearer at the scene's ending. As Marion hurriedly attempts to drive her new car off the lot, the mechanic stops her because she has forgotten her suitcase and coat. By this point, the police officer has made his way over. After Marion finally drives off, the camera lingers at the lot, and we see mechanic, salesman, and police officer, all in a row, watching her leave. All three men appear confused. After the awkwardness of the scene, the image of the three puzzled men feels like a punchline that reinforces the gendered component of the preceding encounters.

All this sets up the sequence at the Bates Motel, in which Marion and Norman Bates's interactions both continue and subvert the awkwardness we have already seen. At first, Marion and Norman's encounters generate humor primarily through Norman's stammering shyness and awkward chivalry. When he shows her to her room, he gestures nervously at the bathroom and says, "The, uh, over there." Marion supplies the missing word: "the bathroom." Even if we already know that Norman will kill

Marion in the bathroom, his awkward nervousness is endearing, and his inability to even utter the word "bathroom" makes him seem harmless. Our main character of identification at this point is Marion, and she seems genuinely charmed by Norman's awkwardness. She smiles when she says "bathroom" for him and, a moment later, laughs outright at his shyness. It is worth noting how different this initial meeting is compared to Marion's earlier encounters with the police officer and the car salesman. Once again, Marion has an awkward encounter with a man, but this time she exudes confidence, and the man is outwardly nervous. While Marion was on guard with the salesman and police officer, she is at ease with Norman. Marion's appearance and gender, however, are still of the utmost importance. Norman is immediately attracted to Marion, and this is why he places her in cabin one, where he can watch her from his secret hole behind the painting. As with the police officer, Marion's visibility is paramount. Norman's inability to reference the bathroom in Marion's presence is also likely due to her being an attractive woman. Marion picks up on most of this but seems to find it cute rather than threatening. The irony, and perhaps part of the film's "big joke," is that Norman is a much greater threat than any of the other male figures with whom she had earlier been so nervous.

The awkwardness between Marion and Norman becomes more pronounced and menacing once Norman's family life is introduced. We see this first when Marion overhears Norman and his "mother" arguing. Mrs. Bates—or Norman's projection of her—is comically prudish in her pronouncement that Norman is "bringing cheap young girls in for supper . . . in the cheap, erotic fashion of young men with cheap, erotic minds." Upon hearing Mrs. Bates's hyperbolic and repetitive speech, Marion moves around the hotel room uncomfortably. Like Betsy in *I Walked with a Zombie*, Marion suddenly finds herself in the middle of an intimate family drama, and the subsequent dinner scene is filled with this tension. Norman is first visibly troubled by the prospect of eating supper in Marion's room (perhaps because of the proximity to the bed?) and instead leads her into the parlor of the hotel's office, which is full of creepy stuffed birds. Then despite the fact that he invited Marion to have supper *with* him, he declines to eat and instead watches as Marion consumes the odd, childlike meal, which appears to consist mostly of sliced bread and milk. These small details highlight Norman's lack of experience entertaining guests, let alone women. Once again, Marion is merely amused by Norman's awkward behavior and only displays discomfort when Norman gets angry at her suggestion that he put his mother "somewhere." This

moment also alerts viewers to the danger at the Bates Motel, as ominous music swells when Norman lashes out at Marion's suggestion. The scene slides from awkward to menacing.

The above examples show how Norman's social ineptitude masks his monstrosity and potential for violence. Viewers who are aware of the twists will find even more humor in the scene. Over the course of the conversation, for example, Norman says such famous lines as "[Mother] isn't herself today" and "A boy's best friend is his mother." He says that his mother is "as harmless as one those stuffed birds" and, perhaps Norman's most famous line, "We all go a little mad sometimes." Each of these lines functions as a macabre joke for viewers who are aware that Norman *is* the voice of the angry mother that Marion overheard and that his real mother is in fact dead and has been preserved like "one of those stuffed birds." The dialogue gives the scene a darkly comic double meaning and mixes with the awkwardness and menace to both continue Marion's day of fraught social interactions and set up her brutal murder. On the one hand, Marion's murder takes *Psycho* in a brand new direction and reveals that the stolen money was only a distraction; on the other hand, Marion's series of comic and unnerving encounters with men establishes her hypervisibility—which reaches its apex when Norman spies on her—and foreshadows her death.

Psycho's influence on horror is immense. It laid the groundwork for the slasher subgenre, and it ushered in the secular, human monster, whose acts of violence are explained through psychoanalysis. The film also brought horror closer to home and rooted it within the dysfunctional American family. As we saw in the previous chapter, *Psycho* also established a template for numerous trans or gender-bending monsters. We can perhaps add to this list that *Psycho* began a trend of using awkward and unnerving social interactions to build tension, generate humor, and foreshadow the violent breakdown of social guidelines. Some texts, like *Rosemary's Baby*, use social tension to fill nearly the entire narrative before the true threat is revealed. More often, though, post-*Psycho* horror texts, particularly during the slasher wave, have a higher kill count and an extended final act. Therefore, the early and awkward social encounters happen more quickly and are more foreboding, even as they are often outrageously comic.

A case in point is the original *Texas Chain Saw Massacre* (1974), which, as Sharrett asserts, addresses "many of the issues of Hitchcock's film while refusing comforting closure."[12] Unlike *Psycho*, *TCM* has no plot twists. First-time viewers will likely not anticipate how weird the movie ultimately gets, but the opening narration plainly states that all or most of the protagonists will be murdered, and the first image of a bizarre corpse

sculpture—described by a radio newscaster as a "grisly work of art"—give audiences a good sense of director Tobe Hooper's grotesque aesthetic. Like *Psycho*, however, *TCM* is loosely based on the Wisconsin serial killer Ed Gein, features shocking kill scenes, and displays a darkly comic sensibility. Also like *Psycho*, it uses unsettling and awkward social humor to establish tension and foreshadow brutal violence.

We see this sort of awkward humor first in the introduction of the film's protagonists/victims. The group—made up of Sally Hardesty (Marilyn Burns); her brother, Franklin (Paul A. Partain); and her friends Pam (Teri McMinn), Jerry (Allen Danziger), and Kirk (William Vail)—is on a road trip to make sure that the grave of Sally and Franklin's grandfather has not been vandalized. Franklin, disabled and confined to a wheelchair, is the "fifth wheel" of this ensemble, and the rest of the group seems to see his presence as a burden. This dynamic is clear in the first real scene when Franklin, seated in his wheelchair, attempts to urinate in a coffee can while the other four, framed in the background, awkwardly wait. Later, Franklin annoys the group by complaining about the heat and repeatedly discussing the ways in which cattle can be killed in a slaughterhouse. Franklin's whining and yelling register as simultaneously comic and annoying, and even though the only blood relatives are Franklin and Sally, Franklin's presence gives the group something of a dysfunctional family dynamic. This awkward opening recalls the beginning of *The Old Dark House* and anticipates Wes Craven's *The Hills Have Eyes* (1977). In all three films—and numerous others—the family that we meet in the beginning serves as both mirror and foil for the other, twisted family that they eventually encounter.

Prior to their fatal run-in with Leatherface (Gunnar Hansen), the group has various comic and unsettling encounters, including a stop at a gas station with no gas. The most prolonged and significant of these occurs when they pick up an insane hitchhiker (Edwin Neal), who is part of the same killer family as Leatherface and the proprietor of the gas station. When Franklin learns that Hitchhiker's family all used to work at the local slaughterhouse, he remarks, in a bit of comically gruesome foreshadowing, that Hitchhiker belongs to "a whole family of Draculas." Neal plays Hitchhiker with a manic intensity, and the ensuing scene has a grotesque, comic sensibility as the group attempts to remain polite despite Hitchhiker's erratic behavior. Joining the group's earlier conversation about how best to slaughter cattle, Hitchhiker tells them that cows "died better" when killed with a sledgehammer as opposed to the more modern air gun. He proudly shows them polaroid pictures of butchered cows, which

he apparently carries around with him, and gives a gruesome lesson on how head cheese is prepared: "They take the head and boil it . . . scrape all the flesh away from the bone . . . they use the jowls, the muscles, and the eyes, the ligaments and everything . . . they boil it down to a big jelly of fat." The emphasis on meat preparation prefigures the slaughter to come and establishes a connection between Hitchhiker and Franklin. The others simply show forced smiles.

It is soon apparent that Hitchhiker is not just strange but actually dangerous. He borrows Franklin's knife and cuts his own hand open. He then proudly displays his *own* knife. "It's a good knife," he beams. Kirk awkwardly replies, "I'm sure it is, man." After this weird exchange, Hitchhiker asks the group to drive him to his house and invites them to stay for dinner: "You like head cheese? My brother makes it real good." As with many of Norman Bates's zingers, the line takes on an additional meaning for viewers who have already seen the film. This head cheese is likely made from humans. The group, at this point sharing pained glances, declines the dinner invitation. Hitchhiker then demands two dollars for a picture he has taken of Franklin ("It's a nice picture!"). When they refuse to pay, Hitchhiker suddenly lights the picture on fire and slices Franklin's arm. The group expels Hitchhiker, and as they drive away, he sticks his tongue out and marks the side of their van with his own blood.

The scene is disturbing and uncomfortable, but it is also quite humorous, and Hitchhiker is a fundamentally comic character. He apparently carries around with him not only a knife, a camera, and pictures of slaughtered cows, but when he lights Franklin's photograph on fire, he produces a long piece of tin foil, a match, and some gunpowder. Like a demented Harpo Marx, Hitchhiker's pockets and knapsack seem to be brimming with odd and unexpected paraphernalia. When we add to this his strong opinions on slaughterhouse practices, his excitement over head cheese, and the casual manner with which he slices his own hand, Hitchhiker emerges as a character that simply does not adhere to normal categories of human behavior. The humor of the scene is not driven so much by Hitchhiker's antics as it is by the group's reaction to him. Unlike the obnoxious, sex-crazed, or bullying teens that tend to populate later slashers, this group is friendly and good-natured. They pick up Hitchhiker in the first place because they are afraid he will "asphyxiate" in the heat, and once he displays his insanity, they attempt to remain polite. There is humor in their pained smiles and awkward nods as he regales them about head cheese and knives. Hitchhiker, for his part, has his own code of social decorum; he appears genuinely hurt when they refuse to buy his

photograph and decline his dinner invitation. The scene thus presents two clashing perspectives on social propriety and generates both discomfort and humor through their awkward, incongruous juxtaposition.

As in *Psycho*, this pained encounter sets the terms for the bloodshed that follows, and even that massacre is rooted in clashing ideas of hospitality and social norms. Leatherface does not initially go hunting for victims. Rather, in a comically repetitive fashion, Kirk, Pam, and Jerry each simply walk into his house uninvited. In each successive case, Leatherface appears and brutally dispatches the trespasser.[13] The fact that the victims seem to think nothing of opening the door and walking into someone else's house evinces both their secure sense of privilege and their naïveté. Leatherface, for his part, is visibly troubled by the intruders. After killing Jerry—the third in a row that afternoon—there is an interesting moment where a squealing Leatherface paces nervously around the house, looks out the window, and then sits down and places his head in his hands. There is no dialogue, but Hansen effectively displays Leatherface's thinking: "Why do these people keep coming into my house?" The character's brutality and his grotesque mask of human skin make him seem like a completely inhuman monster, but a moment like this humanizes him and suggests a sense (albeit a twisted one) of social decorum. One has to wonder what would have happened had the group taken up Hitchhiker on his offer to come for dinner. Perhaps if they were presented as guests rather than intruders, Leatherface would have happily served them some of his head cheese rather than turning them into it.

The Awkwardness of Elevated Horror

The use of awkwardness can be found in several other horror films throughout the late twentieth century, and several of the monstrous fools discussed in chapter 2 generate awkward humor. In the twenty-first century, however, horror's emphasis on social interactions has only increased. In fact, the current wave of respectable, critically acclaimed "elevated horror"[14] films tends to focus just as much on the uncomfortable nuances of personal relationships as on monsters or physical violence. Films like *The Invitation* (2015), *Hereditary* (2018), and *The Lodge* (2019), for example, all have traditional horror elements but generate their dread more through unflinching portrayals of grief and family drama/trauma than through material threats. Many of those movies are not funny at all or use humor very sparsely. Two films at the forefront of the "elevated horror" wave, however, use awkward humor in quite sophisticated ways. The first is Jordan

Peele's *Get Out* (2017), which has proven to be the most important and influential horror movie of the twenty-first century, and the second is Ari Aster's artsy folk-horror film *Midsommar* (2019). In very different ways, each film weaves together the devices of cringe comedy with those of traditional horror in order to explore both social threats and fraught personal relationships.

Get Out tells the story of a Black man, Chris Washington (Daniel Kaluuya), who goes to spend the weekend with the wealthy, seemingly liberal family of his White girlfriend, Rose Armitage (Allison Williams). As the film progresses, Chris and the audience slowly learn that the Armitages, including Rose, are engaged in a modern-day slave trade in which they steal Black people and implant the brains of rich elderly or sick White people into the "superior" Black bodies. The Black victims live out the rest of their days in "the sunken place," a state of semiconsciousness where they helplessly watch as their bodies are controlled by their new White owners. Before this plot is revealed, Peele crafts a series of comic and awkward social encounters between Chris and the film's White characters. While these encounters work as cringe comedy, they are complicated by a sense of looming dread, as viewers (and eventually Chris) suspect that underneath the awkwardness, there is genuine menace. This dual register is essential to the film's angry critique of American race relations.

The first half of *Get Out*, with the exception of a brief prologue that foregrounds horror elements, is driven by awkward humor. In an early scene, Chris expresses concern about meeting Rose's parents and asks if they know he is Black. Chris is openly skeptical of Rose's claim that her parents are not racist. The next several scenes prove Chris right as Rose's family and their friends barrage him with a series of racialized comments and microaggressions. Rose's father Dean (Bradley Whitford) awkwardly attempts to use Black slang, with phrases like "my man" and "this thang." And in what is perhaps the most often-quoted line in the film, he assures Chris that he "would have voted for Obama a third time." On the surface, these and other comments sound simply like the comic attempts of a socially awkward White man trying to convince his Black guest that he is "woke." The comments become more overtly racialized when Rose's brother, Jeremy (Caleb Landry Jones), shows up. Jeremy drunkenly attempts to wrestle with Chris and assures him that with his body and "genetic makeup," he could be a "beast" if he ever practiced mixed-martial arts. Chris endures this discomfort without comment, only later telling Rose, "I told you so." These scenes foreground awkward

social situations and critique White people as either racially oblivious or insensitive, but only later is it revealed that this awkwardness is a cover for a more malicious and systematized racism.

The next day, the Armitages throw a party, which is actually a front for an auction where the wealthy guests can bid on Chris's body. Here, the racially awkward behavior takes on a different tenor. Whereas Rose's family tended to behave in ways that displayed a racial cluelessness or anxiety, the White guests openly ogle Chris and treat his Blackness as an exotic attraction. An older golf fan name-checks Tiger Woods and asks Chris to display his own golfing stance; another man says plainly that "Black is in fashion"; and a woman, while fondling Chris's arm and looking suggestively at his crotch, asks Rose, "Is it true? Is it better?" The comments all display a fascination with Chris's Blackness and with his body. Chris's discomfort is made clear by frequent cuts to his pained facial expressions. The humor is generated by the gap between acceptable behavior and the increasingly inappropriate remarks of the guests. We regularly find similarly comic and inappropriate behavior on *The Office*. Low and ominous music plays throughout the party scenes, however, infusing the humor with a sense of dread.

Chris also has a series of awkward encounters with seemingly Black characters, who are, unbeknown to Chris, inhabited by White minds. The film thus generates an awkward ethnic humor by having Chris attempt to forge connections with Black people who are actually White. Chris, for example, meets a Black man named Logan (LaKeith Stanfield) and attempts to give him a fist bump, but Logan responds to the gesture of Black solidarity by awkwardly and comically shaking Chris's fist. A few moments later, Chris sees Logan holding his arms in the air and turning around while a group of other White guests looks on appreciatively. Only upon a second viewing does it becomes clear that Logan is showing off his stolen Black body. Chris has these sorts of unnerving encounters with other "Black" characters as well. There is a Black grounds keeper and a Black maid who are actually controlled by the minds of Rose's grandparents. Both characters speak in standardized White English and, like Logan, display an obliviousness to Black identity. At one point, Chris has a conversation with the grounds keeper, Walter (Marcus Henderson), who refers to Rose as a "real dog-gone keeper," and in another scene, the maid, Georgina (Betty Gabriel), assures Chris that there was no "funny business" when she unplugged his cell phone; she also does not initially understand the meaning of the word *snitch* and once she does, her eyes light up, and she proclaims, "Tattletale!"

These weird moments with Black characters register as awkward and humorous because of their incongruity with cultural expectations of how young Black people in America actually speak, dress, and act. This humor is complicated by the context, for the film's prologue and other small moments have by this point established it as a horror narrative. In other contexts, the image of a young Black person saying something corny like "dog-gone keeper" or "funny business" or not knowing how to respond to a proffered fist bump may simply mark that individual as the target of comic ridicule or suggest that the character is out of touch with Black identity. The irony, of course, is that these people have no Black identity. They literalize the Oreo cookie metaphor: Black on the outside and White on the inside. In this context, however, the irony and awkward humor are joined by horror and dread; while funny on one level, these moments simultaneously suggest that the Armitage house is a space where Black people are becoming deracinated. The comically eerie behavior of these "Black" characters thus joins together humor and horror to reinforce the film's critique of American racism.

While *Get Out*'s depiction of White people stealing Black bodies works primarily as an allegory for American race relations, the film also depicts an intimate betrayal when viewers and Chris learn that his seemingly progressive and sympathetic girlfriend Rose is part of the plot to steal his body. Ari Aster's *Midsommar* also features an ultimately violent breakup story and leans more heavily into the granularities of a relationship. The film most clearly works in the loose tradition of "folk horror," and the influence of the British film *The Wicker Man* (1973) is quite apparent. Aster, however, is a big fan of the comic filmmaker Albert Brooks and has cited Brooks's 1981 breakup comedy *Modern Romance* as one of the key influences on *Midsommar*.[15] In his essay on Brooks's oeuvre for the Criterion Collection, Aster describes *Modern Romance* as a "comedy of anguish."[16] We could use this same description for *Midsommar* itself, as it blends cringe comedy, violent horror, and an intense study of a failing relationship to craft a uniquely awkward horror.

Midsommar tells of a group of four American graduate students who, upon the invitation of their Swedish friend Pelle (Vilhelm Blomgren), travel to Hårga, a small commune in Sweden, to observe the midsummer festival. The main character, Dani (Florence Pugh), travels with her boyfriend, Christian (Jack Reynor), and two of his friends, Mark (Will Poulter) and Josh (William Jackson Harper). Dani's sister and parents all die in a murder-suicide in the first sequence, and her grief looms over the film. Dani and Christian's relationship is clearly fraught, and it is frequently

suggested that Christian wants to break up. The film thus simultaneously chronicles Dani and Christian's deteriorating relationship and the increasingly disturbing and violent rituals of Hårga's festival. Both story lines feature prominent examples of awkward humor, and they converge in the final sequence when Dani, named the festival's "May Queen," not only ends her relationship with Christian but chooses for him to be sacrificed. The ending suggests that Dani will ultimately join Hårga's community.

As in *Texas Chain Saw Massacre*, *Midsommar* generates uncomfortable humor through its juxtaposition of different cultural perspectives. In this case, humor arises from the dramatization of Americans navigating the ancient and bizarre rituals of the Hårga commune. Several moments of humor come simply from cultural misunderstandings or from an American perspective on Hårga's customs. Mark, for example, is a stereotypically narrow-minded and disrespectful American, and his confusion over the community is often quite comic. In one scene, Pelle shows the group a large community room—decorated with elaborate and sexually explicit murals—where all the villagers sleep in small beds from ages eighteen to thirty-six. Christian points out that the room does not allow for much privacy, but Mark, in a comical fashion, expands on this, saying, "Yeah, what do you do when you need to jerk off, especially with all these dicks on the wall? There's a lot of dicks." In another moment, Mark angers a number of the villagers when he urinates on a dead tree that has symbolic value for the community. In a stereotypical display of American ignorance and disrespect, Mark refuses to apologize, repeatedly asserting that it is "just a dead tree." In these and other moments, Mark (like Michael on *The Office*) generates both awkward humor and a satire of American ignorance through his insensitivity and clueless demeanor. As in *Get Out*, the humor is tempered by a sense of dread, maintained through low and ominous music and looming long shots, both of which create the sense that the characters are not safe. Indeed, not long after urinating on the tree, Mark disappears and is never seen alive again (although his mutilated corpse does make two subsequent appearances).

Somewhat paradoxically, humor is also generated when the characters attempt to show respect for the odd rituals of the Hårga. Both Christian and Josh are anthropology students, and Josh's thesis about European midsummer festivals is the ostensible reason for the trip. The characters' first glimpse of Hårga's violence occurs when they witness a public suicide ritual in which two villagers, having reached the community's predetermined end-of-life age of seventy-four, fling themselves from a cliff. The scene is filmed in graphic detail, and both viewers and characters

see cracked skulls and twisted legs. When one of the sacrifices does not immediately die, a villager smashes his head with a large wooden mallet. Two visitors from London are openly revolted by the display. Christian vomits, and Dani reacts with mute shock. The different responses thus test the limits of each character's ability to accept and understand extreme cultural differences.

There is of course little about the scene described above that could be considered comic. Later, however, Christian tells Josh that he wants to write his dissertation about Hårga; this creates an awkward moment between the two, as Josh sees Christian's decision as an invasion of his own research agenda. Another uncomfortable moment occurs when Dani, still emotionally distraught from witnessing the ritual, asks Christian if he is also disturbed. Christian says that he's "trying to keep an open mind" and that "it's cultural." The subtle humor in these moments works in two ways. First, both Christian and Josh—especially Christian—look to capitalize on the violent rituals. The film thus mocks the ways in which cultural respect can easily slide into exploitation. Second, there is dark irony in the fact that both Christian and Josh end up becoming sacrificial victims to the very cultural practices about which they are trying to write and keep an "open mind." *Midsommar* therefore ridicules both Mark's American-centric, narrow-minded disdain for the Hårga and Christian and Josh's politically correct cultural relativism.

In addition to generating awkward horror through cultural clashes, *Midsommar* offers smaller moments of cringe comedy in its representation of Dani and Christian's failing relationship and in Dani's interactions with Christian's friends. Early in the film, at a party, Christian nonchalantly mentions that he is traveling to Sweden with Mark, Josh, and Pelle. When Dani says that she was unaware of these plans, the group falls into awkward silence. Later, Christian reluctantly invites Dani to join them, and once again, Christian's friends are awkwardly silent when they hear the news. The tension continues on the trip itself. Christian forgets Dani's birthday, and when the woman from London complains that her boyfriend left without telling her goodbye (he was actually killed by someone in the village), Dani tells Christian that she could see him "doing something like that." These and other moments are sometimes played for laughs and sometimes played for drama, but they are always uncomfortable. More important, they lay the groundwork for the film's finale, in which Dani and Christian's "breakup" and the Hårga's violent rituals coincide in a disorienting series of set pieces that are alternately (or perhaps simultaneously) disturbing, funny, awkward, violent, and uplifting.

On the last day of the festival, after Mark and Josh disappear, the villagers separate Dani and Christian. Dani is led away to participate in a maypole dancing competition, and Christian takes part in a mating ritual with Maja (Isabelle Grill), a young villager who had been making advances at him throughout the film. Both Dani and Christian are given a strong hallucinogenic tea, and the entire proceedings have a surreal quality, reinforced through subtle CGI effects that make it appear as if the flowers and trees are pulsating. Dani's sequence has a happy and upbeat feeling: the dancing is beautifully choreographed and filmed, the mise-en-scène is full of bright flowers, and one gets the sense of Dani joining the community. There is even the suggestion of something supernatural as, at one point, Dani speaks Swedish—a language she has never studied—without realizing it. Dani ends up winning the competition and appears happier than at any other point in the film.

The sequence with Christian, on the other hand, is highly uncomfortable, even as it is comic in its absurdity. Christian is led into a barn where Maja lies nude on a bed of flowers, and twelve of the village women stand nude around her. As Christian begins having sex with Maja, the other women softly chant and sway around them. The highly uncomfortable sex scene becomes nearly unbearable when the other women take a more active role in the mating ritual. First, one woman crouches next to Maja, grabs her hand, and begins singing to her. Christian is clearly uncomfortable, and the woman looks directly into his face, only adding to his discomfort. When Maja makes sounds of pleasure, the other communally focused women begin mimicking her. The communal approach to sex is obviously quite alien to an individual-minded American. The discomfort reaches its apex when one of the women gets behind Christian and begins pushing on his buttocks as he nears climax. When the act is over, Maja immediately announces, in Swedish, that she can "feel the baby." Christian runs away in distress.

Viewers surely have a range of reactions to this scene. Most, I suspect, will agree that it is highly uncomfortable and awkward, but many will certainly find humor in the bizarre nature of the scenario and may laugh in surprise at how the ritual plays out. Also, throughout the film, viewers have been primed to dislike Christian due to his poor treatment of Dani, and there may therefore be some pleasure and humor in witnessing his discomfort. However, while Christian seemingly enters the barn and begins to have sex of his own free will, the heavy drugs he has been given certainly raise the question of consent, which may preclude laughter for many viewers. Upon completion, Christian's running away displays

his feelings of horror and humiliation. The next scene shows him running around the village in embarrassment, nude and attempting to cover his genitals. Like the sex scene, the sight of Christian running around naked is simultaneously uncomfortable and funny. It slides straight into horror, however, when Christian finds Josh's foot sticking out of a shallow grave. The horror continues when Christian runs into a building and finds, on display, the mutilated corpse of another sacrifice just before a villager appears and disables him with a paralytic drug.

Unknown to Christian, Dani, peering through a keyhole, witnesses Christian's participation in the sex ritual. She breaks down into uncontrollable sobs. The other young women mimic Dani's sobbing, again suggesting that she has joined the community. This leads to the final stage of the Hårga's midsummer festival. As the May Queen, Dani gets to decide whether the final sacrifice will be Christian or another member of the village. She chooses Christian, who is then dressed in a bear hide and burned alive in the temple. The last image is Dani's smiling face. This is a "happy" ending in the sense that our protagonist has found a new family in the Hårga community and a way to move on from her unhealthy relationship with Christian. This sense of satisfying closure is of course tempered by the extreme violence and discomfort we have witnessed and by the fact that our protagonist has chosen to sever her relationship by allowing her boyfriend of four years to be sacrificed. A film full of uncomfortable humor thus keeps viewers uncomfortable right until the end.

Found Footage, Mockumentary, and Awkward Horror

The awkward horror found in recent prestige films like *Get Out* and *Midsommar* is mainly a continuation of the same sort that was evident decades earlier in films like *Psycho* and *The Texas Chain Saw Massacre*. A different sort of awkward horror, however, can be located in the found footage cycle that has become quite prominent in the twenty-first century. Found footage horror films feature the ostensibly discovered footage of a horrific event, and common features include low production values, handheld cameras, and actors who are not well known. As critics often point out, these devices mimic documentary formats and combine to make the horrors on screen feel more real for audiences.[17] This description of found footage horror echoes Middleton's assessment of awkward humor feeling "too real" and being tied specifically to documentary or mockumentary formats. Indeed, many of the most well-known works of awkward humor—including *The Office*, which parodies a reality television series—are either documentaries

themselves or employ the stylistic devices of documentary.[18] This final section considers the overlap between mockumentary and found footage formats and looks in particular at the manifestation of awkward horror in Patrick Brice's *Creep* films (2014 and 2017).

At first glance, found footage horror is the least likely of horror's subgenres to be mined for humor. As Adam Charles Hart asserts, found footage is "uniquely . . . predicated on tragic endings."[19] *The Blair Witch Project* (1999), certainly the most influential found footage horror film in the United States, set the template for this. In the film's opening, on-screen text informs viewers that three documentary filmmakers "disappeared in the woods" and that only their footage was found. Likewise, the highly successful *Paranormal Activity* (2007) opens with text thanking the families of the film's two main characters. In both cases, the bad end for the protagonists is predetermined, and the films themselves have a bleak and nihilistic aura, wherein even moments of apparent levity are tinged with a feeling of impending doom. These well-known films have trained horror viewers to expect the worst from found footage, so even when there is no opening text of this sort, the deaths of the main characters still seem to be the most likely outcome. I had grown so accustomed to this template that I was quite surprised to see three characters survive the underground found footage film *As Above, So Below* (2014). The happy ending feels downright subversive in a subgenre known for its hopelessness.

Despite its penchant for tragedy, however, there are moments of genuine humor scattered about the subgenre. Films like the slasher mockumentary *Behind the Mask: The Rise of Leslie Vernon* (2006) or the New Zealand vampire mockumentary *What We Do in the Shadows* (2014) parody both horror films and documentaries, but they are not really "found footage" in the traditional sense. *WNUF Halloween Special* (2013), on the other hand, is a genuinely comic found footage film. The movie is presented as a recording of a local television channel's live investigation, on Halloween night in 1987, of a purportedly Amityville-like house where brutal murders had occurred. Like most found footage films, the investigation goes badly for the protagonists. *WNUF*, however, maintains a comic tone through its uses of eccentric characters and particularly through its method of breaking up the broadcast with parodies of 1980s commercials for ridiculous products and places, like "Stay Sure Tampons" or "The Shining Trapeze Strip Club." The film thus emerges as something of a cross between actual found footage and parody.

In a number of more straightforward found footage films, the documentary feel creates opportunities for some genuine awkward humor.

Spree (2020), for example, follows social misfit Kurt Kunkle (Joe Keery), who hopes to raise his social media profile by livestreaming himself murdering the various passengers in his ridesharing business. Kurt is very much a monstrous fool (see chapter 2), and his desperation to be liked and followed online generates plenty of cringeworthy moments, especially when the twenty-something Kurt anxiously attempts to impress the young teenager whom he used to babysit and who has since become a social media star. Another example comes in *Willow Creek* (2013), about a heterosexual couple filming a Bigfoot documentary. Its structure is nearly identical to that of *Blair Witch Project*, but the use of a couple allows audiences to witness various humorously tense moments in their relationship. The biggest of these occurs when the man, Jim (Bryce Johnson), decides to propose to his girlfriend, Kelly (Alexie Gilmore), on camera. His proposal is followed by several seconds of awkward silence before she eventually turns him down. Jim's desire to capture a moment of romance results only in the chronicle of his humiliation, just as the couple's attempt to capture Bigfoot on camera only results in their death. A film like *Willow Creek*, then, relies mostly on the sense of realism and impending doom that is essential for successful found footage horror. At the same time, though, the camera's unflinching documentation of Jim's failed marriage proposal resembles the awkward humor of mockumentary texts like the *Borat* films or *The Office*.

The most sustained example of awkward humor in found footage comes in Patrick Brice and Mark Duplass's films *Creep* and *Creep 2*. Both are directed by Brice and cowritten by Brice and Duplass, and they playfully explore the overlap between found footage and mockumentary. Brice and Duplass have both done extensive work in comedy, and in between the two *Creep* films, Brice wrote and directed the extremely cringey comedy *The Overnight* (2015). These comic credentials are apparent in the *Creep* films, which feature extremely awkward and funny social situations blended with horror and found footage elements. In both films, Duplass plays the Creep, a serial killer who attempts to forge unsettling yet intimate relationships with his victims before killing them. He also creates videos of each victim, which (like the *Creep* films themselves) are edited together from the killer's hidden cameras and from footage filmed by the victims. Both films have only two main characters, the Creep and his potential victim, and the action of each consists primarily of a series of intensely uncomfortable—yet often outrageously comic—situations between the two. The found footage format increases both the humor and the scariness of the situation.

In the first film, Aaron (played by Brice) answers an ad, placed by the Creep, offering one thousand dollars for a one-day videographer. The Creep, who in this film goes by Josef, informs Aaron that he has a terminal brain tumor and only two-to-three months left to live. His wife is pregnant with their first child, and he wants Aaron to record him for the day so that he can leave the video behind for his son. (The Creep openly admits that this is the same plot as the 1993 film *My Life*.) All this is of course a lie, but neither viewers nor Aaron know that for sure. The scenario establishes uncomfortable tension, as Aaron is expected to spend hours full of intimate moments with a man he has just met. The Creep also makes it clear that he wants to form a bond with Aaron over the course of the day: he immediately hugs Aaron; tells him he has a "nice, kind face"; and describes the forthcoming day as a "partnership" and a "journey into the heart." The Creep's emotional forthrightness is unsettling, and he is clearly unbalanced. However, viewers and Aaron could reasonably suspect that his odd behavior and desire to become intimate so soon stems from the emotional toll of a terminal illness or from the cognitive effects of the brain tumor itself. The emotionally sadistic Creep has thus set up a very awkward situation for Aaron. If he does not remain polite and open to the Creep's wishes, then not only would he be backing out of a business deal, but he would be denying a dying man of one of his last wishes.

The Creep's day with Aaron is full of awkward moments. The funniest of these is what the Creep calls "tubby time." Here, the Creep makes Aaron record him while he is naked in the bathtub, pretending to give a bath to his as-yet-unborn baby. The Creep coos for the camera, pretends to dip the baby's toes into the water, and eventually lays back while caressing the imaginary baby's head. The scene generates an intensely awkward humor. The unlikely scenario of Aaron filming a grown man cooing in the bathtub alone is surprising enough to prompt nervous laughter, and Duplass's over-the-top performance only adds to this. More important, the scene simply feels too intimate (too real, as Middleton would say) to witness, let alone record. Since viewers are literally seeing through Aaron's camera (and thus through his perspective) they are invited to share in Aaron's discomfort. As in the most extreme versions of cringe comedy, the violation of social norms may prompt audience laughter, or as we saw with "Scott's Tots," it may simply generate too much discomfort for laughter. Most, I suspect, feel an uneasy mix of amusement and anxiety.

There are numerous other awkward moments in Aaron and the Creep's day. While still in the bath, the Creep pretends to drown himself only to leap out of the water and yell as soon Aaron leans over to investigate.

"I've got a weird sense of humor, man," the Creep admits when he sees Aaron's shock. Later, the Creep dons a wolf mask named Peach Fuzz and performs a bizarre song and dance routine as the "friendly wolf." At lunch, the Creep coerces Aaron into sharing his most shameful memory. Aaron reluctantly tells a childhood story about his mother installing an alarm in his underwear that would go off when he urinates. When he later wets his pants on the playground, the alarm alerts all the other children to Aaron's humiliation. Each of these moments, on its own, is awkward and potentially humorous. Combined, however, they create a relentless pattern of discomfort for viewers and Aaron. The found footage format—in which we are mostly restricted to only Aaron's uncomfortable perspective—only contributes to the uneasy tension.

By the end of the day, the horror elements finally kick in. The Creep tries to prevent Aaron from leaving by stealing his keys and blocking the door while wearing his wolf mask. After a brief scuffle, which can barely be discerned by the shaking camera, Aaron escapes. The last act of the film consists of Aaron receiving odd packages in the mail from the Creep, including a video of the Creep digging what appears to be a grave as well as a heart locket with pictures of Aaron and the Creep inside. These packages again create an odd mix of humor and menace. The gravedigging is menacing for obvious reasons, but the heart locket is comic. We may suspect that the Creep is romantically interested in Aaron; this may be true, but in neither film does the Creep exhibit any interest in physical sex with either gender. He craves emotional intimacy. The heart locket is thus comic because its cultural associations with either romantic love or the "BFF" friendship of teenagers are incongruous with cultural expectations for adult male friendship. And regardless of the relationship or the gender, it is a remarkably forward gift for someone whom you only met once.

Aaron is rightfully creeped out. In the final sequence, however, he receives another video, in which the Creep apologizes and admits to being a compulsive liar who has alienated everyone in his life. In an uncomfortable outpouring of emotion, the Creep says, "I'm a lonely person, and I'm a sad person, and I really need a friend." Aaron feels bad and agrees to meet the Creep by a nearby lake. Keeping with the found footage conventions, Aaron sets up a camera to secretly record the encounter. From a distance, we watch as Aaron waits on a bench for the Creep's arrival. The Creep sneaks up behind Aaron, puts on his wolf mask, and kills him with an axe. The final scene reveals the Creep watching the video of himself killing Aaron. The Creep speaks directly to the camera and tells Aaron—who cannot hear because he is dead—"I will always love you, and you will

always be my favorite of them all." The final image reveals a cabinet full of videos—both VHS and DVD—with different names on them. The Creep adds a DVD inscribed with a heart around Aaron's name.

The Creep is certainly not the first horror monster to display highly awkward social behavior. *Psycho*'s Norman Bates, *Misery*'s Annie Wilkes, and countless others precede him by decades. The Creep, however, is unique in the manner in which he makes such awkward behavior a central part of his ritualized killing. Based on the final image of the Creep's video collection, one gets the sense that the murder itself is but the punctuation mark, and the Creep's pleasure comes from creating intensely uncomfortable social situations for his victims. Aaron has the opportunity to escape numerous times throughout the film; it is his sense of human decency and social propriety that allows him to be murdered. In this sense, the Creep exploits awkwardness and discomfort for his own enjoyment and to lay the groundwork for violence. For audiences, this weaponization of awkwardness generates an uneasy mix of humor and fear. The use of the found footage / mockumentary format and its ability to make events feel more real only adds to this peculiar mixture.

Creep 2 leans into this aspect even more heavily. In the first film, Aaron is not given much personality and thus works as a sort of blank slate on which audiences can project themselves. This approach encourages viewers to share in Aaron's discomfort and fear. The sequel, however, offers a protagonist who is more successfully able to challenge the Creep's awkwardness and who also offers up some cringey moments of her own. *Creep 2* also makes more direct ties between mockumentary and found footage formats. The main character, Sara (Desiree Akhavan), is the creator and host of an unsuccessful web series entitled *Encounters*. For the series, Sara answers online personal ads and throws herself into whatever situation the ad-placer asks. She of course records each "encounter," and early in the film, we see a montage of awkward examples: a man who builds "spirit pods" (it is never explained what that means), a lonely man who simply wants someone to talk to, and another man who wants to be cradled like a baby by Sara. As in *Psycho*, the series of awkward encounters specifically with men prefigures her later interaction with an awkward male killer. Sara's self-proclaimed reason for making the series, however, is to illustrate that "maybe we're all a little bit weirder than we give ourselves credit for." In other words, Sara *wants* to meet social misfits and make awkward documentaries.

The Creep (who in this film adopts the name of part 1's victim, Aaron) seems to be exactly what Sara is looking for. She plans to cancel her web

series due to low-viewership but decides to give it another shot when she finds the Creep's ad, once again offering one thousand dollars for a one-day videographer. In many ways, the plot of *Creep 2* is similar to that of the first: a series of very uncomfortable social situations filmed with a handheld camera, leading up to a violent climax. However, in this film, the audience knows from the beginning that the Creep is a killer; even if viewers missed the first film, *Creep 2* opens with him committing a murder. The Creep even tells Sara that he is a serial killer. He explains that he has lost his love of killing—"it feels like a job"—and hopes that over the course of the day, she can help him to love his work again. The Creep promises not to kill Sara "over the next twenty-four hours," but she does not believe he is a murderer and instead hopes he can give her web series a boost. The film thus generates tension by withholding the Creep's precise intentions toward Sara and through the dramatic irony of the audience understanding Sara's danger well before she does.

Like its predecessor, *Creep 2* combines its horror elements with uncomfortable, awkward humor. This time, though, the Creep is just as often the object of the discomfort as its creator. We see this first in an early scene when the Creep, clearly attempting to make Sara feel uncomfortable, emerges from the bathroom wearing only a towel. He explains that there is "a wall" and a "gender barrier" between men and women that can only be broken by them seeing each other naked. The Creep drops his towel, and there is a full frontal shot of his nude body for several seconds. Full male nudity is rare enough in American cinema that the image is surprising, and the duration of the shot forces viewers to sit with the image for some time. Sara holds the camera at this point, and it is important to note that it never turns away. Sara then announces that it is her turn, and the Creep looks quite uncomfortable as Sara hands him the camera and instructs him to film her as she undresses. While she strips, however, the image zooms closer and closer to her face, so by the time she is completely nude, there is only a close-up, as opposed to the long shot through which Sara filmed the Creep. The Creep is clearly uncomfortable looking at Sara's body.

Both the Creep's stripping and his discomfort with Sara's body recall "tubby time" from the first film. Then, he explicitly said that Aaron was "not getting in the tub," and the same principle seems to hold true here, as the Creep clearly has no desire to have Sara reciprocate. The Creep enjoys making his victims uncomfortable through his own naked body, and he perhaps expects this discomfort because he is clearly disturbed by the sight of another naked person, male or female. The stripping scene's

humor works first through the awkwardness of two people who have just met standing naked in front of each other. The Creep's discomfort, though, adds another layer. The first film presents the Creep as a sort of sadistic mastermind, unsettling and emotionally manipulating his victims before finally killing them. It is thus a pleasant and amusing surprise to see him get flustered.

Much of the film's humor works this way, as Sara seems to intuitively know how to get under the Creep's skin. She never jumps or reacts when he tries to scare her, and she continuously interrupts when he is trying to proselytize for the camera. When the Creep sits alone in a hot tub listening to music, Sara gets in with him. When the Creep admits he has never kissed a woman, she kisses him. In each of these cases, the Creep becomes visibly agitated, and at several points, he goes off to be alone. In a particularly funny moment, Sara comments to the camera that "it turns out, Aaron is a bit of drama queen." At another moment when the Creep refuses to talk, Sara says, "He's so vulnerable right now, and I know the decent thing to do is just give him some space. But at the same time, it would be so easy to go down there and provoke him and get the material I need." Sara's motivation is to create a successful episode of her web series, regardless of the Creep's wishes. Sara and the Creep therefore have a lot in common, as both want to capture intensely awkward and personal moments on camera, and it is funny to watch them needle each other. Since viewers also know that the Creep is a dangerous killer, the comic scenes are also tinged with suspense, as we never know when or if the situation will turn violent.

In the final act, the Creep shows Sara a large grave in the woods and reveals his intention to kill both her and himself. This is followed by a shaky-cam chase through the woods, with both Sara and the Creep doing some of the filming. After a prolonged struggle, Sara finally gets away and seemingly kills the Creep. In a brief epilogue, however, we see her walking through the city, being recorded by an unseen camera. The Creep is apparently still out there. The ending underscores the power of the camera to catch us at our most vulnerable. While the vast majority of found footage films use this conceit to construct realistic-seeming narratives of bleak nihilism and hopelessness, the *Creep* films are unique in their blending of found footage elements with the tools of awkward humor found in mockumentary formats. This results in films that explore our anxieties about uncomfortable social interactions as much as they do the threat of monsters and psychopaths.

Conclusion

As we saw in chapter 3, horror primarily explores threats to our bodies. Horror's widespread use of awkward and cringeworthy social interactions, however, also reveals and reflects our fear of doing or saying the wrong thing or of confronting alien worldviews and value systems. As is made clear in "Awkward at Parties Horror Movie," discussed at the outset of this chapter, feelings of not belonging or of intense embarrassment can be horrifying. From an outside perspective, these awkward moments can also be quite amusing, as we can laugh both at the subject who is unable to adhere to social norms and at the oppressive social norms themselves. This can result in a surprising mixture of tones. Even in straightforward comedy texts like *The Office*, awkward humor is decidedly ambivalent. In horror, this ambivalence is magnified, as moments of social discomfort that may be merely amusing in another context prefigure the total breakdown of social norms that is revealed when the monster finally shows its true threat. In many cases, as we see in films like *Texas Chain Saw Massacre* or *Midsommar*, social transgressions are directly related to the physical violence that eventually occurs. The first *Creep* film goes so far as to suggest that the fear of offending someone or hurting their feelings can actually override our instincts for self-preservation. Like many of the other types of humor discussed throughout this book, awkward horror does not work as comic relief. Rather, horror's mixture of social humor with traditional physical threats forces us to confront the fragility both of our bodies and of our identities as social creatures.

CHAPTER 6

Horror, Humor, and Critique

Satire in Horror

NUMEROUS HORROR FILMS are important to cinematic and cultural history, but occasionally, one can rightfully be called a game changer. Two such films are George A. Romero's *Night of the Living Dead* (1968) and Jordan Peele's *Get Out* (2017). While they are very different in tone and production value, the movies also have quite a bit in common. Both films feature sympathetic Black male protagonists, and both were released during periods of heightened social unrest and anxiety. *Living Dead* came out amid the Vietnam War and various civil rights movements, and *Get Out* was released shortly after President Trump's inauguration, which also inaugurated one of the most divisive periods in American cultural history.[1] Both films also proved to be widely influential on the horror

IMAGE 7: *Dawn of the Dead* (1978). Courtesy of Photofest.

genre. Most important for our purposes, each film has a comic sensibility and uses its humor to foster a pointed social critique of the country at the time of its release. In other words, each film can be considered a *satire*. This chapter considers several films but focuses most heavily on the satirical works of Romero and Peele and their impact on horror's development. Critics often note that the horror films of Romero, Peele, and others have satirical elements but, in doing so, tend to focus more heavily on the horror and social critique and to give relatively short shrift to comic aspects. For both filmmakers, however, humor is an important conduit for both horror and social critique.

Following the lead of James Caron and others, I see satire as a "comic mode that cuts across genres rather than as a form embedded in a literary history."[2] We can thus see satire at work not only in the expected places, like the writings of Mark Twain or the commentary of late-night comedians, but also in narrative film and television genres like science fiction and horror. As a comic mode, satire makes use of many other devices or styles of humor such as parody, irony, or camp. Therefore, quite a few of the works already discussed in previous chapters have a distinct satirical bent. As I discuss in chapter 1, for example, *The Last House on the Left* (1972) and *The Texas Chain Saw Massacre* (1974) both parody the television sitcom in order to satirize—that is, to comically critique—dominant ideas about the structure of American family life. Likewise, a camp horror film like *Jennifer's Body* (2009), discussed in chapter 4, uses a queer aesthetic and heightened performances to satirize mainstream conceptions of gender and the objectification of women. The films I discuss in this chapter follow similar impulses but more heavily foreground the elements of social critique. In particular, satirical horror films tend to challenge dominant social norms and have some form of society itself represented as monstrous.

In their blending of horror elements with humor and social critique, satirical horror films tend to have a striking mixture of tones and often ironically juxtapose dissimilar elements. This sort of juxtaposition is fairly common in many works of satire. Amber Day, for example, notes that much contemporary satire—like that found in satirical news shows—can be seen as "straddling the line between satire and serious political dialogue."[3] Caron builds upon such thinking and asserts that satire actually has a "paradoxical structure. Analogous to light at quantum levels behaving as both wave and particle, satire registers as both serious speech and nonserious (comic) speech."[4] While the narrative horror texts discussed here are different from speech, Caron's point about satire as both serious

and comic is well taken. In satirical horror texts, this paradoxical structure is compounded, as the films not only combine comic elements with serious social critique, but they also employ devices to generate the fear or revulsion that is typically associated with horror. This results in a series of texts that can be at times disorienting or that require viewers to make rapid adjustments to shifts in tone or content. Satirical horror texts also reward active and engaged viewership, as they not only provide the pleasures that are typical of horror and humor but seek to engage with, comment on, and ultimately critique their cultural contexts.

The Roots of Satirical Horror

Satirical horror is most prominent in the modern horror films created since *Night of the Living Dead*. There are, however, much earlier works with a clear satirical thrust, such as previously discussed films like *Freaks* (1932), *The Old Dark House* (1932), or *The Incredible Shrinking Man* (1957). The earliest and clearest precursors for Romero's brand of satirical horror, however, come not from film but from literature. The most obvious example—and one that clearly foreshadows Romero's zombie films—is Jonathan Swift's 1729 essay "A Modest Proposal." Swift adopts the voice of a hyperrational thinker who posits that the best way for poor Irish citizens to confront their poverty is to sell their children as food to the rich. Swift uses this scenario to comment on England's brutal treatment of the Irish and to criticize the sort of rational enlightenment thinking that tends to treat humans as commodities. While it is certainly not a horror text, Swift's essay is full of potentially horrifying passages. Swift's proposer, for example, tells readers that he has "been assured by a very knowing American of my acquaintance in London, that a young healthy child well nursed, is, at a year old, a most delicious nourishing and wholesome food, whether stewed, roasted, baked, or boiled."[5] A sentence like this is clearly intended to disturb or gross out readers even as its irony may generate laughter. In this case, the humor and the repulsiveness combine to create a satire that calls attention to the dehumanization of the Irish. Swift uses cannibalism as a metaphor for economic exploitation.

We see a similar impulse in Mark Twain's 1868 story "Cannibalism in the Cars." Here, the narrator meets a man who relates an instance in which he and several other congressmen got stuck in a snow drift. Trapped without food for several days, the men have no choice but to eat one another. The story generates humor through the ways in which the men use bureaucratic language and follow political proceedings in order to

determine who will be butchered and eaten. We are told, for example, that "Mr. Harris was substituted on the first amendment. The balloting then began. Five ballots were held without a choice. On the sixth, Mr. Harris was elected, all voting for him but himself. It was then moved that his election should be ratified by acclamation, which was lost, in consequence of his again voting against himself."[6] Like Swift's proposer, the congressmen use official language, which denies and conceals the actual brutality of the proceedings. The incongruity between language and actions creates a satire of politicians who use similar bureaucratic language to cover their exploitative practices. Once again, cannibalism works as a metaphor for other atrocities.

The use of cannibalism in these literary examples of satire anticipates a dominant strain in satirical horror. In fact, cannibalism in some form appears frequently throughout a wide range of satirical horror texts. As discussed later, Romero's zombie films use flesh-eating ghouls as a metaphor for American consumerism or military exploitation, and numerous other zombie films have followed suit. The often-satirical *Texas Chainsaw Massacre* franchise similarly uses cannibalism in its representation of a family of displaced slaughterhouse workers who substitute human flesh for cattle after the slaughterhouse closes. As mentioned in chapter 1, Bob Balaban's glossy sitcom parody *Parents* (1989) uses cannibalism to satirize 1950s materialism. In the same year, Brian Yuzna's *Society*, discussed in chapter 3, satirizes class differences in its representation of the upper classes as a distinct species that literally feeds on the poor. And while Peele's *Get Out* is not literally about cannibalism, it does focus on Black bodies becoming commodities for White consumption.

The point of this cataloging is neither to show how often cannibalism occurs in horror nor to assert that Swift and Twain were direct influences on horror filmmakers. Rather, I hope to demonstrate that before horror even emerged as a recognizable genre, satirists understood that gruesome subject matter or revolting imagery could be an effective way to shock audiences and critique a culture's brutality. One can find similarly gruesome moments—even if not tied to cannibalism—in the works of other important satirists, including Voltaire, Ambrose Bierce, and *South Park* (1997–) creators Trey Parker and Matt Stone. Satirical horror films follow a similar impulse in their blending of horror, humor, and critique; the key difference is that they first establish themselves as genre texts, primarily through the inclusion of monsters and other trappings of horror, and weave humor and critique into those genre elements.

George A. Romero's Apocalyptic Satires

Romero is rightfully credited with having invented the zombie subgenre as we know it today and with bringing an effects-driven "gross-out" aesthetic into the modern horror film.[7] Along with these important contributions, Romero also brought a before-unseen level of social consciousness to the horror genre, and he imbued that social consciousness with a bitter irony and dark sense of humor. Given spatial limitations, I focus my analysis of Romero on the role of humor in his apocalyptic satires, primarily his original zombie trilogy (*Night of the Living Dead*, *Dawn of the Dead* [1978], and *Day of the Dead* [1985]) and *The Crazies* (1973). The latter, while not technically a zombie film, has a similar apocalyptic bent and focuses on many of the same themes as the zombie trilogy. Romero's later, less influential zombie films *Land of the Dead* (2005), *Diary of the Dead* (2007), and *Survival of the Dead* (2009) are also relevant and discussed in passing. My focus on apocalyptic satires is not to suggest that Romero's other work is irrelevant; *Season of the Witch* (also known as *Jack's Wife*, 1973) and *Martin* (1977) both offer a smaller-scale satirical treatment of gender and class issues, and the moral fables of *Creepshow* (1982), his horror anthology collaboration with Stephen King, are often quite comic. Readers interested in a fuller approach to Romero's body of work are thus encouraged to look at the wealth of criticism available.[8]

Each of Romero's zombie films features a zombie outbreak in different stages of progression and scale. *Night* focuses on a small, besieged group in an abandoned farmhouse, and its ending suggests that the outbreak may have been subdued by law enforcement and local militia. It nonetheless offers an exceedingly bleak ending by killing all its main characters. *Dawn* begins with an outbreak having already spread through America's major cities, and by the end, it has apparently overtaken all civilization. At the beginning of *Day*, it seems the entire world has fallen, and there are only a small group of confirmed survivors living in an underground bunker. *The Crazies* is about the accidental release of a government-created biological virus that makes people insane. The bulk of the film focuses on its spread (and the military's oppressive attempts at containment) in one American town. The ending, however, places it fully in the apocalyptic mode by making clear the virus's spread to other cities and by cynically suggesting that the government is too inept to stop it. All the films provide a broad critique of American culture, but each tends to focus on different aspects. Robin Wood argues that "*Night* deals centrally with the nuclear family" while "*Dawn* is centered on consumerism" and *Day* offers

an "assault on patriarchy."[9] I generally agree with these emphases but should point out that most of the films also deal with race and the media in important ways. The odd-film-out, *The Crazies*, focuses particularly on issues of patriarchy and military oppression as well as the nuclear family.

Due to their end-of-the-world scenarios and satirical treatment of fundamental American institutions, it is tempting to relegate Romero's films to the category of *degenerative satire*. Steven Weisenburger explains that classic forms of "generative" satire posit a "rationalist discourse" and strive to "construct consensus."[10] In contrast, Weisenburger asserts, degenerative satire "is delegitimizing" and "functions to subvert hierarchies of value and to reflect suspiciously on all ways of making meaning, including its own."[11] Romero's apocalyptic satires seem to fit this definition nicely, and Weisenburger's key exemplars of degenerative satire are postmodern novelists like Thomas Pynchon and Robert Coover, literary contemporaries of Romero. Romero's satire, however, is ultimately closer to what Sam Chesters has recently termed "metamodern satire," which has the "characteristic irony and cynicism" of degenerative satire but also proposes a "genuinely tendered correction," as we might see in classical satire.[12] For Romero, this sort of correction is apparent in the possibility that the films' protagonists may, as Tony Williams suggests, "form a new society uncontaminated by past patterns of behavior."[13] Not all Romero's apocalyptic satires suggest this possibility, but each film moves a little closer to it than its predecessor, and while *Day* ends ambiguously, it expresses a strong desire to move beyond "past patterns of behavior" and start anew.

Romero's sense of humor draws on multiple comic devices. First, his films engage in various aspects of parody and self-parody. As discussed in chapter 1, parody can help to create distance between audience and text and encourage viewers to see the constructed text *as* a text. In the case of Romero's films, parodic elements allow viewers to perceive an organizing intelligence at work and to draw connections between the apocalyptic scenarios and the real world. We see horror parody in an early and famous scene in *Night*. Here, siblings Barbra (Judith O'Dea) and Johnny (Russell Streiner) visit their father's grave. Throughout, Johnny is cynical about the visit and begins teasing Barbra as he did when they were children. Adopting a creepy, horror movie voice, Johnny says, "They're coming to get you Barbra. . . . They're coming for you." He then gestures toward a man walking through the cemetery and says, "Look! There's one of them now." Ironically, the man that Johnny gestures toward is a zombie who immediately attacks Barbra and kills Johnny. This is one of the first of several moments in which the zombies

seem to emerge from or embody family hostilities. (Later, Johnny will return as a zombie to devour his sister.) Johnny's exaggerated horror movie voice, however, also operates as parody, and the moment works on a metatextual level and playfully announces the film's genre awareness. This sort of parodic self-reflexivity recurs throughout Romero's films and reaches its peak in *Diary of the Dead*, a found footage zombie film about a film crew making a horror movie when a real zombie outbreak begins. Throughout, Romero engages in many of the parodic elements that became common in the wake of *Scream*: films within films, reality-mimicking horror cinema, and so on.

Romero does not only parody cinematic horror. Significantly, he also places his films in the tradition of film comedy, particularly slapstick, and Romero is a major director in the genesis of the style of gross-out humor/horror that is sometimes referred to as *splatstick*. All of Romero's zombie films engage in moments of shocking physical violence that, like the films discussed in chapter 3, encourage an ambivalent reaction of laughter and revulsion. In *Day*, for example, a zombie gets the top of his head cut off, but the camera lingers with the halved head for a few moments to show us the eyeballs swiveling back and forth. *Dawn*, however, has the most explicit use of body humor and slapstick. This includes numerous comic shots of zombies walking around the shopping mall with mild instrumental mall music playing in the background. As discussed more fully below, these moments satirize American consumer culture, but they also work as slapstick, as zombies comically trip down escalators and fall into fountains. Romero's reference to cinematic slapstick is most explicit toward the end of *Dawn* when a gang of bikers attempts to take over the mall. The bikers kill several zombies, but they also, in the tradition of vaudeville and silent slapstick films, throw cream pies in the zombies' faces and squirt them with seltzer bottles. The combination of horror imagery with classic slapstick serves to parody both horror and comedy and displays Romero's awareness that he is adapting multiple cinematic traditions.

Another facet of Romero's self-reflexivity comes through the ways in which his films speak to one another and parody specific scenarios, narrative patterns, and character types. One could argue that each of Romero's subsequent apocalypse films is in fact a parody of *Night*. Not all the repetitions are comic, but they are central in placing the films in conversation with one another. For example, *Night*, *Dawn*, and *Day* each have a sympathetic and intelligent Black man as a central character. While Ben (Duane Jones) in *Night* was not originally written as Black, Romero clearly understood the import of Jones's casting, as he continued to cast Black actors

and made ethnic identity increasingly important in *Dawn* and *Day*.[14] In *Day*, in particular, the Black helicopter pilot John (Terry Alexander) seems to represent the point of view that is closest to Romero's own. At one point, he argues that the only way of inhabiting their apocalyptic situation is to "start fresh" and to teach future children to never dig up the remnants of the old, failed society. In *Land of the Dead*, this aspect becomes more explicitly parodic, as the most prominent Black character is actually an intelligent and sympathetic zombie. Romero is aware of audience expectations regarding his zombie films and thus makes a point of playfully revising his own tropes.

We see a similarly progressive treatment of Romero's central White, female characters. In *Night*, Barbra is practically catatonic once the zombie outbreak hits full swing; her counterpart in *Dawn* (Gaylen Ross) takes a more active role over the course of the film. And in *Day*, Sarah (Lori Cardille) is an active hero and the film's protagonist. Interestingly, in the 1990 remake of *Night of the Living Dead*—directed by makeup maestro Tom Savini but written by Romero, who revised his original screenplay—this female progression happens within the film itself. Barbara, played here by Patricia Tallman, begins as a meek damsel in distress but by film's end becomes the primary hero and the core group's only survivor. The film explicitly parodies the original when Barbara repeats a key line in a drastically different context. In the original, the leader of the militia says "another one for the fire" after his sharpshooter kills protagonist Ben. In the remake, Barbara says the same line after purposefully killing the main human antagonist Harry (Tom Towles). The moment displays Romero's comic approach to his own filmography but also demonstrates an evolution of his thinking. The revision of female characters throughout his work, for example, suggests a critical commentary on *Night*'s fairly simplistic treatment of women.

Romero's parodic and metacinematic elements aid in his films' satirical critiques. For unlike the majority of parodies discussed in chapter 1, Romero alludes not only to other films but also to real-world images and situations. The intertextual referencing and extratextual allusion combine to suggest that Romero's genre exercises are more than a game but are also involved in social commentary. Romero thus invites viewers to draw connections between his apocalyptic narratives and contemporary American society. *Night* does this in a variety of ways. As numerous critics point out, the film's black-and-white cinematography lends it the aura of a documentary or newsreel. Shots of helicopters in both *Night* and *Dawn* evoke Vietnam War footage, and *Night*'s posse of zombie

exterminators, which includes both the police and dogs, alludes to similar imagery found in news footage of police violence during 1960s civil rights protests—imagery that contemporary viewers would have seen regularly on television news broadcasts. This aspect is reinforced by *Night*'s bleak and ironic ending, when this posse, mistaking Ben for a zombie, shoots him in the head after he has managed to survive the night. The still photographs of Ben's body being dragged from the house and thrown on to a fire with several other bodies are suggestive of both the lynching of Black men and photographs of piles of corpses from the Holocaust.

The Crazies offers an even more explicit allusion to the "real world." In the film, a priest—either infected by the virus, offended by the military's invasion of his church, or both—douses himself in gasoline and sets himself on fire in the middle of the street. The image of the burning priest directly references the famous photograph of Thích Quảng Đức, the Vietnamese Buddhist monk whose self-immolation in 1963 made many Americans aware, for the first time, of the ongoing conflict in Vietnam. These references here and in the other films are not humorous, but they are an essential part of Romero's satirical critique. When combined with the comic and parodic elements, these real-world references generate the paradoxical mixture of tones that is common in works of satire, and they also serve to suggest that the films' apocalyptic scenarios are but an extreme manifestation of the gruesome violence and social ills that are already inherent in the culture.

The zombies and crazies themselves—the films' key signifiers and the root of much of their horror and humor—are another important way through which Romero's satires draw connections to the actual world and generate humor. As Wood and others point out, all of Romero's zombie films "suggest parallels" between human protagonists, human antagonists, and the actual zombies.[15] These overlaps, in turn, provide commentary on late-twentieth-century human behavior and institutions, for Romero suggests again and again that the zombies are us and that we are the zombies. These parallels are perhaps most pronounced in *The Crazies*, where Romero often makes it difficult to discern whether a character is acting insane due to the virus or just the circumstances themselves. Furthermore, while the antagonists in *The Crazies* are the military men who enact martial law once the virus begins to spread, its main protagonist and his close friend are both Vietnam veterans, suggesting parallels between protagonist and antagonist and, more importantly, suggesting that "craziness" is inherent to the culture and affects all characters, whether or not they are infected with the virus. The point is driven home early in the film

when, amid a montage of the military invading homes to force people into an internment camp, the camera cuts to a shot of plastic toy army men scattered about the floor, and a similar shot shows a little boy attempting to shoot the invading soldiers with his toy gun. The soundtrack during the army takeover scenes features militaristic drums and various versions of "When Johnny Comes Marching Home." The rousing, heroic music provides a comic counterpoint to the military's oppressive behavior while the toys suggest that the oppressive violence is taught to children at a young age.

The behavior of the infected crazies, however, provides the strongest connection between "them" and "us." While Romero's zombies act in a fairly uniform manner, the crazies' insanity is more personalized and unique; in particular, the virus seems to either exaggerate behaviors that were already present or take the form of repressed impulses. Furthermore, the insanity seems to ebb and flow, and victims may later feel guilty for their violent actions. One character, for example, attempts to rape his teenage daughter but later hangs himself. The suggestion is that the virus does not create craziness but rather makes manifest a sickness that is already present. Also, not all the crazies' behavior is violent or sexual. In a particularly comic scene, for example, there is a battle between townspeople and the military. As in other instances, it is unclear how many of the townspeople are infected and how many are simply fighting against an occupying army, and discerning between the two seems beside the point. The battle takes place in a large grassy field and leaves several dead on both sides. Amid the carnage, however, is a young woman—almost certainly a crazy—with a broom, sweeping at the tall grass around the fallen bodies. The bizarre image is immediately comic in its incongruity, and as she is the only woman in the scene, it may suggest that while the men's craziness manifests itself in patriarchal violence, the woman's takes on an absurd performance of domesticity. Additionally, the woman wears bell-bottom pants with a bohemian print, perhaps suggesting a connection to the hippie / flower-power movement, which was certainly on the wane by the time of the film's 1973 release. If this is the case, then the crazy, sweeping woman may additionally suggest the failed promise or futility of the countercultural movement to actually change anything about the surrounding patriarchal and violent culture.

The flesh-eating zombies in Romero's original trilogy fulfill a similar satirical function, even if their behavior is more uniform. Of the three films, *Dawn* makes its connection between human and zombie the most obvious and the most explicitly comic. In the film's satire of consumer culture, both humans and zombies are drawn to the shopping mall, and

as mentioned briefly above, frequent shots of zombies shambling around the mall provide clear commentary on human materialism and consumerism. The zombies in *Dawn*, as nearly every Romero critic points out, thus literalize consumer culture through their endless and unthinking need to consume human flesh. Furthermore, at the film's end, after the remaining human survivors escape in a helicopter to an uncertain future, the film takes us back to the shopping mall. Here, as the credits begin rolling and happy music plays, we once again see the zombies comically roaming about the mall. The point is clear: the zombies inherit the earth, including the consumerist meccas that humans have left behind. Romero asks us, though, if there is really any difference between the zombies' mall walking and our own.

Night has a similar moment in the final sequence when the camera, from above, shows the posse of White, rural zombie hunters slowly walking across a field toward the farmhouse. At first glance, the posse appears to be more zombies, as they move in a similarly deliberate fashion. Later, this posse of course kills Ben, mistaking *him* for a zombie, and when they do, Ben is looking out the window with his gun ready to fire, mistaking *them* for zombies. That the posse ends up killing Ben suggests that whether the militia members are zombies or not is immaterial, as their narrative function remains the same. In the moment, these encounters do not feel particularly comic. In retrospect, however, the sequence emerges as something of a farce, as it becomes clear that we have witnessed (and participated in) a repetitive series of errors in which viewers and characters repeatedly mistake humans for zombies. This ending also ironically mirrors the film's opening sequence, in which a zombie is mistaken for a human before attacking Barbra and Johnny. The entire film, then, is structured around these mistakes, as Romero repeatedly blurs the lines between zombies and humans.

The most interesting exploration of this theme, however, comes in *Day*, where Romero pushes the zombie/human connection to its fullest potential and in doing so offers a scathing satire of patriarchal masculinity. Wood, usually quite attuned to the humor within horror, notes many of the comic elements within *Night* and *Dawn* but asserts that humor "has been eliminated from *Day* altogether."[16] Wood unfortunately misses the humor embedded within *Day*'s critique of masculinity, particularly as it is manifested in the zombie Bub (Sherman Howard), who Dr. Logan (Richard Liberty), referred to throughout as Dr. Frankenstein, spends most of the film trying to train. Logan's ultimate success in training Bub both generates humor and reflects on human behavior in general, but it

more specifically comments on the ways in which American culture both encourages and rewards violent manifestations of masculinity.

While Sarah is the film's central protagonist, *Day* surrounds her with several men who embody different facets of masculinity. On the negative side, we have the arrogant Dr. Logan, who fits the mold of a classic mad scientist, and several obnoxious and violent military men. The latter group is led by Rhodes (Joseph Pilato), who continuously threatens Sarah and Dr. Logan and eventually erupts in violence. On the positive side, there is the Black helicopter pilot John and his close friend (perhaps lover?), the electronics expert McDermott (Jarlath Conroy). John and McDermott live together in a section of the bunker that they have decorated to look like a tropical island—foreshadowing the film's ending and symbolizing their desire to "start fresh"—and they explicitly reject the soldiers' violent posturing. Somewhere in the middle of these extremes is the soldier Miguel, Sarah's lover, who is more sensitive than the other soldiers but is also struggling mentally due to the stress of living in the apocalypse. The other soldiers continuously mock Miguel for his sensitivity, and as a result of this emasculation, Miguel, in the film's final act, lashes out by opening the bunker to the horde of zombies waiting outside, thus killing himself and all the other soldiers. Interestingly, during the first part of the film, Sarah—a scientist working under Dr. Logan—adheres to more traditionally masculine behavior than John or Miguel, and the film suggests that this is necessary for her to be able to maintain the respect of the men who surround her.

Amid these various forms of masculinity, there is the zombie Bub, whom Dr. Logan chains to a wall and attempts to domesticate with positive and negative reinforcement and by tapping into Bub's basic memories of human behavior. For example, when Bub is given a razor, he drags it across his face as if shaving; when he is given a telephone, he holds it to his ear; and significantly, when Rhodes walks into the room, Bub—who had been in the military when alive—salutes him. Through these responses, Romero perhaps most explicitly drives home the similarities between human and zombie. When Dr. Logan explains his training regimen, he says that zombies can be "tricked into being good little girls and boys, the same way we were tricked." Dr. Logan notably uses the words *girls* and *boys*, rather than gender-neutral terms like *citizens* or *children*. Through Logan's explanation, Romero suggests that gendered behavior is conditioned, and this suggestion deepens the film's thematic connection between humans and zombies. In this light, we must also see the toxic behavior of Rhodes and his men as conditioned; like Bub and the other

zombies, Rhodes and the violent soldiers unthinkingly go through the motions of masculine behavior. The conditioned behavior is reinforced through the fact that the soldiers, as well as Sarah in the first act, refuse to let go of the old world. John and McDermott, on the other hand, have found ways to eschew such conditioning and are willing to move on from both the old world and toxic standards of masculinity. Miguel, meanwhile, struggles in the middle space, unable to adhere to the standards of masculine behavior but equally unable to let them go.

This exploration of conditioned masculine behavior reaches its satirical peak in the climax. After discovering the murdered body of Dr. Logan, Bub visibly cries and then procures a gun with which to hunt down Rhodes for revenge. The sight of the zombie weeping over his murdered patriarch is fundamentally comic and incongruous with our previous expectations of zombie behavior, but his desire for violent revenge is consistent with the character's established masculine conditioning. As Bub hunts Rhodes through the corridors of the bunker, the camera provides frequent long shots of the zombie, gun in hand, framed by walls and doorways. He resembles something of an Old West gunslinger, and in these moments, Romero manages to encourage viewers to root for the zombie rather than the terrified human. Bub shoots Rhodes several times, and eventually, a horde of zombies appears to consume him. Bub salutes Rhodes as he gets devoured.

Bub's salute is a significant moment. Like much of Bub's behavior, there is an incongruent humor to the sight of a zombie saluting. More important, however, is the fact that this salute is clearly intended as ironic (by both Romero and Bub). The irony suggests first that Bub has developed a sense of humor. It also stands in sharp contrast to his earlier, unironic salute. That first salute was presented as a conditioned response to the sight of an officer in uniform. Here, however, the salute suggests that Bub has on some level transcended his conditioned behavior. That this transcendence is presented through an act of ironic defiance speaks to the film's comic sensibility, and the fact that this zombie has managed to form an ironic perspective toward his situation (when many of the films' humans have not) is another instance of Romero's biting satire. Throughout his films, Romero repeatedly draws connections between humans and zombies as a means of commenting on real-world human behavior; here he pushes this idea even further by having a zombie be more sympathetic—and paradoxically more human—than the soldier who gets devoured. In doing so, Romero posits a sense of humor as a fundamentally human attitude and a key step in overcoming our conditioned responses.

Despite its apparent bleakness, *Day* remains one of Romero's most positive and optimistic films, and it helps to separate his work from the degenerative satire of his contemporaries. The ambiguous ending of *Dawn* already pointed in this direction, as the film's Black and female protagonists remain the only survivors and ride a helicopter (with low fuel) into an uncertain future. The woman, however, is pregnant, and Romero allows viewers to at least *hope* that they will find a place of safety to raise the unborn child. The film also never suggests a romantic pairing between these two, which also allows viewers to entertain the idea that they can perhaps break free from old patterns of behavior and form a new way of life. *Day* similarly ends with survivors escaping on a helicopter and even allows us a glimpse of the possible new way of life, as we briefly see Sarah, John, and McDermott relaxing on a tropical beach. Romero edits the ending in such a way, however, that it is unclear if this escape really took place or if it is Sarah's final vision as she is devoured by zombies. As in *Dawn*, however, Romero offers audiences the option of hopefulness. Bub's awakening and ironic salute, however, add a further element of positivity. If an undead zombie can somewhat break free of his conditioning and develop an ironic attitude, then perhaps humans can too.

Romero's Legacy of Horrifying Satire

The influence of Romero's zombie trilogy cannot be overstated. *Night* reconceptualized the traditional zombie film—as epitomized in early Caribbean/voodoo-focused films like *White Zombie* (1932) and *I Walked with a Zombie* (1943)—and created the rules for modern zombies, particularly their desire to consume human flesh and the need to destroy their brain to kill them.[17] In this sense, Romero's influence can be seen not only throughout modern horror cinema but throughout global contemporary popular culture. Zombie films have become a prominent staple of horror cinema, and Romero's version of the zombie can be found throughout popular culture in both America and all over the world.[18] Multimedia franchises like *The Walking Dead* and *Resident Evil* display Romero's influence in comics, television, and video games. Furthermore, Romero's shuffling, flesh-consuming, dead-eyed zombies have proven remarkably adaptable to diverse genres, such as the romantic comedy, the musical, and even the heist movie, as evidenced through films like *Warm Bodies* (2013), *Anna and the Apocalypse* (2017) and *Army of the Dead* (2021). Romero thus basically invented a monster that has proven to be nearly as resilient and malleable as witches, ghosts, and vampires. Finally, the influence of

Romero's apocalyptic, end-of-the-world imagery, which was itself influenced by films like *The Last Man on Earth* and *The Earth Dies Screaming* (both 1964), can be found in a wide range of texts outside of the zombie subgenre, such as *The Happening* (2008) or *A Quiet Place* (2018).

A less visible but equally important facet of Romero's legacy, however, comes through his satirical approach. As James Rushing Daniel points out, Romero "deserves special recognition for his influence on horror's social turn."[19] Indeed, *Night of the Living Dead*'s blend of gore, social commentary, and humor opened the door for several other low-budget and socially aware horror films that appeared throughout the 1970s. Like *Night*, *Last House on the Left*, *Texas Chain Saw Massacre*, and *The Hills Have Eyes* (1977) all peel back the facade of the happy American family and draw connections between the Vietnam War and violence at home. Bob Clark's *Deathdream* (also known as *Dead of Night*, 1974) makes its debt to Romero perhaps most explicit, both through its title and its story of the dead coming back to life. The film is about young soldier Andy Brooks (Richard Backus), who is killed in Vietnam but then returns to his childhood home as a walking corpse, seemingly due to his mother's admonition that he "can't die."

Unlike many other 1970s horror films, *Deathdream* is not a Vietnam allegory but is overtly about the Vietnam War and the struggles of soldiers to readjust to life at home. Andy attempts to fit in with his family, but over the course of the film, it becomes clear that he is a sort of zombie or vampire who needs to feed on human blood to keep his dead body from decaying. The film is more haunting tragedy than satire, but it clearly critiques American involvement in the war and often achieves a sardonic humor in its juxtaposition of Andy's distant and chilling behavior and his family's attempt to pretend everything is normal. In an early scene, for example, Andy's mother tells him that they received a telegram that he had been killed. Andy simply responds, "I was." After a long, awkward silence, Andy forces a grin, and he and his family laugh uncomfortably at the apparent joke. In the emotionally brutal conclusion, Andy, decaying badly, buries himself in a shallow grave beneath a tombstone where he has scratched his own name. His mother looks on, sobbing. The image of a zombie voluntarily *returning* to the grave is both an ironic reversal of *Night* and a darkly comic commentary on the country's inability to help returning soldiers readjust. Released during the final stages of U.S. involvement in Vietnam, *Deathdream* anticipates films like *Taxi Driver* (1976) and *First Blood* (1982) in its direct confrontation of U.S. failure both at home and abroad.

There are also scores of comic zombie films that, like Romero's trilogy, use a variety of comedic devices. Most of these, however, play primarily for laughs and thus step back from Romero's full-fledged social critique. *Return of the Living Dead* (1985), for example, positions itself as an unofficial sequel to *Night* and achieves significant humor through its gore effects, its punk aesthetic, and its shuffling zombies, who speak in this iteration, mostly demanding "brains." The film is very funny, but it does not really participate in any sustained critique or social commentary. The same can be said about Peter Jackson's New Zealand cult classic *Dead Alive* (a.k.a. *Braindead*, 1992). Similarly, recent zombie films like *Zombieland* and its sequel (2009 and 2019), *Life after Beth* (2014), and *Scouts Guide to the Zombie Apocalypse* (2015) are really more comedies than horror movies, and their humor is mostly along the lines of parody and body humor and once again stops short of the social critique that we find in Romero. Most of these films thus develop the comic elements that are already inherent in Romero's work but leave out the critical commentary.

The most common sort of satire that we *do* find in Romero-influenced zombie films comes through a continuation of the "zombies are us" theme that Romero explores throughout his work. Zack Snyder's remake of *Dawn of the Dead* (2004), for example, is scarier than Romero's original (the zombies run!), but it also keeps some of the satire, especially in scenes where the group of survivors has a shopping spree in the mall or when they delight in shooting zombies who resemble celebrities. Released the same year, the British *Shaun of the Dead* is even more satirical and works as both a loving parody of Romero and a commentary on its characters' routinized, disconnected, modern lives. The film makes clear that its protagonist, Shaun (Simon Pegg), and his best friend, Ed (Nick Frost), are little more than zombies themselves, unthinkingly repeating the same routine day after day. The point is made in a hilarious sequence early in the film when Shaun, on his way to work, is so hungover that he fails to notice that a zombie apocalypse occurred overnight. Ed eventually gets bitten and turns into a zombie, but Shaun decides to keep him tied up in a shed. The film ends with Shaun and Ed playing video games together, and it seems that becoming a zombie has changed very little about Ed's "life."

The Canadian zombie comedy *Fido* (2006) is very slight on horror elements but is certainly satirical in its representation of contemporary materialism and family life. The film follows through on Dr. Logan's idea in *Day of the Dead* that zombies can be trained and domesticated. *Fido* imagines a future world where a zombie outbreak was quelled in its early stages and where zombies, tamed through electric collars, can be purchased as

household servants and status symbols. The zombie Fido (Billy Connolly) becomes close friends with a young human boy Timmy (Kesun Loder) and eventually becomes Timmy's surrogate father after Timmy's own father is killed. The film's mise-en-scène is evocative of 1950s sitcoms and, like Romero's films, uses the zombie to critique middle-class consumerism and materialism. Furthermore, *Fido* provides a satirical commentary on the nuclear family by suggesting that the zombie Fido is a better and more attentive father than Timmy's biological father ever was.

Family issues are explored more extensively in the darkly subversive *Mom and Dad* (2017), which resembles *The Crazies* more than Romero's zombie films. *Mom and Dad* posits an apocalyptic scenario where a mysterious radio and television broadcast inverts parental instincts and makes all parents have the sudden urge to kill their children. Early scenes show scores of parents murdering or attempting to murder their offspring, including a disturbing hospital delivery-room scene and a mother leaving her car on the train tracks with her baby strapped inside. Eventually, it settles on one specific family and its teenage siblings' struggle to avoid being killed by their parents. Nicolas Cage plays the father and delivers one of his signature over-the-top performances, including a scene where he sings "The Hokey-Pokey" while demolishing a pool table with a sledgehammer. In a manner that recalls and inverts the conditioning motif in *Day of the Dead*, the film cynically and comically suggests that human behavior is little more than a collection of involuntary instincts and impulses. It also points to latent and repressed hostilities within the nuclear family. The point is made clear in the film's unresolved ending, when the father yells at his children, "Sometimes I just want to—." The credits begin before the father can finish his sentence, but most viewers can fill in the "kill you" for themselves and understand that the homicidal impulse has always been below the surface.

A similarly transgressive strain runs through the film *Cooties* (2014). Here, a batch of bad chicken nuggets causes a zombie outbreak that only affects children. The film focuses on the teachers and staff at an elementary school who attempt to survive the horde of flesh-eating children. Horror films, of course, have a long history of bad children. Typically, however, evil children are seen as an anomaly (as in *The Bad Seed* [1956]) or as not really human at all, as in *Village of the Damned* (1960) or *The Omen* (1976). Here, though, we see hordes of monstrous, zombified children as the film irreverently undermines common conceptions of the sanctity of childhood. By having the heroes be the underpaid staff of an elementary school—who must resort to killing the zombie-children attackers—the

film also suggests the failure and inherent instability of our public education system. Neither *Mom and Dad* nor *Cooties* displays the same level of social awareness as Romero, but they each use a blend of humor and horror to challenge our culture's tendency to place children on a pedestal or to romanticize the roles of those who care for our culture's children—namely, parents and teachers.

Jordan Peele and the Return of Satirical Horror

As we see from the above discussion, satirical horror films did not go away after Romero's zombie trilogy and the wave of socially conscious horror films of the 1970s. Many horror texts continued to offer comic social critiques through the 1980s and 1990s and into the twenty-first century. Unlike Romero's films, however, the majority of these works tended to make social critique a subtext and to allow other forms of humor or horror—namely, comic body horror and self-reflexive parody—to take a front seat. And those films that did offer an explicit social critique tended to not perform at the box office and thus had little effect on the dominant strains of American horror. A case in point is *Day of the Dead* itself, which was a commercial failure when it was released in 1985 and feels like something of a coda to socially conscious 1970s horror. This changed, however, in 2017 with the release of Jordan Peele's *Get Out*, which explicitly announces itself as a socially aware, antiracist horror film. *Get Out* was a commercial and critical success and simultaneously catapulted Peele into horror auteur stardom and opened the door for a new wave of satirical and socially aware horror films that is in full force as of this writing.

Get Out is a game-changing film in a number of ways, but it does have important horror precursors in its satirical treatment of race. The most obvious of these is Romero's zombie films, and Peele has pointed to *Night of the Living Dead*—along with *Rosemary's Baby* (1968), *The Stepford Wives* (1975), and others—as an important influence on his own work. *Night*, for example, is included in the film series "Jordan Peele: The Art of the Social Thriller," which Peele curated for the Brooklyn Academy of Music in advance of *Get Out*'s release.[20] And in a *New York Times* interview, Peele draws direct connections between *Get Out*'s protagonist, Chris (Daniel Kaluuya), and Ben in *Night*, noting that for both characters, "racial perspective is the very skill that helps them."[21] However, there are significant differences. Romero's treatment of race, particularly in *Night*, is subtextual. Ben's Blackness certainly informs audiences' understanding of the film, but race is never explicitly mentioned or discussed. In *Get Out*, on

the other hand, race is the dominant theme from beginning to end, and Peele makes American race relations the key target of his satirical critique.

In this sense, *Get Out* is an exemplar of what Robin R. Means Coleman calls "*Black* horror films," which have an "added narrative focus that calls attention to racial identity."[22] This stands in contrast to what Coleman deems "Blacks *in* horror films." These films "present Blacks and Blackness in the context of horror, even if the horror film is not wholly or substantially focused on either one."[23] Due to the Hollywood establishment's tendency to marginalize both Black characters and filmmakers, "Blacks *in* horror films"—which include Romero's zombie films—are much more common than genuine "*Black* horror films." There are several movies, however, that anticipate both *Get Out's* focus on race and its blending of humor and horror. These include the blaxploitation films *Blacula* (1972), *Scream, Blacula, Scream* (1973), and *Blackenstein* (1973); as well as a handful of 1990s films, including *Def by Temptation* (1990) and the Eddie Murphy vehicle *Vampire in Brooklyn* (1995). The majority of these films, however, are fairly light on satirical critique and instead primarily shift familiar horror narrative tropes into a Black social context.

The horror anthology *Tales from the Hood* (1995), however, is worth singling out, for it explicitly blends humor with horror tropes in order to posit a critique of both White American racism and problems within Black communities, particularly gang violence. The film was released at the tail end of a wave of urban Black social problem films, such as *Boyz in the Hood* (1991), *Juice* (1992), and *Menace II Society* (1993), all of which explore inner-city Black life and focus particularly on gangs and gun violence. *Tales from the Hood* explores similar issues and is about three Black criminals who visit a funeral home hoping to score drugs. While there, the undertaker Mr. Simms (Clarence Williams III) tells the men supernatural stories about the untimely deaths of the various corpses on display. The final story is about a violent Black gangster who is confronted by the ghosts of his Black victims. It is then revealed that the three men actually killed this person and were then subsequently killed themselves. Mr. Simms is actually the devil, and the three men will burn in Hell for eternity.

While the final segment and the wraparound story both feature Black gangsters getting punished for their crimes, other stories explore issues of systemic racism that contribute to inner-city poverty and violence. The first story, for example, is about a principled Black politician who is murdered by three corrupt White police officers. The murdered man comes back from the dead as a vengeful zombie to kill the corrupt officers who

murdered him. Another particularly satirical segment is about Southern politician Duke Metger (Corbin Bernsen), who is attempting to whitewash his racist past, including KKK membership, but ends up being killed by a collection of dolls possessed by the spirits of brutally slaughtered slaves. Duke Metger is a barely veiled reference to David Duke, a former KKK Grand Wizard who ran for public office several times and managed to get a seat as a Louisiana state representative in 1989. Furthermore, the story of violent and racist police officers recalls the Rodney King beating and the subsequent Los Angeles riots after the officers who beat him were acquitted. As in Romero's films, *Tales from the Hood* draws direct connections between its horror stories and real events. Furthermore, the stories all have a comic-book aesthetic—inspired in part by Romero's own EC Comics homage *Creepshow*—with exaggerated characters and a humorous sensibility throughout. The blending of horror elements with both broad humor and social commentary thus makes *Tales from the Hood* a rare satirical horror film for the 1990s.

In its satirical attack on racist institutions, *Tales from the Hood* works not only as horror but also as part of a larger tradition of Black satire in the United States, which can be traced back at least to Charles Chesnutt's late-nineteenth-century short stories. Jordan Peele's *Get Out* is part of this same tradition in the ways that it critiques racist systems of oppression and uses humor to give voice to a specifically Black American perspective. Lisa Guerrero argues that "black satire serves to both critique society *and* legitimate black rage in a society that systematically invalidates black rage."[24] Similarly, Terrence T. Tucker posits the term "comic rage," which he defines as an "African American cultural expression that utilizes oral tradition to simultaneously convey humor and militancy."[25] Tucker goes on to explain that comic rage is "a vital source of cultural expression that actively reveals the perpetuation of white supremacist hegemony through its mixture of tones and inversion of traditional discourse."[26] Tucker's definition applies nicely to *Get Out*, which also has a mixture of tones and uses humor and horror to suggest the ongoing legacy of American racism.

Get Out tells the story of an affluent White family (the Armitages) that kidnaps Black people in order to transplant the minds of rich White people into their bodies. The main character, Chris, is lured to the Armitage estate by his girlfriend, Rose Armitage, who sets him up to be auctioned off. The film's early scenes—as discussed in the previous chapter—utilize an uncomfortable awkward humor in which the true sinister intent of the film's White characters is hidden behind comic racial cluelessness and microaggressions. The film's most pointed satirical moments, however,

come through its unveiled representation of the White plot to steal Black bodies and through the humorous monologues of the apparent comic-relief character Rod (Lil Rel Howery). These satirical elements root the film in a Black perspective and establish it as a site of comic rage.

Get Out's satire is most apparent through its representation of two White characters who initially appear to be progressive and sympathetic. The first is Jim Hudson (Stephen Root), a blind art dealer who is familiar with Chris's work as a photographer. Remarking on the other guests at the Armitages' house, Jim says, "They mean well, but they have no idea what real people go through." From the brief conversation, it seems that Chris and Jim have formed an actual bond. As it turns out, though, Jim wins the auction for Chris's body and wants it so that he can regain his sight. Later, Chris asks, "Why us? Why Black people?" Jim's response highlights the film's racial critique. "Who knows," he says. "People want to change . . . to be stronger, faster, cooler." Even as he explains this, though, Jim hopes to not be perceived as racist: "Please don't lump me in with that. I could give a shit what color you are." There is of course a bitter irony in a White man pleading not to be perceived as racist even as he steals a Black man's body.

This scene, in which the true depth of the White characters' evil is revealed, works primarily as horror. However, there is also a subtle joke in this exchange. Jim's response, and his identity as a blind man, tie him to the idea of "color-blindness," a term used when people profess to not "see color" or take race into consideration in any way. The metaphor of color-blindness has been roundly debunked by social scientists, who have explained that instead of ignoring race, color-blindness actually ignores the systemic inequalities that are caused by race. Peele makes this precise point with Jim Hudson. As a blind man, Jim literally cannot see race; this is reinforced by his claim that he does not "give a shit" about what color Chris is. Despite his color-blindness, however, Jim is more than happy to benefit from a racist system that profits from the theft and exchange of Black bodies. Through the literalization of metaphor, Peele thus satirizes White complicity with systems of racist oppression.

The other seemingly good White person is Chris's girlfriend, Rose. In an early scene, as they are driving to the Armitage estate, Rose defends Chris in front of a racist White police officer, and her apparent "woke-ness" is reinforced throughout most of the film. She reacts with shock at the inappropriate behavior of her parents' guests, and she intuits Chris's discomfort throughout the day and seeks to calm him. The final act reveals that Rose is not only a part of the plot to steal Chris's body but that she has been manipulating him all along and has similarly seduced

many other Black people for her family's modern slave trade. Peele uses Rose to subvert both the White savior myth and the historical association between innocence and White femininity. The primary White character who viewers expected (and hoped) would be Chris's ally turns out to be the person who leads him most directly into danger. There is additional irony in that Rose proves much better than her awkward family at convincingly performing progressiveness. Her skilled performance allows her to participate in the most intimate sort of betrayal.

In a late scene, after she believes that Chris has been subdued, Peele uses humor to fully drive home the horrific nature of Rose's character and to suggest the pleasure she finds in her role as predator. Rose sits in her room wearing a white button-up shirt, eating dry Froot Loops, and drinking a glass of white milk with a straw. She listens to the Bill Medley and Jennifer Warnes's song "(I've Had) The Time of My Life" and looks up Black NCAA prospects on her computer. At the end of the brief scene, the camera pulls back, and we see Rose sitting cross-legged on her bed, and several framed photographs of Rose posing with her previous Black conquests are displayed on the wall behind her. The scene underscores Rose's White supremacy. The color white, through Rose's shirt and the glass of milk, is quite prominent, and that she keeps her "colored" cereal separate from her white milk suggests her desire to maintain the purity of Whiteness even as she celebrates her past conquests and begins the hunt for her next victim.

While the scene establishes Rose as a terrifying villain, Peele once again mixes humor with horror to drive the film's satirical vision of Whiteness. The children's cereal and the glass of milk (with a straw!) render Rose childlike, but this aspect is countered by the collection of framed photographs and Rose's current task of looking for another Black person to steal. The music, though, really drives the humor. "(I've Had) The Time of My Life" is the theme song for the eighties romance *Dirty Dancing* (1987) and has since become a cultural touchstone; a staple of high school proms and karaoke, the song is frequently covered and has been used on television shows like *Glee* and *Dancing with the Stars*. Its connotations with romance and youth work, like the Froot Loops, to create a sense of innocence that is comically contrasted with the horrifying context. The song itself is a duet between a male and female singer; in *Dirty Dancing*, it is used in the finale and features dance moves that the protagonists worked on throughout the film. Its use in *Get Out* is thus highly ironic: its connotations of collaboration and romance are flipped when Rose uses the song to celebrate her seduction and domination of

Black people. Finally, the lyrics and title drive home that for Rose, seducing and stealing Black people is more than just support for the family slave trade: she's had the time of her life. *Get Out*'s horrifying and satirical treatment of Whiteness, then, is perhaps most biting in its representation of Rose.

In stark contrast to these characters, *Get Out* has one Black character, Chris's best friend Rod, who most fully embodies an authentic Black voice and who establishes the film as a site of comic rage. Tucker explains that comic rage is "rooted in and fueled by an African American vernacular tradition that has its roots in the culture of the black working class and underclass, often referred to as black folk culture."[27] In mass media, the most common manifestation of such Black folk culture is found in African American stand-up comedy. It is thus fitting that Peele cast stand-up comedian Lil Rel Howery to play Rod. Howery brings his comic persona to the role, and the character is *Get Out*'s most explicit connection to "the African American vernacular tradition." Through Rod, Peele establishes the Black humorist as truth-teller, recognizing realities that others cannot or will not see.

At first, Rod seems to exist simply for comic relief. When audiences meet him, he is presented as a funny character who speaks in a Black vernacular and sees danger everywhere, and his job as a TSA agent gives him many opportunities to find potential threats. In his first conversation with Chris, Rod complains about having gotten in trouble for "patting down an old lady." He goes on to assert, in a short rant that would work nicely in a stand-up routine, that his boss thinks "just 'cause a elderly bitch is elderly, she can't hijack no motherfuckin' plane." Rod's profanity, along with the incongruity of suspecting an elderly woman to be a hijacker, renders Rod's speech comic and establishes him as somewhat paranoid. However, by the end of the film, it becomes clear that Rod's comic voice is also the voice of truth, for the narrative establishes that danger really can be anywhere and that even the elderly can be threatening. In this sense, Rod also speaks on behalf of an imagined Black audience, warning Chris of dangers to which he is oblivious. In this first conversation, Rod warns Chris, "Don't go to a White girl parents' house." Fittingly, in the final scene—after Rod rescues Chris from the Armitage estate and as Chris sits traumatized—Rod says, "I told you not to go in that house." Bookending Rod in this manner establishes him as most in tune with the dangers facing Black people in America.

As such, Rod comprehends the specific dangers that Chris faces well before Chris himself. At one point, Chris calls Rod and admits that Rose's

mother (Catherine Keener) hypnotized him to help him quit smoking (this hypnosis actually lays the groundwork for taking over Chris's body). Rod's response is a telling mix of humor and horror: "Bro, how you not scared of this, man? Look, they could have made you do all types of stupid shit. Have you fuckin' barking like a dog, flying around like you a fuckin' pigeon, lookin' ridiculous . . . or, I don't know if you know this, but White people love making people sex slaves and shit." This is funny because of the hyperbole, the profanity, and Howery's well-timed delivery. The content, however, is deadly serious. Rod's suggestion that the Armitages may have Chris acting like a dog or a pigeon points to an awareness of the long history of Whites treating Black people like animals. Similarly, Rod's discussion of "sex slaves" points to both slavery and the long history of sexual exploitation of Black people. The irony of all this is that Rod's description is pretty much right: there is danger in Chris's hypnosis, and White people are getting sexual gratification from the Black bodies they steal.

Significantly, Rod does much more than simply interpret and comment on Chris's danger. In the last act, he becomes an important player in the narrative, and in a few scenes, the film's action shifts to his point of view. When Rod loses contact with Chris, he begins his own investigation. In a particularly funny scene, Rod attempts to convince the police to intervene. Rod first explains the situation to a Black female officer who then brings in two male officers; one is Black, and the other is Latino. Rod again explains the situation in a manner that is both comic and very close to accurate: "They're probably abducting Black people, brainwashing them, and making them slaves, or sex slaves, not just regular slaves, but sex slaves and shit. See, I don't know if it's the hypnosis that's making them slaves or whatnot, but all I know is, they already got two brothers we know, and there could be a whole bunch of brothers they got already. So what's the next move?" Upon Rod finishing his speech, the three officers erupt into laughter, and it turns out that the first officer only called in her colleagues so that they too could appreciate the humor in Rod's seemingly ridiculous claims. The officers' laughter works as a punchline to Rod's already comic explanation. Furthermore, as Jennifer Ryan-Bryant points out, "in spite of their own experiences as people of color, it is clear that none of these officers find Rod's concerns viable."[28] In this light, Rod is once again quite funny but is simultaneously the most perceptive character in the film. Throughout the film, Peele thus uses humor to drive his antiracist critique.

Peele's follow-up *Us* (2019) continues his use of horror tropes to explore social issues. Although its cultural critique is less specific and its

use of humor is less overt, *Us* still operates as satirical horror, and many of the film's images and themes are explicitly Romero-esque. The film tells the story of the Wilsons, a vacationing middle-class Black family who are attacked by monstrous versions of themselves. As it turns out, these sorts of attacks are widespread, and presumably everyone in the country has a shadow self, referred to as the "Tethered," living underground and going through the motions of the privileged lives of their surface-level counterparts. While the central family kills their shadow selves and survives, the fate of the rest of the country is left unclear. In the film's final twist reveal, we learn that the main character Adelaide (Lupita Nyong'o) was actually born in the underground and managed to steal the "real" Adelaide's identity when they were both young girls. In turn, the original Adelaide—billed in the credits as Red—used her knowledge of the surface world to lead the Tethereds' uprising.

Unlike *Get Out*, which draws attention to prejudice and racial inequality in very direct ways, *Us*'s central situation of the Tethered living underground can be read as a metaphor for any number of systems of privilege and oppression. Economic inequality, however, is the most obvious, as the Tethered are a literal underclass. The point is most explicit when Red, the only Tethered who can speak, identifies herself and the other Tethered as "Americans," suggesting that such a stark system of blatant inequality is endemic to the American experience. The fact that the originally Tethered Adelaide manages to thrive above ground suggests that class differences are arbitrary, and there is nothing inherently superior about those who live above. In this sense, the film also places viewers in the precarious ideological position of rooting *against* the underprivileged revolutionaries and siding with the bourgeois in the defense of their middle-class comforts. The film's ending throws viewers for an additional loop, as we realize that the protagonist we have been identifying with is actually a member of the underclass who has stolen her position in the surface world. In this manner, *Us* encourages viewers to interrogate their own unearned privileges and class positionality.

Peele uses several comic elements in order to drive his critique. First, the film makes heavy use of parody and intertextual allusion. The opening shot, for example, shows a television set with various VHS tapes stacked around it. These tapes include the horror films *A Nightmare on Elm Street* (1984) and *C.H.U.D.* (1984); the latter also deals with monsters who live underground. Many of the film's key scenes are filmed on the same boardwalk in Santa Cruz, CA, where the teen vampire film *The Lost Boys* (1987), discussed in chapter 4, was also filmed. The references to *The*

Lost Boys also tie the film indirectly to the Peter Pan story, and like the Tethered, Peter Pan's shadow occasionally goes rogue. This connection is reinforced through an early, beautiful overhead shot of the family walking along the beach with their long shadows stretched beside them. Additionally, throughout much of the film, Adelaide's son Jason (Evan Alex) wears a *Jaws* (1975) T-shirt, and there is a brief sequence of shots of Adelaide looking around the beach that parodies the famous sequence of shot/reverse shots in *Jaws* when Chief Brody scans the ocean for the shark. These various allusions and references operate like much of horror's parody, as outlined in chapter 1; they reward sharp-eyed viewers, create distance, and encourage audiences to think about the film's larger cinematic context.

Romero is an important part of this context. While *Us* does not, to my knowledge, reference Romero's apocalyptic satires directly, they loom over the film. In fact, *Us*'s entire premise works as a literalization of the "zombies are us" theme that Romero develops throughout his original zombie trilogy. (It also works as a literalization and extension of the mirrored good and bad families in Wes Craven's *The Last House on the Left* and *The Hills Have Eyes*.) The Tethered are not exactly zombies, but they share many qualities with Romero's Living Dead, especially in their shambling impersonations of human behavior. A particularly funny and chilling example of the Tethered impersonating their above-ground counterparts comes after the Wilsons' friends the Tylers are murdered by their own shadow selves. Kitty Tyler's shadow, billed as Dahlia (Elizabeth Moss), primps in front of the mirror. Her face spattered with blood, Dahlia applies lipstick and smiles at herself in a grotesque imitation of her counterpart's beauty rituals. This and other moments recall the scenes in *Dawn of the Dead* when the zombies shuffle around the mall in a dark satire of American consumerism.

As in Romero's films, the satire is also directed at the behavior of the human characters. Much of *Us*'s humor is driven by the interactions of the central family, which has a level of sitcom charm. The father, Gabe (Winston Duke), personifies the "goofy dad" stereotype. The comic family elements, however, are not solely comic relief. First, they normalize middle-class Black families in a way that is still rarely seen in American film. More important, the comic family moments contribute to the film's exploration of class. One particularly funny scene, for example, occurs after Gabe buys a used motorboat and shows it off to his family, who look on with amused skepticism. Gabe's nerdy appreciation of the boat is quite funny. We later learn, though, that Gabe wants the boat, in part, because the Tylers, a wealthier White family, also have a boat. There are numerous other suggestions that the Wilsons are envious of the Tylers' wealth.

When they first escape their doppelgängers, the Wilsons immediately go to the Tylers' house, only to find the whole family murdered. Once they fight off the Tethered Tylers, Gabe and the Wilsons want to stay in their much more lavish house indefinitely. When Adelaide convinces them that they have to keep moving, their main consolation is that they can take the Tylers' more expensive car. These examples make clear that the Wilsons are envious of the Tylers in much the same way as the Tethered to their surface-world counterparts. Like Romero in *Dawn*, Peele thus satirically mocks middle-class American materialism.

Peele extends this critique to the national level by connecting the Tethereds' uprising to the Reagan-era "Hands Across America" campaign. This fundraising effort's stated goal was to have millions of Americans hold hands across the country for fifteen minutes in order to raise money and awareness for homelessness and hunger. *Us*'s prologue refers directly to the campaign, and it is later revealed that a Hands Across America T-shirt partly inspired Red as she planned the Tethereds' uprising. In the finale, Red explains to Adelaide that the Tethereds' goal is to "make a statement." This statement repeatedly takes the form of a hand-holding line. Red draws stick figures of people holding hands, creates paper cutouts of the same, and when the Tethered Wilsons first reveal themselves, they stand in a line, holding hands. Finally, the film's last image consists of an overhead shot of thousands of the Tethered holding hands, across miles of fields and hills. The result is a darkly comic parody of the actual Hands Across America event. In real life, the campaign managed to raise about fifteen million dollars for charity (far short of its stated goal), but it arguably only brought visibility to the privileged hand holders, not to the needy whom it gave lip service to. The Tethereds' uprising, on the other hand, brings real awareness, but with that true awareness comes fear, as it threatens our privileged lives.

The Shadow of Jordan Peele on Contemporary Horror

While Romero's status as one of horror's most important auteurs is well-established, it is too soon to speak definitively about Peele's place in the genre, for as of this writing, he has only written and directed three films. All signs, however, point to his being one of the twenty-first century's most important horror filmmakers. In addition to helming *Get Out*, *Us*, and his third feature, *Nope* (2022),[29] Peele served as an executive producer for the rebooted *Twilight Zone* series (2019–2020) and took the place of Rod Serling as the narrator. He produced the acclaimed HBO horror

series *Lovecraft Country* (2020) and is a writer and producer for the *Candyman* reboot (2021). He has even made a mark outside of horror as a producer for Spike Lee's *BlacKkKlansman* (2018).

More important, however, is the general influence that Peele's films—especially *Get Out*—have had on horror as a whole. This influence can be seen in two overlapping ways. First, due to the critical and commercial success of *Get Out*, Hollywood executives seem to finally understand that Black-led horror films can be profitable and appeal to a wide (and White) audience. In the wake of *Get Out*, Black characters have a much more prominent position in several horror texts, as can be seen in films like *Slice* (2018), *Escape Room* (2018), *Thriller* (2018), *Ma* (2019), *Antebellum* (2020), and *Master* (2022); in television series like *Lovecraft Country* and *Them* (2021); and in international releases like *Little Monsters* (2018) and *His House* (2020). Second, post–*Get Out* horror often grapples more directly with social themes than that of any era since the 1970s. Significantly, many horror films since *Get Out* do not feel the need to bury their social commentary in metaphor but rather confront social issues directly. For example, the 2020 remake of *The Invisible Man* is explicitly about domestic abuse, and the film makes it clear that the villain was monstrous well before achieving invisibility. A similarly direct approach to social ills can be found in *Antebellum*, the Canadian film *Spiral* (2019, not to be confused with the *Saw* spinoff), and the very creepy *Lucky* (2020), about a woman who must fend off the same masked attacker day after day without anyone believing her. *Get Out* does not deserve all the credit for this wave, for nearly all media became increasingly politicized during the Trump era. *Get Out*, however, helped make horror a legitimate space for exploring systemic issues.

A part of this space includes satirical horror. Many of the above-mentioned texts have a satirical bent, and since *Get Out*, numerous satirical horror films have blended humor, horror, and social critique. There have been, for example, two sequels to *Tales from the Hood* (2018 and 2020), both of which continue the original film's satirical approach to the horror anthology film. Other post–*Get Out* satirical horror films include *Bad Hair* (2020) and *Vampires vs. the Bronx* (2020), the latter of which makes a group of ancient White vampires responsible for the attempted gentrification of a multiethnic Bronx community. The film thus comically literalizes the metaphor of White people "sucking the blood" out of ethnic communities. The Canadian satire *Slaxx* (2020) confronts global labor exploitation with the comic premise of a pair of designer blue jeans possessed by the soul of a sweatshop worker out for vengeance. The scenario

encourages viewers to think about the ways in which their seemingly innocuous purchases may be contributing to larger systems of inequality.

While there is not space to fully discuss most of the films in the current wave of satirical horror, *Culture Shock* (2019), which uses humor and horror devices to confront United States–Mexico border issues, is worth singling out for more attention. Directed by Gigi Saúl Guerrero, *Culture Shock* is part of Hulu's horror anthology series *Into the Dark* (2018–), which releases a holiday-themed horror film each month. The majority of the films in *Into the Dark* are satirical in some manner, but most are fairly mediocre. The Fourth of July–themed *Culture Shock*, however, is a standout entry, which immediately received positive critical attention as well as many comparisons to *Get Out*.[30] Furthermore, it is one of only a handful of U.S.-produced horror films that address Latinx identity and immigration issues.

The first third of *Culture Shock* does not have traditional horror genre elements but is horrifying in its representation of an immigrant's journey to the United States. The main character is a pregnant Mexican woman, Marisol (Martha Higareda), who is making her second attempt to cross the border. The child she carries is the result of a rape that occurred during her previous attempt, and her journey is made harder by sexually violent men, corrupt smugglers, and the activity of drug cartels. These early scenes are dimly lit and filmed with a handheld camera, and the characters speak only Spanish. These elements combine to give the film a sense of gritty realism. This changes drastically once Marisol and the other migrants are seemingly captured by the border patrol. Without any explanation, Marisol suddenly wakes up, no longer pregnant, in a stereotypically idyllic American town, full of happy, kind White people and English-speaking Latinx immigrants, many of whom Marisol recognizes from her journey. Here, bright colors and high-key lighting replace the grim and gritty mise-en-scène of the first third. There is an endless supply of food, which the assimilated immigrants eat voraciously, and Marisol's White caretaker Betty (Barbara Crampton), who also cares for Marisol's apparently recently delivered child, tells her that she is in "America now: the land of plenty."

The stereotypical American town is the film's greatest source of both humor and traditional horror elements, and the two combine to create satirical horror. The vast visual disparity between the early, realistic scenes and the bright, otherworldly feel of the American town serves as a striking example of the tonal mixture that often characterizes satire. The town itself registers as both comically ridiculous and eerily creepy. It seems to

be in a perpetual state of preparation for an Independence Day celebration, and the streets are decorated with a hyperbolic number of American flags; red, white, and blue balloons; and other patriotic decorations. Most eerie, however, are the immigrants who comprise the townspeople. Most are visibly Latinx in their heritage, but like the deracinated Black characters in *Get Out*, they dress in stereotypical 1950s-era American clothes and speak in Americanized English. When Marisol attempts to speak to people she knows, they don't seem to remember her, and only give her creepy, wooden smiles. Marisol finally gets through to her friend Santo (Richard Cabral), but when he regains his identity, he stabs himself with a steak knife in a sudden fit of violence. The next day, however, Santo is back in town with a creepy smile on his face. In many ways, the townsfolk thus resemble zombies, and *Culture Shock* draws not-so-subtle connections between cultural assimilation and brainwashing.

Marisol is rightfully suspicious of her seemingly perfect new home and its brainwashed inhabitants. As it turns out, the town is actually a *Matrix*-style virtual simulation generated by a private company hired by the government to solve the border crisis. Significantly, the company is also part of the prison industrial complex, and one character describes their operation as creating a "virtual holding cell" for illegal immigrants. The immigrants themselves are tied to metal tables, hooked up to VR machines, and fed a brown sludge through a feeding tube. There is a particularly comic and disturbing scene that cuts between the town's residents happily eating barbecue and their actual bodies, strapped to tables while the brown sludge is pumped down their throats. The horror/sci-fi scenario symbolically and satirically suggests that the American Dream is a hollow illusion, constructed by the powerful to keep people in their place. Marisol herself comes to this same conclusion. At the end of the film, she and the other immigrants manage to free themselves from the illusion and escape the holding area. In reality, Marisol is still pregnant and gives birth during the escape. While the majority of the immigrants turn north, toward the United States, only Marisol turns around to go home with her new baby. The virtual American Dream, the film suggests, is more than enough America for her.

Conclusion

The most common approaches to horror suggest that it primarily works as a dark mirror for our culture. Horror *reflects* cultural anxieties, or horror *projects* social fears, or perhaps horror helps viewers to channel or

work through what we repress or find revolting. As Robin Wood says, "Horror films are our collective nightmares."[31] All this is undoubtedly true. As we have seen throughout this book, however, horror also works as a funhouse, reflecting not only our fears but also its own stable of icons and genre conventions. Furthermore, horror also makes us laugh through its comic monsters and outrageous bodies. Horror is also often a space where filmmakers and audiences can play with, destabilize, and even overturn our culture's rigid notions of gender and sexuality. Sometimes horror is painfully awkward, and the line between laughter and discomfort becomes so blurred that the two are virtually indistinguishable.

And as we have seen in this chapter, horror can use its humor to not only reflect our culture but critique it. It seems that this sort of horrifying satire is particularly conducive to times of national trauma or turmoil. When Romero, horror's most important satirist, started producing his work, the country was embroiled in an unpopular war overseas, and the civil rights movements were revealing our failures at home to adhere to our basic ideals. Films like *Night of the Living Dead*, *The Crazies*, and later *Dawn of the Dead* provided stories and images that not only reflected that cultural turmoil but also used humor to express indignation and critique our failures. Other horror filmmakers of the period followed suit and provided the first major wave of satirical horror. Similarly, Jordan Peele—Romero's heir apparent—entered the horror genre right after the election of our country's most controversial president and on the cusp of renewed national reckonings with racial and gender inequality. While the full legacy of Peele's horror has yet to be determined, he has already ushered in a second wave of satirical horror that gives audiences an avenue through which to understand, laugh at, and critique our ongoing national struggles.

ACKNOWLEDGMENTS

WRITING A BOOK often feels to me like a deeply selfish activity. I am thus immensely grateful to all my family, friends, and colleagues who not only tolerated my odd obsession with funny horror but actively supported me in the work. This support begins at my institution, the University of Wisconsin, Platteville. I wrote the bulk of this work in spring 2021 while on sabbatical and am very thankful that the university continued to support faculty research during both a budget crisis and a global pandemic. I am also grateful to my colleagues in the humanities department who stepped in to cover my committee assignments during my absence and to the staff at the Karrmann Library who, despite the pandemic, managed to procure for me all my research materials (and who also forgave quite a few late fees).

I presented sections of this book at national conferences for the Popular Culture Association and the Modern Language Association, and this work was made stronger by all the encouraging feedback I received. I also had the opportunity to present and discuss this entire project at a "Books-in-Progress" forum sponsored by the American Humor Studies Association and was buoyed by the support and enthusiasm of my fellow humor scholars. The leadership team at AHSA also organized a series of online forums and workshops throughout the pandemic. These virtual get-togethers fostered a much-needed sense of community during a time when we were all locked in our homes. Thank you! Thanks also go to the entire staff at Rutgers University Press, particularly Nicole Solano, who has offered enthusiastic support from the start. I am also grateful to copy editor Hannah McGinnis for her sharp eye and for cleaning up my sloppy endnotes.

I've loved movies for longer than I can remember, and my mom, Ferne Gillota, is the main reason for that. Thanks, mom, for taking me to the movies just about every week when I was growing up, especially since so

many of those movies you had no desire to see. Thanks also for letting me watch horror from a very young age. My son Isaac, twelve years old as I write this, came up with the title for this book. Thanks, Isaac! I'm amazed every day by your intelligence and sense of humor. Also, sorry for all the times when I left my "horror books" face up. Amanda! What can I say? I hope you know how much you mean to me. I would have never written this, or done much of anything, without your love and support.

Small portions of chapters 5 and 6 were previously published in "'Man, I Told You Not to Go in That House': The Humor and Horror of Jordan Peele's *Get Out*." *Journal of Popular Culture* 54, no. 5 (October 2021): 1031–1050. They are reprinted here with permission.

NOTES

Introduction

1. Quoted in Xan Brooks, "Alfred Hitchcock: 'Psycho Was a Joke,'" *Guardian*, February 8, 2013, https://www.theguardian.com/film/2013/feb/08/alfred-hitchcock-psycho-joke.

2. Stephen King, *Danse Macabre* (New York: Penguin, 1987), 122.

3. Carol Clover, *Men, Women, and Chain Saws: Gender in the Modern Horror Film* (Princeton: Princeton University Press, 1992), 20.

4. Robin Wood, "The American Family Comedy: From *Meet Me in St. Louis* to *The Texas Chainsaw Massacre*," in *Robin Wood on the Horror Film*, ed. Barry Keith Grant (Detroit: Wayne State University Press, 2018): 171–180.

5. For a discussion of horror's genrefication in the 1930s, see chapter 1 of Murray Leeder, *Horror Film: A Critical Introduction* (New York: Bloomsbury, 2018).

6. Clover, *Men, Women, and Chain Saws*, 5n5.

7. Bruce G. Hallenbeck, *Comedy-Horror Films: A Chronological History, 1914–2008* (Jefferson, N.C.: McFarland, 2009).

8. William Paul, *Laughing Screaming: Modern Hollywood Horror and Comedy* (New York: Colombia University Press, 1994).

9. Cynthia J. Miller and A. Bowdoin Van Riper, eds., *The Laughing Dead: The Horror-Comedy Film from "Bride of Frankenstein" to "Zombieland"* (Lanham, Md.: Rowman and Littlefield, 2016); John A. Dowell and Cynthia J. Miller, eds., *Horrific Humor and the Moment of Droll Grimness in Cinema: Sidesplitting sLaughter* (Lanham, Md.: Lexington, 2018).

10. Linda Williams, "Discipline and Fun: Psycho and Postmodern Cinema," in *Reinventing Film Studies*, ed. Christine Gledhill and Linda Williams (London: Oxford University Press, 2000), 351–370; Murray Leeder, "Collective Screams: William Castle and the Gimmick Film," *Journal of Popular Culture* 44, no. 4 (2011): 773–795.

11. For a survey of humor theory, see Simon Critchley, *On Humour* (London: Routledge, 2002). For a survey of horror theory, see Leeder, *Horror Film*.

12. Noël Carroll, "Horror and Humor," *Journal of Aesthetics and Art Criticism* 57, no. 2 (1999): 145–160, 146.

13. Sigmund Freud, *Jokes and Their Relation to the Unconscious*, trans. James Strachey (New York: Norton, 1960).

14. Robin Wood, "An Introduction to the American Horror Film," in Grant, *Robin Wood*, 73–110, 79.

15. Robin Wood, "Return of the Repressed," in Grant, *Robin Wood*, 57–62, 59.

16. John Morreall, *Comic Relief: A Comprehensive Philosophy of Humor* (West Sussex, U.K.: Wiley-Blackwell, 2009), 11.

17. Noël Carroll, *The Philosophy of Horror* (New York: Routledge, 1990), 176.

18. Carroll, "Horror and Humor," 154.

19. For a discussion of laughter as affect, see Maggie Hennefeld, "Affect Theory in the Throat of Laughter: Feminist Killjoys, Humorless Capitalists, and Contagious Hysterics," *Feminist Media Histories* 7, no. 2 (2021): 110–144.

20. Leeder, *Horror Film*, 133–136.

21. Anna Powell, *Deleuze and Horror Film* (Edinburgh: Edinburgh University Press, 2005), 2. Also see Xavier Aldana Reyes, "Beyond Psychoanalysis: Postmillennial Horror Film and Affect Theory," *Horror Studies* 3, no. 2 (2012): 243–261.

22. Linda Williams, "Film Bodies: Gender, Genre, and Excess," *Film Quarterly* 44, no. 4 (1991): 2–13.

23. Henri Bergson, *Laughter: An Essay on the Meaning of the Comic*, trans. Cloudesley Brereton and Fred Rothwell (Mansfield, Conn.: Martino, 2014), 5.

24. See Alice Raynor, "Creating the Audience: It's All in the Timing," *The Laughing Stalk: Live Comedy and Its Audiences*, ed. Judy Batalion (Anderson, S.C.: Parlor, 2012), 28–39; Moira Smith, "Humor, Unlaughter, and Boundary Maintenance," *Journal of American Folklore* 122, no. 484 (2009): 148–171; and David Gillota, "Stand-Up Nation: Humor and American Identity," *Journal of American Culture* 38, no. 2 (2015): 102–112.

25. See, for example, Robin R. Means Coleman, *Horror Noire: Blacks in American Horror Films from the 1890s to Present* (New York: Routledge, 2011); and Harry M. Benshoff, *Monsters in the Closet: Homosexuality and the Horror Film* (New York: Manchester University Press, 1997).

Chapter 1: Parodying Horror, Horror as Parody

1. See Matt Hills, *The Pleasures of Horror* (New York: Continuum, 2005) for both a survey of relevant theories on horror's pleasures and an argument about horror's pleasures being primarily performative.

2. John Morreall, "Humor as Cognitive Play," *Journal of Literary Theory* 3 no. 2 (2009): 241–260, 255.

3. See the introduction to this book and Bergson, *Laughter*.

4. Linda Hutcheon, *A Theory of Parody* (Chicago: University of Illinois Press, 2000), xii.

5. Hutcheon, 51–53.

6. Dan Harries, *Film Parody* (London: British Film Institute, 2000), 126, emphasis original.

7. Simon Dentith, *Parody* (New York: Routledge, 2000), 6, 16.

8. Dentith, 17.

9. Hutcheon, *Theory of Parody*, 33.

10. Rick Altman, *Film/Genre* (London: Palgrave Macmillan, 1999).

11. Harries, *Film Parody*, 9.

12. Harries, 6.

13. Steve Neale, *Genre and Hollywood* (New York: Routledge, 2000), 14–15.

14. Among other works, see chapters 9 and 10 of Hills, *Pleasures of Horror*; and chapter 1 of Isabel Cristina Pinedo, *Recreational Terror: Women and the Pleasures of Horror Film Viewing* (Albany: SUNY Press, 1997).

15. Clover, *Men, Women, and Chain Saws*, 168.

16. Valerie Wee, "The *Scream* Trilogy, 'Hyperpostmodernism,' and the Late-Nineties Teen Slasher Film," *Journal of Film and Video* 57, no. 3 (2005): 44–61, 44, emphasis original.

17. Harries, *Film Parody*, 108. Also see Stanley Fish, *Is There a Text in This Class? The Authority of Interpretive Communities* (Cambridge, Mass.: Harvard University Press, 1982).

18. Hills, *Pleasures of Horror*, 73–90.

19. Mark Kermode, "I Was a Teenage Horror Fan: Or, 'How I Learned to Stop Worrying and Love Linda Blair,'" in *Ill Effects: The Media/Violence Debate*, ed. Martin Barker and Julian Petley (New York: Routledge, 1997), 48–55, 50.

20. Kermode, 51.

21. Morreall, "Humor as Cognitive Play," 255.

22. Thomas M. Leitch, *Find the Director and Other Hitchcock Games* (Athens: University of Georgia Press, 1991), 2.

23. One ad for the film proclaimed, "The Daddy of 'em All! The Monster of *Frankenstein* plus the monster of *Dracula*, plus the 'monstrousness' of Edgar Allan Poe—all combined by the master makers of screen mysteries to give you the absolute apex in supershivery!" Quoted in anonymous review of *The Black Cat*, directed by Edgar Ulmer, Filmsite, accessed December 6, 2022, https://www.filmsite.org/blac.html.

24. See, for example, "References/Other Media/Movies," Friday the 13th Films, accessed December 6, 2022, http://www.fridaythe13thfilms.com/media/references/movies.html; and "References in Other Media," A Nightmare on Elm Street Wiki, accessed December 6, 2022, https://nightmareonelmstreet.fandom.com/wiki/References_in_Other_Media.

25. *Jason Lives* is generally considered the most comic and playful film of the *Friday the 13th* franchise. For a discussion of its comic elements, including subtle references to classic Universal monster films, see Brian Fanelli, "No Clowning around: The Gothic and the Comedic Elements of *Friday the 13th Part VI: Jason Lives*,"

Horror Homeroom, special issue 1 (Spring 2020), http://www.horrorhomeroom.com/no-clowning-around-the-gothic-and-comedic-elements-of-friday-the-13th-part-vi-jason-lives/.

26. For a discussion of *The Funhouse* in relation to familial tensions, see Tony Williams, *Hearths of Darkness: The Family in the American Horror Film* (Jackson: University Press of Mississippi, 2014), 203–206.

27. Bruce Kawin, "*The Funhouse* and *The Howling*," *American Horrors: Essays on the Modern American Horror Film*, ed. Gregory A. Waller (Chicago: University of Illinois Press, 1987), 102–113, 112.

28. Kawin, 111.

29. Williams, *Hearths of Darkness*, 205.

30. Cunningham often appears in documentaries about the horror genre where he discusses the details of *Friday the 13th*'s creation. See *Crystal Lake Memories: The Complete History of* Friday the 13th, directed by Daniel Farrands, documentary, 2013; and *Behind the Monsters*, episode 5, "Jason Voorhees," directed by Gabrielle Binkley, docuseries, 2021, Shudder.

31. Joseph McBride, *Steven Spielberg: A Biography* (Jackson: University Press of Mississippi, 2010), 257.

32. This is a real video game that came out in 1975. Atari wanted to make it an explicit tie-in to the Spielberg film, but Universal would not license the rights. Atari thus added the word "Shark" to the game's title. On the actual game console, however, the word "Shark" is in very small print, while "JAWS" is all caps with much larger letters.

33. Negative reviews at the time commented on what they saw as shoddy special effects.

34. David Greven provides an overview of the critical debates surrounding De Palma in chapter 4 of *Psycho-Sexual: Male Desire in Hitchcock, De Palma, Scorsese, and Friedkin* (Austin: University of Texas Press, 2013).

35. For a full (or nearly full) catalog of De Palma's Hitchcockian elements, see Thomas M. Leitch, "How to Steal from Hitchcock," in *After Hitchcock: Influence, Imitation, and Intertextuality*, ed. David Boyd and R. Barton Palmer (Austin: University of Texas Press, 2006), 251–270.

36. Hutcheon, *Theory of Parody*, 106.

37. Robin Wood, *Hollywood from Vietnam to Reagan . . . and Beyond* (New York: Columbia University Press, 2003): 124.

38. Leitch, "How to Steal from Hitchcock," 264, 268.

39. See Wee, "*Scream* Trilogy"; and Valerie Wee, "Resurrecting and Updating the Teen Slasher: The Case of *Scream*," *Journal of Popular Film and Television* 34, no. 2 (2006): 50–61. Also see Alexandra West, *The 1990s Teen Horror Cycle: Final Girls and a New Hollywood Formula* (Jefferson, N.C.: McFarland, 2018).

40. Robin Wood, "Neglected Nightmares," in Grant, *Robin Wood*, 181–200, 189. Also see Williams, *Hearths of Darkness*, 138–141.

41. For a discussion of *Last House* in relation to the Vietnam War, see chapter 4 of Adam Lowenstein, *Shocking Representation: Historical Trauma, National Cinema, and the Modern Horror Film* (New York: Columbia University Press, 2005).

42. Williams, *Hearths of Darkness*, 194.

43. Kim Newman, *Nightmare Movies: Horror on Screen since the 1960s* (London: Bloomsbury, 2011), 75.

44. Neale, *Genre and Hollywood*, 31.

Chapter 2: Clowns, Fools, and Dummies

1. Peter Straub, *Ghost Story*, reprint ed. (New York: Stephen King Horror Library, 2003), 363.

2. Wood, "Introduction," 73–110, 83, 84.

3. Jeffrey Jerome Cohen, "Monster Culture (Seven Theses)," in *Monster Theory: Reading Culture*, ed. Jeffery Jerome Cohen (Minneapolis: University of Minnesota Press, 1996), 3–25, 7.

4. See Barbara Creed, *The Monstrous-Feminine: Film, Feminism, Psychoanalysis* (New York: Routledge, 1993); Benshoff, *Monsters in the Closet*; and Coleman, *Horror Noire*.

5. Freud, *Jokes and Their Relation*, 177.

6. Werner Sollors, *Beyond Ethnicity: Consent and Descent in American Culture* (New York: Oxford University Press, 1986), 132.

7. Gillota, "Stand-Up Nation," 102–112.

8. For an overview of clowns and tricksters, see the introduction of Kimberly A. Christen, *Clowns & Tricksters: An Encyclopedia of Tradition of and Culture* (Denver: ABC-CLIO, 1998).

9. Joshua Louis Moss, "Cutting to the Punch: Graphic Stunt Comedy and the Emergence of Crisis Slapstick," *Studies in American Humor* 7, no. 1 (2021): 11–38, 17.

10. Moritz Fink, "Phallic Noses, Blood-Filled Balloons, Exploding Popcorn, and Laughing-Gas-Squirting Flowers: Reading Images of the Evil Clown," in Dowell and Miller, *Horrific Humor*, 29–42, 29, 31.

11. See Angela Chen, "The 2016 Clown Panic: 10 Questions Asked and Answered," Verge, October 7, 2016, https://www.theverge.com/2016/10/7/13191788/clown-attack-threats-2016-panic-hoax-debunked.

12. "Understanding Coulrophobia: A Fear of Clowns," Healthline, September 20, 2019, https://www.healthline.com/health/mental-health/fear-of-clowns.

13. Christen, *Clowns & Tricksters*, xiii.

14. Wood, "Introduction," 102–103.

15. Cohen, "Monster Culture," 16.

16. Cohen, 17.

17. Tom Chapman, "Mark Hamill's Joker Voice Influences Include the Invisible Man," ScreenRant, March 29, 2018, https://screenrant.com/mark-hamill-joker-voice-invisible-man/.

18. Tom Breihan, "For Better or Worse, *Independence Day* Supersized the Blockbuster Spectacle," AVClub, October 2, 2020, https://film.avclub.com/for-better-or-worse-independence-day-supersized-the-bl-1845175674.

19. Otto Binder and Jack Davis, "Operation Friendship," in *'Taint the Meat ... It's the Humanity! And Other Stories Illustrated by Jack Davis*, ed. Gary Growth (Seattle: Fantagraphics, 2013), 143–150, 143.

20. See Phillip J. Hutchison, "Frankenstein Meets Mikhail Bakhtin: Celebrating the Carnival of Hosted Horror Television," *Journal of Popular Culture* 53, no. 3 (2020): 579–599.

21. See Laura Mulvey's classic essay "Visual Pleasure in Narrative Cinema," in *Visual and Other Pleasures* (New York: Palgrave Macmillan: 2009).

22. Carol Clover notes that "if Rambo were to wander out of the action genre into a slasher film, he would end up dead." *Men, Women, and Chain Saws*, 99.

23. Linnie Blake, "'I Am the Devil and I'm Here to Do the Devil's Work': Rob Zombie, George W. Bush, and the Limits of American Freedom," in *Horror after 9/11*, ed. Aviva Briefel and Sam J. Miller (Austin: University of Texas Press, 2011), 186–199, 193.

24. Florent Christol, "The Foolkiller Movie: Uncovering an Overlooked Horror Genre," *Interdisciplinary Humanities* 33, no. 3 (2016): 93–106, 97, 98.

25. Christol, 98.

26. Creed, *Monstrous-Feminine*, 3.

27. See Kathleen Margaret Lant, "The Rape of Constant Reader: Stephen King's Construction of the Female Reader and Violation of the Female Body in *Misery*," *Journal of Popular Culture* 30, no. 4 (1997): 89–114; and Harriet Stilley, "Operation Hobble: Masculine Fear versus Female Monstrosity in *Misery*," *Horror Homeroom*, special issue 2 (Fall 2020), http://www.horrorhomeroom.com/operation-hobble-masculine-fear-versus-female-monstrosity-in-misery/.

28. Avalon A. Manly, "Dial M for Misery: Gender Essentialism and the Hollowness of Annie Wilkes," in *Horror Homeroom*, special issue 2 (Fall 2020), http://www.horrorhomeroom.com/dial-m-for-misery-gender-essentialism-and-the-hollowness-of-annie-wilkes/.

29. Sigmund Freud, "The Uncanny," in *An Infantile Neurosis and Other Works*, trans. James Strachey (London: Hogarth, 1964), 218–253, 220.

30. Chifen Lu, "Uncanny Dolls and Bad Children in Contemporary Gothic Narratives," *Concentric* 45, no. 2 (2019): 195–222, 200.

31. Victoria Nelson, *The Secret Life of Puppets* (Cambridge, Mass.: Harvard University Press, 2001), 258.

32. Neil Norman, "Archie Andrews: The Rise and Fall of a Ventriloquist's Dummy," *Independent*, November 26, 2005, https://www.independent.co.uk/news/uk/this-britain/archie-andrews-rise-and-fall-ventriloquist-s-dummy-516992.html.

33. Norman.

34. Hans Staats, "Re-envisioning the Devil-Doll: *Child's Play* and the Modern Horror Film," *Irish Journal of Gothic and Horror Studies*, no. 11 (2012): 54–69, 55.

35. "The Dummy" is the first of two evil dummy *Twilight Zone* episodes. The other is "Caesar and Me" from season 5.

Chapter 3: Painfully Funny

1. For a fuller taxonomy of the types of bodies found in horror films, see Andrew Tudor, "Unruly Bodies, Unquiet Minds," *Body & Society* 1, no. 1 (1995): 25–41.

2. Williams, "Film Bodies," 2–13, 4.

3. Henri Bergson argues that slapstick mishaps may be caused by a physical "mechanical inelasticity." Bergson, *Laughter*, 10. Freud also discusses the importance of bodies, stating that comic "unmasking" occurs when one directs attention to an individual's "dependence of . . . mental functions on bodily needs." Freud, *Jokes and Their Relation*, 250.

4. Williams, "Film Bodies," 4.

5. Moss, "Cutting to the Punch," 11–38.

6. Paul, *Laughing Screaming*, 292.

7. Stephen King, *Night Shift* (New York: Doubleday, 1978), xvii.

8. Julia Kristeva, *Powers of Horror* (New York: Colombia University Press, 1982), 4.

9. Paul, *Laughing Screaming*, 9, 10.

10. See Jay McRoy and Guy Crucianelli, "'I Panic the World': Benevolent Exploitation in Tod Browning's *Freaks* and Harmony Korine's *Gummo*," *Journal of Popular Culture* 42, no. 2 (2009): 257–272.

11. See William Dodson, "Tod Browning's Expressionist Bodies," *Quarterly Review of Film and Video* 31, no. 3 (2014): 231–239.

12. Writer F. Scott Fitzgerald apparently visited the set at one point and had to leave in order to vomit. See Rachel Adams, *Sideshow U.S.A.: Freaks and the American Cultural Imagination* (Chicago: University of Chicago Press, 2001), 60.

13. Paul, *Laughing Screaming*, 288.

14. Paul, 312–313.

15. For a representative example, see Dead Meat, "Top 13 Kills from Friday the 13th!," YouTube video, January 5, 2018, 11:18, https://www.youtube.com/watch?v=_8XqRebkq9s. Dead Meat ranks the kills based on four criteria: "Creativity," "Effects," "Impact on Story Franchise," and "Just How Friggin' Sweet It Is."

16. Numerous other comic gross-out films of the 1980s could be included here. Some are discussed in the next section, but interested readers should see Stuart Gordon's *Re-Animator* follow-up *From Beyond* (1986) and Frank Henenlotter's *Basket Case* (1982) and *Brain Damage* (1988). For very low-budget examples, see Troma studio films like *The Toxic Avenger* (1984) and *Surf Nazis Must Die* (1987).

17. Tudor, "Unruly Bodies, Unquiet Minds," 33.

18. The novel was originally titled *The Shrinking Man*, but later editions added the word "incredible."

19. Cyndy Hendershot, "Darwin and the Atom: Evolution/Devolution Fantasies in *The Beast from 20,000 Fathoms, Them!*, and *The Incredible Shrinking Man*," *Science Fiction Studies* 25, no. 2 (1998): 319–335, 328.

20. Carolina Núñez Puente, "Humor, Gender, and (Sex)uality in Text and Film: Incredible Shrinking Men from Mark Twain to Lorrie Moore," *Lectora*, no. 26 (2020): 133–150, 139.

21. Puente, 140.

22. Richard Matheson, *The Incredible Shrinking Man* (New York: Tom Doherty, 1994), 57.

23. Matheson, 58.

24. Robin Wood, "Cronenberg: A Dissenting View," in Grant, *Robin Wood*, 231–252, 243.

25. For a survey of the AIDS-related criticism of Cronenberg, see Ernest Mathijs, "AIDS References in the Critical Reception of David Cronenberg: 'It May Not Be Such a Bad Disease after All,'" *Cinema Journal* 42, no. 4 (2003): 29–45.

26. Creed, *Monstrous-Feminine*, 7.

27. See April Miller, "'The Hair That Wasn't There Before': Demystifying Monstrosity and Menstruation in *Ginger Snaps* and *Ginger Snaps Unleashed*," *Western Folklore* 64, no. 3/4 (2005): 281–303; and Bianca Nielsen, "Something's Wrong, like More Than You Being Female: Transgressive Sexuality and Discourses of Reproduction in *Ginger Snaps*," *thirdspace* 3, no. 2 (2004): 55–69.

28. See Martin Barker, Ernest Mathijs, and Xavier Mendik, "Menstrual Monsters: The Reception of the *Ginger Snaps* Cult Horror Franchise," *Film International* 4, no. 21 (2006): 68–77.

29. Bergson, *Laughter*, 10.

30. Moss, "Cutting to the Punch," 13.

31. Robin Wood makes this very point, deeming *The Omen* "bourgeois entertainment." Wood, "Introduction," 95.

32. Ian Conrich dubs the *Final Destination* films "grand slashers." Ian Conrich, "Puzzles, Contraptions and the Highly Elaborate Moment: The Inevitability of Death in the Grand Slasher Narratives of the *Final Destination* and *Saw* Series of Films," in *Style and Form in the Hollywood Slasher Film*, ed. Wickham Clayton (London: Palgrave Macmillan, 2015), 106–117.

33. Eugenie Brinkema, "Design Terminable and Interminable: The Possibility of Death in *Final Destination*," *Journal of Visual Culture* 14, no. 3 (2015): 298–310, 301.

Chapter 4: Camping Out

1. *Dragula* is part of the "alt-drag" scene, which stands in contrast to the mainstream drag epitomized by *RuPaul's Drag Race* (2009–). See Chloe Sargeant, "'Dragula' Has an Openness to Gender Diversity That RuPaul's Drag Race Severely

Lacks," SBS.com, September 1, 2020, https://www.sbs.com.au/guide/article/2020/08/27/dragula-has-openness-gender-diversity-rupauls-drag-race-severely-lacks.

2. Benshoff, *Monsters in the Closet*, 4.

3. Benshoff, 14.

4. Benshoff, 14–15.

5. See Alexander Doty, *Making Things Perfectly Queer: Interpreting Mass Culture* (Minneapolis: University of Minnesota Press, 1997).

6. Doty, xvii.

7. Newman, *Nightmare Movies*, 177–197.

8. Susan Sontag, "Notes on Camp," *Cult Film Reader*, ed. Ernest Mathijs and Xavier Mendik (New York: McGraw Hill, 2008), 41–52, 47.

9. Jim Goad, "Best Cheesy/Campy 80s Horror Movies," Creepy Catalog, accessed April 22, 2022, https://creepycatalog.com/best-cheesy-80s-horror-movies/.

10. Sontag, "Notes on Camp," 43.

11. See Cynthia Morrill, "Revamping the Gay Sensibility: Queer Camp and *Dyke Noir*," *The Politics and Poetics of Camp*, ed. Moe Meyer (New York: Routledge, 1994), 110–129.

12. Moe Meyer, "Introduction: Reclaiming the Discourse of Camp," in Meyer, *Politics and Poetics*, 1–22, 7.

13. Meyer, 9.

14. Richard Dyer, *Heavenly Bodies: Film Stars and Society* (New York: Routledge, 2004), 176.

15. Meyer, "Introduction," 1.

16. Meyer, 5.

17. Chuck Kleinhans, "Taking Out the Trash: Camp and the Politics of Parody," in Meyer, *Politics and Poetics*, 182–201, 185.

18. Benshoff discusses both films in *Monsters in the Closet*, 40–46, 49–52. Also see Martin F. Norden, "Sexual References in James Whale's *Bride of Frankenstein*," in *Eros in the Mind's Eye: Sexuality and the Fantastic in Art and Film*, ed. Donald F. Palumbo (Westport, Conn.: Greenwood, 1986), 141–150; Martin F. Norden, "'We're Not All Dead Yet': Humor amid the Horror in James Whale's *Bride of Frankenstein*," in Miller and Van Riper, *Laughing Dead*, 102–120; and Elizabeth Young, "Here Comes the Bride: Wedding Gender and Race in *Bride of Frankenstein*," *Feminist Studies* 17, no. 3 (1991): 403–37.

19. Benshoff, *Monsters in the Closet*, 42.

20. The line "have a potato" is a fan favorite. To give one example, the title of Steve Barton's review of the film's Blu-ray is titled "The Old Dark House Comes to Blu-ray! Have a Potato in High Definition!," Dread Central, September 26, 2017, https://www.dreadcentral.com/news/253675/old-dark-house-comes-blu-ray-potato-high-definition/.

21. Benshoff, *Monsters in the Closet*, 44.

22. Benshoff, 49.

23. Benshoff, 51.

24. Benshoff notes several 1950s creature-features with queer elements, but the vast majority of these films are not camp, as they evince a patriarchal fear of homosexuality.

25. See Dan Avery, "Vincent Price's Daughter Confirms He Was Bisexual—and a Pretty Awesome Dad," Logo TV, October 22, 2015, https://www.logotv.com/news/zvueoo/vincent-princes-daughter-confirms-he-was-bisexual.

26. Harry M. Benshoff, "Vincent Price and Me: Imagining the Queer Male Diva," *Camera Obscura* 23, no. 1 (2008): 146–150, 147.

27. Benshoff, 150.

28. Benshoff, *Monsters in the Closet*, 196. For a discussion of continental European lesbian vampire films during this period, see Bonnie Zimmerman, "*Daughters of Darkness*: The Lesbian Vampire on Film," in *Dread of Difference: Gender in the Horror Film*, 2nd ed., ed. Barry Keith Grant (Austin: University of Texas Press, 2015), 430–438.

29. While *Rocky Horror* was produced by the American studio Twentieth Century Fox, it was filmed in England, and most of the filmmakers are either English or Australian.

30. Benshoff, *Monsters in the Closet*, 220–221.

31. For a contemporary transgender critique, see Caelyn Sandel, "Let's NOT Do the Time Warp Again, Rocky Horror Fans," *Mary Sue*, October 31, 2015, https://www.themarysue.com/lets-not-do-the-time-warp/. For a defense, see Cáel M. Keegan, "In Praise of the Bad Transgender Object: *Rocky Horror*," Flow Journal, November 28, 2019, https://www.flowjournal.org/2019/11/in-praise-of-the-bad/.

32. Louis Peitzman, "The Nightmare behind the Gayest Horror Film Ever Made," BuzzFeed News, February 21, 2016, https://www.buzzfeednews.com/article/louispeitzman/the-nightmare-behind-the-gayest-horror-film-ever-made.

33. In addition to Peitzman, cited above, see Benshoff, *Monsters in the Closet*, 246–50; and the documentary film *Scream, Queen! My Nightmare on Elm Street*, directed by Roman Chimienti and Tyler Jensen, 2019.

34. The film's production and the point of view of its various filmmakers is chronicled in both the documentaries *Never Sleep Again: The Elm Street Legacy*, directed by Andrew Kasch and Daniel Farrands, 2010; and *Scream, Queen!*

35. Benshoff, *Monsters in the Closet*, 253.

36. Lisa Ellen Williams, "'I Always Cry at Weddings': *Bride of Chucky*, *Seed of Chucky*, and the Horror of the American Family at the Millennium," in *Our Fears Made Manifest: Essays on Terror, Trauma, and Loss in Film, 1998–2019*, ed. Ashley Jae Carranza (Jefferson, N.C.: McFarland, 2021), 74–87, 74. Also see Judith Halberstam, "Neo-Splatter: *Bride of Chucky* and the Horror of Heteronormativity," in *Postfeminist Gothic: Critical Interventions in Contemporary Culture*, eds. Benjamin A. Brabon and Stéphanie Genz (New York: Palgrave Macmillan, 2007), 30–42.

37. Lisa Cunningham, "Queerness and the Undead Female Monster," in Miller and Van Riper, *Laughing Dead*, 154–168, 155.

38. Cunningham, 163.

39. Constance Grady, "How Jennifer's Body Went from a Flop in 2009 to a Feminist Cult Classic Today," Vox, October 31, 2018, https://www.vox.com/culture/2018/10/31/18037996/jennifers-body-flop-cult-classic-feminist-horror.

40. See Harriet E. H. Earle, "Introduction: Queering American Horror," in *Gender, Sexuality and Queerness in "American Horror Story,"* ed. Harriet E. H. Earle (Jefferson, N.C.: McFarland, 2018): 1–6. Earle notes the series's advancement of queer representation but also notes that its "representations of queer couples are not typically positive" (3). In the same volume, see Daniel Clarke's discussion of camp in the show's fourth season, Daniel Clarke, "*My Freaks, My Monsters*: Queer Representation, Elsa Mars and Camp," in Earle, *Gender, Sexuality and Queerness*, 59–75.

41. Earle, "Introduction," 2.

42. See Logan Ashley Kisner, "A Timeline of Transgender Horror," *An Injustice Mag*, September 9, 2020, https://aninjusticemag.com/a-timeline-of-transgender-horror-90d707b71e2d; and Jenni Holtz, "Blood, Bodies, and Binaries: Trans Women in Horror," *Fourteen East*, January 18, 2019, http://fourteeneastmag.com/index.php/2019/01/18/blood-bodies-and-binaries-trans-women-in-horror/.

43. Clover, *Men, Women, and Chain Saws*, 59.

44. Peter Marra, "Queer Slashers," PhD diss., Wayne State University, 2018, 70. https://digitalcommons.wayne.edu/oa_dissertations/2049.

45. Willow Maclay, "'How Can It Be? She's a Boy.' Transmisogyny in *Sleepaway Camp*," *Cléo: A Journal of Film and Feminism* 3, no. 2 (2013), http://cleojournal.com/2015/08/10/how-can-it-be-shes-a-boy-transmisogyny-in-sleepaway-camp/.

46. Harmony M. Colangelo, "The Transgender Defense of Angela Baker and 'Sleepaway Camp,'" Medium, February 23, 2020, https://harmonycolangelo.medium.com/the-transgender-defense-of-angela-baker-and-sleepaway-camp-82dd54ddf9cd.

47. Alice Collins, "'Sleepaway Camp': The Elephant in the Room," Bloody Disgusting, August 21, 2020, https://bloody-disgusting.com/editorials/3625816/sleepaway-camp-elephant-room-trapped-gender/.

48. Chris McGee, "Why Angela Won't Go Swimming: *Sleepaway Camp*, Slasher Films, and Summer Camp Horrors," in *Queer as Camp: Essays on Summer, Style, and Sexuality*, ed. Kenneth B. Kidd and Deritt Mason (New York: Fordham University Press, 2019), 174–187, 183.

49. Thomas M. Sipos, *Horror Film Aesthetics: Creating the Visual Language of Fear* (Jefferson, N.C.: McFarland, 2010), 39.

Chapter 5: Cringes and Creeps

1. Jason Middleton, *Documentary's Awkward Turn: Cringe Comedy and Media Spectatorship* (New York: Routledge, 2014), 4, 5–6.

2. Stephen Prince, "Dread, Taboo, and *The Thing*: Toward a Social Theory of the Horror Film," in *The Horror Film*, ed. Stephen Prince (New Brunswick, N.J.: Rutgers University Press, 2004), 118–130, 129.

3. See Kendall R. Phillips, *Projected Fears: Horror Films and American Culture* (Westport, Conn.: Praeger, 2005).

4. Middleton, *Documentary's Awkward Turn*, 24–28. Also see Marc Hye-Knudsen, "Painfully Funny: Cringe Comedy, Benign Masochism, and Not-So-Benign Violations," *Leviathan: Interdisciplinary Journal in English*, no. 2 (2018): 13–31.

5. See Lia Beck, "The Scientific Reason 'Office' Fans Really Can't Watch 'Scott's Tots,' No Matter How Hard They Try," Bustle, December 21, 2018, https://www.bustle.com/p/the-scientific-reason-scotts-tots-is-impossible-for-fans-of-the-office-to-watch-no-matter-how-hard-they-try-13240935.

6. Kayla Cobb, "'The Office's' 'Scott's Tots' Is a Test of Who You Are as a Person," Decider, March 24, 2020, https://decider.com/2020/03/24/the-office-scotts-tots/; Dan Phillips, review of "The Office: 'Scott's Tots,'" *IGN*, May 8, 2012, https://www.ign.com/articles/2009/12/04/the-office-scotts-tots-review.

7. Adam Chitwood, "'The Office': An Ode to 'Scott's Tots,' One of the Most Excruciating Episodes of TV Ever Made," Collider, June 29, 2018, https://collider.com/the-office-scotts-tots/.

8. Brooks, "Alfred Hitchcock: 'Psycho Was a Joke.'"

9. See James Naremore, "Hitchcock and Humor," *Strategies: Journal of Theory, Culture & Politics* 14, no. 1 (2001): 13–25; and Wes D. Gehring, *Hitchcock and Humor: Modes of Comedy in Twelve Defining Films* (Jefferson, N.C.: McFarland, 2019).

10. Naremore, "Hitchcock and Humor," 23.

11. Christopher Sharrett, "The Idea of Apocalypse in *The Texas Chainsaw Massacre*," in *Planks of Reason: Essays on the Horror Film*, ed. Barry Keith Grant and Christopher Sharrett (Lanham, Md.: Scarecrow, 2004), 300–301.

12. Sharrett, 302.

13. Kim Newman notes that in "Texas, a householder is legally entitled to shoot anyone who trespasses on his property, so Leatherface's murder spree barely breaks the law." Newman, *Nightmare Movies*, 75.

14. See Laura Bradley, "This Was the Decade Horror Got 'Elevated,'" *Vanity Fair*, December 17, 2019, https://www.vanityfair.com/hollywood/2019/12/rise-of-elevated-horror-decade-2010s. Many critics have pointed out problems with the term, particularly in the ways that it seems to assume that if some horror is "elevated," most horror must then be trash. See Kate Gardner, "Please Stop Calling Your Scary Movies 'Elevated Horror,'" *Mary Sue*, March 18, 2019, https://www.themarysue.com/stop-calling-scary-movies-elevated-horror/.

15. See David Ehrlich, "Ari Aster Breaks Down 9 Movies That Inspired 'Midsommar,' from 'The Red Shoes' to 'Climax,'" Indie Wire, June 25, 2019, https://www.indiewire.com/gallery/ari-aster-movies-inspired-midsommar/images-w1400/.

16. Ari Aster, "Laughs That Hurt: Albert Brooks's Uncomfortable Comedies," Criterion, September 16, 2020, https://www.criterion.com/current/posts/7100-laughs-that-hurt-albert-brooks-s-uncomfortable-comedies.

17. See Neil McRobert, "Mimesis of Media: Found Footage Cinema and the Horror of the Real," *Gothic Studies* 17, no. 2 (2015): 137–150; and Xavier Aldana Reyes, "Reel Evil: A Critical Reassessment of Found Footage Horror," *Gothic Studies* 17, no. 2 (2015): 122–136. Also see chapter 2 of Kevin J. Wetmore, *Post-9/11 Horror in American Cinema* (New York: Continuum, 2012).

18. See Ethan Thompson, "Comedy Verité? The Observational Documentary Meets the Televisual Sitcom," *Velvet Light Trap* 60, no. 1 (2007): 63–72.

19. Adam Charles Hart, "The Searching Camera: First Person Shooters, Found Footage Horror Films, and the Documentary Tradition," *JCMS: Journal of Cinema and Media Studies* 58, no. 4 (2019): 73–91, 76.

Chapter 6: Horror, Humor, and Critique

1. Russel Meeuf draws a direct connection between the horror films of the two periods, noting that "Horror's reputation for political critique was cemented in the 1960s and 1970s in a cultural moment similar to the Trump years." Meeuf, *White Terror: The Horror Film from Obama to Trump* (Bloomington: Indiana University Press, 2022), 4.

2. James E. Caron, "The Quantum Paradox of Truthiness: Satire, Activism, and the Postmodern Condition," *Studies in American Humor* 2, no. 2 (2016): 153–181, 155.

3. Amber Day, *Satire and Dissent: Interventions in Contemporary Political Debate* (Bloomington: Indiana University Press, 2011), 2.

4. Caron, "Quantum Paradox," 156.

5. Jonathan Swift, "A Modest Proposal" (1729; Project Gutenberg, 1997), https://www.gutenberg.org/files/1080/1080-h/1080-h.htm.

6. Mark Twain, "Cannibalism in the Cars" (1868; American Literature, May 17, 2013), https://americanliterature.com/author/mark-twain/short-story/cannibalism-in-the-cars.

7. See, among others, Kyle William Bishop, *American Zombie Gothic: The Rise and Fall (and Rise) of the Walking Dead in Popular Culture* (Jefferson, N.C.: McFarland, 2010).

8. See Tony Williams, *The Cinema of George A. Romero: Knight of the Living Dead* (New York: Columbia University Press, 2015); Bishop, *American Zombie Gothic*; and Robin Wood's various writings on Romero.

9. Robin Wood, "The Woman's Nightmare: Masculinity in *Day of the Dead*," in Grant, *Robin Wood*, 319–330, 320.

10. Steven Weisenburger, *Fables of Subversion: Satire and the American Novel, 1930–1980* (Athens: University of Georgia Press, 1995), 1.

11. Weisenburger, 3.

12. Sam Chesters, "'Don't Go All Earnest on Us': Metamodern Satire in George Saunders's 'Brad Carrigan, American,'" *Studies in American Humor* 7, no. 1 (2021): 39–60, 41.

13. Williams, *Cinema of George A. Romero*, 95.

14. In the documentary *Birth of the Living Dead* (2013), directed by Rob Kuhns, Romero explains that he made the decision to not change the script of *Night* once Duane Jones was cast, but he also says this was mistake, which may account for the increasing attention to race in the subsequent films.

15. Wood, "Woman's Nightmare," 321. Also see Wood, "Apocalypse Now: Notes on the Living Dead," in Grant, *Robin Wood*, 161–169.

16. Wood, "Woman's Nightmare," 319.

17. See Bishop, *American Zombie Gothic*.

18. Zombie films are truly global as can be seen through various twenty-first century international hits like *28 Days Later* (2002), *[Rec]* (2007), *Dead Snow* (2009), and *Train to Busan* (2016).

19. James Rushing Daniel, "'Another One for the Fire': George A. Romero on Race," *Los Angeles Review of Books*, July 25, 2017, https://blog.lareviewofbooks.org/essays/another-one-fire-george-romero-race/.

20. "Jordan Peele: The Art of the Social Thriller," BAM, accessed December 6, 2022, https://www.bam.org/film/2017/jordan-peele.

21. Jason Zinoman, "Jordan Peele on a Truly Terrifying Monster: Racism," *New York Times*, February 16, 2017, https://www.nytimes.com/2017/02/16/movies/jordan-peele-interview-get-out.html.

22. Coleman, *Horror Noire*, 7.

23. Coleman, 6.

24. Lisa Guerrero, "Can I Live? Contemporary Black Satire and the State of Postmodern Double Consciousness," *Studies in American Humor* 2, no. 2 (2016): 266–279, 268.

25. Terrence T. Tucker, *Furiously Funny: Comic Rage from Ralph Ellison to Chris Rock* (Gainesville: University Press of Florida, 2018), 2.

26. Tucker, 3.

27. Tucker, 17.

28. Jennifer Ryan-Bryant, "The Cinematic Rhetorics of Lynching in Jordan Peele's *Get Out*," *Journal of Popular Culture* 53, no. 1 (2020): 92–110, 105.

29. *Nope* was released too late to include a full discussion of here. However, it clearly continues Peele's penchant for satirical horror, this time using an alien invasion story to parody and satirize media representations of violence and trauma.

30. See, for example, Brian Tallerico, "Into the Dark: Culture Shock," Roger Ebert, July 4, 2019, https://www.rogerebert.com/reviews/into-the-dark-culture-shock-2019.

31. Wood, "Return of the Repressed," 57–62, 58.

BIBLIOGRAPHY

Adams, Rachel. *Sideshow U.S.A.: Freaks and the American Cultural Imagination.* Chicago: University of Chicago Press, 2001.

Altman, Rick. *Film/Genre.* London: Palgrave Macmillan, 1999.

Aster, Ari. "Laughs That Hurt: Albert Brooks's Uncomfortable Comedies." Criterion, September 16, 2020. https://www.criterion.com/current/posts/7100-laughs-that-hurt-albert-brooks-s-uncomfortable-comedies.

Avery, Dan. "Vincent Price's Daughter Confirms He Was Bisexual—and a Pretty Awesome Dad." Logo TV, October 22, 2015. https://www.logotv.com/news/zvueoo/vincent-princes-daughter-confirms-he-was-bisexual.

Bakhtin, Mikhail. *Rabelais and His World.* Translated by Hélène Iswolsky. Bloomington: Indiana University Press, 1984.

Barker, Martin, Ernest Mathijs, and Xavier Mendik, "Menstrual Monsters: The Reception of the *Ginger Snaps* Cult Horror Franchise." *Film International* 4, no. 21 (2006): 68–77.

Barton, Steve. "The Old Dark House Comes to Blu-ray! Have a Potato in High Definition!" Dread Central, September 26, 2017. https://www.dreadcentral.com/news/253675/old-dark-house-comes-blu-ray-potato-high-definition/.

Beck, Lia. "The Scientific Reason 'Office' Fans Really Can't Watch 'Scott's Tots,' No Matter How Hard They Try." Bustle, December 21, 2018. https://www.bustle.com/p/the-scientific-reason-scotts-tots-is-impossible-for-fans-of-the-office-to-watch-no-matter-how-hard-they-try-13240935.

Benshoff, Harry M. *Monsters in the Closet: Homosexuality and the Horror Film.* New York: Manchester University Press, 1997.

———. "Vincent Price and Me: Imagining the Queer Male Diva." *Camera Obscura* 23, no. 1 (2008): 146–150.

Bergson, Henri. *Laughter: An Essay on the Meaning of the Comic.* Translated by Cloudesley Brereton and Fred Rothwell. Mansfield, Conn.: Martino, 2014.

Binder, Otto, and Jack Davis. "Operation Friendship." In *'Taint the Meat . . . It's the Humanity! And Other Stories Illustrated by Jack Davis*, edited by Gary Growth, 143–150. Seattle: Fantagraphics, 2013.

Bishop, Kyle William. *American Zombie Gothic: The Rise and Fall (and Rise) of the Walking Dead in Popular Culture.* Jefferson, N.C.: McFarland, 2010.

Blake, Linnie. "'I Am the Devil and I'm Here to Do the Devil's Work': Rob Zombie, George W. Bush, and the Limits of American Freedom." In *Horror after 9/11*, edited by Aviva Briefel and Sam J. Miller, 186–199. Austin: University of Texas Press, 2011.

Bradley, Laura. "This Was the Decade Horror Got 'Elevated.'" *Vanity Fair*, December 17, 2019. https://www.vanityfair.com/hollywood/2019/12/rise-of-elevated-horror-decade-2010s.

Breihan, Tom. "For Better or Worse, *Independence Day* Supersized the Blockbuster Spectacle." *AVClub*, October 2, 2020. https://film.avclub.com/for-better-or-worse-independence-day-supersized-the-bl-1845175674.

Brinkema, Eugenie. "Design Terminable and Interminable: The Possibility of Death in *Final Destination*." *Journal of Visual Culture* 14, no. 3 (2015): 298–310.

Brooks, Xan. "Alfred Hitchcock: 'Psycho Was a Joke.'" *Guardian*, February 8, 2013. https://www.theguardian.com/film/2013/feb/08/alfred-hitchcock-psycho-joke.

Caron, James E. "The Quantum Paradox of Truthiness: Satire, Activism, and the Postmodern Condition." *Studies in American Humor* 2, no. 2 (2016): 153–181.

Carroll, Noël. "Horror and Humor." *Journal of Aesthetics and Art Criticism* 57, no. 2 (1999): 145–160.

———. *The Philosophy of Horror.* New York: Routledge, 1990.

Chapman, Tom. "Mark Hamill's Joker Voice Influences Include the Invisible Man." *ScreenRant*, March 29, 2018. https://screenrant.com/mark-hamill-joker-voice-invisible-man/.

Chen, Angela. "The 2016 Clown Panic: 10 Questions Asked and Answered." *Verge*, October 7, 2016. https://www.theverge.com/2016/10/7/13191788/clown-attack-threats-2016-panic-hoax-debunked.

Chesters, Sam. "'Don't Go All Earnest on Us': Metamodern Satire in George Saunders's 'Brad Carrigan, American.'" *Studies in American Humor* 7, no. 1 (2021): 39–60.

Chitwood, Adam. "'The Office': An Ode to 'Scott's Tots,' One of the Most Excruciating Episodes of TV Ever Made." *Collider*, June 29, 2018. https://collider.com/the-office-scotts-tots/.

Christen, Kimberly A. *Clowns & Tricksters: An Encyclopedia of Tradition of and Culture.* Denver, Co.: ABC-CLIO, 1998.

Christol, Florent. "The Foolkiller Movie: Uncovering an Overlooked Horror Genre." *Interdisciplinary Humanities* 33, no. 3 (2016): 93–106.

Clarke, Daniel. "*My Freaks, My Monsters*: Queer Representation, Elsa Mars and Camp." In *Gender, Sexuality and Queerness in "American Horror Story,"* edited by Harriet E. H. Earle, 59–75. Jefferson, N.C.: McFarland, 2018.

Clover, Carol. *Men, Women, and Chain Saws: Gender in the Modern Horror Film.* Princeton, N.J.: Princeton University Press, 1992.

Cobb, Kayla. "'The Office's' 'Scott's Tots' Is a Test of Who You Are as a Person." Decider, March 24, 2020. https://decider.com/2020/03/24/the-office-scotts-tots/.

Cohen, Jeffrey Jerome. "Monster Culture (Seven Theses)." In *Monster Theory: Reading Culture*, edited by Jeffery Jerome Cohen, 3–25. Minneapolis: University of Minnesota Press, 1996.

Colangelo, Harmony M. "The Transgender Defense of Angela Baker and 'Sleepaway Camp.'" Medium, February 23, 2020. https://harmonycolangelo.medium.com/the-transgender-defense-of-angela-baker-and-sleepaway-camp-82dd54ddf9cd.

Coleman, Robin R. Means. *Horror Noire: Blacks in American Horror Films from the 1890s to Present*. New York: Routledge, 2011.

Collins, Alice. "'Sleepaway Camp': The Elephant in the Room." Bloody Disgusting, August 21, 2020. https://bloody-disgusting.com/editorials/3625816/sleepaway-camp-elephant-room-trapped-gender/.

Conrich, Ian. "Puzzles, Contraptions and the Highly Elaborate Moment: The Inevitability of Death in the Grand Slasher Narratives of the *Final Destination* and *Saw* Series of Films." In *Style and Form in the Hollywood Slasher Film*, edited by Wickham Clayton, 106–117. London: Palgrave Macmillan, 2015.

Creed, Barbara. *The Monstrous-Feminine: Film, Feminism, Psychoanalysis*. New York: Routledge, 1993.

Critchley, Simon. *On Humour*. London: Routledge, 2002.

Cunningham, Lisa. "Queerness and the Undead Female Monster." In Miller and Van Riper, *Laughing Dead*, 154–168. New York: Rowman and Littlefield, 2016.

Daniel, James Rushing. "'Another One for the Fire': George A. Romero on Race." *Los Angeles Review of Books*, July 25, 2017. https://blog.lareviewofbooks.org/essays/another-one-fire-george-romero-race/.

Day, Amber. *Satire and Dissent: Interventions in Contemporary Political Debate*. Bloomington: Indiana University Press, 2011.

Dentith, Simon. *Parody*. New York: Routledge, 2000.

Dixon, Wheeler Winston. *A History of Horror*. New Brunswick, N.J.: Rutgers University Press, 2011.

Dodson, William. "Tod Browning's Expressionist Bodies." *Quarterly Review of Film and Video* 31, no. 3 (2014): 231–239.

Doty, Alexander. *Making Things Perfectly Queer: Interpreting Mass Culture*. Minneapolis: University of Minnesota Press, 1997.

Dowell, John A., and Cynthia J. Miller, eds. *Horrific Humor and the Moment of Droll Grimness in Cinema: Sidesplitting sLaughter*. Lanham, Md.: Lexington, 2018.

Dyer, Richard. *Heavenly Bodies: Film Stars and Society*. New York: Routledge, 2004.

Earle, Harriet E. H. "Introduction: Queering American Horror." In *Gender, Sexuality and Queerness in "American Horror Story,"* edited by Harriet E. H. Earle, 1–6. Jefferson, N.C.: McFarland, 2018.

Ehrlich, David. "Ari Aster Breaks Down 9 Movies That Inspired 'Midsommar,' from 'The Red Shoes' to 'Climax.'" Indie Wire, June 25, 2019. https://www.indiewire.com/gallery/ari-aster-movies-inspired-midsommar/images-w1400/.

Fanelli, Brian. "No Clowning around: The Gothic and the Comedic Elements of *Friday the 13th Part VI: Jason Lives*." *Horror Homeroom*, special issue 1 (Spring 2020). http://www.horrorhomeroom.com/no-clowning-around-the-gothic-and-comedic-elements-of-friday-the-13th-part-vi-jason-lives/.

Fink, Moritz. "Phallic Noses, Blood-Filled Balloons, Exploding Popcorn, and Laughing-Gas-Squirting Flowers: Reading Images of the Evil Clown." In *Horrific Humor and the Moment of Droll Grimness in Cinema: Sidesplitting sLaughter*, edited by John A. Dowell and Cynthia J. Miller, 29–42. Lanham, Md.: Lexington, 2018.

Fish, Stanley. *Is There a Text in This Class? The Authority of Interpretive Communities*. Cambridge, Mass.: Harvard University Press, 1982.

Freud, Sigmund. *Jokes and Their Relation to the Unconscious*. Translated by James Strachey. New York: Norton, 1960.

———. "The Uncanny." In *An Infantile Neurosis and Other Works*. Translated by James Strachey, 218–253. London: Hogarth, 1964.

Gardner, Kate. "Please Stop Calling Your Scary Movies 'Elevated Horror.'" *Mary Sue*, March 18, 2019. https://www.themarysue.com/stop-calling-scary-movies-elevated-horror/.

Gehring, Wes D. *Hitchcock and Humor: Modes of Comedy in Twelve Defining Films*. Jefferson, N.C.: McFarland, 2019.

Gillota, David. "Stand-Up Nation: Humor and American Identity." *Journal of American Culture* 38, no. 2 (2015): 102–112.

Goad, Jim. "Best Cheesy/Campy 80s Horror Movies." Creepy Catalog, accessed April 22, 2022. https://creepycatalog.com/best-cheesy-80s-horror-movies/.

Grady, Constance. "How Jennifer's Body Went from a Flop in 2009 to a Feminist Cult Classic Today." *Vox*, October 31, 2018. https://www.vox.com/culture/2018/10/31/18037996/jennifers-body-flop-cult-classic-feminist-horror.

Grant, Barry Keith. *Monster Cinema*. New Brunswick, N.J.: Rutgers University Press, 2018.

Greven, David. *Psycho-Sexual: Male Desire in Hitchcock, De Palma, Scorsese, and Friedkin*. Austin: University of Texas Press, 2013.

Guerrero, Lisa. "Can I Live? Contemporary Black Satire and the State of Postmodern Double Consciousness." *Studies in American Humor* 2, no. 2 (2016): 266–279.

Halberstam, Judith. "Neo-Splatter: *Bride of Chucky* and the Horror of Heteronormativity." In *Postfeminist Gothic: Critical Interventions in Contemporary Culture*, edited by Benjamin A. Brabon and Stéphanie Genz, 30–42. New York: Palgrave Macmillan, 2007.

Hallenbeck, Bruce G. *Comedy-Horror Films: A Chronological History, 1914–2008*. Jefferson, N.C.: McFarland, 2009.

Harries, Dan. *Film Parody*. London: British Film Institute, 2000.

Hart, Adam Charles. "The Searching Camera: First Person Shooters, Found Footage Horror Films, and the Documentary Tradition." *JCMS: Journal of Cinema and Media Studies* 58, no. 4 (2019): 73–91.

Healthline. "Understanding Coulrophobia: A Fear of Clowns," accessed September 20, 2019. https://www.healthline.com/health/mental-health/fear-of-clowns.

Hendershot, Cyndy. "Darwin and the Atom: Evolution/Devolution Fantasies in *The Beast from 20,000 Fathoms, Them!*, and *The Incredible Shrinking Man*." *Science Fiction Studies* 25, no. 2 (1998): 319–335.

Hennefeld, Maggie. "Affect Theory in the Throat of Laughter: Feminist Killjoys, Humorless Capitalists, and Contagious Hysterics." *Feminist Media Histories* 7, no. 2 (2021): 110–144.

Hills, Matt. *The Pleasures of Horror*. New York: Continuum, 2005.

Holtz, Jenni. "Blood, Bodies, and Binaries: Trans Women in Horror." *Fourteen East*, January 18, 2019. http://fourteeneastmag.com/index.php/2019/01/18/blood-bodies-and-binaries-trans-women-in-horror/.

Hutcheon, Linda. *A Theory of Parody*. Chicago: University of Illinois Press, 2000.

Hutchison, Phillip J. "Frankenstein Meets Mikhail Bakhtin: Celebrating the Carnival of Hosted Horror Television." *Journal of Popular Culture* 53, no. 3 (2020): 579–599.

Hye-Knudsen, Marc. "Painfully Funny: Cringe Comedy, Benign Masochism, and Not-So-Benign Violations." *Leviathan: Interdisciplinary Journal in English*, no. 2 (2018): 13–31.

Kawin, Bruce. "*The Funhouse* and *The Howling*." *American Horrors: Essays on the Modern American Horror Film*, edited by Gregory A; Waller, 102–113. Chicago: University of Illinois Press, 1987.

Keegan, Cáel M. "In Praise of the Bad Transgender Object: *Rocky Horror*." *Flow Journal* 26, no. 3 (November 28, 2019). https://www.flowjournal.org/2019/11/in-praise-of-the-bad/.

Kermode, Mark. "I Was a Teenage Horror Fan: Or, 'How I Learned to Stop Worrying and Love Linda Blair.'" In *Ill Effects: The Media/Violence Debate*, edited by Martin Barker and Julian Petley, 48–55. New York: Routledge, 1997.

King, Stephen. *Danse Macabre*. New York: Penguin, 1987.

———. *Night Shift*. New York: Doubleday, 1978.

Kisner, Logan Ashley. "A Timeline of Transgender Horror." *An Injustice Mag*, September 9, 2020. https://aninjusticemag.com/a-timeline-of-transgender-horror-90d707b71e2d.

Kleinhans, Chuck. "Taking Out the Trash: Camp and the Politics of Parody." In *The Politics and Poetics of Camp*, edited by Moe Meyer, 182–201. New York: Routledge, 1994.

Kristeva, Julia. *Powers of Horror*. New York: Colombia University Press, 1982.

Lant, Kathleen Margaret. "The Rape of Constant Reader: Stephen King's Construction of the Female Reader and Violation of the Female Body in *Misery*." *Journal of Popular Culture* 30, no. 4 (1997): 89–114.

Leeder, Murray. "Collective Screams: William Castle and the Gimmick Film." *Journal of Popular Culture* 44, no. 4 (2011): 773–795.

———. *Horror Film: A Critical Introduction*. New York: Bloomsbury, 2018.

Leitch, Thomas M. *Find the Director and Other Hitchcock Games*. Athens: University of Georgia Press, 1991.

———. "How to Steal from Hitchcock." *After Hitchcock: Influence, Imitation, and Intertextuality*, edited by David Boyd and R. Barton Palmer, 251–270. Austin: University of Texas Press, 2006.

Lowenstein, Adam. *Shocking Representation: Historical Trauma, National Cinema, and the Modern Horror Film*. New York: Columbia University Press, 2005.

Lu, Chifen. "Uncanny Dolls and Bad Children in Contemporary Gothic Narratives." *Concentric* 45, no. 2 (2019): 195–222.

Maclay, Willow. "'How Can It Be? She's a Boy.' Transmisogyny in *Sleepaway Camp*." *Cléo: A Journal of Film and Feminism* 3, no. 2 (2013). http://cleojournal.com/2015/08/10/how-can-it-be-shes-a-boy-transmisogyny-in-sleepaway-camp/.

Manly, Avalon A. "Dial M for Misery: Gender Essentialism and the Hollowness of Annie Wilkes." *Horror Homeroom*, special issue 2 (Fall 2020). http://www.horrorhomeroom.com/dial-m-for-misery-gender-essentialism-and-the-hollowness-of-annie-wilkes/.

Marra, Peter. "Queer Slashers." PhD dissertation. Wayne State University, 2018. https://digitalcommons.wayne.edu/oa_dissertations/2049.

Matheson, Richard. *The Incredible Shrinking Man*. New York: Tom Doherty Associates, 1994.

Mathijs, Ernest. "AIDS References in the Critical Reception of David Cronenberg: 'It May Not Be Such a Bad Disease after All.'" *Cinema Journal* 42, no. 4 (2003): 29–45.

McBride, Joseph. *Steven Spielberg: A Biography*. Jackson: University Press of Mississippi, 2010.

McGee, Chris. "Why Angela Won't Go Swimming: *Sleepaway Camp*, Slasher Films, and Summer Camp Horrors." In *Queer as Camp: Essays on Summer, Style, and Sexuality*, edited by Kenneth B. Kidd and Deritt Mason, 174–187. New York: Fordham University Press, 2019.

McRobert, Neil. "Mimesis of Media: Found Footage Cinema and the Horror of the Real." *Gothic Studies* 17, no. 2 (2015): 137–150.

McRoy, Jay, and Guy Crucianelli. "'I Panic the World': Benevolent Exploitation in Tod Browning's *Freaks* and Harmony Korine's *Gummo*." *Journal of Popular Culture* 42, no. 2 (2009): 257–272.

Meeuf, Russell. *White Terror: The Horror Film from Obama to Trump*. Bloomington: Indiana University Press, 2022.

Meyer, Moe. "Introduction: Reclaiming the Discourse of Camp." *The Politics and Poetics of Camp*, edited by Moe Meyer, 1–22. New York: Routledge, 1994.

Middleton, Jason. *Documentary's Awkward Turn: Cringe Comedy and Media Spectatorship*. New York: Routledge, 2014.

Miller, April. "'The Hair That Wasn't There Before': Demystifying Monstrosity and Menstruation in *Ginger Snaps* and *Ginger Snaps Unleashed*." *Western Folklore* 64, nos. 3–4 (2005): 281–303.

Miller, Cynthia J., and A. Bowdoin Van Riper, eds. *The Laughing Dead: The Horror-Comedy Film from "Bride of Frankenstein" to "Zombieland."* Lanham, Md.: Rowman and Littlefield, 2016.

Morreall, John. *Comic Relief: A Comprehensive Philosophy of Humor*. West Sussex, UK: Wiley-Blackwell, 2009.

———. "Humor as Cognitive Play." *Journal of Literary Theory* 3, no. 2 (2009): 241–260.

Morrill, Cynthia. "Revamping the Gay Sensibility: Queer Camp and *Dyke Noir*." *The Politics and Poetics of Camp*, edited by Moe Meyer, 110–129. New York: Routledge, 1994.

Moss, Joshua Louis. "Cutting to the Punch: Graphic Stunt Comedy and the Emergence of Crisis Slapstick." *Studies in American Humor* 7, no. 1 (2021): 11–38.

Mulvey, Laura. *Visual and Other Pleasures*. New York: Palgrave Macmillan, 2009.

Naremore, James. "Hitchcock and Humor." *Strategies: Journal of Theory, Culture & Politics* 14, no. 1 (2001): 13–25.

Neale, Steve. *Genre and Hollywood*. New York: Routledge, 2000.

Nelson, Victoria. *The Secret Life of Puppets*. Cambridge, Mass.: Harvard University Press, 2001.

Newman, Kim. *Nightmare Movies: Horror on Screen since the 1960s*. London: Bloomsbury, 2011.

Nielsen, Bianca. "Something's Wrong, like More Than You Being Female: Transgressive Sexuality and Discourses of Reproduction in *Ginger Snaps*." *thirdspace* 3, no. 2 (2004): 55–69.

Norden, Martin F. "Sexual References in James Whale's *Bride of Frankenstein*." In *Eros in the Mind's Eye: Sexuality and the Fantastic in Art and Film*, edited by Donald F. Palumbo, 141–150. Westport, Conn.: Greenwood, 1986.

———. "'We're Not All Dead Yet': Humor amid the Horror in James Whale's *Bride of Frankenstein*." In Miller and Van Riper, *Laughing Dead*, 102–120. New York: Rowman and Littlefield, 2016.

Norman, Neil. "Archie Andrews: The Rise and Fall of a Ventriloquist's Dummy." *Independent*, November 26, 2005. https://www.independent.co.uk/news/uk/this-britain/archie-andrews-rise-and-fall-ventriloquist-s-dummy-516992.html.

Paul, William. *Laughing Screaming: Modern Hollywood Horror and Comedy*. New York: Colombia University Press, 1994.

Peirse, Alison, ed. *Women Make Horror: Filmmaking, Feminism, Genre*. New Brunswick, N.J.: Rutgers University Press, 2020.

Peitzman, Louis. "The Nightmare behind the Gayest Horror Film Ever Made." *BuzzFeedNews*, February 21, 2016. https://www.buzzfeednews.com/article/louispeitzman/the-nightmare-behind-the-gayest-horror-film-ever-made.

Phillips, Dan. "The Office: 'Scott's Tots' Review." *IGN*, May 8, 2012. https://www.ign.com/articles/2009/12/04/the-office-scotts-tots-review.

Phillips, Kendall R. *Projected Fears: Horror Films and American Culture*. Westport, Conn.: Praeger, 2005.

Pinedo, Isabel Cristina. *Recreational Terror: Women and the Pleasures of Horror Film Viewing*. Albany: SUNY Press, 1997.

Powell, Anna. *Deleuze and Horror Film*. Edinburgh University Press, 2005.

Prince, Stephen. "Dread, Taboo, and *The Thing*: Toward a Social Theory of the Horror Film." *The Horror Film*, edited by Stephen Prince, 118–130. New Brunswick, N.J.: Rutgers University Press, 2004.

Puente, Carolina Núñez. "Humor, Gender, and (Sex)uality in Text and Film: Incredible Shrinking Men from Mark Twain to Lorrie Moore." *Lectora*, no. 26 (2020): 133–150.

Raynor, Alice. "Creating the Audience: It's All in the Timing." *The Laughing Stalk: Live Comedy and Its Audiences*, edited by Judy Batalion, 28–39. Anderson, S.C.: Parlor, 2012.

Reyes, Xavier Aldana. "Beyond Psychoanalysis: Post-millennial Horror Film and Affect Theory." *Horror Studies* 3, no. 2 (2012): 243–261.

———. "Reel Evil: A Critical Reassessment of Found Footage Horror." *Gothic Studies* 17, no. 2 (2015): 122–136.

Ryan, Bryant, Jennifer. "The Cinematic Rhetorics of Lynching in Jordan Peele's *Get Out*." *Journal of Popular Culture* 53, no. 1 (2020): 92–110.

Sandel, Caelyn. "Let's NOT Do the Time Warp Again, Rocky Horror Fans." *Mary Sue*, October 31, 2015. https://www.themarysue.com/lets-not-do-the-time-warp/.

Sargeant, Chloe. "'Dragula' Has an Openness to Gender Diversity That RuPaul's Drag Race Severely Lacks." SBS.com, September 1, 2020. https://www.sbs.com.au/guide/article/2020/08/27/dragula-has-openness-gender-diversity-rupauls-drag-race-severely-lacks.

Sharrett, Christopher. "The Idea of Apocalypse in *The Texas Chainsaw Massacre*." In *Planks of Reason: Essays on the Horror Film*, edited by Barry Keith Grant and Christopher Sharrett, 300–320. Lanham, Md.: Scarecrow, 2004.

Sipos, Thomas M. *Horror Film Aesthetics: Creating the Visual Language of Fear*. Jefferson, N.C.: McFarland, 2010.

Smith, Moira. "Humor, Unlaughter, and Boundary Maintenance." *Journal of American Folklore* 122, no. 484 (2009): 148–171.

Sollors, Werner. *Beyond Ethnicity: Consent and Descent in American Culture*. New York: Oxford University Press, 1986.

Sontag, Susan. "Notes on Camp." *The Cult Film Reader*, edited by Ernest Mathijs and Xavier Mendik, 41–52. New York: McGraw Hill, 2008.

Staats, Hans. "Re-envisioning the Devil-Doll: *Child's Play* and the Modern Horror Film." *Irish Journal of Gothic and Horror Studies*, no. 11 (2012): 54–69.

Stilley, Harriet. "Operation Hobble: Masculine Fear versus Female Monstrosity in *Misery*." *Horror Homeroom*, special issue 2 (Fall 2020). http://www

.horrorhomeroom.com/operation-hobble-masculine-fear-versus-female-monstrosity-in-misery/.

Straub, Peter. *Ghost Story*. Reprint ed. New York: Stephen King Horror Library, 2003.

Swift, Jonathan. "A Modest Proposal." 1729. Project Gutenberg, 1997, https://www.gutenberg.org/files/1080/1080-h/1080-h.htm.

Tallerico, Brian. "Into the Dark: Culture Shock." RogerEbert.com, July 4, 2019. https://www.rogerebert.com/reviews/into-the-dark-culture-shock-2019.

Thompson, Ethan. "Comedy Verité? The Observational Documentary Meets the Televisual Sitcom." *Velvet Light Trap* 60, no. 1 (2007): 63–72.

Tucker, Terrence T. *Furiously Funny: Comic Rage from Ralph Ellison to Chris Rock*. Gainesville: University Press of Florida, 2018.

Tudor, Andrew. *Monsters and Mad Scientists: A Cultural History of the Horror Movie*. Oxford: Basil Blackwell, 1989.

———. "Unruly Bodies, Unquiet Minds." *Body & Society* 1, no. 1 (1995): 25–41.

Twain, Mark. "Cannibalism in the Cars." 1868. American Literature, May 17, 2013. https://americanliterature.com/author/mark-twain/short-story/cannibalism-in-the-cars.

Wee, Valerie. "Resurrecting and Updating the Teen Slasher: The Case of *Scream*." *Journal of Popular Film and Television* 34, no. 2 (2006): 50–61.

———. "The *Scream* Trilogy, 'Hyperpostmodernism,' and the Late-Nineties Teen Slasher Film." *Journal of Film and Video* 57, no. 3 (2005): 44–61.

Weisenburger, Steven. *Fables of Subversion: Satire and the American Novel, 1930–1980*. Athens: University of Georgia Press, 1995.

West, Alexandra. *The 1990s Teen Horror Cycle: Final Girls and a New Hollywood Formula*. Jefferson, N.C.: McFarland, 2018.

Wetmore, Kevin J. *Post-9/11 Horror in American Cinema*. New York: Continuum, 2012.

Williams, Linda. "Discipline and Fun: *Psycho* and Postmodern Cinema." In *Reinventing Film Studies*, edited by Christine Gledhill and Linda Williams, 351–370. London: Oxford University Press, 2000.

———. "Film Bodies: Gender, Genre, and Excess." *Film Quarterly* 44, no. 4 (1991): 2–13.

Williams, Lisa Ellen. "'I Always Cry at Weddings': *Bride of Chucky*, *Seed of Chucky*, and the Horror of the American Family at the Millennium." In *Our Fears Made Manifest: Essays on Terror, Trauma, and Loss in Film, 1998–2019*, edited by Ashley Jae Carranza, 74–87. Jefferson, N.C.: McFarland, 2021.

Williams, Tony. *The Cinema of George A. Romero: Knight of the Living Dead*. New York: Columbia University Press, 2015.

———. *Hearths of Darkness: The Family in the American Horror Film*. Jackson: University Press of Mississippi, 2014.

Wood, Robin. "The American Family Comedy: From *Meet Me in St. Louis* to *The Texas Chainsaw Massacre*." In *Robin Wood on the Horror Film*, edited by Barry Keith Grant, 171–180. Detroit: Wayne State University Press, 2018.

———. "Apocalypse Now: Notes on the Living Dead." In Grant, *Robin Wood*, 161–169.

———. "Cronenberg: A Dissenting View." In Grant, *Robin Wood*, 231–252.

———. *Hollywood from Vietnam to Reagan . . . and Beyond*. New York: Columbia University Press, 2003.

———. "An Introduction to the American Horror Film." In Grant, *Robin Wood*, 73–110.

———. "Neglected Nightmares." In Grant, *Robin Wood*, 181–200.

———. "Return of the Repressed." In Grant, *Robin Wood*, 57–62.

———. "The Woman's Nightmare: Masculinity in *Day of the Dead*." in Grant, *Robin Wood*, 319–330.

Young, Elizabeth. "Here Comes the Bride: Wedding Gender and Race in *Bride of Frankenstein*." *Feminist Studies* 17, no. 3 (1991): 403–437.

Zimmerman, Bonnie. "*Daughters of Darkness*: The Lesbian Vampire on Film." In *Dread of Difference: Gender in the Horror Film*, 2nd ed., edited by Barry Keith Grant, 430–438. Austin: University of Texas Press, 2015.

Zinoman, Jason. "Jordan Peele on a Truly Terrifying Monster: Racism." *New York Times*, February 16, 2017. https://www.nytimes.com/2017/02/16/movies/jordan-peele-interview-get-out.html.

INDEX

Page numbers in *italics* refer to figures.

3 From Hell (2019), 55
13 Ghosts (1960), 24
28 Days Later (2002), 212n18
31 (2016), 47
2000 Maniacs (1964), 81

Abbott and Costello Meet Frankenstein (1948), 13, 18, 59
Abbott and Costello monster films, 24
Abominable Dr. Phibes, The (1971), 112
Abraham Lincoln: Vampire Hunter (2011 novel), 40
absurdism, 87, 88, 89–90
Addams Family, The (1964–1966), 50, 107
affect theory, 6–7, 200n19
African-American humor, 184–185, 187
American Horror Story (2011–), 10, 116, 125–127
American Werewolf in London, An (1981), 10, 92–94
Anaconda (1997), 30
Animal House (1978), 92
Anna and the Apocalypse (2017), 40, 178
Annabelle (film franchise), 65
Antebellum (2020), 192
Army of the Dead (2021), 178
As Above, So Below (2014), 156

Attack of the 50 Foot Woman (1958), 87
Attack of the Killer Tomatoes (1978), 18
awkward humor, 3, 10–11; definition of, 136–137; in early horror, 139–141; in "elevated" horror, 148–155; in found footage horror, 155–162; in modern horror, 141–148; and potential for horror, 137–139

Bad Hair (2020), 192
Bad Milo (2013), 86
Bad Seed, The (1956), 181
Basket Case (1982), 205n16
Beast Within, The (1982), 92
Beginning of the End (1957), 87
Behind the Mask: The Rise of Leslie Vernon (2006), 20, 24, 156
Bergson, Henri, 7, 97, 205n3
Beyond Re-Animator (2003), 85
Birds, The (1963), 29, 141
Black Cat, The (1934), 23
Blackenstein (1973), 183
Black humor. See African-American humor
Blacula (1972), 183
Blair Witch Project, The (1999), 156, 157
Blazing Saddles (1974), 19–20
Blob, The (1958), 24

223

Blow Out (1981), 33
Body Double (1984), 33–35
body genres, 7, 74
body horror, 3, 9–10, 77; and "grossout" films, 78–86; and slapstick, 97–101; and transformation, 86–97; types of, 73–74
Boulet Brothers' Dragula, The (2016–), 103, 116, 133
Boy, The (film franchise), 65
Brain Damage (1988), 205n16
Brain That Wouldn't Die, The (1962), 81, 83
Bride of Chucky (1998), 25, 120–121
Bride of Frankenstein, The (1935), 4, 104; and camp, 106, 109–111, 120, 126; parody in, 22; parody of, 19, 25
Bride of Re-Animator (1990), 85
Broad City (2014–2019), 1
Brooks, Albert, 151
Brooks, Mel, 13, 17, 19, 20
Browning, Tod, 10, 23, 27, 79–80
Bucket of Blood, A (1959), 60–61
Burning, The (1981), 35, 58
Butler, Judith, 130

Cabin in the Woods, The (2011), 20
camp (form of queer humor), 3, 10; definition of, 105–106; in modern horror, 115–127; and Vincent Price, 111–115; and trans-coded monsters, 127–133; and James Whale, 106–111, 115, 116, 133
Candyman (2021), 192
"Cannibalism in the Cars" (1868 story), 167–168
Carpenter, John, 50, 78
Carrie (1976), 9, 45–46, 58, 94
Carrie (2002), 63
Carrie (2013), 63
Castle, William, 2, 5, 10, 24, 113, 128–130
Castle Rock (2018–2019), 63
Cat and the Canary, The (1939), 18, 20

Cat People (1942), 87, 94
Cat People (1982), 92
Chaney, Lon, Jr., 13, 18, 23, 24
Child's Play (film franchise), 24, 54, 65, 120
Chucky (fictional character), 24, 54, 120–122
C.H.U.D. (1984), 189
Clover, Carol, 2, 4, 7, 20, 35, 54, 127, 204n22
clowns, 3, 6; definition of, 47; as monsters, 9, 47–58, 71
comedy, definition of, 4
Comedy-Horror (film genre), 4
comic monsters. *See* clowns; dolls; dummies; fools
Cooties (2014), 181–182
Corman, Roger, 60, 114
Craven, Wes, 9, 38–39, 91, 146, 190
Crazies, The (1973), 169–170, 173–174, 181, 195
Creature from the Black Lagoon (1954), 29, 30, 60
Creep (2014), 11, 156, 157–160, 163
Creep 2 (2017), 11, 156, 160–162, 163
Creepshow (1982), 169, 184
Cregger, Zach, 2
cringe comedy. *See* awkward humor
Cronenberg, David, 21, 75–76, 90–92
Crypt Keeper, The (fictional character), 49–50, 53
Culture Shock (2019), 193–194
Cunningham, Sean S., 29
Curb Your Enthusiasm (2000–), 11, 136
Curtis, Jamie Lee, 19, 36

Damien: Omen II (1978), 97–98, 99
Dante, Joe, 2, 9, 29–30
Dawn of the Dead (1978), 165, 169, 171–172, 174–175, 178, 190, 191, 195
Dawn of the Dead (2004), 180
Day of the Dead (1985), 169–172, 175–178, 180, 181, 182

Dead Alive (1992), 180
Dead of Night (1945), 66
Dead Silence (2007), 66
Dead Snow (2009), 212n18
Deadtime Stories (1986), 92
Deathdream (1974), 179
Def by Temptation (1990), 183
De Palma, Brian, 32–35, 45
detachment (audience), 7, 9, 16, 21–22, 35, 43, 74, 82
Devil Doll, The (1936), 127
Devil's Rejects, The (2005), 1, 3, 9, 55–58
Diary of the Dead (2007), 169, 171
Dirty Dancing (1987), 186–187
disgust, 74–75
dolls, 65–66. *See also* dummies
Dracula (1931), 23–24, 26
Dracula (fictional character), 13, 23, 24, 26
Dracula's Daughter (1936), 106
drag, 103, 127, 133, 206n1
Drag Me to Hell (2009), 86
Dressed to Kill (1980), 32, 33, 127
Dr. Giggles (1992), 54–55
Dr. Jekyll and Mr. Hyde (1931), 87
Dr. Jekyll and Mr. Hyde (1941), 87
Dr. Jekyll and Sister Hyde (1971), 115
dummies, 9, 66–71. *See also* dolls
Duplass, Mark, 2, 157–158

Earth Dies Screaming, The (1964), 179
Edward Scissorhands (1990), 115
elevated horror, 148, 210n14
Englund, Robert, 24, 116–117
Escape Room (2018), 192
Evil Dead, The (1981), 84
Evil Dead II (1987), 10, 83, 84–85
Exorcist, The (1973), 15, 20, 45, 50, 74, 82, 137

Fade to Black (1980), 58
False Positive (2021), 2
Fearless Vampire Killers, The (1967), 18

Fido (2006), 180–181
Final Destination (film franchise), 10, 97, 98–101, 102, 206n32
Final Destination (2000), 98–99, 101
Final Destination 2 (2003), 99–101
final girl, 7, 29, 35, 40, 127, 132
Final Girls, The (2015), 20
Fly, The (1958), 87, 112
Fly, The (1986), 21, 73, 74, 76, 91–92, 93, 102
folk horror, 151
fools (type of comic monster), 9, 58–65, 71
found-footage horror, 11, 136, 155–157
Frankenhooker (1987), 81
Frankenstein (1931), 13, 15, 22, 23, 59–60
Frankenstein Meets the Wolf Man (1943), 24
Frankenstein's Monster (fictional character), 6, 13, 23, 24, 59–60; and *The Funhouse*, 26, 28
Freaks (1932), 10, 27, 79–81, 102, 167
Freaky (2020), 40
Freddy Krueger (fictional character), 6, 48; as horror icon, 24–25; as monstrous clown, 9, 52–54; as repressed homosexuality, 116–118, 119
Freddy's Nightmares (1988–1990), 53
Freddy vs. Jason (2003), 25
Freud, Sigmund, 5–6, 65–66. *See also* relief theory (of humor); uncanny, the
Friday the 13th (film franchise), 24–25, 58–59, 131
Friday the 13th (1980), 18, 29, 32, 59
Friday the 13th Part III (1982), 82
Friday the 13th Part VI: Jason Lives (1986), 25, 201n25
Friday the 13th Part VII: The New Blood (1988), 82
Friday the 13th: The Final Chapter (1984), 27
Fright Night (1985), 120

From Beyond (1986), 205n16
Full Moon High (1981), 92
Funhouse, The (1981), 25–28

genre theory, 17, 41
Get Out (2017), 1, 11, 152, 155; and awkward humor, 135–136, 149–151; influence of, 192–194; as satire, 165, 168, 182–189
Ghost Breakers, The, 18
Ghostbusters (1984), 4
Ghost of Frankenstein (1942), 13, 24
Ghost Story (1979 novel), 45
Ginger Snaps (2000), 10, 94–96
Glazer, Ilana, 1
Goldthwait, Bobcat, 2
Goosebumps (film franchise), 66
Gordon, Stuart, 83, 205n16
Great Gabbo, The (1929), 67–68
gross-out film, 4, 10, 78–86, 87, 102, 139; and body transformation, 91; and George A. Romero, 169, 171

Halloween (film franchise), 24
Halloween (1978), 18, 24, 26–28, 29, 32, 51–52; and *Scream*, 36, 37
Halloween (2018), 1, 37
Happening, The (2008), 179
Happy Death Day (2017), 40
Happy Death Day 2U (2019), 40
Hellraiser (film franchise), 24
Henenlotter, Frank, 205n16
Hereditary (2018), 148
High Anxiety (1977), 17
Hills Have Eyes, The (1977), 38, 55, 146, 179, 190
His House (2020), 192
Hitchcock, Alfred, 2, 10, 22, 99, 128, 130; and awkward humor, 141–145; parody of, 17, 32–35
Homicidal (1961), 10, 127, 128–130
Hooper, Tobe, 25–26, 27, 91, 146
horror-comedy (film genre), 4

horror fandom, 3, 21–22, 25, 41–42, 82
horror hosts, 50, 53
Horrorstör (2014 novel), 40
horror theory, 5–8, 194–195, 199n11. *See also* affect theory; impurity (in horror); monster theory; monstrous feminine; return of the repressed (theory of horror)
Hostel (film franchise), 86, 99
House of 1000 Corpses (2003), 55
House of Frankenstein (1944), 24
House of Usher (1960), 114
House of Wax (1953), 24, 65, 112–113
House of Wax (2005), 65
House on Haunted Hill (1959), 24, 112, 113–114
House on Sorority Row (1982), 58
Howling, The (1981), 30, 92
humor, definition of, 4
humor theory, 5–8, 46–47, 199n11. *See also* detachment (audience); incongruity theory (of humor); play mode (humor theory); relief theory (of humor); superiority theory (of humor)

iconography, 19, 20–28
identification (audience), 7, 43
I Know What You Did Last Summer (1997), 19
imitation, 17, 29
impurity (in horror), 6
incongruity theory (of humor), 6, 16, 66, 137–138
Incredible Shrinking Man, The (1956 novel), 89–90, 206n18
Incredible Shrinking Man, The (1957), 10, 87–90, 92, 93, 102, 167
Insidious: Chapter 2 (2013), 127
interpretive community, 21–22
Interview with the Vampire (1994), 120
Invisible Man, The (1933), 48–49, 50
Invisible Man, The (2020), 48, 92

Invisible Man Returns, The (1940), 112
Invitation, The (2015), 148
Island of Lost Souls (1932), 106
It (1986 novel), 9, 52
It (film franchise), 47
I Walked with a Zombie (1943), 11, 140–141, 144, 178

Jason Goes to Hell: The Final Friday (1993), 25
Jason Voorhees (fictional character), 24–25, 50, 59, 73
Jaws (1975), 190; parodied by *Piranha*, 9, 29–32, 128
Jaws 2 (1978), 30
Jennifer's Body (2009), 10, 96, 122–125, 133, 166

Karloff, Boris, 19, 23, 24, 59, 114
Key & Peele (2012–2015), 1
Killer Klowns from Outer Space (1988), 18
King, Stephen, 2, 9, 52, 61, 77, 169
King Kong (fictional character), 27
Krasinski, John, 1, 139

Lake Placid (1999), 30
Landis, John, 2, 92
Land of the Dead (2005), 169, 172
Last House on the Left, The (1972), 9, 38–40, 166, 179, 190
Last Man on Earth, The (1964), 179
laughter, as community building, 46–47
Leatherface (fictional character), 23, 25, 40, 127, 146, 148, 210n13
Lewis, Herschell Gordon, 78, 81
Life after Beth (2014), 40, 180
Little Monsters (2018), 192
Little Shop of Horrors, The (1960), 60–61
Lodge, The (2019), 148
Lost Boys, The (1987), 118–120, 189–190
Lovecraft Country (2020), 191–192

Lucky (2020), 192
Lugosi, Bela, 13, 23–24

Ma (2019), 192
Magic (1978), 69–71
Mark of the Vampire (1935), 23–24
Martin (1977), 169
Marx, Groucho, 9, 56–57
Masque of the Red Death, The (1964), 114–115
Master (2022), 192
Matheson, Richard, 87, 89
May (2002), 63–65
McBride, Danny, 1
Michael Jackson's Thriller (1983), 115
Michael Myers (fictional character), 24, 26–27, 73; as clown, 50–51
Midsommar (2019), 11, 149, 151–155, 163
Misery (1987 novel), 61
Misery (1990), 9, 61–63, 65, 160
mockumentary, 11, 136, 155–156, 157
Modern Romance (1981), 151
"Modest Proposal, A" (1729 essay), 167, 168
Mom and Dad (2017), 181–182
Monster Squad, The (1987), 92
monster theory, 45–46, 48, 71; and queer monsters, 103–105
monstrous feminine, 62, 94
Munsters, The (1964–1966), 50
Munsters, The (2022), 58
Mystery of the Wax Museum (1933), 65, 112

Nightmare on Elm Street, A (film franchise), 9, 24–25, 52–54
Nightmare on Elm Street, A (1984), 52, 189
Nightmare on Elm Street, A (2010), 52
Nightmare on Elm Street Part 2: Freddy's Revenge, A (1985), 10, 116–118, 119
Nightmare on Elm Street 3: Dream Warriors, A (1987), 44, 52–53

Nightmare on Elm Street 4: The Dream Master, A (1988), 25, 53
Night of the Living Dead (1968), 13, 38, 81, 165, 167, 195; influence of, 178–180, 182; satire in, 169–173, 175
Night of the Living Dead (1990), 172
Night Shift (1978 fiction collection), 77
Nope (2022), 191

Office, The (2005–2013), 1, 11, 136, 150, 152, 155, 157, 163; "Scott's Tots" episode, 138–139
Old Dark House, The (1932), 11, 167; and awkward humor, 140, 141, 146; and camp, 106–109, 113, 116, 117, 133
Omen, The (1976), 45, 97–98, 181
Open Water (2003), 30

Paranormal Activity (2007), 156
Parents (1989), 40, 168
parody, 3, 8–9; and camp, 105–106; definition of, 16–17; of horror genre, 17–20, 75, 136; of horror icons, 20–28; of horror texts, 28–37; of nonhorror genres, 38–41, 99, 116; and satire, 16, 38, 40, 166
Peele, Jordan, 1, 11, 147, 165–166, 168; influence of, 191–194; as satirist, 182–191, 195
Pennywise (fictional character), 9, 52
Phantom of the Opera, The (1925), 43–45, 48
Phantom of the Paradise (1974), 40
Piranha (1978), 9, 29–32, 128
Pit and the Pendulum, The (1961), 114
play mode (humor theory), 16, 22
Poltergeist (1982), 65
Price, Vincent, 10; and camp performance, 111–115, 116, 133; as horror icon, 19, 24
Pride and Prejudice and Zombies (2009 novel), 40

Prom Night (1980), 58
Psycho (1960), 2, 4, 5, 10, 11, 45, 135; and awkward humor, 141–145, 148, 155, 160; influence of, 52, 70, 122, 127–130, 131, 145–146; parody of, 17, 26, 27, 28, 32–33
Puppet Master (film franchise), 65
Purge (media franchise), 136

queer parody. *See* camp (form of queer humor)
Quiet Place, A (2018), 1, 179

Rabid (1977), 90
Rage: Carrie 2, The (1999), 59
Raimi, Sam, 84, 86
Raven, The (1963), 114
Re-Animator (1985), 10, 81, 83–84, 85
Rear Window (1954), 32, 33
[Rec] (2007), 212n18
Reef, The (2010), 30
relief theory (of humor), 5–6
Repossessed (1990), 13–15, 19, 20
Resident Evil (media franchise), 178
Return of the Living Dead, The (1985), 13, 180
return of the repressed (theory of horror), 5–6, 66–67, 70–71, 88, 117
Revenge of the Nerds (1984), 59
Rick and Morty (2014–), 75–78
rip-offs. *See* imitation
Rock, Chris, 2
Rocky Horror Picture Show, The (1975), 40, 106, 116, 125, 128, 133
Romero, George A., 4, 11, 13, 15, 91, 183, 184; influence of, 178–182, 189, 190–191; as satirist, 165–166, 167–178, 195
Rosemary's Baby (1968), 1, 85, 137, 145, 182

Salem's Lot (1979), 27
Sand Sharks (2011), 30

satire, 3, 11; and cannibalism, 167–168; definition of, 166–167; and parody, 16, 38, 40, 166; and Jordan Peele, 182–194; and George A. Romero, 167–182
Saturday the 14th (1981), 19
Savini, Tom, 21, 78, 172
Saw (film franchise), 2, 86, 99, 138, 192
Scanners (1981), 90–91
Scare Package (2019), 20
Scary Movie (2000), 8, 19
Scouts Guide to the Zombie Apocalypse (2015), 180
Scream (film franchise), 20, 27, 35–37
Scream (1996), 19, 29, 35–37, 171
Scream (2022), 35, 37
Scream, Blacula, Scream (1973), 183
Scream 2 (1997), 37
Scream 3 (2000), 37
Scream 4 (2011), 14, 35, 37
Season of the Witch (1973), 169
Seed of Chucky (2004), 10, 121–122, 128, 133
self-reflexivity, 15–16, 19–21, 22, 24, 42
Seventh Seal, The (1957), 99
Seventh Victim, The (1943), 106
Sharknado (2013), 30
Shaun of the Dead (2004), 180
Shining, The (1980), 45, 125
Shivers (1975), 76
Silence of the Lambs, The (1991), 55, 127
Silver Bullet (1985), 92
Sisters (1972), 33
situation comedy, 181; and awkward humor, 136, 138; parodies of, 9, 15, 38–40, 57, 76, 166, 168, 188
slapstick, 10, 74, 82, 97–102, 137, 171, 205n3
slasher film, 26, 28, 29, 53–55, 116, 145, 206n32; and body humor, 82–83, 97; and fools, 58, 63; and gender, 7, 127, 132, 204n22; parodies of, 18, 19, 33, 34–36, 40–41, 99, 131

Slaxx (2020), 192–193
Sleepaway Camp (1983), 10, 35, 58, 127, 128, 130–133
Sleepaway Camp II: Unhappy Campers (1988), 25
Slice (2018), 192
Slither (2006), 86
Slumber Party Massacre (1982), 34, 35
Slumber Party Massacre II (1987), 40
Smith, Kevin, 2
Society (1989), 83, 85–86, 168
Son of Dracula (1943), 24
Son of Frankenstein (1939), 13
Spider Baby (1967), 107
Spiral (2019), 192
Spiral (2021), 2, 192
Spree (2020), 63, 157
Stage Fright (2014), 40
stand-up comedy, 46
Stepford Wives, The (1975), 85, 137, 182
Student Bodies (1981), 18
superiority theory (of humor), 43, 74, 97, 137
Surf Nazis Must Die (1987), 205n16
Survival of the Dead (2009), 169
Swift, Jonathan, 11, 167

Tales from the Crypt (media franchise), 49–50
Tales from the Hood (1995), 183–184, 192
Teen Wolf (1985), 92
Teeth (2007), 96
Terrifier (film franchise), 47
Terror Train (1980), 127
Texas Chainsaw Massacre (film franchise), 168
Texas Chain Saw Massacre, The (1974), 11, 25, 38, 50, 55, 81, 127; and awkward humor, 145–148, 152, 155, 163; and parody, 40; and satire, 166, 179
Texas Chainsaw Massacre 2, The (1986), 22–23, 127
Theater of Blood (1973), 112, 114

Them (2021), 192
Them! (1954), 87
There's Something about Mary (1998), 74
Thesiger, Ernest, 22, 107, 109–110
Thing, The (1982), 78, 84
Thriller (2018), 63, 192
Tingler, The (1959), 24
Toxic Avenger, The (1984), 205n16
Train to Busan (2016), 212n18
trans-coded monsters, 10, 127–133
trickster figure, 47–49, 52
Twain, Mark, 11, 166, 167–168
Twilight Zone, The (1959–1964; 2019–2020), 191; "The Dummy" episode, 68–69; "Living Doll" episode, 65
Twins of Evil (1971), 115

uncanny, the, 65–66
Universal Studios horror films, 13, 22, 24, 25, 30, 201n25
Us (2019), 11, 188–191

Valentine (2001), 63
Vamp (1986), 120
Vampire in Brooklyn (1995), 183
Vampire Lovers, The (1970), 115
Vampire's Kiss (1988), 33
Vampires vs. the Bronx (2020), 192
Vertigo (1958), 32, 33–34
Videodrome (1983), 91
Village of the Damned (1960), 181
Vincent (1982), 115
Virgin Spring, The (1960), 38

Walking Dead, The (media franchise), 178
Warm Bodies (2013), 40, 178

Wasp Woman, The (1959), 87
Werewolf of London (1935), 87
Whale, James, 2, 10, 22, 48, 60, 140; and camp, 106–111, 115, 116, 133
What We Do in the Shadows (2014), 156
White Zombie (1932), 178
Wicker Man, The (1973), 151
Willard (1971), 58
Willow Creek (2013), 157
Wishmaster (film franchise), 54
WNUF Halloween Special (2013), 156
Wolfen (1981), 92
Wolf Man, The (fictional character), 13, 23, 26
Wolf Man, The (1941), 87
Wood, Robin, 2, 38, 88, 195; on David Cronenberg, 90; on Brian DePalma, 32–33; on the monster, 5–6, 7, 9, 45–46, 48, 66, 70, 117; on George A. Romero, 169–170, 173, 175. *See also* return of the repressed (theory of horror)

Young Frankenstein (1974), 8, 13, 15, 17, 18–19, 22, 59
Yuzna, Brian, 85

Zombie, Rob, 55–58
Zombieland (film franchise), 180
zombies in film, 13, 40, 41, 73, 83, 103, 136; and George A. Romero, 4, 11, 167–178; post–George A. Romero, 178–182, 212n18; pre–George A. Romero, 178
Zombie Survival Guide: Complete Protection from the Living Dead (2003 book), 40

ABOUT THE AUTHOR

DAVID GILLOTA is an associate professor of English at the University of Wisconsin, Platteville, where he teaches courses in film, literature, and writing. He is the author of *Ethnic Humor in Multiethnic America* and the editor of *Studies in American Humor*.